Digital Photogray For Dummies®

Faker's Guide to Digital Photography Lingo

Stuck in a room full of digital photographers? Sprinkle your conversation with these terms to make it sound like you know more about the topic than you really do.

Term	What It Means
CCD	a type of computer chip used inside most digital cameras; the component responsible for capturing the image
compression	a way of shrinking a large image file to a more manageable size
digicam	a hip way to say "digital camera"
dpi	dots per inch; a measurement of how many dots of color a printer can create per inch
dye-sub	short for <i>dye-sublimation;</i> a type of printer that creates excellent prints of digital images
jpegged	pronounced jay-pegged; slang for an image that has been saved using JPEG compression
pixel	the tiny squares of color used to create digital images; like tiles in a mosaic
ppi	pixels per inch; the higher the ppi, the better the image looks when printed
RGB image	an image in which all colors are created by mixing red, green, and blue light; most digital images are RGB images
resample	to add more pixels to an image or throw away existing pixels
resolution	the number of pixels per linear inch (ppi); higher resolution equals better printed images
sharpening	using a command found in most image-editing programs to create the appearance of a more sharply focused picture

Copyright © 1997 IDG Books Worldwide, Inc. All rights reserved.

Cheat Sheet \$2.95 value. Item 0294-8. For more information about IDG Books, call 1-800-762-2974.

Digital Photography For Dummies®

File Format Guide

Rely on these popular file formats when saving digital images.

Format	Description
TIFF	Files saved in this format can be opened on both PC and Macintosh computers. The best choice for preserving all image data, but usually results in larger file sizes than other formats. Don't use for images going on a World Wide Web page.
JPEG	JPEG files can be opened on both PC and Macintosh computers. JPEG can compress images so that files are significantly smaller, but too much compression reduces image quality. One of two formats to use for Web images.
GIF	Use for Web images only. Offers a feature that enables you to make part of your image transparent, so that the Web page background shows through the image. But all GIF images must be reduced to 256 colors, which can create a blotchy effect.
ВМР	Use only for images that will be used as Windows system resources, such as desktop wallpaper.
PICT	Use for images that will be used as Macintosh system resources, such as a desktop pattern.

Common Keyboard Shortcuts

Press these key combinations to perform basic operations in most image-editing programs, as well as in other computer programs.

Operation	Windows Shortcut	Macintosh Shortcut
Open an existing image	Ctrl+0	% +0
Create a new image	Ctrl+N	₩+N
Save an image	Ctrl+S	% +S
Print an image	Ctrl+P	% +P
Cut a selection to the Clipboard	Ctrl+X	₩+X
Copy a selection to the Clipboard	Ctrl+C	% +C
Paste the contents of the Clipboard into an image	Ctrl+V	% +V
Select the entire image	Ctrl+A	% +A
Undo the last thing you did	Ctrl+Z	% +Z
Quit the program	Ctrl+Q	% +Q

References for the Rest of Us!®

COMPUTER BOOK SERIES FROM IDG

Are you intimidated and confused by computers? Do you find that traditional manuals are overloaded with technical details you'll never use? Do your friends and family always call you to fix simple problems on their PCs? Then the ...For Dummies® computer book series from IDG Books Worldwide is for you.

...For Dummies books are written for those frustrated computer users who know they aren't really dumb but find that PC hardware, software, and indeed the unique vocabulary of computing make them feel helpless. ...For Dummies books use a lighthearted approach, a down-to-earth style, and even cartoons and humorous icons to diffuse computer novices' fears and build their confidence. Lighthearted but not lightweight, these books are a perfect survival guide for anyone forced to use a computer.

"I like my copy so much I told friends; now they bought copies."

Irene C., Orwell, Ohio

"Thanks, I needed this book. Now I can sleep at night."

Robin F., British Columbia, Canada

"Quick, concise, nontechnical, and humorous."

Jay A., Elburn, Illinois

Already, millions of satisfied readers agree. They have made ...For Dummies books the #1 introductory level computer book series and have written asking for more. So, if you're looking for the most fun and easy way to learn about computers, look to ...For Dummies books to give you a helping hand.

DIGITAL PHOTOGRAPHY

FOR

DUMMIES®

by Julie Adair King

IDG Books Worldwide, Inc. An International Data Group Company

Foster City, CA ♦ Chicago, IL ♦ Indianapolis, IN ♦ Southlake, TX

Digital Photography For Dummies®

Published by IDG Books Worldwide, Inc. An International Data Group Company 919 E. Hillsdale Blvd. Suite 400

Foster City, CA 94404

www.idgbooks.com (IDG Books Worldwide Web site) www.dummies.com (Dummies Press Web site)

Copyright © 1997 IDG Books Worldwide, Inc. All rights reserved. No part of this book, including interior design, cover design, and icons, may be reproduced or transmitted in any form, by any means (electronic, photocopying, recording, or otherwise) without the prior written permission of the publisher.

Library of Congress Catalog Card No.: 97-80738

ISBN: 0-7645-0294-8

Printed in the United States of America

10987654321

1E/QX/RR/ZX/IN

Distributed in the United States by IDG Books Worldwide, Inc.

Distributed by Macmillan Canada for Canada; by Transworld Publishers Limited in the United Kingdom; by IDG Norge Books for Norway; by IDG Sweden Books for Sweden; by Woodslane Pty. Ltd. for Australia; by Woodslane Enterprises Ltd. for New Zealand; by Longman Singapore Publishers Ltd. for Singapore, Malaysia, Thailand, and Indonesia; by Simron Pty. Ltd. for South Africa; by Toppan Company Ltd. for Japan; by Distribuidora Cuspide for Argentina; by Livraria Cultura for Brazil; by Ediciencia S.A. for Ecuador; by Addison-Wesley Publishing Company for Korea; by Ediciones ZETA S.C.R. Ltda. for Peru; by WS Computer Publishing Corporation, Inc., for the Philippines; by Unalis Corporation for Taiwan; by Contemporanea de Ediciones for Venezuela; by Computer Book & Magazine Store for Puerto Rico; by Express Computer Distributors for the Caribbean and West Indies. Authorized Sales Agent: Anthony Rudkin Associates for the Middle East and North Africa.

For general information on IDG Books Worldwide's books in the U.S., please call our Consumer Customer Service department at 800-762-2974. For reseller information, including discounts and premium sales, please call our Reseller Customer Service department at 800-434-3422.

For information on where to purchase IDG Books Worldwide's books outside the U.S., please contact our International Sales department at 415-655-3200 or fax 415-655-3295.

For information on foreign language translations, please contact our Foreign & Subsidiary Rights department at 415-655-3021 or fax 415-655-3281.

For sales inquiries and special prices for bulk quantities, please contact our Sales department at 415-655-3200 or write to the address above.

For information on using IDG Books Worldwide's books in the classroom or for ordering examination copies, please contact our Educational Sales department at 800-434-2086 or fax 817-251-8174.

For press review copies, author interviews, or other publicity information, please contact our Public Relations department at 415-655-3000 or fax 415-655-3299.

For authorization to photocopy items for corporate, personal, or educational use, please contact Copyright Clearance Center, 222 Rosewood Drive, Danvers, MA 01923, or fax 508-750-4470.

LIMIT OF LIABILITY/DISCLAIMER OF WARRANTY: AUTHOR AND PUBLISHER HAVE USED THEIR BEST EFFORTS IN PREPARING THIS BOOK. IDG BOOKS WORLDWIDE, INC., AND AUTHOR MAKE NO REPRESENTATIONS OR WARRANTIES WITH RESPECT TO THE ACCURACY OR COMPLETENESS OF THE CONTENTS OF THIS BOOK AND SPECIFICALLY DISCLAIM ANY IMPLIED WARRANTIES OF MERCHANTABILITY OR FITNESS FOR A PARTICULAR PURPOSE. THERE ARE NO WARRANTIES WHICH EXTEND BEYOND THE DESCRIPTIONS CONTAINED IN THIS PARAGRAPH. NO WARRANTY MAY BE CREATED OR EXTENDED BY SALES REPRESENTATIVES OR WRITTEN SALES MATERIALS. THE ACCURACY AND COMPLETENESS OF THE INFORMATION PROVIDED HEREIN AND THE OPINIONS STATED HEREIN ARE NOT GUARANTEED OR WARRANTED TO PRODUCE ANY PARTICULAR RESULTS, AND THE ADVICE AND STRATEGIES CONTAINED HEREIN MAY NOT BE SUITABLE FOR EVERY INDIVIDUAL. NEITHER IDG BOOKS WORLDWIDE, INC., NOR AUTHOR SHALL BE LIABLE FOR ANY LOSS OF PROFIT OR ANY OTHER COMMERCIAL DAMAGES, INCLUDING BUT NOT LIMITED TO SPECIAL, INCIDENTAL, CONSEQUENTIAL, OR OTHER DAMAGES. FULFILLMENT OF EACH COUPON OFFER IS THE RESPONSIBILITY OF THE OFFEROR.

Trademarks: All brand names and product names used in this book are trade names, service marks, trademarks, or registered trademarks of their respective owners. IDG Books Worldwide is not associated with any product or vendor mentioned in this book.

is a trademark under exclusive license to IDG Books Worldwide, Inc., from International Data Group, Inc.

About the Author

Julie Adair King is an experienced author and editor of many computer books for beginning and intermediate computer users. She has contributed to several books on digital imaging and computer graphics, including Photoshop 4 For Macs For Dummies, Photoshop 4 For Windows For Dummies, Photoshop 4 Bible, CorelDRAW! 7 For Dummies, PageMaker 6 For Macs For Dummies, and PageMaker 6 For Windows For Dummies. She is also the author of WordPerfect Suite 7 For Dummies and WordPerfect Suite 8 For Dummies.

ABOUT IDG BOOKS WORLDWIDE

Welcome to the world of IDG Books Worldwide.

IDG Books Worldwide, Inc., is a subsidiary of International Data Group, the world's largest publisher of computer-related information and the leading global provider of information services on information technology. IDG was founded more than 25 years ago and now employs more than 8,500 people worldwide. IDG publishes more than 275 computer publications in over 75 countries (see listing below). More than 60 million people read one or more IDG publications each month.

Launched in 1990, IDG Books Worldwide is today the #1 publisher of best-selling computer books in the United States. We are proud to have received eight awards from the Computer Press Association in recognition of editorial excellence and three from *Computer Currents*' First Annual Readers' Choice Awards. Our best-selling ...For Dummies® series has more than 30 million copies in print with translations in 30 languages. IDG Books Worldwide, through a joint venture with IDG's Hi-Tech Beijing, became the first U.S. publisher to publish a computer book in the People's Republic of China. In record time, IDG Books Worldwide has become the first choice for millions of readers around the world who want to learn how to better manage their businesses.

Our mission is simple: Every one of our books is designed to bring extra value and skill-building instructions to the reader. Our books are written by experts who understand and care about our readers. The knowledge base of our editorial staff comes from years of experience in publishing, education, and journalism — experience we use to produce books for the '90s. In short, we care about books, so we attract the best people. We devote special attention to details such as audience, interior design, use of icons, and illustrations. And because we use an efficient process of authoring, editing, and desktop publishing our books electronically, we can spend more time ensuring superior content and spend less time on the technicalities of making books.

You can count on our commitment to deliver high-quality books at competitive prices on topics you want to read about. At IDG Books Worldwide, we continue in the IDG tradition of delivering quality for more than 25 years. You'll find no better book on a subject than one from IDG Books Worldwide.

John Kilcullen

IDG Books Worldwide, Inc.

Steven Berkowitz

President and Publisher
IDG Books Worldwide, Inc.

Eighth Annual Computer Press Awards 1992

Ninth Annual Computer Press Awards ≥199.

Tenth Annual
Computer Press
Awards → 199

Eleventh Annual Computer Press Awards ≿1995

IDG Books Worldwide, Inc., is a subsidiary of International Data Group, the world's largest publisher of computer-related information and the leading global provider of information services on information technology. International Data Group publishers over 275 computer publishcitors in over 75 countries. Stary million people read one or more international Data Group publishers over 275 computer world Agrentina, & Computerworld Connections, Maeworld, Agrentina, & Computerworld Sustria, EANCH Publish, Websites, Web Mod. Publish, Websites, & Computerworld Connections, Maeworld, Polish, Regeller News, Suprangemover, BULGARIA. Computerworld Sulgrain, Aerworld World Edulary, and Sandary, IndoWorld Canada, NetworkWorld Canada, Webvorld, Cell E. Computerworld Canada, IndoWorld Canada, NetworkWorld Canada, Webvorld, Cell E. Computerworld Canada, IndoWorld Canada, Networld Canada, Networld Sulgrain, Agrentina, Cell Canada, Cell Canada, Clentina, Canada, Clentina, IndoWorld Canada, Networld Sulgrain, Agrentina, Cell Canada, Clentina, Canada, Clentina, Canada, Clentina, Canada, Clentina, Canada, IndoWorld Canada, Networld Sulgrain, Canada, Clentina, Canada, Clentina, Canada, Clentina, Canada, IndoWorld Canada, Networld Canada, Networld Canada, Networld Canada, Networld Canada, Networld Canada, Networld Canada, Clentina, Canada, Clent

Dedication

This book is dedicated to my family (you know who you are). Thank you for putting up with me, even on my looniest days. A special thanks to the young 'uns, Kristen, Matt, Adam, Brandon, and Laura, for brightening these past few years with your smiles and hugs.

Author's Acknowledgments

Many, many thanks to all those people who provided me with the information and support necessary to create this book. I especially want to express my appreciation to the following folks for arranging equipment loans:

Joe Runde and Barbara Woolf at Eastman Kodak Company

Andrea Taft at Saphar & Associates, Inc.

John McIndoe at Fargo Electronics, Incorporated

Jennifer De Anda at De Anda Communications

Dennis Steele at Alps Electric (USA), Inc.

Scott Gardiner at Edelman Public Relations Worldwide

Kelly Lesson at Fuji Photo Film U.S.A., Inc.

Cheryl Balbach at Casio, Inc.

Epson America, Inc.

Steve Rosenbaum and Steve Alessandrini at Bozell Sawyer Miller Group

Minolta Corporation

Keri Walker at Apple Computer, Inc.

Leah Archer at Ricoh Corporation

I also want to express my appreciation to my technical editors, Alfred DeBat and Anne Taylor; to copy editor Gwenette Gaddis; to Shelley Lea and the rest of the production team; and to my always understanding and downright terrific project editor, Jennifer Ehrlich. Thanks also to Gareth Hancock, Mary Bednarek, and Diane Steele for presenting me with the opportunity to be involved in this project, and to Joyce Pepple, Heather Dismore, and Kevin Spencer for putting together the CD that accompanies this book.

Last but absolutely not least, my heartfelt thanks to image-editing guru Deke McClelland. More than anyone, you know that I couldn't have done this book without you. Thanks for being so willing to share your experience and knowledge and for introducing me to the fascinating world of pixels!

Publisher's Acknowledgments

We're proud of this book; please register your comments through our IDG Books Worldwide Online Registration Form located at http://my2cents.dummies.com.

Some of the people who helped bring this book to market include the following:

Acquisitions, Development, and Editorial

Project Editor: Jennifer Ehrlich

Acquisitions Editors: Gareth Hancock, Mike Kelly

Copy Editor: Gwenette Gaddis

Technical Editors: Anne Taylor, Alfred DeBat

Editorial Manager: Leah P. Cameron Editorial Assistant: Michael D. Sullivan

Production

Project Coordinator: Sherry Gomoll

Layout and Graphics: Lou Boudreau, Elizabeth Cárdenas-Nelson, Angela F. Hunckler, Brent Savage, M. Anne Sipahimalani, Kate Snell

Proofreaders: Christine Berman, Kelli Botta, Michelle Croninger, Rachel Garvey, Nancy Price, Rebecca Senninger, Janet M. Withers

Indexer: Sherry Massey

Special Help

Kevin Spencer, Associate Technical Editor; Publication Services; Stephanie Koutek; Elizabeth Kuball

General and Administrative

IDG Books Worldwide, Inc.: John Kilcullen, CEO; Steven Berkowitz, President and Publisher

IDG Books Technology Publishing: Brenda McLaughlin, Senior Vice President and Group Publisher

Dummies Technology Press and Dummies Editorial: Diane Graves Steele, Vice President and Associate Publisher; Mary Bednarek, Acquisitions and Product Development Director; Kristin A. Cocks, Editorial Director

Dummies Trade Press: Kathleen A. Welton, Vice President and Publisher; Kevin Thornton, Acquisitions Manager

IDG Books Production for Dummies Press: Beth Jenkins, Production Director; Cindy L. Phipps, Manager of Project Coordination, Production Proofreading, and Indexing; Kathie S. Schutte, Supervisor of Page Layout; Shelley Lea, Supervisor of Graphics and Design; Debbie J. Gates, Production Systems Specialist; Robert Springer, Supervisor of Proofreading; Debbie Stailey, Special Projects Coordinator; Tony Augsburger, Supervisor of Reprints and Bluelines; Leslie Popplewell, Media Archive Coordinator

Dummies Packaging and Book Design: Patti Crane, Packaging Specialist; Lance Kayser, Packaging Assistant; Kavish + Kavish, Cover Design

The publisher would like to give special thanks to Patrick J. McGovern, without whom this book would not have been possible.

٠

Contents at a Glance

Introduction	1
Part I: Peering through the Digital Viewfinder	7
Chapter 1: Filmless Fun, Facts, and Fiction Chapter 2: Mr. Science Explains It All Chapter 3: In Search of the Perfect Camera Chapter 4: Take Your Best Shot	9 21 39
Part II: From Camera to Computer and Beyond	75
Chapter 5: Building Your Image Warehouse	93
Part III: Tricks of the Digital Trade	137
Chapter 8: Making Your Image Look Presentable Chapter 9: Selections on the Move Chapter 10: Pixel Painting 101 Chapter 11: Unleashing Your Creative Genius	139 171 193
Part IV: The Part of Tens	249
Chapter 12: Ten Ways to Improve Your Digital Images	251 259
Part V: Appendixes	
Appendix A: Digital Image Glossary	273
Index	287
License Agreement	325
Installation Instructions	327
Book Registration Information Back	of Book

Cartoons at a Glance

...and now, a digital image of my dad trying to cheat on his income tax neturn."

By Rich Tennant

page 271

page 249

found these two in the multimedia lab morphing faculty members into farm animals."

page 137

page 75

THE PREAK WE'VE BEEN LOOKING FOR CAPTAIN.
THE THEINES FIGURED OUT HOW TO USE
THE DIGITAL CAMERA."

page 7

Fax: 508-546-7747 • E-mail: the5wave@tiac.net

Table of Contents

Introduction	1
Why a Book for Dummies?	2
Part II: From Camera to Computer and Beyond	
Part III: Tricks of the Digital Trade	
Part IV: The Part of Tens	
Part V: AppendixesIcons Used in This Book	
Conventions Used in This Book	
What Do I Read First?	
Part 1: Peering through the Digital Viewfinder Chapter 1: Filmless Fun, Facts, and Fiction	
-	
Film? We Don't Need No Stinkin' Film!Fine, but Why Would I Want Digital Images?	
Now Tell Me the Downside	
Just Tell Me Where to Send the Check	
Image-capture options	
Image-processing and printing equipment	19
Chapter 2: Mr. Science Explains It All	21
From Your Eyes to the Camera's Memory	22
The Secret to Living Color	23
Resolution Rules!	
Pixels: The building blocks of every image	25
Image size + number of pixels = image resolution So how do I raise the resolution?	26
How many pixels are enough?	
The many flavors of resolution	
Monitor and camera resolution	
Printer resolution	31
What all this resolution stuff means to you	32

Aperture, f-stops, and shu	tter speeds: The traditional way	. 33
	and f-stops: The digital way	
	itivity	
	l Acronyms	
	•	
Chapter 3: In Search of the Perf	ect Camera	39
Mac or PC — or Does It Matter?	?	. 40
You Say You Want a Resolution		. 40
	e	
Memory Matters		. 43
	ls	
	screen TV	
Exposure exposed		. 53
Is that blue? Or cyan?		. 53
	ot	
Essential, and Not-So-Essential,	, Extras	. 56
Sources for More Shopping Gui	dance	. 58
Try Before You Buy!		. 59
Chapter 4: Take Your Best Shot		61
-		
	tuation	
	down the sun?	
important Technical Decisions		. 12
Part II: From Camera to Com	puter and Beyond	75
Chapter 5: Building Your Image	Warehouse	77
•		
	mputer	
i ne importance of Being TWAII	N	. 02

Floppies, Zips, and Other Storage Options	83
File Format Free-for-All Electronic Photo Albums	89
Chapter 6: Can I Get a Hard Copy, Please?	
A Plethora of Personal Printers	
Print technologies	94
So which type of printer should you buy?	98
Comparison shopping	99
The Daily Paper	104
Let the Pros Do It	105
Sending Your Image to the Dance	105
Print size and image resolution	107
These colors don't match!	110
More words of printing wisdom	
Chapter 7: On Screen, Mr. Sulu!	113
Step Inside the Screening Room	113
That's About the Size of It	115
What About Image Resolution?	116
Nothing but Net: Images on the Web	118
Some basic Web rules Decisions, decisions: JPEG or GIF?	110
GIF: 256 colors or bust	121
JPEG: The photographer's friend	125
Drop Me a Picture Sometime, Won't You?	128
Redecorate Your Computer's Living Room	131
Creating Windows wallpaper	132
Creating Macintosh wallpaper	133
art III: Tricks of the Digital Trade	137
Chapter 8: Making Your Image Look Presentable	
A Word about Image Editors	140
A Brief Tour of Your Studio	141
How to Open Images	143
Save Now! Save Often!	144 147
Editing Safety Nets Editing Rules for All Seasons	147
Cream of the Crop	149
Help for Unbalanced Colors	152
Using the Color Balance command	152
Using the Variations command	153

	10000000
Bring Your Image Out of the Shadows	15
Give Your Colors More Oomph	15
Focus Adjustments (Sharpen and Blur)	
Sharpening	15
Blur to sharpen?	163
An Instant Fix Is Seldom the Best Fix	16.
Resizing Do's and Don'ts	16
Resizing without altering the pixel count	
Dumping excess pixels	16
Hey Vincent, Get a Larger Canvas!	169
Chapter 9: Selections on the Move	17
Why (And When) Do I Select Stuff?	17
Strap On Your Selection Toolbelt	17
Displaying and using the Selections palette	17
Foisting your selection weapon	
Rectangle, Oval, Circle, and Square tools	17
Color Wand tool	
Trace and Polygon tools	17
The SmartSelect tool	17
Object Selection tool	
Refining your selection outline	
Selection Moves (And Copies and Pastes)	
Cut, Copy, Paste: The old reliables	10
Paste Into: Pasting your selection inside a fence	184
Dragging to move and copy	
Sayonara, Selection!	186
Put a Feather in Your Selection Cap	18
Covering up unsightly image blemishes	
Fading your image into nothingness	190
Chapter 10: Pixel Painting 101	193
Choosing Your Paint Colors	194
Using the Windows color picker	
Using the Apple color picker	19
Brushing on Color	
Plying the paint brush	
Changing brush size and softness	190
Changing tool opacity	200
Painting a Line in the Sand	
Giving Your Cursor a New Shape	201
Smudging Colors Together	
Pouring Color into a Selection	200
Playing with Blend Modes	204
Creating a Gradient Fill	

Adding a BorderBrushing on Transparency	209
Brushing on Transparency	210
Cloning without DNA	211
Swapping One Color for Another	214
Painting Words on Your Image	217
Creating ordinary text	218
Creating special text effects	220
Chapter 11: Unleashing Your Creative Genius	223
Uncovering Layers of Possibility	224
Editing a multilayered image	226
Navigating the Layers palette	227
Adding and deleting layers	228
Moving, resizing, and rotating layers	230
Shuffling layers	231
Fading layers in and out	232
Putting your layers in the blender	233
Smashing layers together	234
Building a multilayered collage	235
Stretching Your Image Beyond Recognition	239
Twirling, Pinching, and Other Funhouse Effects	241
Going Gray	244
Inventing Clouds	245
Turning Garbage into Art	247
Part IV: The Part of Tens	249
Chapter 12: Ten Ways to Improve Your Digital Images	251
5 · · · · · · · · · · · · · · · · · · ·	
Domamhar the Pagalution!	
Remember the Resolution!	252 252
Don't Overcompress Your Images	252
Don't Overcompress Your ImagesLook For the Unexpected Angle	252 253
Don't Overcompress Your Images Look For the Unexpected Angle Light 'Er Up!	252 253 254
Don't Overcompress Your Images Look For the Unexpected Angle Light 'Er Up! Use a Tripod	252 253 254 254
Don't Overcompress Your Images Look For the Unexpected Angle Light 'Er Up! Use a Tripod Compose from a Digital Perspective	252 253 254 254
Don't Overcompress Your Images Look For the Unexpected Angle Light 'Er Up! Use a Tripod Compose from a Digital Perspective Take Advantage of Image-Correction Tools	252 253 254 254 255
Don't Overcompress Your Images Look For the Unexpected Angle Light 'Er Up! Use a Tripod Compose from a Digital Perspective Take Advantage of Image-Correction Tools Print Your Images on Good Paper	252 253 254 255 256 256
Don't Overcompress Your Images Look For the Unexpected Angle Light 'Er Up! Use a Tripod Compose from a Digital Perspective Take Advantage of Image-Correction Tools Print Your Images on Good Paper Practice, Practice, Practice!	252253254254256256256
Don't Overcompress Your Images Look For the Unexpected Angle Light 'Er Up! Use a Tripod Compose from a Digital Perspective Take Advantage of Image-Correction Tools Print Your Images on Good Paper Practice, Practice, Practice! Read the Manual (Gasp!)	252 253 254 255 256 256 256
Don't Overcompress Your Images Look For the Unexpected Angle Light 'Er Up! Use a Tripod Compose from a Digital Perspective Take Advantage of Image-Correction Tools Print Your Images on Good Paper Practice, Practice, Practice! Read the Manual (Gasp!) Chapter 13: Ten Great Uses for Digital Images	252253254254256256256257
Don't Overcompress Your Images Look For the Unexpected Angle Light 'Er Up! Use a Tripod Compose from a Digital Perspective Take Advantage of Image-Correction Tools Print Your Images on Good Paper Practice, Practice, Practice! Read the Manual (Gasp!)	252254254255256256256257259

	Put Your Mug on a Mug	261
	Create a Family or Company Calendar	262
	Add Visual Information to Databases and Spreadsheets	262
	Print Customized Stationery and Greeting Cards	263
	Put a Name with the Face	263
	Wallpaper Your Computer Screen	263
	Create a New Masterpiece for Your Wall	
	Chapter 14: Ten Great Online Resources for Digital	
	Photographers	265
	www.kodak.com	266
	www.powershot.com	
	www.digicam.org	267
	www.digitalphoto.com.nf/	267
	www.zonezero.com	267
	www.hyperzine.com	267
	www.publish.com	268
	rec.photo.digital	268
	comp.periphs.printers	268
	www.manufacturer'snamegoeshere.com	269
ar		271
	t <i>V: Appendixes</i> Appendix A: Digital Image Glossary	
	t V: Appendixes	273
	t <i>V: Appendixes</i> Appendix A: Digital Image Glossary Appendix B: What's on the CD	273 277
	Appendixes Appendix A: Digital Image Glossary Appendix B: What's on the CD	273 277
	Appendix A: Digital Image Glossary	273 277 277 278
	Appendix A: Digital Image Glossary	
	Appendix A: Digital Image Glossary Appendix B: What's on the CD System Requirements How to Use the CD Using Microsoft Windows How to Use the CD Using a Mac OS Computer What You'll Find	
	Appendix A: Digital Image Glossary Appendix B: What's on the CD System Requirements How to Use the CD Using Microsoft Windows How to Use the CD Using a Mac OS Computer What You'll Find ACDSee, from ACD Systems	
	Appendix A: Digital Image Glossary Appendix B: What's on the CD System Requirements How to Use the CD Using Microsoft Windows How to Use the CD Using a Mac OS Computer What You'll Find ACDSee, from ACD Systems Before & After, from Polaroid Corporation	
	Appendix A: Digital Image Glossary Appendix B: What's on the CD System Requirements How to Use the CD Using Microsoft Windows How to Use the CD Using a Mac OS Computer What You'll Find ACDSee, from ACD Systems Before & After, from Polaroid Corporation GraphicConverter, from Lemke Software	
	Appendix A: Digital Image Glossary Appendix B: What's on the CD System Requirements How to Use the CD Using Microsoft Windows How to Use the CD Using a Mac OS Computer What You'll Find ACDSee, from ACD Systems Before & After, from Polaroid Corporation GraphicConverter, from Lemke Software LivePix, from The LivePix Company	
	Appendix A: Digital Image Glossary Appendix B: What's on the CD System Requirements How to Use the CD Using Microsoft Windows How to Use the CD Using a Mac OS Computer What You'll Find ACDSee, from ACD Systems Before & After, from Polaroid Corporation GraphicConverter, from Lemke Software LivePix, from The LivePix Company MGI PhotoSuite SE, from MGI Software	
	Appendix A: Digital Image Glossary Appendix B: What's on the CD System Requirements How to Use the CD Using Microsoft Windows How to Use the CD Using a Mac OS Computer What You'll Find ACDSee, from ACD Systems Before & After, from Polaroid Corporation GraphicConverter, from Lemke Software LivePix, from The LivePix Company MGI PhotoSuite SE, from MGI Software Paint Shop Pro, from JASC, Inc.	
	Appendix A: Digital Image Glossary Appendix B: What's on the CD System Requirements How to Use the CD Using Microsoft Windows How to Use the CD Using a Mac OS Computer What You'll Find ACDSee, from ACD Systems Before & After, from Polaroid Corporation GraphicConverter, from Lemke Software LivePix, from The LivePix Company MGI PhotoSuite SE, from MGI Software Paint Shop Pro, from JASC, Inc. PhotoDeluxe 2.0, from Adobe Systems	
	Appendix A: Digital Image Glossary Appendix B: What's on the CD System Requirements How to Use the CD Using Microsoft Windows How to Use the CD Using a Mac OS Computer What You'll Find ACDSee, from ACD Systems Before & After, from Polaroid Corporation GraphicConverter, from Lemke Software LivePix, from The LivePix Company MGI PhotoSuite SE, from MGI Software Paint Shop Pro, from JASC, Inc. PhotoDeluxe 2.0, from Adobe Systems PhotoImpact, from Ulead Systems	
	Appendix A: Digital Image Glossary Appendix B: What's on the CD System Requirements How to Use the CD Using Microsoft Windows How to Use the CD Using a Mac OS Computer What You'll Find ACDSee, from ACD Systems Before & After, from Polaroid Corporation GraphicConverter, from Lemke Software LivePix, from The LivePix Company MGI PhotoSuite SE, from MGI Software Paint Shop Pro, from JASC, Inc. PhotoDeluxe 2.0, from Adobe Systems PhotoImpact, from Ulead Systems PhotoRecall, from G&A Imaging	
	Appendix A: Digital Image Glossary Appendix B: What's on the CD System Requirements How to Use the CD Using Microsoft Windows How to Use the CD Using a Mac OS Computer What You'll Find ACDSee, from ACD Systems Before & After, from Polaroid Corporation GraphicConverter, from Lemke Software LivePix, from The LivePix Company MGI PhotoSuite SE, from MGI Software Paint Shop Pro, from JASC, Inc. PhotoDeluxe 2.0, from Adobe Systems PhotoImpact, from Ulead Systems PhotoRecall, from G&A Imaging PolyView, from Polybytes	
	Appendix A: Digital Image Glossary Appendix B: What's on the CD System Requirements How to Use the CD Using Microsoft Windows How to Use the CD Using a Mac OS Computer What You'll Find ACDSee, from ACD Systems Before & After, from Polaroid Corporation GraphicConverter, from Lemke Software LivePix, from The LivePix Company MGI PhotoSuite SE, from MGI Software Paint Shop Pro, from JASC, Inc. PhotoDeluxe 2.0, from Adobe Systems PhotoImpact, from Ulead Systems PhotoRecall, from G&A Imaging PolyView, from Polybytes Portfolio, from Extensis Presto! PhotoAlbum, from NewSoft	
	Appendix A: Digital Image Glossary Appendix B: What's on the CD System Requirements How to Use the CD Using Microsoft Windows How to Use the CD Using a Mac OS Computer What You'll Find ACDSee, from ACD Systems Before & After, from Polaroid Corporation GraphicConverter, from Lemke Software LivePix, from The LivePix Company MGI PhotoSuite SE, from MGI Software Paint Shop Pro, from JASC, Inc. PhotoDeluxe 2.0, from Adobe Systems PhotoImpact, from Ulead Systems PhotoRecall, from G&A Imaging PolyView, from Polybytes Portfolio, from Extensis Presto! PhotoAlbum, from NewSoft Images on the CD	
	Appendix A: Digital Image Glossary Appendix B: What's on the CD System Requirements How to Use the CD Using Microsoft Windows How to Use the CD Using a Mac OS Computer What You'll Find ACDSee, from ACD Systems Before & After, from Polaroid Corporation GraphicConverter, from Lemke Software LivePix, from The LivePix Company MGI PhotoSuite SE, from MGI Software Paint Shop Pro, from JASC, Inc. PhotoDeluxe 2.0, from Adobe Systems PhotoImpact, from Ulead Systems PhotoRecall, from G&A Imaging PolyView, from Polybytes Portfolio, from Extensis	

Index	287
License Agreement	325
Installation Instructions	327
Book Registration Information Back	of Book

xxii

Introduction

In the 1840s, a clever Englishman with the lengthy name of William Henry Fox Talbot combined light, paper, a few chemicals, and a wooden box to produce the first modern photograph. Over the years, the process was refined, and people everywhere discovered the joy of photography. They started trading pictures of horses and babies with relatives and friends. They began displaying their handiwork on desks, mantels, and walls. And they finally figured out what to do with those little plastic sleeves inside their wallets.

Today, 150 years and countless *Star Trek* reruns after Talbot's discovery, we're entering a new photographic age. The era of the digital camera has arrived, and with it comes a new and exciting way of thinking about photography. In fact, the advent of digital photography has spawned an entirely new art form — one so compelling that major museums now host exhibitions featuring the work of digital photographers.

With a digital camera, a computer, and some image-editing software, you can explore an entire world of creative possibility that simply doesn't exist with film photography. Even if you have minimal computer experience, you can easily bend and shape the image that comes out of your camera to suit your personal artistic vision. You can combine elements of several different pictures into a photographic collage, for example, and create special effects that are either impossible or extremely difficult to achieve with film.

On a more practical note, digital photography dramatically reduces the time required to touch up everyday images. With a few clicks of a mouse button, you can fix color balance problems, crop away distracting background elements, and even create the appearance of sharper focus.

Digital photography also enables you to share visual information with people around the world almost instantaneously. Literally minutes after snapping a digital picture, you can put the image in the hands of friends, colleagues, or strangers across the globe by attaching it to an e-mail message or posting it on the World Wide Web.

Blending the art of photography with the science of the computer age, digital cameras serve as both an outlet for creative expression and a serious communication tool. Just as important, digital cameras are *fun*. When was the last time you could say *that* about a piece of computer equipment?

Why a Book for Dummies?

Digital cameras have been around for several years, but at a price tag that few people could afford. But now, stores like Wal-Mart are selling entry-level cameras for less than \$300, which moves the technology out of the realm of exotic toy and into the hands of ordinary mortals like you and me. Which brings me to the point of this book (finally, you say).

Like any new technology, digital cameras can be a bit intimidating. Browse the digital camera aisle of your local electronics store, and you'll come face to face with a slew of technical terms and acronyms — *CCD*, *pixel*, *JPEG compression*, and the like. These high-tech buzzwords may make perfect sense to the high-tech folks who have been using digital cameras for a while, but if you're an average consumer, hearing a camera salesman utter a phrase like "This model has a megapixel CCD and uses JPEG compression" is enough to make you run screaming back to the film counter.

Don't. Instead, arm yourself with *Digital Photography For Dummies*. This book explains everything you need to know to become a successful digital photographer, from choosing a camera to shooting, editing, and printing your pictures. And you don't need to be a computer or photography geek to understand what's going on. *Digital Photography For Dummies* speaks your language — plain English, that is — with a dash of humor thrown in to make things more enjoyable.

This book does assume that you have a little bit of computer knowledge, however. For example, you should understand how to start programs, open and close files, and get around in the Windows or Macintosh environment, depending on which type of system you use. Knowing just the right spot to whack your computer if it misbehaves is also valuable. If you're brand new to computers as well as to digital photography, you may want to get a copy of *Windows 95 For Dummies*, by Andy Rathbone, or *Macs For Dummies*, 4th Edition, by David Pogue, as an additional reference.

What's in This Book?

Digital Photography For Dummies covers all aspects of digital photography, from figuring out which camera will work best for your needs to preparing your images for printing or for publishing on the World Wide Web. Although some of the book is devoted to helping newcomers select the right equipment, I also provide a great deal of information that will help those who already own digital cameras to turn out better pictures.

In addition to general background information that will give you a better understanding of how to use your digital camera, you'll also find specific instructions for performing certain image-editing jobs, such as adding text to an image and creating photographic collages.

In order to provide this kind of detail, of course, I had to choose an image-editing program to feature. Dozens of image editors are available, ranging from basic, bare-bones programs to sophisticated, professional-level software, and there was simply no way to cover them all in a book this size. After looking at many different programs, I decided on Adobe PhotoDeluxe 2.0, for two main reasons. First, this program is included with many brands of digital cameras, so many people are using it. Second, the program is available in both Macintosh and Windows versions, while most other image editors are Windows only or Mac only. In addition, this program offers many of the features found in the more sophisticated Adobe Photoshop, which most folks agree is the best image editor on the planet.

If you use a different image editor, however, don't think that this book isn't for you. For the most part, different image editors work much the same way — a crop tool in one program isn't all that different from a crop tool in another program, for example. And the general approach to different editing tasks is the same no matter what program you use. So you can refer to this book for the solid background information you need to understand different editing functions and then easily adapt the specific steps I give to your own image editor.

As a special note to my Macintosh friends, I want to emphasize that although the screen shots in this book were taken on a Windows computer, this book is for Mac as well as Windows users. Whenever I give instructions for how to accomplish a certain digital feat, for example, I provide both Macintosh and Windows commands.

Now that I've firmly established myself as neutral in the computer platform wars, here's a brief summary of the kind of information you can find in *Digital Photography For Dummies*.

Part 1: Peering through the Digital Viewfinder

This part of the book gets you started on your digital photography adventure. The first three chapters in this part of the book help you understand what digital cameras can and can't do, how they work, and how to track down the best camera model for the kind of pictures you want to take. Chapter 4 shares techniques for taking better pictures, from composing an image for greater visual impact to dealing with difficult lighting situations.

Part II: From Camera to Computer and Beyond

After you fill up your camera with images, you need to get them off the camera and out into the world. Chapters in this part of the book show you how to do just that.

Chapter 5 explains the process of transferring image files to your computer and also discusses ways to store and catalog all those images. Chapter 6 gives you a thorough review of your printing options, including information on the different types of color printers. And Chapter 7 looks at ways to display and distribute images electronically — placing them on Web pages, attaching them to e-mail messages, and even creating a personalized desktop background for your computer monitor.

Part III: Tricks of the Digital Trade

In this part of the book, you find out how to perform all kinds of image-editing magic. Chapter 8 discusses basic retouching and image preparation topics, such as how to brighten up an overly dark picture, crop away unwanted portions of the image, and adjust the image size. Chapter 9 explains how to select a portion of your image so that you can edit a specific area, and Chapter 10 examines ways to paint on your image and play with the existing colors in your picture. Chapter 11 flings you full force into the world of image-editing creativity, showing you how to cut and paste several images together, create special effects, and even how to turn a horrible image into an interesting work of art.

Part IV: The Part of Tens

Information in this part of the book is presented in easily digestible, bite-sized nuggets. Chapter 12 contains the top ten ways to improve your digital photographs; Chapter 13 offers ten ideas for using digital images; and Chapter 14 lists ten great on-line resources for times when you need help sorting out a technical problem or just want some creative inspiration. In other words, Part IV is perfect for the reader who wants a quick, yet filling, mental snack.

Part V: Appendixes

In most cases, the back of a book is reserved for unimportant stuff that wasn't useful enough to earn a position in earlier pages. But the back of *Digital Photography For Dummies* is every bit as helpful as the rest of the book.

Appendix A, for example, contains a glossary of hard-to-remember digital photography terms. And Appendix B provides a guide to all the stuff provided on the CD included with this book. The CD has trial versions of a host of great image-editing, viewing, and cataloging software, including Ulead PhotoImpact, MGI PhotoSuite SE, and LivePix, from The LivePix Company. I've also provided some sample images so that you can get your feet wet with digital editing if you haven't yet taken any of your own pictures.

Icons Used in This Book

Like other books in the ... For Dummies series, this book uses icons to flag especially important or helpful information. Here's a quick guide to the icons used in Digital Photography For Dummies:

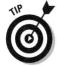

The Tip icon points you to shortcuts that help you avoid doing more work than necessary. This icon is also used to highlight ideas for creating better pictures and suggestions on how to get around problems.

This icon marks stuff that I really think you should commit to memory. Doing so will make your life easier and less stressful, believe me.

When you see this icon, pay attention — danger is on the horizon. Read the text next to a Warning icon to keep yourself out of trouble and to find out how to fix things if you leapt before you looked.

Just when you think you've mastered all the computer lingo you need to know, along comes a whole batch of new terms demanding your understanding. Text marked with this icon breaks the technical gobbledygook down into plain English. In many cases, you really don't need to know this stuff, but boy, will you sound impressive if you do.

This icon lets you know when a product or image that I'm describing is included on the CD at the back of the book. You can try out the program for yourself or open the image and experiment with the technique being discussed.

Conventions Used in This Book

In addition to icons, *Digital Photography For Dummies* follows a few other conventions. When I want you to choose a command from a menu, you see the menu name, an arrow, and then the command name. For example, if I want you to choose the Cut command from the Edit menu, I write it this way: "Choose Edit Cut."

If you need to press two or more keys in succession to accomplish something, I connect those keys with a plus sign. "Press Ctrl+A," for example, means that you should press the Ctrl key and then the A key. Whenever I provide keyboard combinations, by the way, I present the Windows combination first and the Macintosh combination second, like so: "Press Ctrl+A (%+A on the Mac)."

What Do I Read First?

The answer to that question depends on you. You can start with Chapter 1 and read straight through to the index, if you like. Or you can flip to whatever section of the book interests you most and start there.

This book is designed so that if you want to read it cover to cover, you can, and have a mighty fine time doing so. But information is also presented in such a way that you can read and understand one section without having to read anything that comes before or after. So if you need information on a particular topic, you can get in and get out quickly, without having to wade through page after page of unrelated details.

The one thing this book isn't designed to do, however, is to insert its contents magically into your head. You can't just put the book on your desk or under your pillow and expect to acquire the information inside by osmosis — you have to put eyes to page and do some actual reading.

With our hectic lives, finding the time and energy to read is always easier said than done. But I promise that if you spend just a few minutes a day with this book, you'll increase your digital photography skills tenfold. Heck, maybe even elevenfold, or twelvefold. Suffice it to say that you'll discover a whole new way to communicate, whether you're shooting for business, for pleasure, or both.

Digital cameras are the next Big Thing. And with *Digital Photography For Dummies*, you get all the information you need to take advantage of this powerful new tool — quickly, easily, and with more than a few laughs along the way.

Part I Peering through the Digital Viewfinder

"IT'S THE BREAK WE'VE BEEN LOOKING FOR, CAPTAIN.
THE THIEVES FIGURED OUT HOW TO USE
THE DIGITAL CAMERA."

In this part . . .

hen I was in high school, the science teachers insisted that the only way to learn about different creatures was to cut them open and poke about their innards. In my opinion, dissecting dead things never accomplished anything other than providing the boys a chance to gross out the girls by pretending to swallow various formaldehyde-laced body parts.

But even though I'm firmly against dissecting our fellow earthly beings, I am wholly in favor of dissecting new technology. It's my experience that if you want to make a machine work for you, you have to know what makes that machine tick. Only then can you fully exploit its capabilities.

To that end, this part of the book dissects the machine known as the digital camera. Chapter 1 looks at some of the pros and cons of digital photography, while Chapter 2 pries open the lid of a digital camera so that you can get a better understanding of how the thing performs its magic. Chapter 3 puts the magnifying glass to specific camera features, giving you the background you need to select the right camera for you. Then it's out of the lab and into the field for some real-life interaction with your camera in Chapter 4, where you find advice that will help you shoot better pictures.

Alright, everybody put on your smocks and prepare to dissect your digital specimens. And boys, no flinging camera parts around the room or sticking cables up your nose, okay? Hey, that means you, mister!

Chapter 1

Filmless Fun, Facts, and Fiction

In This Chapter

- ▶ Understanding the differences between digital cameras and regular cameras
- Discovering some great uses for digital cameras
- Exploring other options for getting images into your computer
- Assessing the pros and cons of digital photography
- ▶ Knowing when to shoot with film and when to go digital
- ▶ Calculating the digital impact on your wallet

love hanging out in computer stores. I'm not a super gigageek — not that there's anything *wrong* with that — I just enjoy seeing what new gadgets I may be able to justify as tax write-offs.

You can imagine my delight, then, when digital cameras started showing up on the store shelves at a price that even my meager equipment budget could handle. Here was a device that not only offered time and energy savings for my business, but at the same time was a really cool new toy for entertaining friends, family, and any strangers I could corral on the street.

If you, too, have talked your accountant, manager, or significant other into investing in a digital camera, I'd like to offer a hearty "way to go!" — but also a little word of caution. Before you invest in a digital camera, be sure that you understand how this new technology works — and don't rely on the salesperson in your local electronics or computer superstore to fill you in. From what I've observed, many salespeople don't yet have a firm grasp on what digital cameras can and can't do. As a result, people are being fed some major misconceptions about digital photography and are winding up frustrated and disappointed, stuck with cameras that don't fit their needs.

Nothing's worse than a new toy . . . er, *business investment* that doesn't live up to your expectations. Remember how you felt when the plastic action figure that came to life and flew around the room in the TV commercial just

stood there doing nothing after you dug it out of the cereal box? To make sure that you don't experience this same sort of letdown with a digital camera, this chapter sorts out the facts from the fiction, explaining the pros and cons of digital imagery in general and digital cameras in particular.

Film? We Don't Need No Stinkin' Film!

As shown in Figure 1-1, digital cameras come in all shapes and sizes. But although features and capabilities differ from model to model, all digital cameras were created to accomplish the same goal: to simplify the process of creating digital images.

Ricoh RDC-2

Minolta Dimage V

Apple QuickTake 200

Kodak DC120

Figure 1-1: A sampling

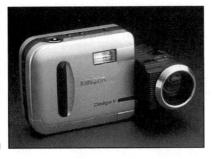

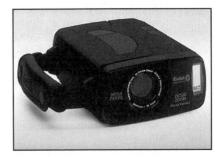

Just in case you're entirely new to the game, let me elucidate a bit: When I speak of a *digital image*, I'm referring to a picture that you can view and edit on a computer. Digital images, like anything else you see on your computer screen, are nothing more than bits of electronic data. Your computer analyzes that data and presents the image to you on-screen. (For a more detailed look at how digital images work, check out Chapter 2, which provides all the gory details.)

Digital images are nothing new — folks have been creating and editing them using programs such as Adobe Photoshop and Corel Photo-Paint (which is part of the CorelDraw package) for years now. But until the advent of digital cameras, the process of getting a stunning sunset scene or endearing baby picture into digital form required some time and effort. After shooting the picture with a film camera, you had to get the film developed and then have the photographic print or slide *digitized* (that is, converted to a computer image) using a piece of equipment known as a *scanner*. Assuming that you weren't well-off enough to have a darkroom and a scanner in the east wing of your mansion, all this could take several days and involve several middlemen and associated middleman costs.

The film-and-scanner approach is still the most common way to create digital photographs. But digital cameras provide an easier, more convenient option. While traditional cameras capture images on film, digital cameras record what they see using computer chips, creating images that can be immediately accessed by your computer. No film, film processing, or scanning is involved — you snap the shutter button, and voilà: You have a digital image. To get images from camera to computer, you simply connect the two devices and transfer the images from one to the other. (See "Out of the Camera, onto the Computer," in Chapter 5, for more details on this process.)

Fine, but Why Would I Want Digital Images?

Whether you use a digital camera to snap your images or take the film-and-scanner approach, going digital opens up a world of artistic and practical possibilities that you simply can't get with traditional photographic prints. Here are just a few advantages you enjoy when you work with digital images:

✓ You gain quality control over your pictures. With traditional photos, you have no input into an image after it leaves your camera — everything rests in the hands of the film developer. If you have a digital image, you can use image-editing software to touch up your pictures, if necessary. You can correct contrast and color-balance problems, improve a poorly focused shot, and crop out unwanted elements, such as ex-boyfriends or ex-girlfriends.

Figure 1-2 illustrates the point: The top image shows the original digital photo. The picture isn't bad, but zooming in on the central subjects and getting rid of that stray cup in the background makes for a much more dynamic image. I performed this editing magic in a few minutes using Adobe PhotoDeluxe, an entry-level image-editing program provided with many digital cameras. (You can find a demo of PhotoDeluxe, as well as several other image editors, on the CD accompanying this book.)

Some would say that I could have created the same image with a traditional camera, simply by paying attention to the background and framing before I took the picture. But moments like the one in Figure 1-2 have to be captured quickly — especially when they involve this many nieces and nephews. Had I taken the time to go pick up the cup and

Figure 1-2: With a little editing, my original pool scene (top) becomes even more compelling (bottom).

frame the picture perfectly, chances are that at least one of my subjects would have started crying, picked a fight, or otherwise destroyed the scene. And the children no doubt would have started acting up, too.

You can send an image to friends, family members, and clients almost instantaneously by attaching it to an e-mail message. This capability is undoubtedly one of the biggest benefits of digital imagery. Journalists covering stories in far-off lands can get pictures to their editors moments after snapping the images. Salespeople can send pictures of products to prospective buyers while the sales lead is still red hot. Or, to pull an example from my own thrilling life, part-time antique dealers can share finds with other dealers all over the world without so much as leaving their homes. When I recently needed some help identifying a Danish antique print, for example, I posted a message to an antiques newsgroup on the Internet. A gentleman in Denmark offered to help if I could send him a copy of the print. No problem. I picked up a digital camera, snapped a picture of the print, sent the image off via e-mail, and had a response the next day. Is this a great day we live in, or what?

Again, you can achieve the same thing with print photographs and the U.S. mail — and don't think we don't all love receiving the 5 x 7 glossy of your dog wearing the Santa hat every Christmas. But if you had a digital image of Sparky, you could get the picture to all interested parties in a matter of minutes, not days. Not only is electronic distribution of images quicker than regular mail or overnight delivery services, it's also more convenient. You don't have to address an envelope, find a stamp, or truck off to the post office or delivery drop box.

- You can include pictures of your products, your office headquarters, or just your pretty face on your company's site on the World Wide Web. A picture, as they say, is worth a thousand words, especially when you're trying to do business with people who live halfway across the planet. Chapter 7 explains everything you need to do to prepare your images for use on the Web.
- ✓ You can include digital images in business databases. For example, if your company operates a telemarketing program, you can insert digital images of your products into the product order database so that when sales representatives pull up information about a certain product, they can see a picture of the product and describe it to customers. Or, you may want to insert product shots into inventory spreadsheets, as I did in Figure 1-3.
- ✓ You can have a heck of a lot of fun exploring your artistic side. Using an image-editing program, you can apply wacky special effects, paint mustaches on your evil enemy, and otherwise distort reality, as discussed in Chapters 10 and 11. You can also combine several images into one, creating an electronic photo montage such as the one shown in Color Plates 11-2 and 11-3 and examined in Chapter 11. Figure 1-1, shown earlier in this chapter, is a photo montage as well; the various camera vendors provided images of their products, and I combined the images into one picture.

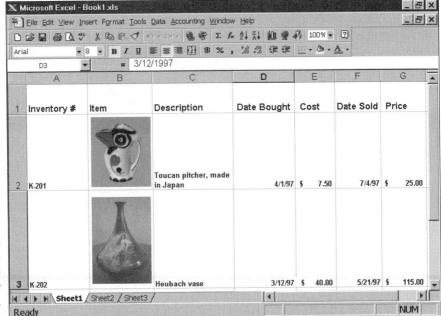

You can insert digital images into spreadsheets to create a visual inventory record.

- ✓ You can create your own personalized calendars, mugs, T-shirts, postcards, and other goodies, as shown in Figure 1-4. Many color printers, such as the Fargo FotoFUN! shown in the figure, come with special accessories that enable you to slap your favorite picture on a variety of objects, from your company-picnic T-shirts to advertising calendars. If you don't have access to a printer with this capability, you can take your image to a quick-copy shop to have the job done.
- ✓ You can incorporate digital images into multimedia presentations created with Microsoft PowerPoint, Corel Presentations, Adobe Persuasion, and other presentations programs. Several digital cameras even come equipped with video-out ports that enable you to display images on a regular old TV set and record them on your VCR.

These advantages are just some of the reasons digital photography is catching on so quickly. For convenience, quality control, flexibility, and efficiency, digital does a slam dunk on film.

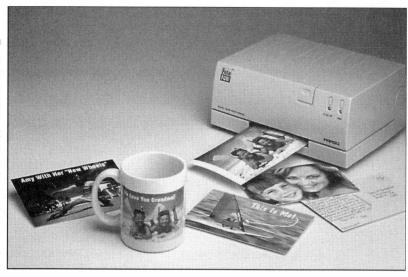

Now Tell Me the Downside

As wonderful as digital photography may be, the technology is not without its drawbacks. In the interest of fairness, the following list discusses some of the problems facing digital photographers:

✓ **Print quality:** Perhaps the biggest problem with digital images is print quality. Consumer-grade digital cameras and color printers (that is, the stuff that you and I can afford) simply can't deliver the same rich colors and crisp detail that you get with traditional photographic prints, although you can come close if you use a higher-end camera such as the Kodak DC120 and one of the new digital photo printers, such as those from Fargo, Epson, and Alps. The quality problem stems from a number of issues, including image resolution and printer technology, two thorny issues discussed in Chapters 2 and 6, respectively.

The good news is that the technology for creating ultra-high quality digital prints is already here. The bad news is that the price of the necessary equipment is prohibitive for individual users. In time, manufacturers will no doubt figure out how to bring the price down to a level affordable to the masses. In the meantime, if you need a very high-quality digital image, such as for a four-color magazine ad, team up with a commercial digital photography studio or service bureau to do the job. If you don't already have a relationship with a studio or service bureau, ask your printer for a recommendation.

- ✓ Original image quality: Digital images rarely come out of the camera or scanner perfectly. You can count on having to do at least a little touch-up work to correct problems with color balance, focus, and contrast on almost all your images. Fortunately, today's image-editing programs make easy work of these types of corrections, and most digital cameras ship with image-editing software. You can read more about image editing in Chapters 8 through 11, and the CD accompanying this book provides demos and trial versions of some popular image-editing programs.
- ✓ Lighting requirements: When you're shooting with a digital camera, lighting becomes a special concern. As discussed in Chapter 4, images tend to lose detail when the lighting is dim. But getting just the right light can be difficult. Shooting in bright sunlight or using a flash or studio lights can create reflections that show up as drop-outs or hot spots spots of pure white that look more like a hole in your image than a beam of sunlight reflecting off your subject. In most cases, though, a few simple editing tricks can correct the problem. "Covering up unsightly image blemishes" in Chapter 9 and "Cloning without DNA" in Chapter 10 explore two different techniques for fixing hot spots.
- ✓ Image capture time: After you press the shutter button on a digital camera, the camera requires a few seconds to store the image in its memory. During that time, you can't shoot another picture. This lag time makes it more difficult to capture action-oriented events, such as a tennis match, with most digital cameras. You can't shoot the same kind of rapid-fire sequential photos as you can with a 35mm camera with an automatic film advance, for example.
- Learning curve: Becoming a digital photographer does involve learning some new concepts and skills. If you're familiar with a computer, you shouldn't have much problem getting up to speed with digital images. If you're a novice to both computers and digital cameras, expect to spend a fair amount of time making friends with your new machines. A digital camera may look and feel like your old film camera on the surface, but underneath, it's a far cry from your father's Kodak Brownie. This book will guide you through the process of becoming a digital photographer as painlessly as possible, but you do need to be willing to invest the time to read the information it contains.

As manufacturers continue to refine digital imaging technology, these problem areas should see great improvement. Whether or not digital will completely replace film as the foremost photographic medium remains to be seen, but for now, don't throw away your film camera. Digital photography and film photography each offer unique advantages and disadvantages, and choosing one option to the exclusion of the other limits your creative flexibility.

Just Tell Me Where to Send the Check . . .

Digital photography equipment was once priced out of range of all but the most high-end photography or graphics studio. But over the past year, prices of cameras, printers, and other necessary equipment have fallen dramatically, making this new art form available to ordinary folks like you and me. Still, digital photography isn't cheap. If you're starting from scratch — that is, you don't even have a computer yet — you can expect to spend a minimum of \$3,000 for even a bare-bones digital setup.

The following sections outline the various costs involved in going digital. Keep in mind that prices mentioned here are valid as of the time of printing — by the time you read this book, prices may have dropped even further. (Don't you wish *everything* would keep coming down in price the way computer technology does?)

Image-capture options

As mentioned earlier in this chapter, you can take two approaches to creating digital images: shoot your pictures with a digital camera, or shoot on film and then digitize your images on a scanner.

Digital cameras aimed at the consumer market cost between \$299 and \$1,000. However, cameras at the low-end of the price range typically produce only low-resolution images and lack other features, such as an LCD monitor, that you may want in certain situations.

The topic of resolution is thoroughly hashed out in Chapter 2, in the section "Resolution Rules!," but to sum up quickly, low-resolution cameras are suitable only for taking pictures that will be displayed on a computer monitor or TV screen (such as images on a World Wide Web page) or printed at very small sizes — about 2 x 3 inches or smaller. If you want to create larger printed images, you need a mid- to high-resolution camera, for which you can expect to pay \$500 and up.

If you think that price tag is hefty, consider the ultra-high-end cameras marketed toward professional photography and graphics studios. These models cost anywhere from \$5,000 to \$50,000 — and up. Figure 1-5 gives you a look at some of the professional-level equipment used at Digitally Done, a commercial photography studio in Indianapolis, Indiana.

Figure 1-5:
A glimpse
of the
equipment
used at
Digitally
Done, a
commercial
photography
studio
geared
toward
clients who
need digital
images.

Scanners come in an equally broad range of prices. As with cameras, a higher price translates to better image quality. But unless you're doing very high-end graphics work, you can get a decent scanner for a few hundred bucks. If you like to shoot 35mm slides, you may want a scanner that can handle both slides and photographic prints, such as the Hewlett-Packard PhotoSmart photo scanner, which retails for \$499. And if you own one of the new APS (Advanced Photo System) film cameras, you may want to investigate products like the Fuji AS-1 Filmscan-it, which can scan developed APS film cartridges. The AS-1, shown in Figure 1-6, retails for \$499.

Figure 1-6:
The Fuji
AS-1
Filmscan-it
can scan
developed
film
cartridges
from APS
film
cameras.

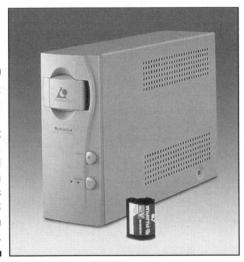

Although having your own digital camera or scanner is by far the most convenient option for creating images, buying your own equipment may not make sense if you have only occasional need for digital images. Many quick-copy shops and film processing labs can scan your photographic print, negative, or slide for you. For quick turnaround, you can go to a one-hour film lab or copy shop, where you pay about \$9 per image to get your pictures scanned onto a floppy disk. If money is more important than time, some discount-store photo labs (such as those in Wal-Mart and Kmart) offer image scanning for less than a dollar an image if you're willing to wait two weeks for delivery.

If you have the option, get your images scanned to a CD rather than a floppy disk. The cost is usually lower — about \$2 per image — and images are typically scanned in the Kodak Photo CD format, which stores the same image at several different resolutions. For more information on CD-ROM storage and the Photo CD format, see "Floppies, Zips, and other Storage Options" and "File Format Free-for-All," both in Chapter 5.

Each Photo CD can hold 100 images. By comparison, a floppy disk can hold only a handful of images, and only then if those images are very small. A single large, high-resolution image may not fit at all on a floppy disk. To find a place that scans to Photo CD, look in the Yellow Pages under "Photo Finishing — Retail" and "Photo Finishing — Custom Laboratories."

If you have several digital images that you need to capture, renting a digital camera may be cheaper and more convenient than shooting on film and having your pictures scanned. A local camera store in my neck of the woods rents cameras for \$20-\$30 per day or \$90 a week (pricing depends on which model you choose).

Renting is an especially good option if you can get by with low-resolution images most of the time, but need high-resolution images every now and then. Instead of investing \$1,000 in a high-resolution camera, spend a few hundred on a low-resolution model to use for your everyday digital needs, and rent a high-resolution model when a project demands it. Call around to local camera stores and computer rental companies for leads on where you can rent a camera in your area.

Image-processing and printing equipment

On top of the camera itself, digital photography involves a slew of peripheral hardware and software, not the least of which is a fairly powerful computer for viewing, storing, editing, and printing your images. You need a machine with a robust processor, such as a Pentium-based PC or a Power Mac. You also need at least 16MB of RAM (more is definitely better) and a big hard drive with lots of empty storage space. Unless you have a better source than I do, the very least you can expect to spend on such a system is \$1,600, including monitor.

Getting your images from computer to paper requires an additional investment. Currently, several decent color printers are being marketed to home and small-office users, with prices ranging in the \$300 to \$500 neighborhood. Chapter 6 explores all your printing options in greater detail.

Add to those expenses the cost of image-editing software, storage devices to hold your images (such as Zip drives and floppy disks), special paper for printing your photos (as discussed in Chapter 6), and camera batteries — and digital cameras suck up battery life like you wouldn't believe. If you're a real photography buff, you'll probably also want to buy special lenses, lights, a tripod, and some of the other bells and whistles discussed in Chapter 3.

Nope, setting up a digital darkroom isn't cheap. Then again, neither is traditional film photography, if you're a serious photographer. And when you consider all the benefits of digital imagery, especially if you do business nationally or internationally, justifying the expense isn't all that difficult. Just in case you're getting queasy, however, look in Chapters 3 and 6 for more details on the various components involved in digital photography — plus some tips on how to cut budgetary corners when possible.

Chapter 2

Mr. Science Explains It All

In This Chapter

- ▶ How digital cameras record images
- ▶ How your eyes and digital cameras see color
- ▶ Which side you should take in the CCD versus CMOS debate
- A perfectly painless primer on pixels
- Everything you need to know about resolution
- The undying relationship between resolution and image size
- ▶ Photographer's guide to f-stops and shutter speeds
- ▶ An introduction to color models
- ▶ Plus a bit about bit depth

f discussions of a technical or scientific nature make you nauseous, please keep a supply of Pepto-Bismol or some other stomach-soothing potion handy while you read this chapter. The following pages are chock-full of the kind of technical babble that makes science teachers and other smart folks drool but leaves us ordinary mortals feeling decidedly motion-sick.

Unfortunately, you just can't be a successful digital photographer without getting acquainted with the science behind the art. But never fear: This chapter provides you with the ideal lab partner as you explore such important concepts as pixels, resolution, f-stops, bit depth, and more. Sorry, you don't dissect any pond creatures or analyze the protein structure of your fingernails in this science class, but you do get to peel back the skin of a digital camera as well as examine the guts of a digital image. Neither exercise is for the faint of heart, but both are critical for gaining the understanding you need to turn out quality images.

From Your Eyes to the Camera's Memory

A traditional camera creates an image by allowing light to pass through a lens onto film. The film is coated with a light-sensitive chemical, and wherever light hits the film, a chemical reaction takes place, recording a latent image. During the film development stage, more chemicals are used to transform the latent image into a printed photograph.

Digital cameras also use light to create images, but instead of film, digital cameras capture images using an *imaging array*, which is a fancy way of saying "a bunch of light-sensitive computer chips." Currently, these chips come in two main flavors: CCD, which stands for *charge-coupled device*, and CMOS, which is short for *Complimentary Metal-Oxide Semiconductor*. (No, Billy, that information won't be on the test, so you can safely forget it right now.)

Although CCD and CMOS each have their advantages and disadvantages (see the Chapter 3 sidebar, "The war between CCD and CMOS"), both chips do essentially the same thing. When struck by light, they emit an electrical charge, which is analyzed and translated into digital image data by a processor inside the camera. The more light, the stronger the charge.

After the electrical impulses are converted to image data, the data is saved to the camera's memory, which may come in the form of a miniature hard drive, a removable memory card, or even a regular old floppy disk. (You can find out more about the different types of memory options in "Memory Matters" in Chapter 3.)

To get the images out of the camera and into your computer, you just attach the two devices with a cable and copy the images to your computer using special image-transfer software. Or, with some cameras, you can hook the camera directly to a printer, enabling you to print your photographs without ever turning on your computer.

Keep in mind that the preceding paragraphs provide a *very* basic overview of how digital cameras record images. I could write an entire chapter on the different types of CCD designs, for example, but you would only wind up with a big headache. Besides, the only time you need to think about this CCD and CMOS stuff at all is when deciding which camera to buy.

The Secret to Living Color

As mentioned in the preceding section, digital cameras create an image by reading areas of light and darkness in a scene. But how does the camera translate that brightness information into the colors you see in the final image? As it turns out, a digital camera does the job pretty much the same way as the human eye does.

To understand how digital cameras — and your eyes — see color, you first need to know that light can be broken down into three primary spectrums: red, green, and blue. Inside your eyeball, you have three receptors corresponding to those spectrums of light. Each receptor measures the brightness of the light in that receptor's particular color spectrum. Your brain combines the information from the three receptors into one multicolored image in your head.

At this point, you may be scratching your head and thinking, "Huh?" If so, here's an analogy that may help: Imagine that you're standing in a darkened room and have one flashlight that emits red light, one that emits green light, and one that emits blue light. If you point all the flashlights at one spot, you end up with white light. Remove all the lights, and you get black. And by turning the beam of each light up or down, so that you produce a higher or lower intensity beam, you can create just about every color of the rainbow. (If you can find three toddlers who own those toy flashlights with colored lenses over the bulbs, you can test this theory for yourself.)

Just like your eyes, a digital camera captures the light intensity — sometimes referred to as *brightness value* — for the red, green, and blue spectrums. When the image is recorded, the values for each color are stored separately in the image file, creating three distinct areas of image information. Digital image professionals refer to these vats of brightness information as *color channels*.

In sophisticated image-editing programs such as Adobe Photoshop, you can view and even edit each color channel independently of the others. Figure 2-1 and Color Plate 2-1 show a color image broken down into its red, green, and blue color channels.

Note that in the color plate, I added red, green, and blue tints to the color channel images to help you see which channel contains which brightness information. In truth, each color channel contains a grayscale image, as in Figure 2-1. That's because the camera records only brightness — or the absence of it — for each color.

Computer monitors and television sets also create images by combining red, green, and blue light, by the way. Images created using these three primary colors of light are known as *RGB images*, oddly enough.

Composite

Red

Green

Figure 2-1:

An RGB
image
(top left)
comprises
three color
channels,
one each
for storing
red, green,
and blue
brightness
values.

At the risk of confusing the issue, I should point out that not all digital images contain three color channels. If you convert an RGB image to a grayscale image inside an image editor, for example, the brightness values for all three color channels are merged together into one channel. And if you convert the image to the *CMYK color model* in preparation for professional printing, you end up with four color channels, one corresponding to each of the four primary colors of ink (cyan, magenta, yellow, and black). For more on this intriguing topic, see "RGB, CMYK, and Other Colorful Acronyms" later in this chapter.

Don't let this color channel stuff intimidate you. Until you become a seasoned image editor, you probably will never need to think twice about channels. I bring them up only so that when you see the term RGB bandied about — and it's bandied about a lot in the digital image world — you have some idea what's going on behind the scenes.

Resolution Rules!

Without a doubt, the number one thing you can do to improve the quality of your digital images is to understand the concept of *resolution*. Unless you make the right choices about resolution, your images will be a disappointment, no matter how captivating the subject, how perfect the setting, how ideal the lighting conditions.

In other words, don't skip this section!

Pixels: The building blocks of every image

Have you ever seen the painting "A Sunday Afternoon on the Island of La Grande Jatte," by the French neo-impressionist painter Georges Seurat? Seurat was a master of a technique known as *pointillism*, in which scenes are composed of millions of tiny dots of paint, created by dabbing the canvas with the tip of a paintbrush. When you stand across the room from a pointillist painting, the dots blend together, forming a seamless image. Only when you get up close to the canvas can you distinguish the individual dots.

Digital images work something like pointillist paintings. Rather than being made up of dots of paint, however, digital images are composed of tiny squares of color known as *pixels*. For those whose brains have cells available for storing technical details, the term *pixel* is short for *picture element*. Don't you wish you could get a job thinking up these clever computer words?

If you magnify an image on-screen, you can make out the individual pixels, as shown in Figure 2-2. Zoom out on the image, and the pixels seem to blend together, just as when you step back from a pointillist painting.

Herein lies one of the difficulties of working with digital images. When printed at small sizes, digital images look great, like the one in the bottom portion of Figure 2-2. But if you enlarge them too much, the pixels become noticeable and the image appears jagged, as in the inset in Figure 2-2. Most low-end digital cameras can't produce a smooth-looking printed image larger than 4×6 inches in size. For more on this thorny issue, keep reading.

Figure 2-2: Zooming in on an image enables you to see the individual pixels.

Image size + number of pixels = image resolution

The number of pixels per inch determines the *image resolution*, which in turn determines how good your image looks when printed. The more pixels, the greater the resolution, and the crisper the image, as illustrated by Figures 2-3 through 2-5. The first image has a resolution of 300 pixels per inch, or *ppi*; the second has a resolution of 150 ppi; and the third has a resolution of 75 ppi. For living-color examples of these three images, see Color Plate 2-2.

Figure 2-3: A grayscale image with a resolution of 300 ppi looks crisp and terrific.

Figure 2-4: When the resolution of the image in Figure 2-3 is reduced to 150 ppi, the image quality is somewhat reduced, but still acceptable for blackand-white printing.

Figure 2-5: Reducing the resolution of the image in Figure 2-4 by 50 percent, to 75 ppi, results in significant image degradation.

Resolution is measured in terms of pixels per *linear* inch, not square inch. So a resolution of 72 ppi means that you have 72 pixels horizontally and 72 pixels vertically, or 5,184 pixels for each square inch of image.

Why does the 75 ppi image in Figure 2-5 look so much worse than its 150 ppi counterpart in Figure 2-4? Because the pixels are bigger. After all, if you divide an inch into 75 squares, the squares are significantly larger than if you divide the inch into 150 squares. And the bigger the pixel, the easier it is for your eye to figure out that it's really just looking at a bunch of squares.

So how do I raise the resolution?

Suppose that you want to convert that 75 ppi image in Figure 2-5 into a higher resolution image. For the sake of easier math, say that you want to double the resolution, to 150 ppi. One way to get that higher resolution is to open the image in an image-editing program and reduce the size of the image by 50 percent. You wind up with the same number of image pixels, but the pixels shrink in order to fit into the new, smaller image territory. The result is a higher number of pixels per inch. Conversely, if you double the size of an image, you cut the resolution in half.

Another way to alter the resolution of an image is to use an image-editing program to *resample* the image, which means to add or eliminate pixels. The problem with this option is that it only works well when you want to reduce the resolution.

Assuming that the image resolution is higher than what you need for the image's intended purpose (see Table 2-1 for guidelines on appropriate resolution values), you can safely toss away extra pixels. But if you add pixels, the program has to guess at the color and brightness of the pixels it should add. And even high-end image-editing programs using sophisticated calculations don't do a very good job of pulling pixels out of thin air, as illustrated by Figure 2-6. To create this figure, I started with the 75 ppi image shown in Figure 2-5 and resampled the image up to 150 ppi in Adobe Photoshop, arguably one of the best image-editing programs available. Compare this new image with the 150 ppi version in Figure 2-4, and you can see just how poorly the computer does at adding pixels to pictures.

So remember: If you want to improve the resolution of an existing image, the only good way to do it is to shrink the image. That's why the cardinal rule of digital photography is to always capture images at the highest resolution setting your camera offers. If you wind up with more pixels than you need, you can always get rid of them, but you can never add pixels after the fact with any degree of success.

Figure 2-6:
The result
of
resampling
the 75 ppi
image from
Figure 2-5
up to a
resolution
of 150 ppi.

Some lower-end image-editing programs don't allow you to reduce image size to raise resolution, however. Instead, they simply resample the image back down to the original resolution when you shrink the image size. So if you start out with a 72-ppi image, you can never improve the resolution, no matter how much you reduce the image. If you're using such an image editor, capturing your images at the highest possible resolution is doubly important.

How many pixels are enough?

"Okay," you're thinking, "so if higher resolution means better-looking images, I want all my images to have lots and lots of pixels, right?" Well, yes and no. Yes, you should always capture your images at the highest resolution your camera (or scanner) permits to give yourself the most flexibility in editing. But the resolution you should use for your final, edited image depends on how you want to use the image.

If you plan on posting the image on a World Wide Web page, for example, a resolution of 72 to 96 ppi is plenty, because most computer monitors aren't set up to display more pixels than that anyway. (Macintosh monitors usually display 72 ppi, while PC monitors generally display 96 ppi.) But if you plan on printing your image in full color in a magazine or other professional publication, you should strive for a resolution of at least 225, preferably higher. Table 2-1 lists some common uses for digital images and the appropriate range of resolution for each use.

Consider Table 2-1 a general guideline only. The capabilities of your output device (printer or monitor) also play an important role in determining the right image resolution. If you're having your image printed professionally, ask the printing technician which resolution to use for optimum print quality. And if you're printing on your own home or office printer, check your printer's manual for resolution guidelines.

Table 2-1 Resolution Guidelines	
Image use	Resolution
World Wide Web page	72 to 96 ppi
Multimedia presentation	72 to 96 ppi
Grayscale images for laser or inkjet printing	90 to 120 ppi
Grayscale images for output on a commercial imagesetter	160 to 300 ppi
Color images for a color laser printer	120 to 180 ppi
Color images for professional four-color printing (and for best results on a color inkjet or microdry printer)	225 to 300 ppi

The many flavors of resolution

As if sorting out all that pixel, resampling, and other image resolution stuff discussed in the preceding sections isn't challenging enough, you also need to be aware that *resolution* doesn't always refer to image resolution as just described. The term is also used to describe the capabilities of digital cameras, monitors, and printers, as explored in the next two sections.

Monitor and camera resolution

Monitor and digital camera resolutions are stated in terms of the *pixel dimensions* — the number of pixels wide by the number of pixels tall.

Most monitors today can display 640×480 pixels or 800×600 pixels. Some monitors can also display $1{,}024 \times 768$ pixels and even $1{,}280 \times 1{,}024$ pixels. The higher the numbers, the smaller the pixels and the greater the resolution.

Digital cameras capture images using the same width/height ratio as monitors (and TVs, for that matter): 4:3. Lower-end cameras can typically deliver 320-x-240-pixel images or 640-x-480-pixel images. Cameras at the higher end of the consumer-model spectrum can capture larger images.

So how do these pixel dimensions relate to the image resolution values discussed in the preceding sections? It depends on the size of the image, of course. Remember, image resolution equals the number of pixels per linear inch. So if you shoot an image at 640 x 480 pixels, and your printed image measures 4 inches by 3 inches, you get an image resolution of 160 ppi. (640 pixels divided by 4 equals 160; 480 pixels divided by 3 also equals 160.)

Now turn your attention toward the somewhat more confusing issue of displaying your images on-screen. Monitors devote one screen pixel to each image pixel. (The exception is when you're working in an image editor and zoom in on the image, in which case several screen pixels are devoted to displaying each image pixel.) So if you display a 640-x-480-pixel image on a monitor that's set to display 640 pixels by 480 pixels, your image fills the entire screen. But the ppi value depends on the size of the monitor. The bigger the screen, the lower the ppi, because you have to spread the available pixels over a greater area. At the 640-x-480 display setting, resolution on a 15-inch monitor is in the 72 ppi range, while the resolution falls to the 55 ppi range on a 17-inch monitor. (If you're doing the math, remember that these monitor sizes reflect the distance from the top-left corner of the screen to the bottom-right corner. And the actual display area is usually much less than the monitor's stated size. A 17-inch monitor, for example, may have a display only $11\ ^{1/2}$ inches wide.)

When creating images for the Web, keep in mind that you can't accurately predict the size your image will appear, because you don't know what monitor display setting your viewers are using. A 640-x-480-pixel image consumes the full screen on a monitor using the 640-x-480 display setting, but only a portion of the screen on a monitor using the 1,280-x-1,240 setting. For more on this topic, including an illustration of how the same image appears when displayed at two different screen settings, see "That's About the Size of It" in Chapter 7.

Printer resolution

Printer resolution is measured in terms of *dots per inch*, or *dpi*, rather than pixels per inch. But the concept is the same: Printed images are made up of tiny dots of color, and dpi is a measurement of how many dots per inch the printer can produce. In general, the higher the dpi, the smaller the dots and the better-looking the printed image. But, as discussed in Chapter 6, gauging a printer solely by dpi can be misleading. Different printers use different printing technologies, some of which result in better images than others. So some 300 dpi printers can actually deliver better results than some 600 dpi printers.

When you think about printer resolution — and really, I hope you don't have to do so very often — also keep in mind that most printers, including laser and inkjet printers, use several printer dots to reproduce each image pixel. So even though a printer resolution of 300 dpi may sound high when compared to image resolution, you're really talking apples and oranges.

What all this resolution stuff means to you

Head starting to hurt? Mine, too. So to help you sort out all the information you accumulated by reading the preceding sections — and to cater to all the scofflaws who didn't take the time to read the preceding sections — here's a brief summary of resolution matters that matter most:

- ✓ Image size ÷ number of pixels = image resolution (ppi). Change one value, and one of the other two values must also change.
- ✓ The higher the resolution, the better the print quality. Refer to
 Table 2-1 for the appropriate resolution values to use for different kinds
 of images.
- ✓ Enlarging a picture reduces image quality. When you enlarge an image, one of two things has to happen either the pixels expand to fit the new image boundaries or the pixels stay the same size and the image-editing software adds pixels to fill in the gaps. Either way, your image quality suffers.
- ✓ To raise the resolution of an existing image, reduce the image size. Note that this technique doesn't work in some low-end image editors that insist on maintaining the original image resolution when you resize the image. In that case, pixels are dumped when you reduce the image, so you don't get any increase in resolution.

Also, some image-editing programs enable you to add pixels to the image, thereby raising the resolution without changing the image size. But even the best software can't perform this task adequately, so never try to resample up (add pixels).

For more information on changing image size and resolution, see "Resizing Do's and Don'ts" in Chapter 8.

- ✓ Always capture images at the highest resolution possible. Remember, you can safely toss away pixels if you want a lower resolution later, but you can never add pixels without degrading your image. Also, you may only need a low-resolution image today for example, if you want to display a picture on the Web but you may decide later that you want to print the image at a large size, in which case you're going to need those extra pixels.
- ✓ To determine what image resolution you can get from a digital camera, divide the camera resolution by the size of the final image. For example, if a camera offers a maximum resolution of 640 x 480 pixels, and you want to create a print that's 4 inches wide by 3 inches tall, divide 640 by 4 or 480 by 3. Either way, you come up with a maximum image resolution of 160 ppi.

✓ More pixels means a bigger image file. And even if you have tons of file-storage space on your computer, bigger isn't always better. Large images take longer to open, edit, and print than small images. If your image has a much higher resolution than you need for the way the image will be used (refer to Table 2-1), dump some pixels, as explained in Chapter 8. Of course, keeping a copy of the file at its original size is always a good idea; one day, you may want to use the image again for a purpose that requires a higher resolution.

File size is a special consideration for images that you plan to post on the Web. The larger the file, the longer it takes your Web audience to download and view the image. See Chapter 7 for information on how to trim your images to an appropriate size for Web distribution.

Lights, Camera, Exposure!

Whether you're working with a digital camera or a traditional film camera, the brightness or darkness of the image is dependent on *exposure* — the amount of light that hits the film or image-sensor array. The more light, the brighter the image. Too much light results in a washed out, or *overexposed*, image; too little light, and the image is dark, or *underexposed*.

Many digital cameras, like many point-and-shoot film cameras, don't give you much control over exposure; everything is handled automatically for you. But some cameras offer a few different automatic exposure settings, and a few higher-end cameras even provide you with complete exposure control.

Regardless of whether you're shooting with an automatic model or one that offers manual controls, you should be aware of the different factors that affect exposure so that you can understand the limitations and possibilities of your camera. To that end, the following sections discuss the various factors that affect exposure, including shutter speed, aperture, and ISO rating.

Aperture, f-stops, and shutter speeds: The traditional way

Before taking a look at how digital cameras control exposure, it helps to understand how a film camera does the job. Even though many digital cameras don't function in quite the same way as a film camera, manufacturers describe their exposure control mechanisms using traditional film terms, hoping to make the transition from film to digital easier for experienced photographers.

In a film camera, a device called a *shutter* is placed between the film and the lens, as shown in Figure 2-7. When the camera isn't in use, the shutter is closed, preventing light from reaching the film. When you take a picture, the shutter opens, and light hits the film. (Now you know why the little button you press to take a picture is called the *shutter release button* and why people who take lots of pictures are called *shutterbugs*.)

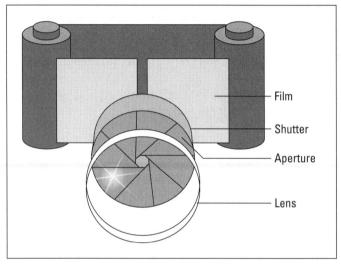

Figure 2-7:
A look at the shutter and aperture setup in a traditional film camera.

You can control the amount of light that reaches the film in two ways: by adjusting the amount of time the shutter stays open (referred to as the *shutter speed*) and by changing the *aperture* opening. As labeled in Figure 2-7, the aperture is a disc set between the lens and the shutter. In the center of the aperture is a hole that can be adjusted in size. Light coming through the lens is funneled through this hole to the shutter and the film. So if you want more light to strike the film, you make the aperture opening bigger; if you want less light, you make the opening smaller.

The size of the aperture opening is measured in *f-numbers*, more commonly referred to as *f-stops*. Standard aperture settings are f/1.4, f/2, f/2.8, f/4, f/5.6, f/8, f/11, f/16, and f/22.

Contrary to what you may expect, the larger the f-stop number, the *smaller* the aperture and the less light that enters the camera. Each f-stop setting lets in half as much light as the next *smaller* f-stop number. For example, the camera gets twice as much light at f/11 as it does at f/16. (And here you were complaining that computers were confusing!) See Figure 2-8 for an illustration that may help you get a grip on f-stops.

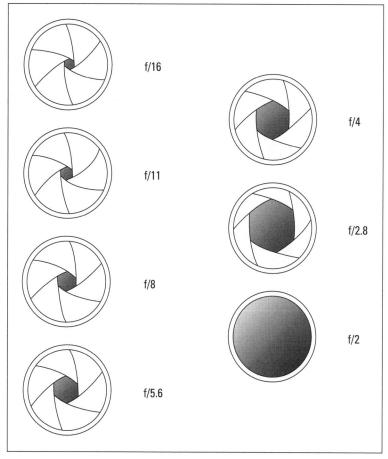

Figure 2-8:
The smaller
the f-stop
number, the
larger the
aperture
opening,
and the
more light is
captured.

Shutter speeds, thankfully, are measured in more obvious terms: fractions of a second. A shutter speed of $^1/8$, for example, means that the shutter opens for $^1/8$ second. That may not sound like much time, but in camera years, $^1/8$ second is in fact a *very* long period. Try to capture a moving object at that speed and you wind up with a big blur. You need a shutter speed of about $^1/500$ second to capture action clearly.

On cameras that offer aperture and shutter speed control, you manipulate the two settings in tandem to capture just the right amount of light. For example, if you are capturing fast action on a bright, sunny day, you can combine a fast shutter speed with a small aperture (high f-stop number). To shoot the same picture at twilight, you need a wide-open aperture (small f-stop number) in order to use the same fast shutter speed.

Aperture, shutter speed, and f-stops: The digital way

Digital cameras, like film cameras, can vary the amount of light that makes its way onto the camera's image-sensor array. But many digital cameras don't have a mechanical shutter or aperture at all. Instead, the chips in the array simply turn on and off for different periods of time, thereby capturing more or less light. In some cameras, exposure is also varied — either automatically or by some control the user sets — by boosting or reducing the strength of the electrical charge that a chip emits in response to a certain amount of light.

Even on cameras that don't incorporate an actual shutter or aperture, however, the camera's capabilities are usually stated in terms of f-stops and aperture settings. For example, you may have a choice of two exposure settings on a camera, and those settings may be labeled with icons that look like the aperture openings shown in Figure 2-8. But in reality, no aperture opens or closes — you simply get the *equivalent* exposure that you would get with a film camera using the same f-stop.

So regardless of whether your camera uses an actual shutter and aperture or just manipulates the chips on the image-sensor array to arrive at exposure, you need to be familiar with the concepts of f-stops and shutter speeds. (So go back and read the preceding section, if you haven't done so yet.)

Aperture and shutter speed aren't the only factors involved in image exposure, however. The sensitivity of the film or chips in the image-sensor array also plays a role, as explained next.

ISO ratings and chip sensitivity

Pick up a box of film, and you should see an ISO number; film geared to the consumer market typically offers ratings of ISO 100, 200, or 400. This number tells you how sensitive the film is to light. The ISO number is also referred to as the *film speed*. The higher the number, the more sensitive the film, or, if you prefer photography lingo, the *faster* the film. And the faster the film, the less light you need to capture a decent image. The advantage of using a faster film is that you can use a faster shutter speed and shoot in dimmer lighting than you can with a low-speed film.

Most digital camera manufacturers also provide an ISO rating for their cameras. This number tells you the *equivalent* sensitivity of the chips on the image-sensor array. In other words, the value reflects the speed of film you'd be using if you were using a traditional camera rather than a digital camera. Typically, consumer-model digital cameras have an equivalency of ISO 100.

I bring all this up because it explains why digital cameras need so much light to produce a decent image. Were you really shooting with ISO 100 film, you would need a wide-open aperture or a slow shutter speed to capture an image in low lighting — assuming that you weren't aiming for the *ghostly shapes in a dimly lit cave* effect on purpose. The same is true of digital cameras. (For more on lighting issues, see Chapter 4.)

RGB, CMYK, and Other Colorful Acronyms

Earlier in this chapter, in the section "The Secret to Living Color," I explained that cameras, monitors, and television sets are called *RGB devices* because they create images by mixing red, green, and blue light. When you edit images, you also mix red, green, and blue light to create the colors you apply with the image-editing program's painting tools.

But RGB is just one of many color-related acronyms and geekspeak terms you may encounter on your image-editing adventures. So that you aren't confused when you encounter these buzzwords, the following list offers a brief explanation:

- ✓ RGB: Just to refresh your memory, RGB stands for red, green, and blue.

 RGB is the color model that is, method for defining colors used by digital images, as well as any device that transmits or filters light (cameras, projectors, monitors, and so on).
- ✓ CMYK: While light-based devices mix red, green, and blue light to create images, printers mix primary colors of ink to emblazon a page with color. Instead of red, green, and blue, however, commercial printers use cyan, magenta, yellow, and black ink. Images created in this way are called CMYK images (the K is used to represent black because everyone figured B could be mistaken for blue). Four-color images printed at a commercial printer need to be converted to the CMYK color mode before printing. (See the sidebar "The separate world of CMYK" in Chapter 6 for more information on CMYK printing.)
- ✓ Bit depth: You sometimes hear people discussing images in terms of bits, as in 24-bit images. (I don't recommend hanging around with these kinds of people, by the way, as they can make you feel inadequate quite quickly.) The number of bits in an image also called the image bit depth indicates how many colors it contains.

Bit is short for *binary digit*, which is a fancy way of saying a value that can equal either 1 or 0. On a computer, each bit can represent two different colors. The more bits, the more colors you see. An 8-bit image has $256 \text{ colors } (2^8=256)$. A 16-bit image has about 32,000 colors, and a

- 24-bit image has about 16 million colors. If you want the most vibrant, full-bodied images, naturally, you want the highest bit depth you can get. But the higher the bit depth, the larger the image file.
- ✓ Indexed color: Indexed color refers to images that have had some of their colors stripped away in order to reduce the image bit depth and, therefore, the file size (see the preceding item). Many people reduce images to 8-bit (256 color) images before posting them on a Web page; in fact, a popular file format for Web images, GIF, doesn't permit you to use any more than 256 colors. Where does the term *indexed* come from? Well, when you ask your image editor to reduce the number of colors in an image, the program consults a color table, called an *index*, to figure out how to change the colors of the image pixels. For more on this topic, see "Decisions, decisions: JPEG or GIF?" in Chapter 7, and also take a look at Color Plate 5-1, which illustrates the difference between a 24-bit image and an 8-bit image.
- ✓ **Grayscale:** A grayscale image is comprised solely of shades of black and white. All the images on the regular pages of this book that is, not on the color pages are grayscale images. Some people (and some image-editing programs) refer to grayscale images as black-and-white images, but a true black-and-white image contains only black and white pixels, with no shades of gray in-between. Graphics professionals often refer to black-and-white images as *line art*.

✓ CIE Lab and HSB: These acronyms refer to two other color models for digital images. Until you become an advanced digital imaging guru, you don't need to worry about them. But just for the record, CIE Lab defines colors using three color channels. One channel stores luminosity (brightness) values, and the other two channels each store a separate range of colors. (The *a* and *b* are arbitrary names assigned to these two color channels.) HSB defines colors based on hue (color), saturation (purity or intensity of color), and brightness.

About the only time you're likely to run into Lab and HSB color options is when mixing paint colors in an image-editing program. Even then, the on-screen display in the color-mixing dialog boxes makes it easy to figure out how to create the color you want. Some programs also give you the option of opening images from certain Photo CD collections in the Lab color mode. But you can safely ignore that option for now.

Chapter 3

In Search of the Perfect Camera

In This Chapter

- Deciding whether to go Macintosh or PC
- Interpreting the numbers you see on the box
- Compressing images and how it affects image quality
- Deciding which bells and whistles you really need and which ones you may be able to do without
- ▶ Considering image storage options: On-board memory or removable media?
- ▶ Choosing accessories to complete your digital photography studio
- Asking other important questions before you hand over your cash

s soon as manufacturing engineers figured out a way to create digital cameras at a price range the mass market could swallow, the rush was on to jump on the digital bandwagon. Today, everyone from long-standing icons of the photography world, such as Kodak, Nikon, and Fuji, to powerhouse players in the computer and electronics market, such as Hewlett-Packard, Apple, and Epson, offers some sort of digital photography product.

Having so many different fingers in the digicam pie is both good and bad. On the upside, more competition means better products, a wider array of choices, and lower prices for consumers. On the downside, you need to do a lot more research to figure out which camera is right for you. Different manufacturers take different approaches to winning the consumer's heart, and sorting through the various options takes some time and more than a little mental energy.

If you're the type who hates to make any decisions on your own, you may be disappointed to learn that I don't give specific brand or model recommendations in this book. The problem is that the digital camera marketplace is in a constant state of flux, with new models and new vendors entering the game every day. Okay, that "every day" part is an exaggeration — every few months, then. The point is, by the time this book gets from my desk to the printer, any model and pricing information may be out-of-date and a batch of new cameras may be on the way to your local stores.

In addition, buying a camera is a very personal decision. The camera that fits snugly into one person's hand may feel awkward in someone else's hand. You may enjoy a camera that has lots of levers, buttons, and dials to play with, while the guy down the block may prefer a model that's plain and simple, with few decisions required on the photographer's part.

But even though I can't guide you to a specific camera, I can help you determine which camera features you really need and which ones you can do without. I can also provide you with a list of questions to ask as you're evaluating different models. As you're about to find out, you need to consider a wide variety of factors before you plunk down your money.

Mac or PC — or Does It Matter?

Here's a relatively easy one. Most — not all, but most — digital cameras work on both the Macintosh and PC platforms. The only difference lies in the cabling that hooks the camera to your computer and the software that you use to download and edit your pictures. Most cameras come with the appropriate cabling and software for both platforms, although you should verify this before making your final selection. Sometimes you do need to pay a few bucks to get the necessary cables and software for your platform.

Nor do you need to worry that your Mac friends won't be able to open your images if you work on a PC, or vice versa. As I discuss in Chapter 6, several image file formats (ways to save your images) work on both platforms. Several image-editing programs are also available for both platforms.

You Say You Want a Resolution

As I discuss in Chapter 2, the number of pixels in an image — also known as the image resolution — plays a large role in the image quality. More pixels means crisper image details and better-looking printed images. Different cameras can capture different numbers of pixels; generally, the more you pay, the more pixels you get. Typically, cameras costing less than \$600 capture a maximum of 640×480 pixels. For \$800 to \$1,000, you can get a pixel count in the 1,280 x 960 range.

How many pixels do you need? That depends on how you want to use your pictures. If you mainly want to share images via e-mail or post pictures on a Web page, a camera delivering 640×480 pixels is more than enough. But if you want to print copies of your pictures or use them in brochures, ads, and the like, you may need a higher resolution. At 640×480 pixels, you can print good snapshot-size photographs, but you won't be happy with the image quality at larger sizes. (For more information on what resolution you need for different image uses, see Table 2-1 in Chapter 2.)

As you compare the resolutions of different models, though, be aware that different cameras deliver a specified resolution in different ways. And the route the camera takes to create image pixels can have an impact on your images. For this reason, you can't simply look at the pixel values on the camera box and make a wholesale judgment about image quality.

Say that a camera offers you a choice of two resolution settings: You can capture an image at either 320 x 240 or 640 x 480 pixels. On some cameras, the camera actually captures the number of pixels you select. But some cameras capture the image at the smaller size and *interpolate* — make up — the rest of the pixels. The camera's brain analyzes the color and brightness information of the existing pixels and adds additional pixels based on that information. But because interpolation is an imperfect science, images captured in this way usually don't look as good as those captured without interpolation. Then again, cameras that work this way are typically cheaper than those that don't.

Just to make things even more confusing, some cameras deliver top-notch images even though they do some interpolation. The Kodak DC120 is a case in point. This camera captures 836,400 pixels. But the pixels captured by the camera are rectangular, not square like an image pixel. These rectangular pixels are *bigger* than those of a regular image pixel; according to Kodak, one camera pixel translates to $1^1/2$ image pixels. So the DC120 produces images that have 1.2 million pixels. Technically, the process of converting those rectangular pixels to regular old square image pixels involves interpolation, and yet the image quality of this camera is very good. The images in Color Plate 2-2 and Color Plate 3-1 were shot with this camera, for example.

Not confused enough yet? Then add this information to the mix: Some cameras *compress* images in order to store them in the camera's memory, and others don't. As discussed in the next section, to *compress* an image means to squish all the data together so that it takes up less room in the camera's memory. Being able to store more images in less space is an advantage, obviously. But because compression can destroy some image data, a highly compressed high-resolution image may come out of the camera looking worse than an uncompressed image at a lower resolution.

The moral of the story is this: For top image quality, look for the camera that delivers the most pixels with the least amount of compression. But because image quality is affected by many other factors, such as how well the camera captures colors and how sensitive the image sensor is to light, don't rely totally on these numbers. Instead, use your head — more specifically, your eyes. Shoot test images on several different cameras, using the same resolution on each camera, and judge for yourself which image quality is better.

The war between CCD and CMOS

Image-sensor chips — the chips that capture the image in digital cameras — fall into two main camps: *CCD*, or charge-coupled device, and *CMOS*, which stands for complimentary metal-oxide semiconductor.

The main argument in favor of CCD chips is that they're more sensitive than CMOS chips, so you can get better images in dim lighting. CCD chips also tend to deliver cleaner images than CMOS chips, which sometimes have a problem with "noise" — small defects in the image.

On the other hand, CMOS chips are less expensive to manufacture, and that cost savings translates into lower camera prices. In addition, CMOS chips are less power-hungry than CCD chips, so you can shoot for longer periods of time before replacing the camera's batteries.

Currently, the overwhelming number of cameras use CCD technology; as I write this, only two CMOS-based models are on the market. But camera manufacturers are working to refine CMOS technology, and when they do, you can expect to hear more about this type of camera in the future.

The Great Compression Scheme

Some digital cameras offer you a choice of image resolutions: You may be able to capture an image at 320×240 pixels, for example, or 640×480 . Other cameras capture all images at the same resolution but offer you a choice of "quality" settings — usually, these settings are labeled something like "Good, Better, Best," "Fine and Superfine," or "Normal Mode and Economy Mode."

Whatever the names, these quality settings indicate the amount of *compression* done to the image in order to store it in the camera's memory. To compress an image means to squeeze out all the excess data, cramming all the image information into the smallest possible package. Several forms of compression are available, but most digital cameras use a type known as JPEG (*jay-peg*) compression.

JPEG stands for Joint Photographic Experts Group, which was the group of people who developed JPEG. (I bet you can't wait to drop that sparkling nugget of information at your next neighborhood picnic.)

Anyway, by compressing your images, the camera can store more pictures in its memory. The more compression, the smaller the image file and the more pictures you can store. The drawback is that JPEG compression sacrifices some image data as it shrinks the image file. The more the image is compressed, the more data you lose and the more the image suffers.

Color Plate 3-1 shows an original, uncompressed image (top image) and the same image after it was saved at a low level of JPEG compression (middle image) and a high level of compression (bottom image). At a low level of compression, the quality loss is barely distinguishable. But at a high level of compression, you can see a definite loss of image detail. All three images have a resolution of 300 ppi.

Different cameras compress images different amounts, and not all cameras use the exact same form of compression — many variations of JPEG exist. So making an apples-to-apples comparison without actually looking at the images from each camera is difficult. But supposing that the two cameras capture images at the same resolution — say, 640 x 480 — you can get an idea of which camera compresses images more by finding out how many images you can store in 1MB of memory at the camera's highest quality setting. The camera that can fit the most images into that 1MB is doing the most compression at that quality setting.

Does that mean that you should steer away from cameras that compress images? Absolutely not. For some projects, such as creating a household insurance inventory or sharing a picture over the Web, most people are happy to sacrifice a little image quality in order to take more pictures between downloading sessions. If you're always going to need the highest possible image quality, though, and you don't want to take the slightest risk of sacrificing data, look for a camera that either doesn't compress images at all or offers a no-compression or low-compression setting.

Memory Matters

Another specification to examine when you shop for digital cameras is what kind of memory the camera uses to store images. Some cameras have built-in memory (if you want to be hip, call it *on-board memory*). After you fill up the camera memory, you can't take any more pictures until you transfer (download) the images to your computer and then delete the images from the camera memory.

Other cameras store images on removable memory cards, sometimes referred to as *removable storage media*. When a memory card is full, you can swap it for another card, much as you do with floppy disks on your computer.

A few cameras, including the Sony Digital Mavica models, have a regular floppy disk drive built into the camera, which enables you to store images on a standard floppy disk. But most cameras use one of two other types of removable memory cards: credit-card sized cards called PC cards (formerly known as PCMCIA cards), and smaller, matchbook-sized cards such as the

SmartMedia and CompactFlash cards. Figure 3-1 shows the Fuji DS-7 digital camera along with a SmartMedia card. The SmartMedia card slips into a slot on the camera's side, as shown in the figure.

Figure 3-1:
The Fuji
DS-7
with its
SmartMedia
memory
card
exposed.

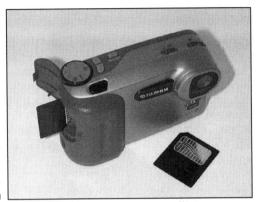

Some cameras offer one memory setup or the other: The Fuji DS-7 has no onboard memory, for example, whereas the Afga ePhoto 307 has 2MB of onboard memory but can't accept removable memory. Other cameras, such as the Kodak DC120, give you limited on-board memory (2MB in this case) plus the option of using removable memory cards.

How much memory is enough, and which option should you use? That depends on how far you want to roam from your computer during photography sessions, the size of the images you want to shoot, how much you're willing to compress images, and how much money you want to spend.

If you plan to do a lot of travel photography, for example, and you won't have access to a computer you can use to download your images, you definitely want a camera that offers a removable storage option. Removable memory is also a plus if you want to shoot most images at a high resolution or using a minimum of image compression (as explained in the preceding sections). The higher the resolution and the lower the amount of compression, the more memory the image consumes. On some cameras, you can store fewer than 10 pictures at the highest resolution or quality setting. Even if you don't plan to do a lot of field shooting, and you're never far from your computer, it's a pain to have to download after every few pictures. So if you're going to invest in a camera that can take high-resolution/low-compression images, plan on investing in some removable memory as well.

When you're thinking about this whole memory issue, keep in mind that you usually can't download images on computers that have less than 16MB of RAM (random access memory). So if you buy a camera without the capacity for removable memory, expecting to be able to download onto that five-year-old laptop you lug with you on your travels, you may be in for a nasty

surprise. I learned this lesson the hard way during a family reunion in Texas. I knew that my sister had a fairly new computer, so I took along a camera that offered only on-board memory. I'd forgotten that not everybody buys computers with megaRAM like us computer nerds, and discovered that my sister's machine had only 8MB of memory. How about my brother-in-law's laptop? He's a cutting-edge kind of guy, so surely . . . nope, only 8MB. Dad's computer? No way — he's still hanging on to his old 386 machine. Anyway, there I was, with a full camera on the first day of the reunion, with no way to download the images so that I could take more pictures.

Removable memory also offers some advantages from the downloading standpoint. With cameras that store images on a floppy disk, you don't have to go through the rigmarole of cabling the camera to the computer to transfer images — you just pop the floppy out of the camera and into your computer's floppy drive. Similarly, PC cards can be inserted into the PC card slot on a notebook computer or a PC card reader attached to your desktop computer for direct card-to-computer transfer. You can do the same thing with miniature memory cards, although you have to buy a special adapter that makes the cards compatible with a PC card reader.

The drawback to removable camera memory, of course, is cost. Memory cards aren't cheap: For PC card and miniature card memory, you pay around \$15–\$20 per megabyte of memory. Floppy disk memory, of course, costs much less — less than \$1 per megabyte. But the floppy-disk setup presents some problems that you don't get with PC cards or miniature memory cards. Because cameras that store images on floppies have built-in floppy disk drives, they consume more battery power and are bulkier than cameras using the two other memory options. In addition, you get less than 1.5MB of storage space per disk, while PC card and miniature cards come in 2MB, 4MB, and larger sizes.

When you're comparing camera memory, be sure to also look closely at the camera manufacturer's "maximum storage capacity" claims — the maximum number of images you can store in the available memory. The maximum storage capacity reflects the number of images you can store at either the lowest resolution or the highest level of compression. So if Camera A can store more pictures than Camera B, and both cameras offer the same amount of memory, Camera A's images must either be of a lower resolution or more highly compressed than Camera B's images. (See "The Great Compression Scheme," earlier in this chapter, for more information.)

To LCD or Not to LCD

Many cameras, including the Apple QuickTake 200 and Casio QV-120 shown in Figure 3-2, have an LCD (*liquid-crystal display*) screen. The LCD screen is like a miniature computer monitor, capable of displaying images stored in

the camera. The LCD is also used on some cameras to display menus that enable you to change the camera settings and delete images from the camera's memory.

Figure 3-2: Many cameras, such as the **Apple** QuickTake 200 and Casio **QV-120** shown here, offer an LCD screen on which you can review the images in the camera's

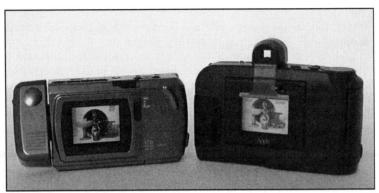

memory.

The ability to review and delete images right on the camera is very helpful, because you avoid the time and hassle of downloading unwanted images. If an image didn't come out the way you wanted, you delete it and try again.

Some cameras with LCD screens, however, don't offer a traditional viewfinder. Instead, you frame your images using the LCD. And some cameras that do offer a viewfinder require you to use the LCD screen to frame pictures when shooting in macro (close-up) mode. I find it difficult to shoot pictures using the LCD as the viewfinder, because you have to hold the camera a few inches away from you in order to see what you're shooting. If your hands aren't that steady, taking a picture without moving the camera can be tricky. Using a tripod is especially helpful in this situation.

LCD screens have a few other drawbacks, too. They add some weight to the camera, and they consume lots of battery juice. Additionally, when you're shooting in bright light, the LCD display tends to wash out, making it difficult to see your images. And of course, an LCD adds to the cost of the camera. Some manufacturers offer the LCD as an optional accessory, while others include it in the basic camera package.

That said, I personally couldn't do without *both* an LCD screen and a viewfinder. Without the LCD, you can't review and delete your pictures on the camera. Without the viewfinder, picture-taking is sometimes awkward — and, on a bright, sunny day, downright difficult.

Special Breeds for Special Needs

As shown in Figure 1-1 in Chapter 1, digital cameras come in all shapes and sizes. Some are styled to look and feel like a 35mm point-and-shoot camera, while others look more like a video camera. There's no right or wrong here — all other things being equal, buy the camera that feels the most comfortable to you.

A few cameras, however, are designed to meet specific needs:

▶ Desktop digital video cameras: A few cameras, including the Kodak DVC-300 and the Connectix QuickCam, are designed to perch atop your computer monitor or desk, as shown in Figure 3-3. These cameras have no viewfinder or LCD — you can see what you're shooting only while the camera is tethered to the computer.

Unlike the cameras that I discuss in the rest of this book, these cameras are digital video cameras, not still-image cameras. Although digital video cameras can capture still images, their primary purpose is to record live video. In fact, when you snap a still image, you're really "freezing" one video frame.

Figure 3-3:
Desktop
cameras
like the
Kodak
DVC-300
are digital
video
cameras
designed
primarily for
videoconferencing
and Internet
telephony.

What's the point? Well, these cameras are designed primarily for videoconferencing and Internet telephony (making phone calls over the Internet). You sit in front of the camera, and the camera transmits your image to the monitor of the person on the other end of the telephone line — assuming that the other person also has the necessary hardware and software. (My greatest fear is that someday this type of thing will become the norm, and everyone who calls will be able to see how I look when I'm working at home.)

Although you find digital video cameras mixed in with all the other digital cameras in computer and electronics stores, they're really a different breed, designed for a narrow market. For that reason, and because capturing and editing digital video is an entirely different process from capturing and editing still digital images, these few paragraphs represent the extent to which I address the subject in this book.

✓ Camera on a card: If you're a bicoastal business warrior and you like to travel light, you may want to check out the Nikon Coolpix 100, which is shown in Figure 3-4. This clever camera is perched on the end of a PC card (also known as a PCMCIA card). After you snap a picture, you insert the PC card end of the camera into your laptop computer's PC card slot to download the images. You can also connect the camera to a PC card reader, a special device that enables you to transfer data from a PC card to a desktop computer. If you don't have either a PC card reader or a portable notebook with a PC card slot, this camera isn't for you.

Figure 3-4: The Nikon Coolpix 100 is a digital camera mounted on a PC card.

Digital SLRs and camera backs: I mention this last category of camera just to make the serious camera buffs in the crowd drool. If you have the money and the inclination, you can buy an ultra-high-resolution digital SLR (single-lens reflex) camera or an adapter that enables you to

take digital images with your existing SLR. Figure 3-5 shows the Canon EOS • DCS1, a digital SLR that merges a Canon camera body with Kodak digital imaging technology. This camera can capture a whopping six million pixels — roughly six times what you can get from a top-of-the-line consumer model. At a list price of just under \$29,000, though, the EOS • DCS1 probably won't be appearing under your Christmas tree anytime soon. Then again, it never hurts to ask, does it?

Cameras that can capture one million pixels or more are called *megapixel* cameras, by the way.

Figure 3-5: **Built for** professional photographers, the Canon EOS • DCS1 is an example of a digital SLR. This camera can capture six million pixels and has an equally impressive price tag: \$28,995.

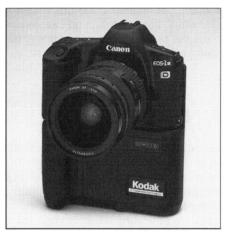

What? No Flash?

When you take pictures using film, a flash is a must for indoor photography and for shooting outdoors in dim lighting. You may be surprised to learn, then, that the same isn't always true for digital cameras.

Some cameras, such as the Fuji DS-7 and its virtual twin, the Apple QuickTake 200, take good indoor pictures without a flash. But not all cameras have the same capability, so before you consider a model that doesn't have a flash, snap some sample pictures in a variety of low-light situations. Also, remember that just as with film cameras, a flash can be very useful even when shooting outdoors, as examined in the section "Let There Be Light" in Chapter 4. You may want a flash to compensate for backlighting, for example, or to light up a subject standing in the shade or shadows.

On cameras that do offer a flash, find out how many different flash options you have. Usually, cameras with a built-in flash give you three settings: *automatic* (the flash fires only when the camera thinks the light is too low); *fill-in flash* (the flash fires no matter what); and *no flash*.

In many cases, you're better off *not* using a flash. Just like the built-in flashes on automatic film cameras, those on digital cameras often cause "red eye" problems — your subject's eyes come out glowing red because the flash is reflected in their eyes. When you're shooting highly reflective objects, such as a ceramic or glass vase, a flash can create *hot spots* or *drop-outs* — areas that reflect too much light and end up completely white in your image. For ideas on how to brighten up a scene so you can go flash-less, see Chapter 4.

Some cameras offer a red-eye reduction flash setting, which is supposed to prevent the red-eye phenomenon. Just as on regular film cameras, this feature isn't terribly reliable, though. Fortunately, you can easily remove red eye using the techniques discussed in "Covering up unsightly image blemishes" in Chapter 9 and "Cloning without DNA" in Chapter 10.

Through a Lens, Perfectly

The size of the camera lens affects how much image area you can capture. Most consumer digital cameras offer lenses equivalent to what you'd find on your basic point-and-shoot film camera. As with aperture settings, discussed in Chapter 2, manufacturers list lens sizes in terms of "equivalencies" — "equivalent to a 36mm focal-length lens on a 35mm camera," for example. The actual lenses on digital cameras are much smaller than those on film cameras.

Color Plate 3-2 shows how lenses of slightly different sizes record the same scene. As you can see, the smaller the lens number, the wider the angle of view. (The Minolta and Kodak models have zoom lenses; I used the widest zoom setting to shoot this image.)

The building in the figure, by the way, is the Lilly Mansion, on the grounds of the Indianapolis Museum of Art. The mansion houses the museum's decorative arts collection, one of several world-class collections you can see at the IMA. If you're ever in Indianapolis, the museum and its grounds are well worth a visit.

Some cameras, such as the Kodak DC120 and Minolta Dimâge V, offer a zoom lens, while others offer dual lenses — one for regular shots and one for telephoto or wide angle shots, for example. Just as with film cameras, you pay extra for zoom or dual-lens cameras.

A few digital cameras offer a lens option you don't find on film cameras: The ability to remove or rotate the lens. The Minolta Dimâge V, for example, has a lens that you can detach from the camera body. You can then hold the lens up in the air to shoot over a crowd or even mount the lens on an optional headband, creating a head-cam, as it were. Whether or not you find the ability to manipulate the lens in this fashion more fun than useful, I can't predict. But what's wrong with having a little fun, anyway?

If you're a serious photographer, you may want to look for a camera that can accept accessory lenses, such as those for extreme close-up work, wide-angle or fisheye shots, and special effects. The Kodak DC120 and the Dycam 10-C are two cameras that can accept auxiliary lenses.

Still More Features to Consider

The preceding sections in this chapter cover the major factors to consider when you're evaluating cameras. But features discussed in the following sections, presented in no particular order, may also be important to you, depending upon the kind of photography you want to do.

Now playing, on your big-screen TV

A number of cameras offer *video-out* capabilities. Translated into plain English, this means that you can connect your camera to your television and display your pictures on the TV screen or record the images on your VCR. Some cameras can also capture frames from your TV or VCR and store them as digital images — this capability is known as *video-in*, of course.

When might you use such a feature? One scenario is when you want to show your pictures to a group of people — such as at a seminar or family gathering. Let's face it, most people aren't going to put up with crowding around your 15-inch computer monitor for very long, no matter how terrific your images are.

Fortunately, video-out is one option that doesn't cost big bucks. Even a few low-price cameras offer this feature.

You may sometimes hear video-out called *NTSC output* (or input). NTSC, which stands for National Television Standards Committee, refers to the standard format used to generate TV pictures in North America. Europe and some other parts of the world go by a different standard, known as *PAL*, an acronym for *Phase Alteration Line-rate*. You can't display NTSC images on a PAL system.

In addition to video input/output options, some cameras, such as the Ricoh RDC-2, enable you to record audio clips along with your images. So when you play back your image, you can actually hear your subjects shouting "cheese!" as their happy mugs appear on-screen.

Ready, set, run!

Many cameras offer a *self-timer* mechanism. Just in case you've never been to a large family gathering and haven't had experience with this particular option, a self-timer enables the photographer to be part of the picture. You press the shutter button, run into the camera's field of view, and after a few seconds, the picture is snapped automatically.

This feature is always good for a few laughs — everyone ends up with silly expectant grins on their faces, because you're never quite sure when that shutter release is going to fire. And the person who has to run into the frame inevitably trips over someone's foot or a table leg on the way from the camera into the scene. Still, a self-timer is the only way to include the photographer in the family portrait, so I give this feature a big thumbs-up.

What's in focus?

Some cameras have *fixed-focus* lenses, which means that the point of focus is unchangeable and fixed at a midpoint distance for normal photography. Typically, the zone of sharpness is very great, so images appear in sharp focus from a few feet in front of the camera to infinity. Many fixed-focus lens cameras also have a macro mode, which permits shooting close-up photos at a distance of only a few inches from the subject. Other cameras enable you to manually set the distance to the subject for the best focus. For example, a camera may have a macro mode for extreme close-ups, a portrait mode for subjects a dozen feet from the camera, and a landscape mode for very distant subjects.

Different cameras offer different focus ranges, which is probably most important in the area of close-up photography. If you want to do lots of close-up work, compare the minimum distance you can put between the camera and the subject.

Cameras with *autofocus* automatically adjust the focus depending on the distance of the subject from the lens. Some autofocus cameras determine the appropriate focus based on the distance of the object that's centered in the frame. This kind of focus is known as *single-spot focus*. Others use *multi-spot focus*, in which the camera measures the subject's distance at three different spots in the frame and then focuses on the nearest object. Some cameras let you choose between these two different focusing schemes.

In addition, some cameras with autofocus abilities offer a very useful feature called *focus lock*. You can use this feature to specify exactly what object you want the camera to focus on, regardless of the object's position in the frame. On most cameras that offer autofocus, you center the subject in the viewfinder, press the shutter button halfway down to lock the focus, and then reframe and snap the picture.

Exposure exposed

Most digital cameras offer *aperture-priority* automatic exposure, which means that you choose the aperture setting, and the camera then reads the available light and adjusts the shutter speed as necessary to deliver a decent exposure. Most cameras give you at least two aperture settings — typically, one setting is for low-light situations and one is for bright-light situations.

If you're an experienced film photographer, you'll want to compare the aperture settings and shutter speeds offered by various cameras. (See Chapter 2 for more on this subject.) And if you're really advanced (or would like to be someday), you'll appreciate cameras like the Kodak DC120, which give you the option of manual exposure control.

Is that blue? Or cyan?

Just as different types of film see colors a little differently, different digital cameras have different interpretations of color. One camera may emphasize the blue tones in an image, whereas another may slightly overstate the red hues, for example.

Color Plate 3-2 illustrates the different color perspectives of three cameras. When looking at this figure, keep in mind that these three cameras represent three points on the price spectrum: the Kodak has an estimated street price of \$799; the Minolta, \$599; and the Casio, \$379. The Kodak delivered the sharpest image, which is to be expected, as the camera captures 1,0.280-x-960-pixel images versus the 640-x-480-pixel images the other two cameras can deliver. None of the cameras produced dead-on color accuracy — the actual colors of the grass and the sky fell somewhere between the colors produced by the Kodak and the Minolta.

Naturally, you want a camera that captures colors as accurately as possible. But in order to compare cameras, you need to actually shoot and download some images — you can't really rely on a camera's LCD to give you an accurate impression of the colors in your images. Keep in mind, too, that your monitor throws its own color prejudices into the mix, as does your printer. So even if a camera catches the colors in a scene accurately, your monitor or your printer may screw things up.

Accurately calibrating camera, monitor, and printer output isn't easy, and even with sophisticated calibration software, called color-management software, sometimes the best you can hope for is pretty-close color matching. So don't expect your interior decorator to be able to use a digital photograph to find a chair that perfectly matches the colors in your couch. If you need super-accurate color matching, you need a professional digital photographer with a professional color-calibration system.

Additionally, keep in mind that today's image-editing programs make it fairly easy to adjust the colors in an image. In the bottom-right image in Color Plate 3-2, I tweaked the Casio image to bring the grass back to life (if only it were that easy to revive a real lawn!). The process took only a few seconds; you can get the how-to's in "Help for Unbalanced Colors" in Chapter 8.

Actually, most cameras do some preliminary color correction as they process and save the image to memory. The amount and type of color correction is based in part on the manufacturer's consumer research. If a manufacturer finds that the target audience for a camera prefers highly saturated colors and deep blues, for example, the saturation and the blues are boosted during the in-camera color correction process. So the final result you see may not be as much a reflection of the camera's ability to record color accurately as an indication of the manufacturer's decisions about what types of colors will please the majority of its customers.

Little things that mean a lot

When you're shopping for digital cameras, you can sometimes focus so much on the big picture (no pun intended) that you overlook the details. The following list presents some of the minor features that may not seem like a big deal in the store, but can really frustrate you after you get the camera home.

✓ Batteries and AC Adapters: Thinking about batteries may seem like a trivial matter, but trust me, this issue becomes more and more important as you shoot more and more pictures. On some cameras, you can suck the life out of a set of batteries in just a few hours of shooting. On cameras with LCD screens (explained in the next section), the battery consumption is even higher.

Some cameras can accept the new AA lithium batteries, which have about three times the life of a standard AA alkaline battery — and cost twice as much. Other cameras use rechargeable NiCad batteries or 3-volt lithium batteries, and others can accept only regular AA alkalines. Be sure to ask which types of batteries the camera can use and how many pictures you can expect to shoot on a set of batteries. Then factor that battery cost into the overall cost of camera ownership.

Many cameras offer an AC adapter that enables you to run the camera off AC power instead of batteries. Some manufacturers include the adapter as part of the standard camera package, whereas others charge extra for it. Either way, the adapter is something you definitely want. That way, you can run the camera on AC power while downloading images — which can take several minutes — and save your batteries for actual picture-taking.

- ✓ Ease of use: When you're looking at cameras, have the salesperson demonstrate how you operate the various controls, and then try working those controls yourself. How easy or how complicated is it to delete a picture, for example, or change the resolution or compression settings? Are the controls clearly labeled and easy to manipulate? After you take a picture or turn the camera off, do all the settings return to the default settings, or does the camera remember your last instructions? If the controls aren't easy to use, you may ultimately be frustrated by the camera.
- ✓ **Tripod mount:** As with a film camera, if you move a digital camera during the time when the camera is capturing the image, you get a blurry picture. And holding a digital camera steady for the length of time the camera needs to capture the exposure can be difficult, especially when you're using the LCD as a viewfinder or if you're shooting in low light (the lower the light, the longer the exposure time). For that reason, using a tripod can greatly improve your pictures. Unless you have very steady hands, be sure to find out whether the camera you're considering can be screwed onto a tripod not all cameras can.
- ✓ Selective delete: As mentioned earlier in the section "To LCD or Not to LCD," cameras that have an LCD screen enable you to review the pictures in the camera's memory and then delete the ones you don't want to keep. But not all cameras let you delete individual images; sometimes you have to erase all pictures in the memory or none at all. If you can't delete individual images (called *selective delete*), you're not likely to use the on-camera delete function much.
- ✓ Physical fit: Don't forget to evaluate the personal side of the camera: Does it fit into your hands well? Can you reach the shutter button easily? Can you hold the camera steady as you press the shutter button? Do you find your fingers getting in the way of the lens, or your nose bumping up against the LCD when you look through the viewfinder? Is the viewfinder large enough that you can see through it easily? All these factors affect your ability to take a good picture, so don't downplay their importance.
- ✓ Durability: Does the camera seem well-built, or is it a little flimsy? For example, when you open the battery compartment, does the little door or cover seem durable enough to withstand lots of opening and closing, or does it look like it might fall off after 50 or 60 uses?

- ✓ Lag time: How long does it take for the computer to store an image in memory? If you take lots of action-oriented photographs, you want the shortest lag time possible.
- Computer connection: How does the camera connect to your computer? Some cameras connect via a serial port, others via a parallel port, others through a SCSI (scuzzy) port, and one the Nikon Coolpix 100 via a PC card slot. Find out which setup the camera uses, and then check out your computer. Do you have the right port or slot available? Or is it currently being used by other peripherals your modem, printer, or mouse, for example? If so, remember that you need to unhook the current peripheral each time you want to connect your camera. Alternatively, you can get a switching device that lets you connect two peripherals into the same port and then switch from one to the other as needed.
- ✓ **Software:** Every camera comes with software for downloading images. But many also come with image-editing software, such as Adobe PhotoDeluxe. Because the programs included with cameras typically retail for under \$50, having an image editor included with the camera isn't a huge deal. Then again, 50 bucks is 50 bucks, so if all other things are equal, the included software is something to consider.

Warranty, restocking fee, exchange policy: As you would with any major investment, find out about the camera's warranty and the return policy of the store. Be aware that some major electronics stores and mail-order companies charge a restocking fee, which means that unless the camera is defective, you're charged a fee for the privilege of returning or exchanging the camera. Some sellers charge restocking fees of 10–20 percent, which can mean a sizable sum out of your pocket.

Essential, and Not-So-Essential, Extras

As I mention in Chapter 1, digital photography involves more than a mere camera. You also need a fairly hefty computer — one with at least 16MB of RAM — plus a good monitor and printer. (Chapter 6 gives you the lowdown on printer options.)

Aside from those essentials, you may also need — or just want — the following extras:

✓ Extra memory cards: As explained earlier in "Memory Matters," memory cards come in several different forms, with two of the most popular being the credit-card-sized PC card (also known as the PCMCIA card) and the smaller SmartMedia and CompactFlash type cards.

Fortunately, you don't have to spend time assessing which type of card to buy, because your camera can likely accept only one kind. As for cost, the price per megabyte is roughly the same no matter which type of card you use: between \$15 and \$20. You can usually buy cards in 2MB, 4MB, or 10MB configurations. If your camera is one that stores images on floppy disks, you can simply use the same floppies you use in your computer's floppy drive. Floppy disks currently cost less than \$1 per disk, with each disk able to hold just under 1.5MB of data.

✓ Memory card adapters and readers: If your camera accepts PC cards, you can pop the memory card out of the camera and into a PC card slot or reader. You then can download your images directly from the card instead of cabling the camera to the computer. If your computer doesn't have a PC card slot, you can buy a PC card reader for about \$125.

If your camera uses SmartMedia or CompactFlash cards, you can buy an adapter that enables you to use the cards with a PC card reader. Fuji offers such an adapter for about \$119.

- ► Extra storage space: Digital image files can be large very large. A high-resolution image can consume several megabytes of memory. Especially if you're shooting a lot of high-res images, you need to seriously consider the storage issue. You could keep all your images on your computer's hard drive, assuming that you have the available storage space. But what if your hard drive crashes? There go all your images. For safety's sake, you should always back up your images onto some form of remo-vable storage media a Zip drive, for example. You also need removable storage if you ever want to share your images with someone by some route other than electronic distribution (e-mail or Internet transmission). And no, your floppy disk drive isn't the answer, at least not for high-resolution or uncompressed images. See Chapter 5 for solutions to the image storage dilemma.
- ✓ Special lens adapter and lenses: If your camera can accept other lenses, you may want to expand your range of creativity by investing in a wide-angle, telephoto, or close-up lens. You can also buy special lens filters, such as those that reduce glare (called polarizing filters). The price range of these accessories varies depending on the quality and type you can spend as little as \$20 for a simple polarizing filter or as much as \$100 for a super-wide-angle lens.
- ✓ **Tripod:** As mentioned earlier, using a tripod can vastly improve your digital images, especially in dim light or when shooting close-ups. You can spend a little or a lot on a tripod, with models available for anywhere from \$20 to several hundred dollars. I can tell you that I've been quite happy with my \$20 model, though. And at that price, I don't worry about tossing the thing into the trunk when I travel, either. Just be sure that the tripod you buy is sturdy enough to handle the weight of your camera.

✓ **Software:** Almost every digital camera comes with some form of image-editing software. These programs enable you to perform basic editing, such as cropping photos and correcting color balance. If you want to perform more advanced editing, you need to upgrade to a professional-level image editor, such as Adobe Photoshop, available for about \$550, or Corel Photo-Paint, which costs about \$350 when purchased on its own and about \$450 when bought as part of the CorelDRAW! suite of graphics programs.

- ✓ In addition to editing software, though, you may also want to invest in a catalog program. Cataloging software enables you to organize and keep track of all your scads of images. Presto! PhotoAlbum (\$29.95, from NewSoft) and PhotoRecall (\$49.95, from G&A Imaging) are two such programs. You can find out more about cataloging your images in Chapter 5. The CD at the back of this book includes trial copies of both Presto! PhotoAlbum and PhotoRecall.
- ✓ Special printing media: When you get ready to print your images, you have a huge assortment of paper from which to choose, from plain old copy paper to specially coated photographic stock. You can also print your images on mugs, greeting cards, and other special media. Chapter 6 discusses the different options and how much you'll pay for each.

✓ Camera case or bag: A few digital cameras come with a camera case, but most don't. Please don't even think about not buying a case for your camera. You're spending a few hundred dollars, minimum, on the camera, so spend a few bucks to prolong its life. You can pick up a decent, padded carrying case for about \$10 at a discount store, or, if you want to spend a little more, head for a camera store, where you can buy a full-fledged camera bag that has room for all your batteries and other gear for about \$30–\$75.

Sources for More Shopping Guidance

If you read this chapter, you should have a solid understanding of the features you do and don't want in your digital camera and what peripherals you may need. But I urge you to do some more in-depth research so that you can find out the details on specific makes and models.

First, look in magazines like *Shutterbug, PC Photo, Macworld*, and *PC World* for reviews on individual digital cameras and peripherals. Some of the reviews may be too high-tech for your taste or complete understanding, but if you first digest the information in this chapter as well as Chapter 2, you should be able to get the gist of the reviewer's comments.

If you have Internet access, log into a digital photography or computer newsgroup and ask whether anyone has any personal experience with models you're considering. You can also find good information on several Web sites dedicated to digital photography. See Chapter 14 for suggestions on a few newsgroups and Web sites worth visiting.

Try Before You Buy!

Some camera stores offer digital camera rentals. If you can find a place to rent the model you want to buy, I *strongly* recommend that you do so before you make a purchase commitment. For about \$30 a day, you can spend a day testing out all the camera's bells and whistles. If you decide that the camera isn't right for you, you're out 30 bucks, but that's a heck of a lot better than spending several hundred dollars to buy the camera and finding out too late that you made a mistake.

To find a place that rents cameras, call your local camera, computer, and electronics stores. As digital cameras become more and more popular, more and more outlets may begin offering short-term camera rentals.

Chapter 4

Take Your Best Shot

In This Chapter

- Evolving from picture-taker to photographer
- ▶ Composing your image for maximum impact
- Shooting images for easier compositing
- Compensating for backlighting and low light
- ▶ Choosing the right resolution, f-stop, and shutter speed

fter you figure out the mechanics of your camera — how to load the batteries, how to turn on the LCD, and so on — taking a picture is a simple process. Just aim the camera at the subject and press the shutter button. Taking a *good* picture, however, isn't so easy. Sure, you can record an okay image of your subject without much effort. But if you want a crisp, clear, dynamic image, you need to consider a few factors before you point and shoot.

This chapter explores the elements that go into a superior image, from traditional photographic concerns, such as composition, to issues specific to digital cameras, such as choosing the right resolution. By mulling over the concepts presented in this chapter, you can begin to move from the realm of so-so picture-taker into creative, knock-their-socks-off photographer.

One thing I can't do in this chapter is give you specifics on how to use your particular camera. So before you dig into this chapter, spend a little time with your camera's instruction manual. I know, reading manuals is a drag, but you can't exploit your camera's capabilities fully unless you take the time to find out how all those little buttons, knobs, and dials work.

Composition 101

Consider the image in Figure 4-1. As pictures go, it's not bad. The subject, a statue at the base of the Soldiers and Sailors monument in downtown Indianapolis, is interesting enough. The image is crisp, and the lighting is good. But overall, the picture is . . . well, a little boring.

Now look at Figure 4-2, which shows two additional images of the same subject, but with more powerful results. What makes the difference? In a word, *composition*. Simply framing the statue differently, zooming in for a closer view, and changing the camera angle created much more captivating images.

Figure 4-1:
This image falls flat because of its uninspired framing and angle of view.

Figure 4-2:
Getting
closer to
the subject
and
shooting
from lessobvious
angles
results in
more
interesting
pictures.

Not everyone agrees on the "best" ways to compose an image — art being in the eye of the beholder and all that. And for every composition rule, there's an incredible image that proves the exception. That said, the following list offers some suggestions that can help you create images that rise above the ho-hum mark on the visual interest meter:

- ✓ Remember the rule of thirds: For maximum impact, don't place your subject smack in the center of the frame, as was done in Figure 4-1. Instead, mentally divide the image area into thirds, as illustrated in Figure 4-3. Then position the main subject elements at spots where the dividing lines intersect.
- ✓ Draw the eye across the frame: To add life to your images, compose the scene so that the viewer's eye is naturally drawn from one edge of the frame to the other, as in Figure 4-4. The figure in the image, also part of the Soldiers and Sailors monument, appears ready to fly off into the big, blue yonder. You can almost feel the breeze blowing the torch's flame and the figure's cape.

Figure 4-3:
One rule of
composition
is to divide
the frame
into thirds
and position
the main
subject at
one of the
intersection
points.

Figure 4-4:
To add life
to your
images,
frame the
scene so
that the eye
is naturally
drawn from
one edge of
the image
to the other.

- ✓ Avoid the plant-on-the-head syndrome: In other words, watch out for distracting background elements such as the vase, flower, and computer monitor in Figure 4-5. That's IDG editor extraordinaire, Jennifer Ehrlich, in the picture, by the way. Most editors do have telephones permanently affixed to their ears, but very few actually have big glowing monitors and flowers growing out of their heads, as this image makes it seem.
- ➤ Shoot your subject from unexpected angles: Again, refer to Figure 4-1. This image accurately represents the statue. But it's hardly as captivating as the images in Figure 4-2, which show the same subject from more unusual angles. Don't be afraid to climb up on a chair (a sturdy chair, of course) or lie on the ground to catch your subject from a unique point of view. Sure, people will point and stare, and you may occasionally get stepped on by some inattentive passerby, but that's the price that all great artists pay for making their creative mark.

Figure 4-5:
A classic example of a beautiful subject set against a horrendous background.

- ✓ Come closer . . . closer: Often, the most interesting shot is the one that reveals the small details, such as the laugh lines in a grandfather's face or the raindrop on the rose petal. Don't be afraid to fill the frame with your subject, either. The old rule about "head room" providing a nice margin of space above and to the sides of a subject's head is a rule meant to be broken on occasion.
- ✓ Try to capture the subject's personality: The most boring people shots are those in which the subjects stand in front of the camera and say "cheese" on the photographer's cue. If you really want to reveal something about your subjects, catch them in the act of enjoying a favorite hobby or using the tools of their trade. This tactic is especially helpful with subjects who are camera-shy focusing their attention on a familiar activity helps put them at ease and replace that stiff, I'd-rather-be-anywhere-but-here look with a more natural expression.

Composing for Compositing

For the most part, the rules of digital image composition are the same rules that film photographers have followed for years. But when you're creating digital images, you need to consider an additional factor as you set up your shots: how the image will be used. If you want to be able to lift part of your image out of its background — for example, in order to paste the subject into another image — you need to pay special attention to the background and framing of the image.

Digital image gurus refer to the process of combining two images as *compositing*.

Suppose that you're creating a product brochure. On the front cover, you want to put a photo montage that combines images of three or four products. To make your life easier in the image-editing stage, shoot each product against a plain background. That way, you can easily separate the product from the background when you're ready to cut and paste the product image into your montage.

Why does a plain background make the editing job easier? Well, as explained in Chapter 9, most image editors offer a tool called a *color wand* or *magic wand* or something similar. This tool enables you to select areas of continuous color with just one click of your mouse. (In image-editing programs, you have to select elements before you can manipulate them.) If you have a blue vase on a red background, for example, you can select the vase by simply clicking on a blue pixel in the vase. If you can't select your vase this way, you have to draw your selection outline manually by tracing around it with your mouse, which is a fairly difficult proposition for most folks.

All this color wand stuff is explained more thoroughly in Chapter 9, but for now, just remember that if you want to be able to separate an object from its background in your image editor, shoot that object against a plain background. Make sure that the background color is distinct from the subject color — if you have a dark subject, for example, use a white backdrop. See Color Plate 11-1 for a look at this concept in action. When shooting these images, I knew that I wanted to be able to cut and paste each object into a montage, so I chose appropriately contrasting backgrounds when shooting my pictures.

Another important rule of shooting images for compositing is to fill as much of the frame as possible with your subject. That way, you devote the maximum number of pixels to your subject, rather than wasting them on a background you're only going to trim away. As noted in Chapter 2, the more pixels you have, the better the image quality you can achieve.

Also, in your photographic expeditions, look for surfaces that you can use as backgrounds in your composite images. For example, a close-up image of a nicely colored marble tile or a section of weathered barn siding can serve as an interesting background in a montage.

Let There Be Light

Digital cameras are extremely demanding when it comes to light. A typical digital camera has a light sensitivity approximately equivalent to that of ISO 100 film. If you don't have the photography background to understand the implications of that fact, suffice it to say that image detail tends to get lost when objects are in the shadows. Too much light can also create problems. A ray of sunshine bouncing off a highly reflective surface can cause *hot spots* or *drop outs* — areas where all image detail is lost, resulting in a big white blob in your picture.

Color Plate 4-1 illustrates the problems that too much and too little light can create. In the lower-right corner of the image, where shadow falls over the scene, the detail and contrast suffer. On the other side of the coin, too much light in the top-center portion of the image causes a severe hot spot on the lemon. In this area, all image detail is lost. (The inset area provides a close-up view to give you a better look at this phenomenon.) In the upper-left corner of the image, where the light is neither too low nor too strong, the detail and contrast are excellent.

Getting just the right amount of light on your subject can be difficult, but the techniques discussed in the following sections should help you avoid major lighting problems. Minor problems can often be corrected in the image-editing stage. See "Bring Your Image Out of the Shadows" in Chapter 8 for details on how to brighten up a dark image; check out "Covering up unsightly image blemishes," in Chapter 9, and "Cloning without DNA," in Chapter 10, for information on fixing small hot spots.

Adjust for backlighting

A *backlit* picture is one in which the sun or light source is behind the subject. With auto-exposure cameras, strong backlighting often results in too-dark subjects because the camera adjusts the exposure based on the strength of the light in the overall scene, not just on the amount of light falling on the subject. The left image in Figure 4-6 is a classic example of a backlighting problem.

To remedy the situation, you have several options:

Reposition the subject so that the sun is behind the camera instead of behind the subject.

Figure 4-6: Backlighting can cause your subjects to appear lost in the shadows (left). Increasing the exposure or using a flash can compensate backlighting (right).

- ✓ Use a flash. Most cameras offer a setting that fires the flash regardless of the amount of light in the scene this setting is sometimes called *fill flash*. Adding the flash can light up your subjects and bring them out of the shadows. However, because the working range of the flash on most consumer digital cameras is relatively small, your subject must be fairly close to the camera for the flash to do any good.
- Adjust the exposure. If the backlighting isn't terribly strong and your camera offers exposure adjustment, try increasing the exposure. Check your camera's manual for information on ways to adjust the exposure.

Keep in mind that while increasing the exposure may brighten up your subjects, it may also cause the already bright portions of the scene to appear overexposed. You may even wind up with some flares or hot spots in areas.

In the image on the right in Figure 4-6, I increased the exposure slightly and also used a flash. The image still isn't ideal — the subjects are still too dimly lit for my taste, and some regions border on being overexposed — but it's a vast improvement over the original. A little bit of additional brightness adjustment in an image editor could no doubt improve things even more. To fix this image, I would raise the brightness level of the foreground subjects only, leaving the sky untouched. For information on this kind of image correction, see "Bring Your Image Out of the Shadows" in Chapter 8.

Shed some light on the situation

When the light is dim, you have two choices: Increase the exposure or add more light. As discussed in the preceding section, increasing the exposure can work in many situations, but when your scene contains some very light areas, increasing the exposure can cause those areas to become overexposed.

If an exposure adjustment doesn't deliver the results you want, you simply have to find a way to bring more light onto your subject. The obvious choice, of course, is to use a flash. A flash can be helpful not just for interior shots, but also for outdoor shots, as illustrated by Figure 4-7. In the image on the left, shot outside on a sunny day, the shadow from the hat obscures the subject's eyes. Shooting with a flash threw some additional light on her face, bringing her eyes into visible range.

Using a flash is not always the answer, however. In the first place, not all digital cameras have a flash. Second, when you're shooting at close range to your subject, a flash can cause hot spots or leave some portions of the image looking overexposed, similar to the problems caused by the sun in Color Plate 4-1. You can often cover up hot spots in an image editor, but avoiding them in the first place is always a better option.

When you're shooting small, highly reflective objects such as the one in the figure, you may have better results if you turn off the flash and use another light source to illuminate the scene. If you're a well-equipped film photographer and you have studio lights available, go dig them up. Some digital cameras can also accept an auxiliary flash unit, which helps reduce hot spots because you can move the flash further away from the subject.

Figure 4-7: An outdoor image shot without a flash (left) and with a flash (right).

But you really don't need to go out and spend a fortune on lighting equipment. If you get creative, you can probably figure out a lighting solution using stuff you already have around the house. For example, I get great light through one of my living room windows in the morning, so I often shoot still-life scenes in front of that window. The window happens to be draped with a sheer white curtain, so if I want to tone down the light a little, I simply pull the curtain. The result is a soft, diffused light source. (You may want to try a similar trick to tone down the impact of a built-in flash — just place a piece of sheer white cloth over the flash unit when you take the picture.)

When shooting small objects, I often use the setup shown in Figure 4-8. The white background is nothing more than a cardboard presentation easel purchased at an art and education supply store — teachers use these things to create classroom displays. I placed another white board on the table surface. The easel and board brighten up the subject because they reflect light onto it. If I need still more light, I switch on a regular old desk lamp. And if I want a colored background instead of a white one, I clip a piece of colored tissue paper, also bought at that education supply store, onto the easel.

Okay, so professional photographers and serious amateurs will no doubt have a good laugh at this cheap little setup. But I say, whatever works, works. Besides, you've already spent a good sum of money on your camera, so why not save a few bucks where you can?

Figure 4-8: You can create a makeshift studio using nothing more than a sunny window, a few pieces of white cardboard. some tissue paper, a tripod, and an office lamp.

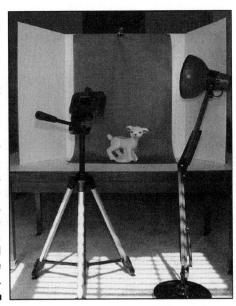

When using an artificial light source, whether it be a true-blue photography light or a makeshift solution like my desk lamp, you get better results if you don't aim the light directly at the object you're photographing. Instead, aim the light at the background and let the light bounce off that surface onto your subject. For example, when using a setup like the one in Figure 4-8, you might aim the light at one of the side panels. This kind of lighting is called bounce lighting, in case you were curious.

Excuse me, can you turn down the sun?

Adding more light to a scene is considerably easier than reducing the light. If you're shooting outdoors, you can't exactly hit the dimmer switch on the sun. If the light is too strong, you really have only a few options. You can move the subject into the shade (in which case you can use a fill flash to light the subject) or you can reduce the exposure. Check your camera's manual for information about how to reduce the exposure on your model.

If you can't find a suitable shady backdrop, you can create one with a piece of cardboard or some other large, flat object. Just have a friend hold the cardboard between the sun and the subject. Voilà — instant shade. By moving the cardboard around, you can vary the amount of light that hits the subject.

Hold That Thing Still!

In the preceding section, I neglected to mention one critical aspect of capturing good images in low lighting: holding the camera absolutely still. Move the camera, and you end up with a blurry image, just as if the subject had moved in front of the camera while you were taking the picture.

Holding the camera still is essential in any lighting, of course. But in low light, a longer exposure time is needed to capture the image. That means that you have to hold the camera steady for a longer period of time than if you were shooting in bright lighting. (For more on exposure see Chapter 2.)

To help steady the camera, try keeping your elbows pressed against your sides as you snap the picture. You can also place the camera on a table or countertop, providing that the height of the surface is appropriate for what you're shooting. But for the absolute best results, use a tripod. As mentioned in Chapter 3, you don't need to spend a lot of money on a tripod — you can get a decent entry-level model for about \$20. Especially when you're shooting indoor close-ups, a tripod is well worth the small investment.

Focus on Focus

Many digital cameras don't offer any focus control at all; the focus is set at the factory and can't be changed. Some cameras do offer a few different focus settings, however — one for close-up shots, another for subjects a few feet away, and another for long-distance landscape shots, for example. If your camera offers different focus options, check the manual to find out the appropriate subject-to-camera distances for each setting. Because even perfectly focused digital images have a tendency to look a little soft, make sure that you're using the right setting for your subject; you want the image to come out of the camera looking as sharp as possible.

Although you can't completely restore focus to a badly out-of-focus image, you may be able to improve it slightly using your image editor's sharpening filters. See "Focus Adjustments: Sharpen and Blur" in Chapter 8 for details.

As discussed in Chapter 3, some cameras offer autofocus, which means that the camera automatically adjusts the focus after gauging the distance between lens and subject. If your camera has this capability, find out how the camera sets the focus. Some cameras "read" the distance of the element that's at the center of the frame. This type of autofocus is called *single-spot* focus. Other cameras measure the distance at several spots around the frame and set the focus relative to the nearest object. This kind of autofocus is known as *multi-spot* focus.

Many cameras that offer autofocus features also offer *focus lock*. This feature enables you to focus on any element in the scene, regardless of that element's position in the frame. First, you frame the scene so that the element you want in sharpest focus falls within the camera's focusing zone — in the center of the frame for single-spot focusing, for example. On most cameras, you then press the shutter button halfway down to lock the focus. Keeping the shutter button halfway down, you can then reframe the scene if necessary. When you press the shutter button the rest of the way, the image is captured using the original focus distance you locked in.

Important Technical Decisions

In addition to considering the aesthetics of your shot, you need to make two technical decisions before you press the shutter button:

✓ Choose a resolution and/or image quality setting: Chapters 2 and 3 contain information that helps you make the right choices. But as a quick recap, remember that the higher the resolution or image-quality

- setting, the better your images look. Whenever possible, choose the highest resolution and the best image quality (lowest compression amount). But remember that the higher the resolution or quality, the fewer images you can store in the camera's memory.
- ✓ Set the exposure: Few consumer models give you manual control over exposure, but most give you a choice between a low-light and bright-light exposure setting. Usually, the camera lets you know in some way if the exposure isn't correct an icon flashes in the viewfinder, the shutter button won't go down, or a message appears on the LCD. If none of the available exposure settings corrects the problem, you need to increase or decrease the available light, as discussed in the section "Let There Be Light!"

Part II From Camera to Computer and Beyond

In this part . . .

ne of the big advantages of digital photography is how quickly you can go from camera to final output. In minutes, you can download and print or electronically distribute your images while your film-based friends are cooling their heels, waiting for their pictures to be developed at the one-hour photo lab.

Chapters in this part of the book contain everything you need to know to get your pictures out of your camera and into the hands of friends, relatives, clients, or anyone else. Chapter 5 explains the process of transferring images to your computer and also discusses various ways to store image files. Chapter 6 describes all your printing options and provides suggestions for which types of printers work best for different printing needs. And Chapter 7 explores electronic distribution of images — placing them on the World Wide Web, sharing them via e-mail, and the like — and offers ideas for other on-screen uses for your images.

In other words, you find out how to coax all the pretty pixels inside your camera to come out of hiding and reveal your photographic genius to the world.

Chapter 5

Building Your Image Warehouse

In This Chapter

- Downloading images from the camera to your computer
- Importing directly into an image-editing or catalog program
- Playing images on a TV and recording images on videotape
- ▶ Choosing your storage media
- Deciding which image file format to use
- Cataloging your images

aybe you're a highly organized photographer. As soon as you bring home a packet of prints from the developer, for example, you immediately sort them according to date or subject matter, slip them between the pages of a photo album, and neatly record the date the picture was shot, the negative number, and the location where the negative is stored.

Then again, maybe you're like the rest of us — full of good intentions about organizing your life, but never quite finding the time to do it. I, for one, currently have no fewer than 10 packets of pictures strewn about my house, all waiting patiently for their turn to make it into an album. Were you to ask me for a reprint of one of those pictures, you'd no doubt go to your grave waiting for me to deliver, because the odds that I'd be able to find the matching negative are absolutely zilch.

If you and I are soulmates on this issue, I have some unfortunate news for you. Digital photography demands that you devote some time to organizing and cataloging images after you download them to your computer. If you don't, you're going to have a really tough time finding specific images when you need them. With digital images, you can't flip through a stack of prints to find a particular shot — you have to use an image editor or viewer to look at each image. Trust me, unless you set up some sort of orderly cataloging system, you waste a *lot* of time opening and closing images before you find the picture you want.

Before you can catalog your images, of course, you have to move them from the camera to the computer. You also have to figure out where you're going to store all those images.

This chapter gives you a look at the image-downloading process, discusses the pros and cons of various storage options, explains the various file formats you can use when saving your images, and introduces you to image-cataloging software. By the end of this chapter, you'll be so organized that you may even be motivated to tackle that disaster of a closet in your bedroom.

Out of the Camera, onto the Computer

You've got a camera full of images. Now what? You transfer them to your computer, that's what.

Some digital photography aficionados refer to the process of moving images from the camera to the computer as *downloading*, by the way. Other folks use the term *uploading*. I guess it's a matter of local computer dialect — sort of like how some people call the center of the city *downtown* and others call it *uptown*.

At any rate, to transfer images from most digital cameras to the computer, you first have to link the two devices. A few new cameras can transfer images via a wireless infrared system (similar to the way your television remote control sends commands to your TV). And with the Nikon Coolpix 100, which is mounted on the end of a PC card, you simply slip the PC-card end of the camera into your computer's PC card slot. But for the majority of cameras on the market, you use a cable to join camera and computer.

Regardless of which setup your camera uses, you also need to install the camera's special image-transfer software. The connection cable (if needed) and transfer software are usually included with the camera. If you're a Macintosh user, however, you may have to order the appropriate cable and/or software for your system — some manufacturers include only the Windows components with their cameras. *Quel discrimination!*

Because transfer software differs substantially from camera to camera, I can't give you specific steps for downloading your images. You need to check your camera's manual for that information. But in general, the process works as outlined in the following steps. Note that these steps assume that you're using a camera that requires a cable connection between camera and computer.

1. Turn off your computer and camera.

2. Connect the camera to your computer.

Plug one end of the connection cable into your camera and the other into your computer. On a Macintosh, you typically plug the camera cable into the printer or modem port, as shown in the top half of Figure 5-1. On a PC, the camera usually connects to a COM port (often used for connecting external modems to the computer), as shown in the bottom half of Figure 5-1.

Figure 5-1:
On a Mac,
you
typically
use the
printer or
modem
port. On a
PC, you
usually
connect
camera to
computer
via a COM
port.

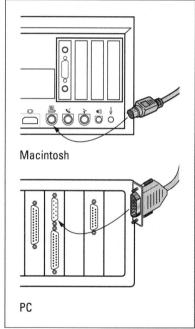

3. Turn the computer and camera back on.

4. Set the camera to the appropriate mode for image transfer.

On some cameras, you put the camera in playback mode; other cameras have a PC setting. Check your manual to find out the right setting for your model.

5. Start the image-transfer software.

You have to install the software before you can use it, of course. Your manual should tell you how.

6. Download away.

Or upload, if you prefer. From here on out, the commands and steps needed to get those pictures from your camera onto your computer vary depending on the camera and transfer software.

Well, I hope that little list of steps was at least somewhat helpful — sorry that I can't be more specific. I can offer you a few additional downloading tips, however:

- ✓ If you get a message saying that the software can't communicate with the camera, check to make sure that the camera is turned on and set to the right mode (playback, PC mode, and so on).
- ✓ On a Macintosh, you may need to turn off AppleTalk, Express Modem, and/or GlobalFax, which can conflict with the transfer software. Check the camera manual for possible problem areas.
- On a PC, check the COM port setting in the transfer software if you have trouble getting the camera and computer to talk to each other. Make sure that the port selected in the download program is the one into which you plugged the camera.
- ✓ Some transfer software gives you the option of choosing an image file format and compression setting for your transferred images. Unless you want to lose some image data which results in lower image quality choose the no compression setting or use a lossless compression scheme, such as LZW for TIFF images. (If that last sentence sounded like complete computer gibberish to you, you can find a translation in the section "File Format Free-For-All," later in this chapter. Also check out "The Great Compression Scheme" in Chapter 3.)
- ✓ In most cases, the transfer software assigns your image files meaningless names such as DCS008.jpg and DCS009.jpg (for PC files) or Image 1, Image 2, and the like (for Mac files). If you previously downloaded images and haven't renamed them, files by the same names as the ones you're downloading may already exist on your hard drive.

The transfer software should alert you to this fact and ask whether you want to replace the existing images with the new images, but just in case, here's a little safeguard system I use. Before I download, I create a new folder on my desktop. Then I transfer all camera images to that folder to keep them separate from any other images on my hard drive. That way, there's no chance that any existing images will be overwritten. Later, I review and rename the images I want to keep, deleting the rest. I then move images I plan to use right away into a central image folder on my hard drive and move the rest onto a Zip disk. (See the upcoming "Floppies, Zips, and Other Storage Options" for more on Zip disks.) Finally, I delete the download folder to keep my desktop uncluttered (well, reasonably so, anyway) until the next downloading session.

- ✓ If your camera has an AC adapter, be sure to use it when downloading images. The process can take quite a while, and you need to conserve all the battery power you can for your photography outings.
- ✓ Some transfer software gives you the option of having the software automatically delete all images from the camera's memory after the download process is finished. At the risk of sounding paranoid, I never select this option. After you transfer images, always review them onscreen before you delete any images from your camera. Glitches can happen, so make sure that you really have that image on your computer before you wipe it off your camera.

Now Playing on Channel 3

Many cameras come with a *video-out* jack and video connection cable. Translated into English, that means that you can display your images on a regular old TV set if you like. You can even connect the camera to a VCR and record your images on videotape.

As with connecting the camera to a computer, you need to consult your camera's manual for specific instructions on how to hook your camera to a TV or VCR. Typically, you plug one end of an AV cable (supplied with the camera) to the camera's video- or AV-out jack and then plug the other end into your TV or VCR's video-in jack, as shown in Figure 5-2. If your camera has audio recording capabilities, as does the Ricoh RDC-2 shown in the figure, the cable has a separate AV plug for the audio signal. That plug goes into the audio-in jack, as in the figure. If your TV or VCR supports stereo sound, you typically plug the camera's audio plug into the mono input jack.

To display your pictures on the TV, you generally use the same procedure as when reviewing your pictures on the camera's LCD monitor. Check your manual for specific steps to follow with your model. To record the images on videotape, just put the VCR in record mode, turn on the camera, and display each image for the length of time you want to record it.

Most digital cameras output video in NTSC format, which is the format used by televisions in North America. You can't display NTSC images on televisions in Europe and other countries that use the PAL format instead of NTSC. So if you're an international business mogul needing to display your images abroad, you may not be able to do it using your camera's video-out feature.

Figure 5-2: Cameras such as the Ricoh RDC-2 enable you to send video and audio signals from the camera to your TV or VCR for playback or recording on videotape.

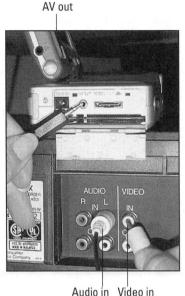

The Importance of Being TWAIN

Chances are good that your camera comes with a CD or floppy disk that enables you to install something called a *TWAIN driver* on your computer. TWAIN is a special protocol (language) than enables your image-editing or catalog program to communicate directly with a digital camera or scanner. Providing that your image editor or catalog program is *TWAIN compliant* (as most are these days), you can open your images directly from the camera after installing the TWAIN driver. Of course, you camera still needs to be cabled to the computer.

The command you use to open images in this way varies from program to program. Typically, the command is found in the File menu and is named something like Acquire TWAIN. (In some programs, you first have to select the TWAIN source — that is, specify which piece of hardware you want to access. This command is also usually found in the File menu and is named something like File Select TWAIN Source.)

In Adobe PhotoDeluxe 2.0, an image editor supplied with many brands of digital cameras, you choose File Open Special Get Digital Photo. You're then presented with a list of devices for which you've installed TWAIN drivers. Click on the device you want to access and then click on OK. PhotoDeluxe launches your camera's image-transfer program, and you can then select the images you want to open.

Floppies, Zips, and Other Storage Options

As I've said about half a dozen times in earlier chapters, digital image files can be big — really big. Depending on the camera, resolution, and image-quality setting you use, your images may comprise more than 4MB of data. Shoot a few months' worth of pictures at that image size, and you can quickly fill up your every inch of storage space on your computer's hard drive.

Even if you have mega-gigabytes of hard drive storage, I don't recommend storing all your images there. Hard drives can, and do, go kaplooey. And if your hard drive decides that life isn't worth living and jumps over the digital cliff, all your images will follow like lemmings, throwing themselves into the great beyond, never to be seen again.

So what's a better option? Store only those images that you're currently editing or otherwise using on your hard drive, and copy the rest to some sort of removable storage media. The following list looks at a few of the most popular storage options:

- ✓ The most common removable storage option is the floppy disk. Almost every computer today, Mac or PC, has a floppy disk drive. The disks themselves have become incredibly cheap: You can get a floppy for less than \$1 if you watch the sale ads. The problem is that a floppy disk can hold only 1.5MB of data, which means that it's suitable for storing small, low-resolution, or highly compressed images, but not large, high-resolution, uncompressed pictures.
- ✓ Several companies offer removable storage devices that serve as floppy drives on steroids. Often referred to as *floppy disk replacements*, these drives save data on disks that are just a little larger than a floppy but can hold 100MB or more of data. The most popular option in this category is the Iomega Zip drive, which costs about \$150. Each Zip disk can hold 100MB of data and costs about \$15.
- ✓ For a little more cash, you can move up to drives that store data on cartridges that can hold about 200–250MB of data. One example is the SyQuest EZFlyer 230, which costs \$150. Data cartridges for this drive cost about \$25 each and can store 230MB.
- ✓ If you care to spend even more, you can get drives capable of storing anywhere from 650MB to more than 4GB (yes, that's gigabytes) of data. Many people use these drives as second hard drives. Two popular choices in this category are the Iomega Jaz and the SyQuest SyJet. The Jaz drive costs about \$300−\$400, depending on whether you want an external drive or an internal drive; data cartridges cost \$125 and can hold 1GB of data. The SyJet drive and cartridges cost roughly the same as the Jaz drive and disk, but a SyJet cartridge can hold 1.5GB of data.

✓ You can have your images transferred to a writeable CD at a digital imaging lab (check your Yellow Pages for a lab in your area that may offer this service). A typical CD can hold about 650MB of data. Cost per image varies; in my neck of the woods, transferring 1–150MB worth of images costs about \$40.

Writeable CD-ROM drives are now available for the consumer market, so theoretically, you can do your own image transfers if you like. But this technology still has a lot of kinks in it, and the process of recording data can be tricky. So I wouldn't recommend this option just yet. For now, leave the job to the professionals.

Cyberstorage: The image closet of the future?

Eastman Kodak Company recently launched a new venture called the Kodak Picture Network, an online service for digital photography enthusiasts. Through the Picture Network, you can store all your images in Kodak's giant digital warehouse instead of on your home or office computer.

Launched in September 1997, the Picture Network is still in its initial phase and currently is geared primarily toward those who shoot on film but want digital copies of their images as well. You drop off your undeveloped film at a participating photo lab, and your pictures are developed and printed as usual. But after printing, your pictures are scanned and uploaded to the Kodak Picture Network Web site. When you pick up your prints, you're given a customer account number that enables you to log on to the Web site and view and download the digital versions of your pictures. You can also give your account number to others so that they can have access to your pictures, too. Or you can create and e-mail "electronic postcards" featuring your images.

Digital photographers and film photographers with scanners can upload digital images to the Picture Network for storage and on-line

viewing. In the future, you'll also be able to order prints of your images on standard photographic paper and to create on-line photo albums. The cost for all this convenience? You pay a membership fee of \$4.95 a month, which includes free storage of 100 images. Storing additional pictures costs a penny per picture per month. Having a 24-exposure roll of 35mm film processed, scanned, and transmitted to the Picture Network costs approximately \$5.

Whether or not consumers will flock to the Picture Network remains to be seen. Some folks are worried about security issues, wondering how easy it might be for others to access their images. Kodak promises that security will be top-notch, but as the numerous breakdowns in other so-called secure Internet sites have demonstrated, nothing is 100 percent safe these days. Also, having to log in to the Internet to download an image is hardly as convenient as being able to access the image from your hard drive or a removable disk.

At any rate, the concept is an innovative one, and it will be interesting to see how well the idea catches on. To find out more, visit the Kodak Web site at www.kodak.com.

As with any computer data, digital-image data will degrade over time. How soon you begin to lose data depends on the storage media you choose. If your storage device uses magnetic media (which is the case for floppies, Zip disks, and all the other products mentioned in the preceding list), image deterioration starts to become noticeable after about 10 years. Drives that use magneto-optical cartridges are thought to have a storage life of about 30 years. However, accessing data from this kind of drive is pretty slow, which is why most people don't go this route for routine storage of digital images — and why I didn't cover magneto-optical devices in my little rundown of storage options.

To give your images the longest possible life, opt for CD-ROM storage, which gives you about 100 years before data loss becomes noticeable — which happens to be roughly the same life span as a print photograph. Be sure that the service bureau or film lab that transfers your images uses a CD that has a special coating designed to prevent data loss, such as Kodak's InfoGuard. Without this type of coating, data can start to degrade in just a few years.

When choosing a storage option, remember that the various types of disks and cartridges aren't interchangeable. Jaz cartridges, for example, don't fit in a Zip drive. So if you want to be able to swap images regularly with friends, relatives, or coworkers, you need a storage option that's in widespread use. You probably know many people who have a Zip drive, for example, but you may not find anybody in your circle of acquaintances using a Jaz drive. Also, if you're going to send images to a service bureau or commercial printer, find out what types of media it can accept before making your purchase.

File Format Free-for-All

After you open and edit a digital image, you need to decide which file format you want to use to save the revised image. You may also be asked to choose a file format when you transfer images from your camera to your computer. Many different image formats exist, and each one takes a unique approach to storing data.

Some formats are *proprietary*, which means that they're used only by the specific software or camera you're using to edit or capture the image. (Proprietary formats are sometimes also referred to as *native* formats.) If you want to edit or view your image in any other program, you need to convert your image to a different format. (See "Save Now! Save Often!", in Chapter 8, for details on how to do this.)

Some formats are used only on the Mac, and some formats are for PCs only. A few formats are so obscure that almost no one uses them anymore, while others have become so popular that almost every program on both platforms supports them.

The following list details the most common file formats for storing images, along with the pros and cons of each format:

✓ JPEG: Say it jay-peg. The acronym stands for Joint Photographic Experts Group, which was the organization that developed this format. JPEG is one of the most widely used formats today, and almost every program, Macintosh and Windows, can save and open JPEG images. JPEG is also one of the two main file formats used for images on the World Wide Web.

One of the main advantages of JPEG is that it compresses image data, which results in smaller image files. Smaller image files consume less space on disk and take less time to download on the Web.

The catch is that JPEG uses a *lossy compression scheme*, which means that some image data is actually sacrificed during the compression process. Each time you open, edit, and resave your image, the image is recompressed, and more damage is done.

When you save to the JPEG format, you're usually presented with a dialog box similar to the one in Figure 5-3, where you can specify the amount of compression you want to use. (The dialog boxes shown in Figures 5-3 and 5-4 are from Adobe PhotoDeluxe.)

To keep data loss to a minimum and ensure the best printed images, choose the highest-quality setting (which results in the least amount of compression). For Web images, you can get away with a medium-quality, medium-compression setting. See Color Plate 3-1 for a look at how a large amount of JPEG compression affects an image, and read "The Great Compression Scheme," in Chapter 3, for more on this subject.

The Format options shown in Figure 5-3 are related to saving images for the Web. For more on this topic, see "JPEG: The photographer's friend" in Chapter 7.

Figure 5-3:
When you save to the JPEG format, you can specify the amount of compression you want to apply.

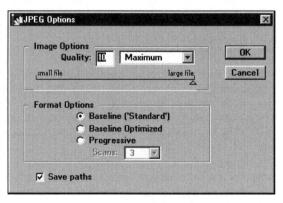

If you need to save your image in the JPEG format, wait until after you've done all your image editing. While you're working on the image, save the image in the program's native format or the TIFF format (explained next), which retains all your image data. Save to JPEG only when you're completely finished editing the image. That way, you only compress the image once, keeping data loss to a minimum.

✓ TIFF: TIFF stands for tagged image file format, in case you care, which you really shouldn't. TIFF ranks right up there with JPEG on the popularity scale except for use on the World Wide Web. Like JPEG images, TIFF images can be opened by most Macintosh and Windows programs.

When you save an image to the TIFF format, you're usually asked to specify a *byte order*, as shown in Figure 5-4. If you want to use the image on a Mac, choose the Macintosh option; otherwise, use the PC option. You also usually get the option of applying LZW compression. LZW is a *lossless compression scheme*, which means that virtually no data is lost when the image is compressed. Unfortunately, compressing an image in this way doesn't reduce the image file size as much as using JPEG compression, which is why TIFF isn't a good option for Web images.

Figure 5-4:
TIFF files
can be
compressed
using the
lossless
LZW
compression
scheme.

Most, but not all, programs support LZW-compressed TIFF images. If you have trouble opening a TIFF image, compression may be the problem. Try opening and resaving the image in another program, this time turning compression off.

✓ Photo CD and Pro Photo CD: Developed by Eastman Kodak, Photo CD is a format used expressly for transferring slides and film negatives onto a CD-ROM. Image-editing and cataloging programs can open Photo CD images, but can't save to this format.

The Photo CD format stores the same image at five different sizes, from 128×192 pixels all the way up to $2,048 \times 3,072$ pixels. The Pro Photo CD format, geared to those professionals who need ultra-high-resolution images, saves one additional size, $4,096 \times 6,144$ pixels.

When you open a Photo CD image, you can select which image size you want to use. For images that you plan to print, select the largest size available. Remember that the more pixels in the image, the higher the image resolution and the better your printed output. If your computer complains that it doesn't have enough memory to open the image, try the next smaller size. For Web images, you can go with one of the smaller image sizes. (For more on image size and resolution, see "Resolution Rules!" in Chapter 2 and "You Say You Want a Resolution" in Chapter 3.)

✓ FlashPix: FlashPix is a new format being developed by several different companies, including Kodak, Hewlett-Packard, The LivePix Company, and Microsoft. The goal of this format is to speed up the image-editing process and to enable consumers to edit large images on computers that don't have gargantuan amounts of RAM.

At the present time, only a few image-editing programs support FlashPix — among them, LivePix, from The LivePix Company, Microsoft Picture It!, and Adobe PhotoDeluxe. With all the industry muscle being poured into the development of FlashPix, the format will no doubt become more widely accepted in the future. But for now, I don't recommend using this format unless you want to work expressly in an image-editing program that supports FlashPix and you don't plan on sharing your images with anyone who uses a different program.

✓ GIF: This format, which some people swear should be pronounced jiff and others say should be said gif, was developed to facilitate transmission of images on CompuServe bulletin board services. Today, GIF (Graphics Interchange Format) and JPEG are the two most widely accepted formats for World Wide Web use. One variety of GIF, thoughtfully named GIF89a, enables you to make areas of your image transparent, so that your Web page background is visible through the image.

GIF is similar to TIFF in that it uses LZW compression, which creates smaller file sizes without dumping image data. The drawback is that GIF is limited to saving 8-bit images (256 colors or less). To see the difference this limitation can mean to your image, look at Color Plate 5-1. The top image is a 24-bit image, while the bottom image is an 8-bit image. The 8-bit image has a rough, blotchy appearance because there aren't enough different colors available to express all the original shades in the fruit. One shade of yellow must be used to represent several different shades of yellow, for example. For information on converting your image to 256 colors and creating a transparent GIF image, see "Decisions, decisions: JPEG or GIF?" and "GIF: 256 colors or bust" in Chapter 7.

✓ PNG: PNG, which stands for Portable Network Graphics format and is pronounced ping, is a relatively new format designed for Web graphics. Unlike GIF, PNG isn't limited to 256 colors, and unlike JPEG, PNG doesn't use lossy compression. The upside is that you get better image quality; the downside is that your file sizes are larger, which means longer download times for Web surfers wanting to view your images.

- Like FlashPix, PNG is still in its infancy and so doesn't have widespread support among Web-page creation and browser programs. For now, GIF or JPEG is a better option for your Web images.
- ✓ BMP: Pronounce this by just saying the letters . . . B-M-P. A popular format in the past, BMP (Windows Bitmap) is used today primarily for images that will be used as wallpaper on PCs running Windows. Programmers sometimes also use BMP for images that will appear in Help systems.
 - BMP offers a lossless compression scheme known as RLE (Run-Length Encoding), which is a fine option except when you're creating a wall-paper image file. Windows sometimes has trouble recognizing files saved with RLE when searching for wallpaper images, so you may need to turn RLE off for this use. To find out how to use one of your digital images as wallpaper, see "Redecorate Your Computer's Living Room" in Chapter 7.
- ✓ PICT: PICT is based on Apple's QuickDraw screen language and is the native graphics format for Macintosh computers. If QuickTime is installed on your Mac, you can apply JPEG compression to PICT images. But be aware that QuickTime's version of JPEG compression does slightly more damage to your image than what you get when you save an image as a regular JPEG file. Because of this, saving your file to JPEG is a better option than PICT in most cases. About the only reason to use PICT is to enable someone who doesn't have image-editing or viewing software to see your images. You can open PICT files inside SimpleText, Microsoft Word, and other word processors.
- ✓ EPS: EPS (*Encapsulated PostScript*) is a format used mostly for high-end desktop publishing and graphics production work. If your desktop publishing program or commercial service bureau requires EPS, go ahead and use it. Otherwise, choose TIFF or JPEG. EPS files take up much more room on disk than TIFF and JPEG files.

Electronic Photo Albums

After you get all those images onto your hard drive, Zip disk, or other image warehouse, you need to organize them so that you an easily find a particular image.

If you're a no-frills type of person, you can simply organize your images into folders, as you do your word processing files, spreadsheets, and other documents. You may keep all images shot during a particular year or month in one folder, with images segregated into subfolders by subject. For example, your main folder may be named 1997, and your subfolders may be named Family, Sunsets, Holidays, Work, and so on.

Many image editors include a utility that makes it possible for you to browse through your image folders and view thumbnails of each image. These utilities make it easy to track down a particular image if you can't quite remember what you named the thing. Figure 5-5 shows the EasyPhoto browser utility included with the Windows version of Adobe PhotoDeluxe 2.0, for example.

You can also buy stand-alone viewer utilities, such as PolyView, a Windows shareware program from Polybytes. This particular viewer enables you to see your images in several different layouts, including one that mimics the Windows 95 Explorer format, as shown in Figure 5-6. To organize images, you can drag and drop them from one folder to another. You can also perform some limited image editing in this program. (If you want to try this program out, install the trial version included on the CD-ROM included with this book.)

If you want a fancier setup, several programs enable you to organize and view your images using an old-fashioned photo album motif. Figure 5-7 offers a look at one such program, Presto! PhotoAlbum, from NewSoft. You drag images from a browser onto album pages, where you can then label the images and record information such as the date and place the image was shot. You can also place your images inside frames and add other special on-screen touches.

Figure 5-6:
PolyView
is a
shareware
program
that
enables you
to view your
images
using a
Windows
Explorerstyle
interface.

Figure 5-7:
Programs
such as
Presto!
PhotoAlbum
enable you
to organize
your
pictures
using a
traditional
photo
album motif.

You can find trial versions of Presto! PhotoAlbum, as well as another program that uses the photo album approach, PhotoRecall, on the CD-ROM accompanying this book.

Photo album programs are great for those times when you want to leisurely review your images or show them to others, much as you would enjoy a traditional photo album. And creating a digital photo album can be a great project to enjoy with your kids — they'll love picking out frames for images and adding other special effects. For simply tracking down a specific image or organizing images into folders, however, I prefer the folder-type approach like the one used by PolyView. I find that interface quicker and easier to use than flipping through the pages of a digital photo album.

If your image collection is large, you may want to look for a catalog program that enables you to store reference data with each image, such as a category, description, and the date the picture was taken. Some programs also enable you to list a few "keywords" with each image that can make hunting down the image easier in the future. For example, if you have an image of a Labrador retriever, you might enter the keywords "dog," "retriever," and "pet." When you later run the search portion of the browser, entering any of those keywords as a search criteria brings up the image. These kinds of tools can be extremely helpful when you start to accumulate large quantities of images. PhotoRecall is among programs offering such features on the Windows side; Extensis Portfolio provides similar options for Macintosh users (this program is available for Windows as well). Trial versions of both programs are on the CD-ROM at the back of this book.

Chapter 6

Can I Get a Hard Copy, Please?

In This Chapter

- Sorting through the maze of printer options
- ▶ Understanding CMYK
- Letting the pros print your images
- ▶ Choosing the right paper for the job
- ▶ Evaluating printing costs
- Choosing the right image resolution for your printer
- ▶ Getting on-screen colors to match printed colors
- ▶ Tips for better prints

These days, getting a roll of film turned into printed photographs is a nobrainer. You check a few boxes on the photo lab order form, hand over the order form and film canister, and skip off to your next errand. Film developing technology is so refined that you're virtually guaranteed goodlooking pictures, even if the teenager who's processing your film doesn't know an f-stop from a shortstop.

When you take the leap into the digital frontier, however, things aren't so simple. (I bet you knew that's where I was headed, didn't you?) Taking your images from computer to paper involves several technical decisions, not the least of which is choosing the right type of printer for the job. You also need to worry about things like image resolution, lines per inch, color matching, and paper type.

This chapter helps you sort through the various issues involved in printing your images, whether you want to do the job yourself or have a commercial printer do the honors. In addition to discussing the pros and cons of different types of printers, the pages to come offer tips and techniques to help you get the best possible print quality on any printer.

If you're just dying to print a dozen copies of that picture of your boss looking foolish at the company picnic, skip ahead to "Sending Your Image to the Dance," near the end of this chapter, for instructions. In cases like this, image quality isn't as important as timeliness, especially with your annual performance review just weeks away. But promise to come back later and read the first part of the chapter to find out how to make those images look better the next time around.

A Plethora of Personal Printers

As the number of consumers embracing digital imaging has exploded, so too has the number of home- and small-office printers. Everybody from Hewlett-Packard to Xerox to Fuji is trying to capture the printing side of the digital imaging market. And just as with digital cameras, the wide variety of available options can make shopping for a printer an exercise in confusion.

If you're in the market for a new printer, I urge you *not* to head for the store without reading the following sections, which explore the pros and cons of different types of printers and provide some comparison-shopping tips. I'm guessing that you're going to buy your printer in a discount computer, office supply, or electronics store, as most people do. And if your experience is like mine, the information provided by salespeople in such outlets, while well-meaning, is sometimes a little off the mark — and other times, so far from the mark that you wonder if the salesperson has any idea where the mark *is*.

Print technologies

When they aren't in high-level conferences thinking up acronyms like *CMOS* and *PCMCIA*, the engineers in the world's computer labs are busily trying to devise the perfect technology for printing digital images. In the commercial printing arena, the technology for delivering superb prints is already in place. (See "Let the Pros Do It," later in this chapter, for more information about commercial printing.)

On the consumer front, several vendors, including Hewlett-Packard, Epson, Alps, and Fuji, sell color printers specially geared toward printing digital images. The marketing folks like to use terms such as "photo-realistic" and "near-photographic quality" and even "photo quality" when describing printers in this category. The suggestion is that your images come out of the printer looking like traditional photographic prints. Some printers deliver on the promise better than others, however. Several printers come very close to true photographic output, but don't expect your images to be exactly the same in look and feel as the 35mm prints you pick up from the lab at the corner drugstore.

Different manufacturers have adopted different printing technologies, and the technology you should choose depends on your budget, your daily printing needs, and your print-quality expectations. The following list discusses the pros and cons of the main categories of printers on the market today:

✓ Inkjet: Inkjet printers work by forcing little drops of ink through nozzles onto the paper. Inkjet printers deliver decent image reproduction at a decent cost: The printers themselves cost in the \$250 to \$500 range, with ink cost-per-page about two to four cents. You can print on plain paper or thicker, glossy photographic-type stock; cost per page increases as you upgrade your paper stock. (See "The Daily Paper," later in this chapter, for more on paper costs.)

Before I go any further, I want to emphasize that estimating ink costs with any degree of accuracy is next to impossible, because the amount of ink used per image varies with the image size and the selected print quality setting (draft mode, photo-quality mode, and so on). So think of that two to four cents a page (and other ink cost numbers you see in this chapter) as a general guideline only.

The downside to inkjet printers is that the picture quality can sometimes be a little fuzzy, due to the fact that the ink droplets tend to spread out when they hit the paper, causing colors to bleed into each other. In addition, the wet ink can cause the paper to warp slightly, and the ink can smear easily until the paper dries. (Remember when you were a kid and painted with watercolors in a coloring book? The effect is similar with inkjets, although not as pronounced.) You can lessen both problems by using specially coated inkjet paper (see "The Daily Paper" later in this chapter).

In addition, inkjet printers can be maddeningly slow, especially when you use the highest-quality print setting the printer offers. Printing a color image can take several minutes — and with some printers, you can't perform any other functions on your printer until the print job is complete (see "Host-based printing" in the section "Comparison shopping" later in this chapter).

Despite these drawbacks, however, inkjets remain a good, economical solution for many users. Some of the newer inkjet models, such as the Epson Stylus Color 600, incorporate refined inkjet technology that produces much higher quality, less color bleeding, and less page warping than models in years past.

Laser printers: Laser printers use a technology similar to that used in photocopiers. I doubt that you want or need to know the details, so let me just say that the process involves a laser beam, which produces electric charges on a drum, which rolls toner — the ink, if you will — onto the paper. Heat is applied to the page to permanently affix the toner to the page (which is why pages come out of a laser printer warm).

Color lasers can produce near-photographic quality images, and you don't need to use any special paper (although you get better results if you use a high-grade laser paper as opposed to cheap copier paper). Toner cost per page is equivalent to the cost of ink in an inkjet — about two to five cents a page. However, the cost of the machine itself is too high for most casual users. Prices fall in the \$3,600 to \$9,000 range.

✓ Dye-sub: Dye-sub is short for dye-sublimation, which is worth remembering only for the purposes of one-upping the former science-fair winner who lives down the street. Dye-sub printers transfer images to paper using a plastic film or ribbon that's coated with colored dyes. During the printing process, heating elements move across the film, causing the dye to fuse to the paper.

Dye-sub printers are also called *thermal-dye* printers — heated (thermal) dye . . . get it?

To my eyes — and to most eyes, I believe — dye-sub printers come closest to delivering true photographic quality. In fact, dye-sub is the technology used by many commercial printers. Dye-sub printers output images on a special glossy stock that looks and feels closest to a traditional film print.

Currently, only a handful of dye-sub printers are manufactured for the consumer market. One of the most popular is the Fargo FotoFUN!, which has an estimated street price of about \$499. Like most consumer models in this category, the FotoFUN! is strictly a *snapshot* printer, which means that it can print only snapshot-sized images. The FotoFUN! can print images up to 4 x 6 inches.

A specialty player in the dye-sub field, the Casio QG-100, produces even tinier prints. This printer outputs images on rolls of glossy paper coated on one side with a special adhesive. After printing the image, you can peel the protective paper off the adhesive and stick the print onto just about any surface. You can buy the rolls in various sizes, with the maximum print size $1^1/_{16}$ x $2^3/_{16}$ inches. What uses might you find for these peel-and-stick images? Well, you can use them for creating instant employee or visitor badges, for example. And small children get a bang out of slapping their picture on everything in the house. (My four-year-old nephew, recently besieged by the arrival of twin siblings, was especially pleased to be able to designate his bedroom a baby-free zone by putting a sticker with his picture on it on the door.) Still, with such a small print size, this printer is definitely a special-purpose model. The QG-100 has an estimated street price of \$199.

To print full-page dye-sub images, you need to move up to something like the Fargo Primera Pro, which has an estimated street price of \$1,595, or the Primera Pro Elite, which costs about \$1,895. Both models enable you to switch between dye-sub and thermal wax printing (explained in the next bullet point).

Although you can't beat them for print quality, dye-sub printers have two drawbacks that may make them inappropriate for your home or office. First, unlike inkjets and laser printers, dye-sub printers are *only* for printing photographs; they aren't designed to do double-duty as text printers. Industry poohbahs refer to this kind of printer as *photocentric*, meaning that its whole life is centered around printing photographs.

The other disadvantage is that you pay more per print than with other types of printers. You can't print on plain paper — you have to use special glossy photo-grade stock. Film and paper included, a 4-x-6-inch print costs about \$1; an $8^1/2$ -x-11-inch page costs about \$3. Of course, you end up with a product that comes closer to a real photograph than with any other printer.

✓ Thermal wax: Thermal wax printers use a heat-based technology similar to dye-sub (thermal dye) printers. But instead of delivering dye onto the page, thermal wax printers apply colored wax to the page. Some thermal wax printers can print on plain laser paper; others require specially coated paper.

Thermal wax printers are great for printing drawn graphics and text, and the cost per page is relatively cheap — about 50 cents for an $8^{1}/2$ -x-11-inch page. Unfortunately, these printers don't do such a hot job on photographs.

If you want the quality of dye-sub but you're concerned about the perprint cost, you may want to consider a combination thermal wax/ thermal dye printer, however. With these printers, you can output draft copies using the less-expensive thermal wax mode, and switch to dye-sub mode when you're ready for final output. The Fargo Primera Pro and Primera Pro Elite are two printers offering this setup.

✓ **Micro-dry:** A few printers, including the MD-1000 (estimated street price, \$349) and others from Alps Electric, use a new printing technology known as *micro-dry*. Like thermal dye and thermal wax printers, micro-dry printers use heat to transfer color to the page. In this case, however, the color comes from ribbons coated with resin-based ink. Micro-dry printers can print on plain paper as well as on glossy photographic stock.

Micro-dry printers deliver excellent results, both with color and grayscale images, even on plain paper. Because the ink is dry when it hits the page, you don't get the color bleeding and page warping that sometimes occurs with inkjet printers. The print costs per page are about the same as for inkjet printing.

About the only drawback I've experienced with this type of printer is slight color banding in light-colored image areas, especially when printing on glossy photographic paper. For example, if you have a

picture that includes an eggshell colored background, you can sometimes distinguish tiny patterns of cyan, magenta, and blue where you should see only eggshell. For users who demand absolute color purity from their images, this phenomenon is a big problem; for others (including me), it's not a major issue.

✓ Thermal autochrome: A handful of snapshot-sized printers use thermal autochrome technology. With these printers, you don't have any ink cartridges, sticks of wax, or ribbons of dye. Instead, the image is created using light-sensitive paper — the technology is similar to that found in fax machines that print on thermal paper.

Two printers in this category are the Fuji Print-It (\$399 estimated street price) and Panasonic TruPhoto (\$480). The advantage to thermal autochrome is that you never have to buy ink cartridges or ribbons, and you don't have to mess with installing those cartridges or ribbons, either. And the special photographic paper has the look and feel of a traditional print. Cost per print is about 75 cents per image.

The drawback is that, like dye-sub printers, thermal autochrome printers can print only on the special photo paper. And like the Fargo FotoFUN!, the Print-It and TruPhoto are both snapshot-sized printers, limited to printing 4-x-6-inch images. Print quality is good, but not as good as what you get from dye-sub models. And you may find that you need to tweak the printer's software quite a bit to get your printed output to match your original image colors.

So which type of printer should you buy?

The answer to that question depends on your printing needs and your printing budget. Here's my take on which of the printing technologies discussed in the preceding section works best for which situation:

- ✓ If you want to produce glossy prints of the best possible quality, and you don't mind the slightly higher per-print cost, go for a dye-sub model. Just remember that you can't print on plain paper, and you can't use a dye-sub printer to print letters, memos, and other text documents.
- ✓ If you're a graphics professional who needs to output high-quality proofs of color graphics as well as digital images, consider a combo dye-sub/thermal wax model. You can use the cheaper thermal wax mode for outputting graphics and drafts of images, and then switch to dye-sub mode for final output of images. Again, though, remember that you can't print on plain paper.
- If you're primarily concerned with printing high-quality color and grayscale images on plain paper — as opposed to generating glossy photographic prints — opt for a color laser if you have a big budget.

When you want images printed on glossy stock, you do have the option of having them printed at a commercial photo lab; see "Let the Pros Do It" for details.

✓ If you don't have a laser-printer budget, opt for a micro-dry or inkjet model. You can produce good-looking color and grayscale images, although you need to use high-grade paper and use the printer's highest quality settings to get the results you want. With both micro-dry and inkjet printers, you can print on glossy photographic paper as well.

Inkjet and micro-dry printers are also good choices if you can only afford one printer and you need to be able to print text documents as well as images (or if you're printing documents that include both text and images).

Keep in mind, though, that none of the color printers discussed here are engineered with text printing as the primary goal, so your text may not look as sharp as it would on a low-cost black-and-white laser or inkjet printer. Also, your text printing costs may be higher than on a black-and-white printer because of ink costs.

I feel compelled at this point to offer a brief warning about inkjets, though. Some of the inkjets I've tried have been so slow and had such page warping problems that I would never consider using them on a daily basis. Others do a really good job, delivering sharp, clean images in a reasonable amount of time, with little evidence of the problems normally associated with this printing technology. The point is, all inkjets are not created equal, so shop carefully. For the record, I've been impressed with the output of the Epson Color Stylus 600 — not surprising, because this printer has a top resolution of 1,440 ppi (pixels per inch), compared to the standard 600 ppi offered by most color inkjets. This printer has an estimated street price of \$269.

Comparison shopping

After you determine which type of printer is best for your needs — inkjet, laser, dye-sub, and so on — you can get down to the nitty-gritty and compare models and brands. Print quality and other features can vary widely from model to model.

Unfortunately, the information you see on the printer boxes or marketing brochures can be a little misleading. So here's a translation of the most critical printer data to study when you're shopping:

✓ Dpi: As explained in Chapter 2, in "Printer resolution," dpi stands for dots per inch. Dpi refers to the printer's resolution — the number of dots of color the printer can print per linear inch. You can find consumer-level color printers with resolutions of anywhere from 300 dpi up to more than 1400 dpi.

A higher dpi means a smaller printer dot, and the smaller the dot, the harder it is for the human eye to notice that the image is made up of dots. So in theory, a higher dpi should mean better-looking images. But because different types of printers create images differently, an image output at 300-dpi on one printer may look considerably better than an image output at the same or even higher dpi on another printer. For example, a 300-dpi dve-sub printer can produce prints that look substantially better than those from a 600-dpi inkjet. So although printer manufacturers make a big deal about their printers' resolutions, dpi isn't always a reliable measure of the print quality you can expect.

The separate world of CMYK

As discussed in Chapter 2, on-screen images are RGB images. RGB images are created by combining the three primary colors of light: red, green, and blue. Printers create images by mixing four, not three, colors of ink - cyan, magenta, yellow, and black. Colors created using these four colors are called CMYK images. (The K is used instead of B because the people who created this acronym were afraid someone might think that B meant blue instead of black.)

You may be wondering why four primary colors are needed to produce colors in a printed image, while only three are needed for RGB images. (Okay, I know you're probably not wondering that at all, but indulge me. You never know when this question is going to come up on Jeopardy, after all.) The answer is that unlike light, inks are impure. Black is needed to help ensure that black portions of an image are truly black, not some muddy brown, as well as to account for slight color variations between inks produced by different vendors.

Aside from nailing that question on Jeopardy, what does all this CMYK stuff mean to you? First, if you're sending your image to a service bureau or commercial printer for four-color

printing, you need to convert your image to the CMYK color mode. Not all image editors offer this option; your service bureau or printer can no doubt do the conversion if you can't do it yourself. Keep in mind that CMYK has a smaller gamut than RGB, which is a fancy way of saying that you can't reproduce with inks all the colors you can create with RGB. CMYK can't handle the really vibrant, neon colors you see on your computer monitor, for example, which is why images tend to look a little duller after conversion to CMYK.

In addition, professional color printing requires that color separations be produced. If you read "The Secret to Living Color" in Chapter 2, you may recall that CMYK images comprise four color channels - one each for the cyan, magenta, yellow, and black image information. Color separations are nothing more than grayscale printouts of each color channel. During the printing process, your printer combines the separations to create the full-color image. Again, if your image editor offers the appropriate commands, you can create and print your own color separations; if not, your service bureau or printer can do the job for you.

✓ Quality options: Many printers give you the option of printing at several different quality settings. You can usually choose a lower quality for printing "rough drafts" of your images and then bump up the quality for final output. Typically, the higher the quality setting, the longer the print time.

Ask to see a sample image printed at each of the printer's quality settings, and determine whether those settings will work for your needs. For example, is the draft quality so poor that you would need to use the highest quality setting even for printing proofs? If so, you may want to choose another printer if you print a lot of drafts.

Also, if you need to print many grayscale images as well as color images, find out whether you're limited to the printer's lowest resolution for grayscale printing. Some printers offer different resolutions for color and grayscale images.

- ✓ Print speed: If you use your printer for business purposes and you print a lot of images, be sure that the printer you pick can output images at a decent speed. And be sure to find out the per-page print speed for printing at the printer's highest quality setting. Most manufacturers list print speeds for the lowest-quality or draft-mode printing. When you see claims like "Prints at speeds up to . . . ," you know you're seeing the speed for the lowest-quality print setting.
- ✓ Consumables (a.k.a. ink and paper costs): If you want to invest in digital-imaging companies that are poised to make the big bucks in the coming years, look beyond the camera and printer manufacturing sector. The real money is in the ink and paper consumed by all those color printers sitting in homes and offices around the world. After all, a camera or printer purchase is a one-shot deal the manufacturer gets your money once every few years, and that's it. But ink and paper supplies have to be replenished on a regular basis, and the more images you print, the more often you hand over your cash.

In fact, some stock-market analysts suggest that printer manufacturers are selling color printers at less than hefty margins because they're banking on huge profits from their ink and/or paper manufacturing divisions. Whether or not that's true, I can't tell you; if you want professional Wall Street analysis, ask your broker, not me. (However, I did pick lomega as a rising star back when nobody had heard of the stock and it was selling for \$11 a share. Sadly, I wasn't clever enough to ignore the analysts who said the stock had peaked, so I didn't buy any.) I can tell you that you can't afford to ignore the ink and paper side of the image-printing equation.

With the exception of dye-sub printers, which can print only on special coated stock, most printers can accept a variety of paper types, from plain old copy paper to glossy photographic stock. Typically, the better (and more expensive) the paper, the better the printed results. Ask to see samples printed on various paper stocks to see just how expensive a paper you're going to need to produce acceptable results.

Paper costs are relatively straightforward — see the section "The Daily Paper," later in this chapter, for more information. Ink costs are another matter entirely. Manufacturers typically state ink costs in terms of x percentage of ink coverage per page — for example, "three cents per page at 15 percent coverage." In other words, if your image covers 15 percent of an $8^{1/2}$ -x-11 sheet of paper, you spend three cents for your print.

On some printers, ink costs rise as you raise the print-quality setting. Some printers, for example, lay down more ink at "photo-realistic" print mode than in draft mode. Other printers deliver the same amount of ink no matter what the quality mode. If you print mainly in draft mode on the latter type of printer, your print costs are higher than on the former, but if you print mainly at high-quality mode, your print costs are lower. Egads, sorting this stuff out isn't easy, is it?

With inkjet printers, you can lower your ink costs somewhat by choosing a printer that uses a separate ink cartridge for each ink color (typically, cyan, magenta, yellow, and black) or at least uses a separate cartridge for the black ink. On models that have just one cartridge for all inks, you usually end up throwing away some ink because one color will be depleted before the others. This is especially true if you print lots of grayscale images, thereby printing using exclusively black ink on many occasions.

Some printers require special cartridges for printing in photographicquality mode. In some cases, these cartridges lay down a clear overcoat over the printed image. The overcoat gives the image a glossy appearance when printed on plain paper and also helps protect the ink from smearing and fading. In other cases, you put in a cartridge that enables you to print with more colors than usual — for example, if the printer usually prints using four inks, you may insert a special photo cartridge that enables you to print using two additional inks. These special photographic inks and overlay cartridges are normally more expensive than standard inks. So when you compare output from different printers, find out whether the images were printed with the standard ink setup or with more expensive photographic inks.

✓ **Host-based printing:** With a so-called *host-based printer*, all the data computation necessary to turn pixels into prints is done on your computer, not on the printer. In some cases, the process can tie up your computer entirely — you can't do anything else until the image is finished printing. In other cases, you can work on other things while the image prints, but your computer runs more slowly because the printer is consuming a large chunk of the computer's resources.

If you print relatively few images during the course of a day or week, having your computer unavailable for a few minutes each time you print an image may not be a bother. And host-based printers are generally cheaper than those that do the image processing themselves.

But if you print images on a daily basis, you're going to be frustrated by a printer that ties up your system in this fashion. On the other hand, if you buy a printer that does its own image processing, be sure that the standard memory that ships with the printer will be adequate. You may need to buy additional memory to print large images at the printer's highest resolution, for example.

✓ PostScript printing: If you want to be able to print EPS illustrations created in illustration programs such as Adobe Illustrator, you need a printer that offers PostScript printing functions. Some printers have this feature built in, while others can be made PostScript-compatible with add-on software.

Although the preceding specifications should give you a better idea of which printer you want, be sure to also go to the library and search through computer and photography magazines for reviews of any printer you're seriously considering. In addition, you can get customer feedback on different models by logging in to one of the digital photography or printing newsgroups on the Internet (rec.photo.digital and comp.periphs. printers are just two to sample). See Chapter 14 for a list of other sources for finding the information you need.

Just as with any other major purchase, you should also investigate the printer's warranty — one year is typical, but some printers offer longer warranties. And be sure to find out whether the retail or mail-order company selling the printer charges a restocking fee if you return the printer. Many sellers charge as much as 15 percent of the purchase price in restocking fees. (In my city, all the major computer stores charge restocking fees, but the office supply stores don't — yet.)

Personally, I resent the heck out of restocking fees, especially when it comes to costly equipment like printers, and I never buy at outfits that charge these fees. Yes, I understand that after you open the ink cartridges and try out the printer, the store can't sell that printer as new (at least, not without putting in replacement ink cartridges). But no matter how many reviews you read or how many questions you ask, you simply can't tell for certain that a particular printer can do the job you need it to do without taking the printer home and testing it with your computer, with your own images.

Few stores have printers hooked up to computers, so you can't test print your own images in the store. Some printers can output samples using the manufacturer's own images, but those images are carefully designed to show the printer at its best and mask any problem areas. So either find a store where you can do your own pre-purchase testing, or make sure that you're not going to pay a hefty fee for the privilege of returning the printer.

The Daily Paper

With paper, as with most things in life, you get what you pay for. The more you're willing to pay for your paper, the more your images will look like "real" photographs. In fact, if you want to upgrade the quality of your images, simply changing the paper stock to a higher grade can do wonders, as illustrated by Color Plate 6-1, which features the famous Love sculpture, by artist Robert Indiana, on the grounds of the Indianapolis Museum of Art. I printed the same image on plain copier paper, photo-quality inkjet paper, and photoquality glossy paper. All three images were printed on the Epson Stylus Color 600 at a print setting of 720 dpi. (The printer can print at a higher resolution, but not on plain paper.) Although the image colors are about the same in all three prints, the image appears noticeably sharper on the higher-grade papers. Of course, you can upgrade paper only when using an inkjet, laser, micro-dry, or thermal wax printer; thermal autochrome and dye-sub printers require special paper designed just for that particular printer type.

Table 6-1 shows some sample prices of different paper stocks, with the least expensive stocks listed first. If your printer can accept different stocks, print drafts of your images on the cheaper stocks, and reserve the stocks at the end of the table for final output. Note that prices in the table reflect what you can expect to pay in discount office supply or computer stores. The paper size in all cases is $8^{1/2} \times 11$ inches. You can buy photographic stock in smaller sizes, however, to use with some printers.

Table 6-1:	Paper Types and Costs	
Туре	Description	Cost Per Sheet
Multipurpose	Lightweight, cheap paper designed for everyday use in printers, copiers, and fax machines. Similar to the stuff you put in your photocopier and typewriter for years.	\$.01 to .02
Inkjet	Designed specifically to accept inkjet inks. At higher end of price range, paper is heavier and treated with special coating that enables ink to dry more quickly, reducing ink smearing, color bleeding, and page curl.	\$.01 to .10
Laser	Engineered to work with the toners used in laser printers. So-called "premium" laser papers are heavier, brighter, smoother, and more expensive. The smooth surface makes images appear sharper; the whiter color gives the appearance of higher contrast.	\$.01 to .04
Photo-realistic	Thick, glossy stock; creates closest cousin to traditional film print. Sometimes called simply photo paper.	\$.50 to \$1

Let the Pros Do It

As you have no doubt deduced if you've read the meaty paragraphs prior to this one — as well as the less meaty, but still nutritious ones — churning out photographic-quality prints of your digital images can be a pricey proposition. When you consider the cost of special photographic paper stock along with special inks or coatings that your printer may require, you can easily spend \$1 or more for each print. When you want high-quality prints, you may find it easier — and even more economical — to let the professional printers handle your output needs. Here are a few options to consider:

- Many neighborhood photo labs now offer digital printing services, and you can also find companies offering digital printing via the Internet. (You transmit your images to the company over the Internet, and you receive your printed images in the mail.) These services are great for times when you want just a few high-quality prints of an image.
- ✓ If you don't like doing your business online, you may be able to find a retail photo-processing outlet or image processing lab that offers printing from digital files. A photo store in my city, for example, charges \$10 to create a photographic negative of a digital image file. You then pay 45 cents for each print off that negative. The images are printed on standard photographic paper.
- ✓ If you need many (50 or more) copies of an image or you want to print on a special stock say, for example, a glossy, colored stock call upon the services of a commercial printer or service bureau. You can then have your images reproduced using traditional four-color printing. The cost per printed image will depend on the number of images you need (typically, the more you print, the lower the per-print cost) and the type of stock you use.
- ✓ For those times when you want a superior quality, large-size print of your image one that's suitable for framing find a service bureau or printer that offers dye-sub printing. You'll pay about \$20 per print, but you should be really pleased with the results. You could buy a large-format dye-sub printer of your own, of course, but at roughly \$1,600 and up for the printer, plus paper and film, you need to print many images before buying your own printer makes more sense than having the job professionally done.

Sending Your Image to the Dance

Enough about all your different printer options! Time to get down to business and get that image on paper. The printing process requires a few thoughtful decisions on your part, which are outlined in the following steps:

1. Open your image.

Sadly, you can't just slap your computer and make the image walk its digital self to the printer. To get the print process rolling, you first need to fire up your image editor and open the image. In most programs, you use the File⇔Open File command or something similar to open an image.

2. Resize the image if necessary.

To find out how big your image will print, use your image editor's size command (depending on the program, the command will be named something like Image Size, Photo Size, or simply Size). If the image is larger than your desired print size, use your image editor's tools to either crop or reduce the image.

If the image is too small, you can enlarge it, but don't forget that enlarging your image lowers the image resolution, which in turn lowers your print quality. You can probably get away with enlarging the image slightly without doing any noticeable damage, but if you raise the image size too much, your printed image likely will appear grainy or blurry.

For details on cropping and resizing images, see "Cream of the Crop" and "Resizing Do's and Don'ts," both in Chapter 8.

3. Choose the Print command.

In almost every program on the planet, the Print command resides in the File menu. Choosing the command results in a dialog box through which you can change the output (print) settings, including the printer resolution or print quality and the number of copies you want to print. You can also specify whether you want to print in portrait mode, which prints your image in its normal, upright position, or landscape mode, which prints your image sideways on the page.

You don't have to go to all the trouble of clicking on File and then on Print, though. You can choose the Print command more quickly by pressing Ctrl+P in Windows or \HP on a Mac. (Some programs bypass the Print dialog box and send your image directly to the printer when you use these keyboard shortcuts, however. So if you need to adjust any printing settings, as in the next few steps, you need to use the File⇔Print approach.)

4. Specify the print options you want to use.

The available options — and the manner in which you access those options — vary widely depending on the type of printer you're using and whether you're working on a PC or Mac. In some cases, you can access settings via the Print dialog box; in other cases, you may need to go to the Page Setup dialog box, which opens like magic when you choose the Page Setup command, generally found in the File menu, not too far from the Print command. (You can sometimes access the Page Setup dialog box by clicking on a Setup button inside the Print dialog box, too.)

I'd love to explain and illustrate all kazillion variations of Print and Page Setup dialog box options, but I have neither the time, page space, or psychotherapy budget that task would require. So please read your printer's manual for information on what settings to use in what scenarios, and for heaven's sake follow the instructions. Otherwise, you aren't going to get the best possible images your printer can deliver.

Also, if you have more than one printer — you rich thing, you — make sure that you have the right printer selected before you go setting all the printer options.

5. Send that puppy to the printer.

In Windows, press Enter or click OK to send your image scurrying for the printer. On the Mac, click Print or press Return.

With that broad overview under your belt — and with your own printer manual close at hand — you're ready for some more specific tips about making hard copies of your images. The following section tells all.

Print size and image resolution

As discussed ad nauseum in Chapters 2 and 3, image resolution is measured in pixels per inch (ppi), while printer resolution is measured in dots per inch (dpi). Both ppi and dpi play a role in determining your image quality. In general, higher resolutions translate to better image quality.

Many people have the mistaken idea that they need to match their image resolution to the printer's dpi (dots per inch) setting. So they assume that for 300 dpi printing, they need 300 ppi images. Not true. Most printers (dye-sub printers being a notable exception) require several printer dots to represent each image pixel, so you're not comparing apples to apples when you talk about dpi and ppi.

So what resolution should you use for optimum printed output? It depends on what you mean by optimum. Do you mean optimum as in, "exactly the size I want the image to be," or optimum as in "I want that image to be as sharp and clear as possible"? If your printing project requires that the image be a certain size, use your image editor to reduce or enlarge the image and don't worry about resolution. Yes, if you have to enlarge that image very much, you're not going to get the print quality you'd like. But what are you going to do? Unless you want to spend several thousand dollars on a professional digital camera, you just have to accept the fact that, for now, digital cameras just can't capture enough pixels to produce both large images and superior image quality.

On the other hand, if quality is more important than size to you, consult your printer's manual or printer manufacturer technical support service for information on appropriate image resolutions. The optimum ppi will vary from printer to printer. Then reduce your image size until you reach the desired resolution. (Again, see "Resizing Do's and Don'ts" in Chapter 8 for how-tos.) If you don't have any luck getting the information you need from your manual or tech support line, follow the general guidelines given in Table 2-1 in Chapter 2.

These colors don't match!

As noted in the sidebar "The separate world of CMYK," you may notice a significant color shift between your on-screen and printed images. This color shift is due in part to the fact that you simply can't reproduce all RGB colors using printer inks. In addition, the brightness of the paper, the purity of the ink, and the lighting conditions in which the image is viewed can all lead to colors that look different on paper than they do on-screen.

The software provided with most color printers includes color-matching controls that are designed to get your screen and image colors to jibe as closely as possible, though. Check your printer manual for information on how to access these controls. Figure 6-1 shows the color-matching options available when using the Alps MD-1000 and Windows 95.

Figure 6-1: To get your printed image colors to more closely match onscreen image colors, try using different colormatching options.

If playing with the color-matching options doesn't work, the printer software may offer controls that enable you to adjust the image's color balance. When you adjust the color balance using the printer software, you don't make any permanent changes to your image. Figure 6-2 shows the color balance controls available for the MD-1000. (Again, you need to consult your printer manual for information on specific controls and how to access and use them.)

Figure 6-2:
You can
also try
adjusting
the color
balance of
the image
prior to
printing by
using the
controls
provided by
the printer
software.

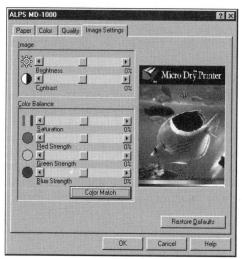

In some cases, you may find that you get better results with the color-matching option turned off. I've found this to be especially true when I'm printing images that I've converted from RGB to CMYK.

If your job or personal level of fussiness demands more accurate colormatching controls than your printer software delivers, you can invest in professional color-matching software. This software enables you to calibrate all the different components of your image-processing system — scanner, monitor, and printer — so that colors stay true from machine to machine. However, remember that even the best color-matching system can't deliver 100 percent accuracy. Also, expect to spend some time tweaking the software's color profiles (files that tell your computer how to adjust colors to account for different types of scanners, monitors, and printers). The default profiles usually don't deliver maximum results.

These same comments apply to the color-management systems that may be included free with your operating system software, such as ColorSync on the Macintosh side.

More words of printing wisdom

In parting — well, at least for this chapter — let me offer these final tidbits of printing advice:

- ✓ The grade and type of paper you use greatly affects image quality. For those special pictures, invest in glossy photographic stock or some other high-grade option. See "The Daily Paper," earlier in this chapter, for more paper news.
- Don't limit yourself to printing images on paper, though. You can buy accessory kits that enable you to put images on coffee cups, T-shirts, calendars, greeting cards, transparencies for use in overhead projectors, and all sorts of other stuff.
- ✓ Do a test print using different printer-resolution or print-quality settings to determine which settings work best for which types of images and which types of paper. The default settings selected by the printer's software may not be the best choices for the types of images you print. Make sure to note the appropriate settings so that you can refer to them later. Also, some printer software enables you to save custom settings so that you don't have to reset all the controls each time you print. Check your printer manual to find out whether your printer offers this option.
- ✓ If your image looks great on-screen but prints too dark, your printer software may offer brightness/contrast controls that enable you to temporarily lighten the image. You may get better results, though, if you do the job using your image editor's levels or brightness/contrast controls. In any case, if you want to make permanent changes to brightness levels, you need to use your image editor, not your printer software. See "Bring Your Image Out of the Shadows" in Chapter 8 for details.

- ✓ Speaking of printer software known in geek collectives as a driver don't forget to install it on your computer. Follow the installation instructions closely so that the driver is installed in the right folder in your system. Otherwise, your computer can't communicate with your printer.
- ✓ And speaking of communication between printer and computer, make sure that you're using the right kind of cable to connect the two devices. Most new printers require bi-directional, IEEE 1284 compliant cables. Don't worry about what that means — just look for the words on the cable package. And don't cheap out and buy less-expensive cables that don't meet these specifications, or you won't get optimum performance from your system.

Don't ignore your printer manual's instructions regarding routine printer maintenance. Print heads can become dirty, inkjet nozzles can become clogged, and all sorts of other gremlins can gunk up the works. When testing an inkjet model for this book, for example, I almost wrote the printer off as a piece of junk because I was getting horrendous printouts. Then I followed the troubleshooting advice in the manual and cleaned the print heads. The difference was like night and day. Suddenly, I was getting beautiful, rich images, just like the printer's advertisements promised.

- ✓ Images printed using ink, dye, toner, and wax fade when exposed to sunlight. (Micro-dry inks don't fade, because the ink is comprised of a plastic resin.) So if you're printing an image for framing, you may want to invest in special UV-protected glass to give your image extra life. Also try to hang the picture in a place where it won't be exposed to strong sunlight on a daily basis. And keep a backup copy of that image on disk, so that when the image starts to fade, you can print a new copy.
- If you're printing on glossy photographic paper, try not to touch the image side of the print. You can leave fingerprints on the image.

Chapter 7

On Screen, Mr. Sulu!

In This Chapter

- Creating images for screen display
- Preparing images for use on a Web page
- Trimming your file size for faster image downloading
- ▶ Choosing between the two Web file formats, GIF and JPEG
- Making part of your Web image transparent
- Attaching an image to an e-mail message
- Using an image as a desktop background

ithout a doubt, the ideal use for today's digital cameras is to create images for on-screen display. Most consumer-level cameras can't deliver the image resolution needed to produce top-notch printed pictures at anything larger than snapshot size. But all cameras, even the most inexpensive, entry-level models, are capable of creating great images for onscreen display, where resolution demands are minimal.

This chapter explores a variety of on-screen uses for digital images, from adding pictures to Web pages to creating a custom background for your Mac or PC screen. Among other things, you find out how to prepare an image for use on the Web, which image file formats work best for different on-screen uses, and how to send a picture along with an e-mail message.

Step Inside the Screening Room

With a photographic print (or a digital print, for that matter), your display options are fairly limited. You can pop the thing into a frame or photo album. You can stick it to a refrigerator with one of those annoyingly cute refrigerator magnets so abundant these days. Or you can slip it into your wallet so that you're always prepared when a stranger or acquaintance inquires after you and yours.

In their digital state, however, images can be displayed in all sorts of new and creative ways, including the following:

- ✓ You can add pictures to your company's site on the World Wide Web assuming that your company is progressive enough to operate said site. Many folks these days even have personal Web pages devoted not to selling products but to sharing information about themselves and their families with interested parties around the world. See "Nothing but Net: Images on the Web," later in this chapter, for details on preparing an image for use on a Web page.
- ✓ You can e-mail an image to friends, clients, or relatives, who then can view the image on their computer screens, save the image to disk, and even edit and print the image if they like. Check out "Drop Me a Picture Sometime, Won't You?," later in this chapter, for information on how to attach an image to your next e-mail missive.
- ✓ You can import the image into a multimedia presentation program such as Microsoft PowerPoint or Corel Presentations. The right images, displayed at the right time, can add excitement and emotional impact to your presentations and also clarify your ideas. Most presentation programs can accept images in the major file formats, including TIFF and JPEG. Check your presentation program's manual for specifics on how to import an image into your next really big show.
- ✓ You can use your favorite image as desktop wallpaper the image that rests behind all the icons, windows, and other elements of your computer's operating environment. Turn to "Redecorate Your Computer's Living Room," later in this chapter, for how-tos.
- ✓ You can create a personalized screen saver featuring your favorite images. If you work on a PC, the EasyPhoto browser program that ships with PhotoDeluxe makes creating a screen saver easy, as do many other entry-level image editors and browsers. In EasyPhoto, first create a gallery containing all the images you want to include in the screen saver (choose File Create or Open Gallery and then click Create New Gallery). Add images to the gallery by using the File⇔Add Photos to Gallery command. Then choose File

 Use Gallery as Screen Saver to complete the process.

If you're a Macintosh user, you can create a screen saver using the After Dark program that ships with the Mac version of PhotoDeluxe. To add an open image to the After Dark screen saver, use the PhotoDeluxe Guided Activities buttons. Click the Send button, then the To Disk tab, and then the Screen Saver Slide Show icon. Follow the on-screen instructions to add your image to the screen saver.

Cool as screen savers are, though, I have to vote against them. In the first place, screen savers are no longer necessary to prevent the damage that used to occur when a monitor was left on and unattended for a long period of time (the on-screen image used to "burn in" to the

- screen). In the second place, screen savers suck up system resources that you sorely need when editing images, especially when the image file is large. If you really want to create a screen saver, go for it. But before you fire up your image editor, you may want to deactivate the thing.
- ✓ With some digital cameras, you can even download images to your TV set or VCR. You can then show your pictures to a living room full of captive guests and even record your images to tape. Load up the camera with close-up pictures of your navel, cable the camera to your TV, and you've got an evening that's every bit as effective as an old-time slide show for convincing people whom you don't like to never set foot in your house again. For information on this intriguing possibility, see "Now Playing on Channel 3" in Chapter 5.

That's About the Size of It

Sizing images for the screen is a little different than sizing them for printed output. When producing screen images, you need to size your pictures in terms of pixels, not inches or picas or any of the traditional measurement schemes you may be using for your print work.

In most cases, monitors display images using one screen pixel for every image pixel. (The exception is when you're working in an image-editing program or other application that enables you to zoom in on an image, thereby devoting several screen pixels to each image pixel.) So when sizing your image, you simply figure out how many pixels wide by how many pixels tall your monitor displays and then determine how much of that screen real estate you want your image to consume.

Most monitors can be set to a choice of resolutions: 640×480 pixels, 800×600 pixels, $1{,}024 \times 768$, and $1{,}280 \times 1{,}024$, for example. So if your image is 640×480 pixels, it consumes the entire screen on a monitor running at the 640×480 setting. On a monitor set up to display a higher number of pixels, the image no longer fills the entire screen. Figure 7-1 shows two shots of my 17-inch screen. In the top example, I displayed a 640×480 image with the screen display set at 640×480 pixels. The image fills the entire screen (a portion of the image is hidden by the Windows 95 taskbar at the bottom of the frame). In the bottom example, I displayed the same 640×480 image but switched the screen display to $1{,}280 \times 1{,}024$ pixels. The image now eats up about one-fourth of the screen.

Unfortunately, you often don't have any way to know or control what monitor resolution will be in force when your audience views your pictures. Someone viewing your Web page in one part of the world may be working on

a 21-inch monitor set at 1,280 x 1,024 pixels, while another someone may be working on a 13-inch monitor set at 640 x 480 pixels. So you just have to strike some sort of compromise.

I recommend sizing your image assuming a 640 x 480 display — the least common denominator, if you will. If you create an image larger than 640 x 480, viewers with 640 x 480 monitors have to scroll the display back and forth to see the entire image. Of course, if you're preparing images for a multimedia presentation and you know what size monitor you'll be using, work with that monitor's resolution in mind.

To resize your image for screen display, follow the steps outlined in "Resizing Do's and Don'ts" in Chapter 8, but select pixels as the unit of measurement for the Width and Height values in the Photo Size dialog box. Then just specify how many pixels wide by how many pixels tall you want your image to be.

Remember that if you increase the Width or Height values, the software has to make up — interpolate — the new pixels, and your image quality can suffer. But in most cases, you'll have more pixels than you need, and you can reduce the Width and Height values with little or no damage to your image.

Be sure to make a backup copy of your image before you resize it — you may want the original pixels back some day!

Also remember that the more pixels you have, the larger the image file. If you're preparing images for the Web, file size is a special consideration because larger files take longer to download than smaller files. See "Nothing but Net: Images on the Web" for more information about preparing images for use on Web pages.

What About Image Resolution?

The on-screen resolution of an image is controlled by the monitor and software used to view the image, not the resolution of the original image file. For most on-screen uses, your image will be displayed between 72 and 96 ppi, even if you set the image resolution at 300 ppi in your image editor. So as long as you follow the resizing instructions given in the preceding section that is, you use pixels as your unit of measurement — you don't need to worry your already tired brain with resolution issues when working with screen images.

If you're wondering where the 72 to 96 ppi figure comes from, wonder no more. This resolution range reflects the default screen resolutions of Macintosh and PC monitors. Most Macintosh monitors are set up to display 72 pixels per inch, while most PC monitors display 96 pixels per inch.

Figure 7-1: When the monitor is set to the standard 640-x-480 pixel display, a 640-x-480pixel image consumes the entire screen (top). When the monitor display is switched to 1,280 x 1,024, the same image consumes roughly one-quarter of the screen.

Newcomers to the digital image world often have trouble sizing images in terms of pixels, however. And some image editors don't offer pixels as a unit of measurement in their image size dialog boxes. If you can't resize your image using pixels as the unit of measurement or you prefer to work in inches, then you do need to think about resolution — but not too much. Just set the resolution between 72 and 96 ppi and be done with it. If you don't change the resolution to match the typical screen resolution (72 to 96 ppi), your images won't be displayed at the size you set in your image editor.

If making the mental conversion between inches and pixels is all that's troubling you, here's an easy solution: Just multiply the number of inches you want by 72 (or whatever screen resolution in the 72 to 96 ppi range you use). For example, if you want your image to be four inches wide on-screen, your image needs to be 288 pixels wide (72 x 4 = 288).

Remember, too, that changing the resolution of an image doesn't affect the size of the image on the disk unless you add or dump pixels (resample) to achieve the new resolution. A 640-x-480-pixel image consumes as much disk space at 72 ppi as it does at 300 ppi. To eliminate pixels in PhotoDeluxe, you can either lower the Width and Height values in the Photo Size dialog box with pixels as your unit of measurement, or, if any other unit of measurement is selected, deselect the File Size check box and lower the Resolution value.

Nothing but Net: Images on the Web

If your company operates a World Wide Web site or if you maintain a personal Web site, you can easily place images from your digital camera or scanned images onto your Web pages. In fact, this use of digital images is probably one of the main reasons for buying a digital camera today.

Because I don't know what Web-site creation program you're using, I can't give you specifics on the commands and tools you use to place images on your pages. But I can offer some advice on a general artistic and technical level, which is just what happens in the next few sections.

Some basic Web rules

If you want your Web site to be one that people love to visit, take care when it comes to adding images (and other graphics, for that matter). Too many images or images that are too big quickly turn off viewers — especially impatient ones with slow modems. Every second that a viewer has to sit and wait for your images to download brings that viewer a second closer to giving up and moving on from your page.

To make sure that you attract, not annoy, visitors to your Web site, follow these ground rules for images:

- ✓ Keep image size to a minimum no more than 20K per picture and a total of 50K per page is optimal. To find out how large your image is when working in PhotoDeluxe, choose Size⊕Photo Size and check the Current Size value at the top of the dialog box. If the image is too big, resize it following the guidelines discussed in "That's About the Size of It" and "What About Image Resolution?," earlier in this chapter. Or, if you're saving the image as a JPEG file, as discussed in the upcoming "JPEG: The photographer's friend," use a higher compression setting.
- ✓ Speaking of file formats, save your images in either the JPEG or GIF file format. These formats, both of which offer a high degree of image compression, are the only ones widely supported by different Web browsers. Two other formats, PNG (pronounced *ping*) and FlashPix, are in development, but not fully supported by either browsers or Webpage creation programs yet. You can read more about JPEG and GIF in the next three sections.
- ✓ Make sure that every image you add is *necessary*. Don't junk up your page with lots of pretty pictures that do nothing to convey the message of your Web page in other words, images that are pure decoration. These kinds of images waste the viewer's time and cause people to click away from your site in frustration.
- ✓ If you use an image as a hyperlink that is, if people click the image to travel to another page also provide a text-based link. Why? Because many people (myself included) set their browsers so that images are not automatically downloaded. Images appear as tiny icons that the viewer can click to display the entire image. It's not that I'm not interested in seeing important images it's just that so many pages are littered with irrelevant pictures. When I use the Internet, I'm typically seeking information, not just cruising around looking at pretty pages. And I don't have time to download a bunch of meaningless images.
 - If you want to appeal to antsy folks like me, as well as anyone who has a limited amount of time for Web browsing, set up your page so that people can navigate your site without downloading images if they prefer. My favorite sites are those that provide some descriptive text with the image icon for example, "Product shot" next to a picture of a manufacturer's hot new toy. This kind of labeling enables me to decide which pictures I want to download and which ones will be of no help to me. At the very least, I expect navigational links to be available as text-based links somewhere on the page.
- ✓ To accommodate the widest range of viewers, size your images with respect to a screen display of 640 x 480 pixels. For more on this topic, see "That's About the Size of It," earlier in this chapter.

Finally, a word of caution: Remember that anyone who visits your page can download, save, edit, print, and distribute your image. So if you want to control the use of your picture, don't post it on your Web page.

Decisions, decisions: JPEG or GIF?

As discussed in the preceding section, you can choose from two file formats for saving images that you want to put on a Web page: JPEG or GIF. Both formats have their advantages and drawbacks.

JPEG is a better choice than GIF when you want the best possible image reproduction. JPEG supports 24-bit color, which means that your images can contain 16 million colors. GIF, on the other hand, can save only 8-bit images, which restricts you to 256 colors. To see the difference this color limitation makes, take a look at Color Plate 5-1. In the Color Plate, I zoomed way in on the same bowl of fruit shown in Color Plate 4-1. (The image in Color Plate 5-1 was taken from a different angle, though.) The top image is a 24-bit image; the bottom has been converted to a 256-color image.

The color loss is most noticeable in the banana in the right half of the image. In the 24-bit image, the subtle color changes in the banana are realistically represented. But when the color palette is limited to 256 colors, the range of available yellow shades is seriously reduced, so one shade of yellow must represent many similar shades. The result is a banana that has a blotchy, unappetizing appearance.

For this reason, JPEG is better than GIF for saving continuous-tone images images like photographs, in which the color changes from pixel to pixel are very subtle. GIF is usually reserved for grayscale images — which have only 256 colors to begin with — and for non-photographic images, such as line art.

However, JPEG does have its down side, file size being one of the major disadvantages. With more color information to store, a JPEG version of an image is much larger than a GIF version. Both JPEG and GIF compress image data in order to reduce file size, but JPEG uses lossy compression, while GIF uses lossless compression. As explored in "File Format Free-for-All" in Chapter 5, lossy compression dumps some image data, resulting in a loss of image detail. Lossless compression, on the other hand, retains virtually all image data. So although you can reduce a JPEG file to the same size as a GIF file, doing so requires a high degree of lossy compression, which can damage your image just as much as converting it from a 24-bit image to a 256-color GIF file. For a look at how various compression amounts affect an image, see Color Plate 3-2.

So choosing between JPEG and GIF sometimes becomes a question of the lesser of two evils. Experiment with both formats to see which one results in the best-looking image at the file size you need. In some cases, you may discover that shifting the image to 256 colors really doesn't have that much of an impact — if your image has large expanses of flat color, for example. Similarly, you may not notice a huge loss of quality on some images even when applying the maximum amount of JPEG compression, while other images may look like garbage with the same compression.

Also keep in mind that the problems created by both GIF and JPEG compression are less noticeable when the image is displayed at small sizes. To illustrate the color loss that resulted from converting the image in Color Plate 5-1 to GIF, I had to zoom way in on the image — from a distance, the damage was barely noticeable.

GIF does offer one additional feature that JPEG does not: the ability to make a portion of your image transparent, so that the underlying Web page background shows through. For more information on creating transparent GIFs, see the next section.

GIF: 256 colors or bust

As discussed in the preceding section, the GIF format can support only 8-bit (256-color) images. This color limitation results in small file sizes that make for shorter download times, but can also make your images look a little pixel-y and rough. (See Color Plate 5-1 for an illustration.)

However, converting to 256 colors may not be too noticeable with some images, and GIF does offer a feature that enables you to make a portion of your image transparent so that the background of your Web page can show through the image.

GIF comes in two flavors: 87a and 89a. My, those are user-friendly names, aren't they? Anyway, the second flavor is the one that enables you to create a partially transparent image. With 87a, all your pixels are fully opaque.

Why would you want to make a portion of your image transparent? Well, suppose that you have an image of your company's newest product — a new tennis shoe, maybe. The shoe was shot against a red background. If you make the background transparent, only the shoe portion of the image shows up on the Web page — it's as if you took some scissors and clipped away the background. If you save the image as a regular GIF image, though, viewers see both shoe and background. Neither approach is right or wrong; GIF transparency just gives you an additional creative option.

Would you like that picture all at once, or bit by bit?

Both JPEG and GIF enable you to specify whether your images display gradually or all at once. If you create an *interlaced* GIF or *progressive* JPEG image, a faint representation of your image appears as soon as the initial image data makes its way through the viewer's modem. As more and more image data is received, the picture details are filled in bit by bit. With noninterlaced or nonprogressive images, no part of your image appears until all image data is received.

As with most things in life, this option involves a tradeoff. Interlaced/progressive images create the *perception* that the image is being loaded faster because the viewer has something to look at sooner. But in reality,

interlaced and progressive images take a little longer to download.

When I'm browsing the Web, I prefer interlaced images because I can find out more quickly whether the image is one I want to see. If not, I can click the browser Stop button to interrupt the download and move on to something else. And if I do want to see the image, well, at least I have something to entertain me while I wait. Although I really would appreciate having you create your Web pages with my personal preferences in mind, I do recognize that other people feel differently about the subject, and I'll try to understand if you opt for noninterlaced/nonprogressive images.

If you're not using PhotoDeluxe, check your on-line help system or manual for information about creating GIF images. Some image editors automatically convert your image to 256 colors when you save the file as a GIF file. But others require you to choose a preliminary command to strip the image down to its 256-color bare bones — called *indexing* the colors — before the GIF format even becomes available as a format choice when saving files.

To save your image as a standard GIF file — without taking advantage of GIF89a transparency — follow these easy-as-pie steps in PhotoDeluxe:

1. Choose File⇔Send To⇔GIF89a Export.

The dialog box shown in Figure 7-2 appears.

Figure 7-2: The first step to saving an image as a GIF file.

GIF89a Export Options	
Convert Photo to GIF Format.	OK]
	Cancel
	Advanced

2. Click Advanced.

Now you see the more complex dialog box shown in Figure 7-3. But don't worry: For your purposes, you need only consider the Interlaced check box. To create an interlaced GIF image — one that appears gradually as the image data is downloaded — select the check box. To create an image that does not display until all data is received by the viewer, deselect the check box. See the sidebar "Would you like that picture all at once, or bit by bit?," in this chapter, for more information on interlacing.

And, for future reference, if you don't care a whit about whether your images are interlaced or not, you can skip straight from Step 1 to Step 4.

Figure 7-3:
The
Interlaced
option
creates
images
that fade
gradually
into view
as image
data is
downloaded.

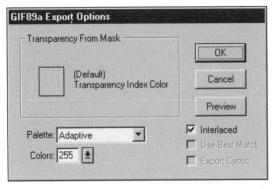

3. Click OK to return to the first GIF89a Export Options dialog box.

4. Click OK.

PhotoDeluxe converts your image to an 8-bit image and displays the GIF89a Export dialog box, which is the standard Export dialog box dressed up to make it appear unique. See Figure 8-2 in Chapter 8 if you don't have a computer handy and you want to see what the Export dialog box looks like.

5. Enter the file name and specify where you want to save the image.

The GIF format is already selected for you automatically as the file type.

6. Click Save.

If your image already contains only 256 colors, you can simply choose the File⇔Send To⇔File Format command as you do when saving to TIFF, JPEG, or other file formats. But the GIF format is available as a format option only if the image is 256 colors or less. Otherwise, you need to use the GIF89a Export command.

To use the GIF transparency option, point and click your way through these not-quite-as-easy-as-pie, but still-not-brain-surgery steps instead:

1. Choose File⇔Send To⇔GIF89a Export.

The dialog box shown back in Figure 7-2 appears, just as before.

2. Click the Advanced button.

You see the GIF89a Export Options dialog box shown back in Figure 7-3. Do not — I repeat — do *not* touch the Palette and Colors options. Leave them set at Adaptive and 255, respectively.

3. Set the transparency preview color.

The color swatch in the Transparency From Mask area of the dialog box shows you what color will be used to represent the transparent pixels in your image when you view the image inside PhotoDeluxe. The default color is the gray used in the background of many Web pages. If your image contains lots of gray, you may want to change the preview color so that you can more easily see which pixels are transparent and which ones are opaque. Click the color swatch to display the Color Picker dialog box and select a color just as you do when picking your paint colors. (See "Choosing Your Paint Colors" in Chapter 10 if you need help.) Click OK to exit the Color Picker and return to the GIF89a Export Options dialog box.

4. Click Preview.

A big, black limo arrives and whisks you to the Select Transparent Colors dialog box shown in Figure 7-4. This dialog box is the meat of the GIF89a transparency option. Here, you choose the colors that you want to be transparent.

To make a color transparent, click the eyedropper icon and click on the color inside the image preview. Or click one of the color swatches at the bottom of the dialog box. You can select as many colors as you want. The selected colors are surrounded by a thick outline, as is the bottom-right color swatch in Figure 7-4. If you change your mind and decide you don't want a particular color to appear transparent, Ctrl+click the color swatch with the eyedropper (%+click on a Macintosh).

If you need to zoom in on the preview, click the magnifying glass icon and then click inside the preview. Alt+click (Option+click) to zoom out. To scroll the preview so that you can see another portion of your image, click the hand icon and then drag inside the preview.

After you select your colors, click OK to go back to the dialog box shown back in Figure 7-3.

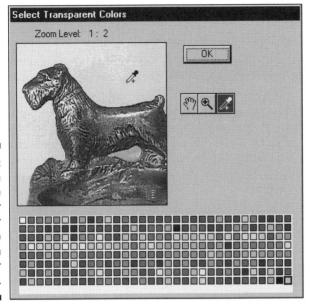

Figure 7-4: Click in the image preview or on a color swatch to make a color transparent.

5. Turn the Interlaced option on . . . or off.

As discussed in the sidebar "Would you like that picture all at once, or bit by bit?", this option determines how your image appears when a viewer downloads your page. Select the check box to turn interlacing on; deselect it to create a noninterlaced image.

6. Click OK.

Off you go to the Export GIF89a dialog box, which is your standard-issue Save/Export dialog box with a fancy name. Enter a name for your image, specify the folder and drive where you want to store the image, and click Save. The appropriate file type (GIF) is selected for you automatically.

After you strip your image down to 256 colors, you can't get those colors back. So be sure to make a backup copy of your image before converting it to a GIF file. Also, editing in 256 colors can be difficult, so be sure that your image is just how you want it before you save to the GIF format.

IPEG: The photographer's friend

JPEG, which can save 24-bit images (16 million colors), is the format of choice for the best representation of continuous-tone images, including photographs. For more on the advantages and drawbacks of JPEG, see "Decisions, decisions: JPEG or GIF?", a few sections ago.

To save an image in the JPEG format, take these exciting steps:

1. Choose File⇔Send To⇔File Format.

(If you're not using PhotoDeluxe, the appropriate command may instead be named File

Save As or File

Export; check your manual or on-line help system for information.)

The Export dialog box, which is a variation of the standard Save dialog box, appears. Name your image, specify the drive and folder where you want the image to be saved, and choose JPEG as the file type. Then click Save to display the dialog box shown in Figure 7-5.

Figure 7-5: Click the Options button to control how your JPEG file is saved.

2. Click Options.

You get the JPEG Options dialog box, shown in Figure 7-6.

3. Set the compression amount.

Using the Quality option box, the neighboring drop-down list, or the slider bar, you choose the amount of compression, thereby determining the image quality and file size. (The higher the Quality value, the less compression is applied, and the larger the file size.) The pop-up menu offers you four general settings, Maximum, High, Medium, and Low, with Maximum providing the best quality/least compression and Low providing the least quality/most compression. The slider bar and option box enable you to get a little more specific. You can choose from 11 settings, with 0 giving you the lowest image quality (maximum compression) and 11 the best image quality (least amount of compression). For print images, you generally should use the High or Maximum setting, but for Web images, you can usually get by with the Medium quality setting. Either choose the setting from the pop-up menu or enter 4 or 5 in the Quality option box. Alternatively, you can drag the slider bar until those values appear in the option boxes.

Figure 7-6:
Choose a
Quality
setting to
specify how
much you
want to
compress
your image.

4. Select a format option.

If you want to create a progressive JPEG file, select the Progressive option in the Format Options section of the dialog box. As discussed in the earlier sidebar, "Do you want that picture all at once, or bit by bit?", a progressive image is displayed gradually when a viewer downloads your Web page. At first, viewers see a low-quality version of your image, and then the image gradually improves as more and more image data is received. The Scans value determines how many intermediate images the viewer sees before the image is displayed in full. You don't have much latitude here — you can specify 3, 4, or 5 scans. You'll be fine if you leave the option set to its default of 3.

For a nonprogressive Web image — that is, one that doesn't appear until all image data is downloaded — choose the Baseline Optimized option. The other option, Baseline ("Standard"), is the right choice for images that will be printed rather than distributed over the Web.

5. Ignore the Save Paths option.

This option is related to an image-editing function available in Adobe Photoshop, but not little brother PhotoDeluxe. The JPEG Options dialog box, like many in PhotoDeluxe, is lifted from Photoshop, which is why the option is included.

6. Click OK.

The file is saved without further ado.

Before you save an image using JPEG with a high degree of compression, be sure to save a backup copy using a file format that doesn't use lossy compression — TIFF, for example, or the native PhotoDeluxe format (PDD). After you apply JPEG compression, you can't get back the image data that gets eliminated during the compression process.

Also be aware that progressive JPEGs demand more RAM to view and are not supported by some older Web browsers. In most cases, neither issue is a major concern. But if people complain that they're having trouble accessing or viewing the images on your Web site, try exchanging the images with nonprogressive versions.

Drop Me a Picture Sometime, Won't You?

Being able to send digital photos to friends and family around the world via e-mail is one of the most enjoyable aspects of owning a digital camera. With a few clicks of your mouse, you can send an image to anyone who has an e-mail account. That person can then view your image on-screen, save it to disk, and even edit and print it.

Of course, this capability comes in handy for business purposes as well. As a part-time antique dealer, for example, I often exchange images with other dealers and antique enthusiasts around the country. When I need help identifying or pricing a recent find, I e-mail my contacts and get their feedback. Someone in the group usually can provide the information I'm seeking.

Although attaching an image to an e-mail message is really simple, the process sometimes breaks down due to differences in e-mail programs and how files are handled on the Mac versus the PC. Also, newcomers to the world of electronic mail often get confused about how to view and send images — which isn't surprising, given that e-mail software often makes the process less than intuitive.

One way to help make sure that your image arrives intact is to prepare it properly before sending. First, size your image according to the guidelines discussed in this chapter, in "That's About the Size of It" and "What About Image Resolution?"

Also, save your image in the JPEG format, as explained in the preceding section. Use the Baseline Optimized setting and a Medium or High Quality setting. Some e-mail programs can accept GIF images, but not all can, so use JPEG for safety's sake.

Note that these instructions don't apply to images that you're sending to someone who needs the image for some professional graphics purpose for example, if you created an image for a client who plans to put it in a company newsletter. In that case, save the image file in whatever format the client needs, and use the image resolution appropriate for the final output. as explained in "Resolution Rules!" in Chapter 2 and "Resizing Do's and

Don'ts" in Chapter 8. With large image files, expect long download times. As a matter of fact, unless you're on a tight deadline, putting the image on a Zip disk or some other removable storage media and sending it off via overnight mail may be a better option than e-mail transmission.

That said, the following steps explain how to attach an image file to an e-mail message in Netscape Navigator. If you're using some other program to send and receive e-mail, the process is probably very similar, but check your program's on-line help system just to be sure.

- 1. Choose File⇔New Mail Message to open a new mail window.
- 2. Enter the recipient's name, e-mail address, and subject information as you normally do.
- 3. Choose File⇒Attach File or click the Attach button on the toolbar.

Most programs provide such a toolbar button — look for a button that has a paper clip icon on it. The paper clip has become the standard icon to represent the attachment feature.

The Attachments dialog box, shown in Figure 7-7, appears.

Figure 7-7:
In Netscape
Navigator,
you attach
an image to
an e-mail
message
via this
dialog box.

4. Click the Attach File button.

You see a dialog box that looks much like the one you normally use to locate and open a file. Track down the image file you want to attach, select it, and click the Open button. You're then returned to the Attachments dialog box.

5. Make sure that the As Is option is selected.

The Convert to Plain Text option is certainly intriguing, what with a picture being worth a thousand words and all, but unless you want to send someone a page full of gibberish, stick with As Is.

6. Click OK.

Or, if you want to attach more images to the same message, repeat Steps 4 and 5 and then click OK.

7. Click Send to launch that image into cyberspace.

If everything goes right, your e-mail recipient should receive the image in no time. In Netscape Navigator, the image either appears as an *inline graphic*—that is, it is displayed right in the e-mail window— as in Figure 7-8, or as a text link that the user clicks to display the image. To save the image to disk in Netscape, you right-click the image or link and choose either Save This Image (for an inline image) or Save This Link (for an image link).

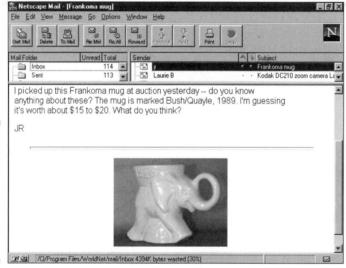

Figure 7-8: Right-click an inline image in Netscape to save the image to disk.

But as mentioned earlier, several technical issues can throw a monkey wrench into the process. If the image doesn't arrive as expected or can't be viewed, the first thing to do is call the tech support line for the recipient's e-mail program or service. Find out whether you need to follow any special procedures when sending images and verify that the recipient's software is set up correctly. If everything seems okay on that end, contact your own e-mail provider or software tech support. Chances are, some e-mail setting needs tweaked, and the tech support personnel should be able to help you resolve the problem quickly.

Redecorate Your Computer's Living Room

Tired of that plain old background that you see behind your program windows? You can turn one of your images into a customized background, as I did in Figure 7-9.

Somewhere along the line, the people who sit around dreaming up names for computer stuff decided that background screens should be referred to as *wallpaper*. Fortunately, hanging up new computer wallpaper isn't nearly as problematic as repapering a real room.

If you work on a Windows computer, PhotoDeluxe provides a command that automatically converts your image to wallpaper. To use this command, choose File\$\scrip\$Send To\$\scrip\$Wallpaper. Each time you choose the command, the current wallpaper image is deleted and replaced with the new image.

If you want the image to fill the entire screen, size the image to match the screen resolution. If your monitor is set to display 640×480 pixels, for example, make your image 640×480 pixels large.

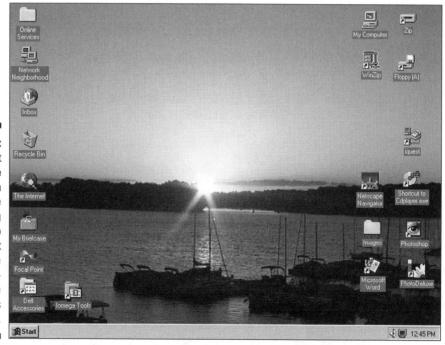

Figure 7-9:
My sunset
image
creates a
far more
soothing
desktop
environment
than the
standardissue
Windows
wallpaper.

Just in case you're not using PhotoDeluxe or you want to create several different wallpaper images, the following sections explain how to create wallpaper using Windows 95, Windows 3.1, Macintosh System 7.5, and Mac OS 8.

Creating Windows wallpaper

If you're using Windows 95, follow these steps to splatter your favorite image across your desktop:

1. Save your image in the BMP format.

This is the format required by the Windows system software. If you need help with the saving process, flip to "Save Now! Save Often!" in Chapter 8.

2. Right-click anywhere on the Windows 95 desktop and choose Properties from the resulting pop-up menu.

The dialog box shown in Figure 7-10 appears. (The dialog box may have slightly different panels depending on the video card your system uses.)

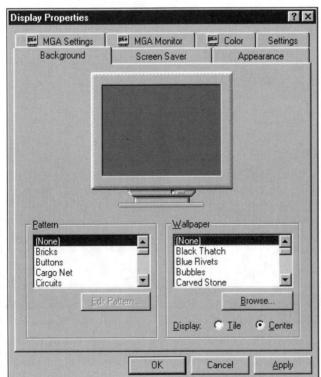

Figure 7-10: Replace your desktop wallpaper with a custom image via this dialog box.

3. Click the Background tab.

4. Click the Browse button.

In the resulting dialog box, track down the BMP file you just created. Click it and click OK.

5. Choose the Tile or Center option.

If you choose Center, the image is centered in the desktop area. If you choose Tile, the image is repeated across the screen, as many times as necessary to fill the entire desktop.

6. Click OK.

That's all there is to it. If you ever want to select a different wallpaper, repeat Steps 1 through 3, select a different wallpaper file from the Wallpaper scrolling list, and click OK.

To create custom wallpaper in Windows 3.1, save your image in the BMP format. Then double-click the Control Panel icon, which should be in the Main program group if you haven't moved it. Double-click the Desktop icon to display the Desktop dialog box and select your wallpaper image file from the Wallpaper drop-down list. Choose the Center option to center the image on your screen; choose Tile to repeat the image as many times as needed to fill the screen. Click OK to adhere your new wallpaper to your screen.

Creating Macintosh wallpaper

Macintosh users can also replace their system wallpaper with an image. If you're using OS 8, you can fill your entire screen with an image, but if you're using System 7.5, you're limited to a 128-x-128-pixel image that repeats across the screen.

Here's how to create a customized background pattern when using System 7.5:

1. Create a 128-x-128-pixel image.

Use an image resolution of 72 ppi. If you need help resizing your image or changing the image resolution, see "Resizing Do's and Don'ts" in Chapter 8.

- 2. Press \Re +A to select the entire image.
- 3. Press #+C to copy the image to the Clipboard.
- 4. Open the Desktop Patterns program.

The program should be located in the Control Panels folder. The Desktop Patterns dialog box appears.

- 5. Press **%**+V to paste your image into the dialog box.
- 6. Click the Set Desktop Pattern button.

Your pattern fills the screen, making you the envy of all your less-clever Mac enthusiasts.

Note that you may need to Increase the amount of memory available to the Desktop Pattern program in order to create a customized pattern. To do so, exit out of the program, switch to the Finder, and click the Desktop Pattern program icon. Press #+I to open the Info dialog box for the program and raise the value in the Preferred Size option box.

For those of you who have made the move to OS 8, things are a little different. You can use any PICT or JPEG image as your wallpaper. Just follow these incredibly easy steps:

1. Choose Control Panels Desktop Patterns from the Apple menu.

The dialog box shown in Figure 7-11 appears.

Figure 7-11:
In OS 8,
head for
this dialog
box to use
a custom
image as
your
desktop
wallpaper.

Display options menu

- 2. Click the Picture button.
- 3. Click Remove Picture.

This step removes the current desktop picture and changes the Remove Picture button into the Select Picture button.

4. Click Select Picture.

Choose your image file from the dialog box that appears when you click the button. Click Open to select the file and return to the Desktop Pictures dialog box.

5. Choose a display option from the drop-down menu.

(The menu is labeled in Figure 7-11.) You have five options: Fill Screen fills the screen with your image, oddly enough. Scale to Screen enlarges or reduces your image so that it fits on screen. Center on Screen puts your image smack dab in the middle of the screen, while Tile on Screen repeats the image as many times as necessary to fill the screen. Position Automatically scales or fills the screen with the picture, depending on the image size.

6. Click the Set Desktop button.

Your image is plastered to your screen.

Another way to change your desktop wallpaper is to simply drag the image file to the picture preview in the Desktop Pictures dialog box (refer to Figure 7-11). You can drag a whole folder of images to the preview to make the system display a group of images randomly.

Part III Tricks of the Digital Trade

"I found these two in the multimedia lab morphing faculty members into farm animals."

In this part . . .

f you watch many spy movies, you may have noticed that image editing has worked its way into just about every plot line lately. Typically, the story goes like this: A Mel Gibson-type hero snags a photograph of the bad guys. But the photograph is taken from too far away to clearly identify the villains. So Mel takes the picture to a buddy who works as a digital imaging specialist in a top-secret government lab. Miraculously, the buddy is able to enhance the picture enough to give Mel a crystal-clear image of his prey, and soon all is well for earth's citizens. Except for the buddy, that is, who invariably gets killed by the villains just moments after Mel leaves the lab.

I'm sorry to say that in real life, image editing doesn't work that way. Maybe top-secret government-types have software that can perform the tricks you see in movies — hey, for all I know, our agents may really have ray guns and secret decoder rings, too. But the image editors available to you and me simply can't create photographic details out of nothing.

That doesn't mean that you can't perform some pretty amazing feats, though, as this part of the book illustrates. Chapter 8 shows you how to do minor touch-up work, such as cropping your image and correcting color balance. Chapter 9 explains how to apply edits to just part of your image by creating selections, and Chapter 10 introduces you to tools that enable you to paint on your pictures and otherwise monkey around with image colors. Chapter 11 gives you a taste of some advanced editing techniques, such as creating photographic montages, and shows you how to turn a crummy image into art by using special effects filters.

Although real-world image editing isn't nearly as dramatic as Hollywood would have you believe, it's still way, way cool, not to mention a lot safer. Real-life image editors hardly ever get whacked by villains — although, if you doctor an image to show your boss or some nemesis in an unflattering light, you may want to stay out of dimly lit alleys for a while.

Chapter 8

Making Your Image Look Presentable

In This Chapter

- Opening and saving images
- Cropping out unwanted elements
- ▶ Adjusting color balance
- > Brightening up images that are too dark
- ▶ Increasing color saturation
- ▶ Sharpening image focus
- Blurring backgrounds
- Resizing and resampling images
- Changing the size of your image canvas

ne of the great things about digital photography is that you're never limited to the image that comes out of the camera, as you are with traditional photography. With film, a lousy picture stays a lousy picture forever. Sure, you can get one of those little pens to cover up red-eye problems, and if you're really good with scissors, you can crop out unwanted portions of the picture. But that's about the extent of the corrections you can do without a full-blown film lab at your disposal.

With a digital image and a basic image-editing program, however, you can do amazing things to your pictures — and with surprisingly little effort. In addition to cropping, color balancing, and lightening too-dark images, you can cover up distracting background elements, bring back washed-out colors, paste two or more images together, and apply all sorts of creative effects.

Chapter 9 explains how to remove, move, and combine elements in a single image or in several images, while Chapters 10 and 11 explore painting tools, special-effects filters, and other advanced image-editing techniques. This chapter explains the basics: simple image-editing tricks you can use to correct minor defects in your image. You find out how to crop, improve

color balance and saturation, lighten and darken, and sharpen images. You also find out how to resize your images and reduce resolution without doing major damage to image quality.

Although you may think that the stuff discussed in Chapters 9, 10, and 11 sounds like more fun (you're right, by the way), the concepts discussed in this chapter are essential to making your images presentable. In fact, almost every image you shoot or scan can be improved by using the techniques in this chapter.

A Word about Image Editors

In this chapter, and in others that describe specific image-editing commands, I show you how to get the job done using the Windows version of Adobe PhotoDeluxe 2.0. I chose this software because it's included with many brands of digital cameras and also because it's available for both Mac and PC. Furthermore, this program offers you many of the same features found in the more sophisticated (and more expensive) Adobe Photoshop, one of the best professional-level image editors.

At an estimated street price of \$49, PhotoDeluxe is a terrific program for the price. But PhotoDeluxe is by no means the only good image-editing solution in this price range. You can buy several other equally worthy image editors for about the same money, including Microsoft PictureIt!, MGI PhotoSuite, Ulead PhotoImpact, and The LivePix Company's LivePix, to name a few.

If you're using an image editor other than PhotoDeluxe, please be assured that almost everything in this chapter and the rest of the book can be adapted easily to your system. Most programs in this price range provide a similar assortment of image editing tools and commands, although the exact tool names and command implementation may be slightly different. Also, the basic editing concepts and photographic ideas presented are the same no matter what image editor you're using.

So use this book as a guide for understanding the basic approach you should take to your image editing, and consult your software's manual or online help system for the specifics of applying certain techniques.

If you don't have any image-editing software or you're shopping for a new program, you can find trial and demo versions of several different image editors on the CD accompanying this book. I've also included some sample images on the CD in case you don't yet have any at your disposal. The images are stored in the Images folder on the CD.

A Brief Tour of Your Studio

Because I have only so much room in this book, I opted to dive right into specific image-editing techniques rather than spend much time explaining the PhotoDeluxe interface. This section gives you a brief introduction to the PhotoDeluxe working environment, but be sure to spend some time with the PhotoDeluxe manual (or the manual for the software you're using) to completely familiarize yourself with your on-screen editing studio.

Also, I'm assuming that you are familiar with basic mouse techniques, such as clicking, dragging, and so on, and with the fundamentals of using your computer. For example, you should understand how to navigate through your files to find the image you want to use and how to start and close programs. If you need help with these basics, pick up a copy of *PCs For Dummies* or *Macs For Dummies*, both published by IDG Books Worldwide.

Now that the important legal disclaimers have been dealt with, let me move on to more exciting things. Figure 8-1 gives you a look at the Adobe PhotoDeluxe window with an image open. (The next section explains how to open images.) Here's a brief field guide to the PhotoDeluxe environment:

✓ You can access tools and commands in three ways. You can choose them from menus, as in traditional programs, or you can use the Guided Activities buttons and Project tabs beneath the menus. (Both are labeled in Figure 8-1.) For example, to open an image, you can either choose File⇔Open File, or click on the Get Photo button and then on the Get Photo tab.

By default, only a few menus are displayed. To see them all, as in Figure 8-1, choose File⇔Preferences and click on the Long Menus item.

To choose some commands, you can also use keyboard shortcuts. For example, to open a file, you can press Ctrl+O on a PC and %+O on a Mac. I mention these shortcuts when they're available. Also look on the menus in your program; usually, the available shortcuts are shown next to the command names.

- ✓ Guided Activities provide you with step-by-step instructions for performing various editing tasks, from adjusting color balance to putting your image on a calendar page. Activities are grouped by category; click on one of the Guided Activities buttons to display tasks in that category on the Project tabs to the right. Then click on the icon or tab for the project you want to try. Some projects require that you have the PhotoDeluxe CD-ROM in your CD-ROM drive.
- ✓ Although you can access most commands from either menus or Guided Activities, some options are available only from the Guided Activities buttons. Projects in the Cards and More category, for example, aren't available via the menus. (These projects provide templates that make it

easy to put your photo on a greeting card, label, calendar, and so forth.) Likewise, some special-effects filters and commands are available from the Effects menu only.

Personally, I prefer working from menus and using keyboard shortcuts, because doing so is the quickest route to accomplishing most tasks. But if you're a newcomer to image editing, you may find the Guided Activities helpful.

Because the Guided Activities are designed to be self-explanatory and do a really good job at living up to that purpose — I don't spend time here showing you how to use them. Also, I don't give you the Guided Activities steps to follow when explaining editing techniques in this book; instead, I present only the traditional menu-based steps and keyboard shortcuts. As I just mentioned, the Guided Activities method usually requires more steps than using menus, and I think it's my job to show you the quickest way to get things done. I do, however, urge you to try out the Guided Activities on your own.

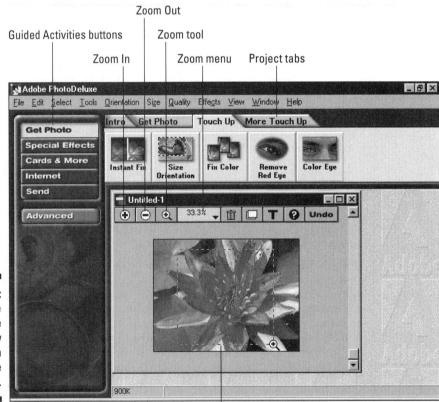

Figure 8-1: The Adobe **PhotoDeluxe** window with an image displayed.

Zoom marquee

- ✓ Unfortunately, you can't turn off the Guided Activities display area to make more room for your images, even if you prefer to use menus. To give yourself the largest possible area for editing, use a monitor display setting of 800 x 600 pixels or greater. (In fact, if you use a lower resolution, some elements at the bottom of the PhotoDeluxe window may be cut off.) But remember that the higher the monitor resolution you use, the more computer resources you use, which means you have fewer resources available for image editing. If you experience out-of-memory errors or other problems when working on large images, try changing to a lower monitor resolution.
- When you first open an image, PhotoDeluxe displays the image at a size that can fit entirely on-screen. To get a closer look, click on the Zoom In button or choose a higher zoom value from the Zoom menu. Or, to magnify a specific area, click on the Zoom tool to select it. Then drag around the area you want to magnify, as shown in Figure 8-1. PhotoDeluxe fills the image window with the area enclosed by the zoom marquee (the dotted line you created when you dragged with the zoom tool, as labeled in Figure 8-1).

To zoom out, click on the Zoom Out button, choose a smaller zoom value from the Zoom menu, or Alt+click with the Zoom tool (Option+click on a Mac).

You can also press Ctrl and the plus key (+) to zoom in and Ctrl along with the minus key (-) to zoom out. On a Macintosh, press the \Re in conjunction with the plus or minus key.

✓ As you work in PhotoDeluxe, the program occasionally displays small boxes — called Clue Cards — containing information about the command or tool you just selected. If you don't want to see the box again, select the check box at the bottom of the Clue Card. To prevent any Clue Cards from appearing, choose File⇔Preferences⇔Turn Off All Clue Cards.

How to Open Images

To open an existing image, you use the same procedure that you use to open files in most programs: Choose File⇔Open File or press Ctrl+O (%+O on a Mac). Locate the image on disk and then click on Open. In PhotoDeluxe and in many other editors, you can also open images directly from some digital cameras. See "The Importance of Being TWAIN" in Chapter 5 for more information on this option.

Here are a few other scandalous bits of gossip related to opening images:

✓ In PhotoDeluxe, choosing File

My Photos launches EasyPhoto, a cataloging and viewing program that ships with Version 2.0. (Figure 5-5, in Chapter 5, gives you a look at EasyPhoto.) You can simply double-click an image thumbnail in an EasyPhoto image gallery to open the image in PhotoDeluxe.

- ✓ By default, you can have only one image open at a time. At times, though, you may want to have multiple images open. No problem: Just choose File⇔Preferences⇔Allow Multiple Document Windows. Now you can open as many images as your computer's memory can handle.
 - In fact, you can open several images with one trip to the Open dialog box. Click on the first image you want to open and Ctrl+click on the others (%+click on a Mac). After you click the Open button, all the selected images are opened at one time.
- ✓ If your image opens up lying on its side, choose Orientation⇔Rotate Right or Orientation⇔Rotate Left to turn things around. To flip the image horizontally or stand it on its head, choose Flip Horizontal or Flip Vertical from the Orientation menu.

If you want to create an entirely new image, starting from scratch instead of editing an existing photo, choose File™New or press Ctrl+N (ૠ+N). PhotoDeluxe displays a dialog box in which you can specify the name, size, and resolution of the image. After you click on OK, you're presented with a blank canvas on which to create. (See "Hey Vincent, Get a Larger Canvas!" at the end of this chapter for more information about the image canvas.)

Save Now! Save Often!

Actually, a more appropriate name for this section would be "Saving Your Sanity." Unless you get in the habit of saving your images on a frequent basis, you can easily lose your mind.

Until you save your image, all your work is vulnerable. If your computer crashes, your system locks up, the power goes out, or some other cruel twist of fate occurs, everything you've done in the current editing session is lost forever. And don't think it can't happen to you because you popped for that state-of-the-art system last month. Large digital images can choke even the most pumped-up system. I work on a 266 MMX Pentium II with 32MB RAM (boy, I love talking like that!), and I still get the occasional "This program has performed an illegal operation and will be shut down" message when working on large images.

To protect yourself, commit the following image-safety rules to memory:

- ✓ Stop, drop, and roll! Woops, no, that's fire safety, not image safety. Neither stopping, dropping, nor rolling will prevent your image from going up in digital flames should you ignore my advice on saving. Then again, when you tell your boss or client that you just lost a day's worth of edits, the stop-drop-roll maneuver is good for dodging heavy objects that may be hurled in your direction.
- ✓ To save an image for the first time, choose File

 Save or press Ctrl+S

 (%+S on the Mac). When the Save As dialog box appears, enter a name for your image and choose a storage location on disk, just as you do when saving any other type of document.
- ✓ After you first save an image, resave it after every few edits. You can simply press Ctrl+S or choose File⇔Save to resave the image without opening the Save As dialog box. If you want to save the image under a different name, choose File⇔Save As.
- ✓ In most programs, you can specify which file format you want to use when you choose the Save As or Save command. But in PhotoDeluxe, both commands restrict you to saving only in the native PhotoDeluxe format, PDD. If you need to save the image in any other format TIFF, JPEG, GIF, or whatever choose File→Send To→File Format. (In other programs, this command may be File→Export.)

PhotoDeluxe then displays the Export dialog box, shown in Figure 8-2. The Export dialog box is just like the Save As dialog box except that it offers a choice of file formats. For more information on the various file formats and options that appear when you save to them, see "File Format Free-for-All," in Chapter 5, as well as "JPEG: The photographer's friend" and "GIF: 256 colors or bust" in Chapter 7.

Figure 8-2:
To save an image in a format other than the native PhotoDeluxe format, go to the Export dialog box.

Note that when you save your image in this fashion, all you're doing is making a *copy* of the on-screen image and storing that copy on disk. The command is designed to be used after you finish editing an image and want to export it (open it in some other program), not as a routine save option. When you use the Fileth Send Toth File Format command, the working image — the one on-screen — isn't saved or protected in any way. For this reason, save your image to the PhotoDeluxe (PDD) format until you're finished editing and then export it to the desired format. That way, you can easily resave your image as you work by simply pressing Ctrl+S, as explained a few paragraphs ago.

✓ Why does PhotoDeluxe set things up so that you're virtually forced to work in the PDD format? For one thing, saving in a program's native format speeds up your editing work. Programs can open and work on images in their native format more quickly than images saved in other formats.

Perhaps more importantly, though, the PDD format is one of only two formats that can retain image layers. Layers come into play when you're combining images, as discussed in Chapter 11. The other format that can save layers is the PSD format, which is the native format for Adobe Photoshop.

When you export the image to another format, your layers are smushed together whether you like it or not. Before saving to a format that merges layers, you may want to save a backup copy using the PDD or PSD formats, so that if you ever want to rearrange or otherwise work with your layers, you can.

✓ If you want to add the saved image to an EasyPhoto gallery, select the Add to Gallery check box at the bottom of the Save As or Export dialog box. Choose the gallery name from the neighboring drop-down list. To add a bunch of images to the gallery, launch the EasyPhoto program outside of PhotoDeluxe, open the gallery you want to edit, and choose File⇒Add Photos to Gallery.

While you're working on an image, store it on your hard drive, rather than on a floppy disk or some other removable media. Your computer can work with files on your hard drive faster than images stored on removable media. But always save a backup copy on whatever removable storage media you use, too, to protect yourself in the event of a system crash. See "Floppies, Zips, and Other Storage Options," in Chapter 5, for information about different types of removable media.

Editing Safety Nets

As you make your way through the merry land of image editing, you're bound to take a wrong turn every now and then. Perhaps you clicked when you should have dragged. Or cut when you meant to copy. Or painted a mustache on your girlfriend's face when all you really intended to do was cover up a little hot spot.

Fortunately, most mistakes can be easily undone by using one of the following commands:

- ✓ File⇔Revert to Last Saved restores your image to the way it appeared the last time you saved it. This command is helpful when you totally make a mess of your image and you just want to get back to square one. However, it works only after you save your image to the PDD format using File⇔Save or Save As. (See "Save Now! Save Often!", earlier in this chapter, for information on saving images.)
- ✓ Edit

 Undo takes you one step back in time, undoing your last editing action. If you painted a line on your image, for example, Undo removes the line.

The Revert to Last Saved command is pretty straightforward. Basically, using this command is the same as closing your image without saving it and then reopening the image. You simply save a few clicks getting the job done.

Undo is also simple to use, but I need to pass along a bit more information on this command:

- ✓ To choose Undo quickly, press Ctrl+Z (ૠ+Z on the Mac). Or click the Undo button in the image window (see Figure 8-1).
- ✓ Undo can't take care of all problems. For example, if you screw up and forget to save an image before you close it, Undo can't help you. Nor can Undo reverse the Save command. Also, you must choose Undo immediately after you perform the edit you want to undo. If you use another tool or choose another command including the Save command you lose your opportunity to undo.

The one exception is the Print command. You can make an edit, print your image, and then use Undo if you don't like the way your image looks.

In some programs, you can undo more than the most recent action. You may be able to reverse the last five or even ten edits you made. PhotoDeluxe, however, can undo only one action. Boo.

✓ Change your mind about that undo? Choose Edit⇔Redo or press Ctrl+Z (ૠ+Z) to put things back to the way they were before you chose the Undo command. You can also click on the Undo button in the PhotoDeluxe image window; although the button name doesn't say Redo, clicking on it after undoing something invokes the Redo command.

Almost every program offers an Undo command these days, so as long as you remember to choose Undo right after you screw up, you're fairly well protected from your own devices. Don't you wish you had a button that could fix your real-life mistakes as easily?

In addition to Undo and Revert to Last Saved, PhotoDeluxe offers three additional gaffe-proofing features: selections, layers, and the Eraser tool. For information on using selections, read the first part of Chapter 9. For an introduction to the Eraser tool, see "Brushing on Transparency" in Chapter 10, and for all the scoop on using layers, see "Uncovering Layers of Possibility" in Chapter 11.

Editing Rules for All Seasons

Before you jump whole-hog into editing, you need to review a few basic rules of the road:

- ✓ If you want to apply an edit to just a portion of your image, you must first *select* that area. (Chapter 9 explains how to select stuff.) Otherwise, your changes are applied to the entire image.
- Many editing commands, including special effects commands, display a dialog box that includes a Preview check box, as in Figure 8-3. If you select the box (click on it so that a check mark appears in the box), you can preview the effects of the edit in the image window. With the check box turned off, the effects of your edits don't show in the main image window until you click on OK to apply the edits and close the dialog box.

- While you're in the dialog box, you can toggle the Preview check box on and off to switch back and forth between the original image and the edited version. Use this technique when you're trying to decide whether you like the image better with or without the effect or adjustment you're applying.
- ✓ A blinking line underneath the Preview check box means that PhotoDeluxe is still working on applying your edits to the image.
- ✓ In dialog boxes that contain a thumbnail size preview (like the one in Figure 8-3), you can zoom in and out on the image in the thumbnail by clicking on the plus or minus button beneath the preview.

Figure 8-3:
When you apply some types of edits, you can preview your changes both in the dialog box and in the image window.

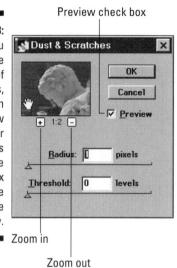

- ✓ To display a different portion of your image in the thumbnail preview, move your cursor onto the preview area. Your cursor changes into a little hand, as in Figure 8-3, and you can then drag to adjust the preview.
- ✓ In most dialog boxes, you can reset all options to the settings that were in force when you opened the dialog box by Alt+clicking on the Cancel button (Option+click on the Mac).
- ✓ Don't forget that if you don't like the results of your edits, you can usually reverse them by choosing Edit Undo immediately. Press Ctrl+Z (第+Z) to apply the Undo command from the keyboard.

Cream of the Crop

Take a look at the left image in Figure 8-4. This picture isn't bad, but it has a bit too much grass in the foreground for my liking. Also, the cathedral tower is almost smack dab in the middle of the frame, creating a rather boring composition.

Were this a film photograph, I'd have to live with the results or find myself a sharp pair of scissors. But because this isn't a film photograph, and because PhotoDeluxe (and virtually every other image editor) offers a crop tool, I can simply clip away the extra grass. I can also trim a little off the left side of the image, which repositions the main subject (the tower) in the frame. The tower is now placed according to the "rule of thirds," one of the basic tenets of dynamic image composition. (See "Composition 101" in Chapter 4 for more information.)

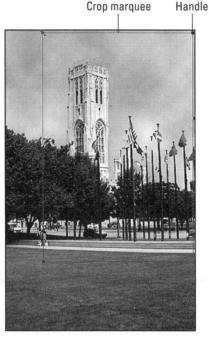

Figure 8-4:
By
indulging in
a little
creative
cropping, I
turned a
so-so photo
into a
keeper.

Here's how to give your image a haircut:

1. Choose Size⇔Trim to activate the crop tool.

For an even faster way to pick up the crop tool, press Ctrl+F7 ($\Re+F7$ on the Mac).

2. Drag to create a crop marquee.

Marquee is digital-image lingo for *outline*. The area inside the marquee is what will be left after you complete your cropping operation. To create the marquee, drag from one corner of the area you want to keep to the other corner.

After you release the mouse button, you see a solid outline with a little square box at each corner, as in the left image in Figure 8-4.

People who do this stuff for a living call those little square boxes *handles. Boxes* could be too easily understood by outsiders, you know.

Drag any handle to resize the marquee. To move the marquee, hold down Ctrl (%) as you drag a handle.

If you decide not to go forward with your crop, press Esc to get rid of the marquee.

4. Click to crop.

As soon as you click the mouse button, PhotoDeluxe crops the image. On a PC, pressing Enter also completes the crop. On a Mac, press Return.

If you don't like what you see, click the Undo button or press Ctrl+Z (\mathbb{H}+Z on the Mac).

A special function of the crop tool enables you to rotate and crop an image in one fell swoop. Using this technique, you can straighten out images that look off-kilter, like the left image in Figure 8-5.

After drawing a crop marquee, press and hold the Alt key (Option on the Mac) as you drag a marquee handle. While Alt (Option) is down, you can rotate the marquee. After you click to initiate the crop, PhotoDeluxe rotates and crops the image in one step, as shown in the second image in Figure 8-5. The leaning tower of Indianapolis leans no more.

Use this technique sparingly. Each time you rotate the image, PhotoDeluxe reshuffles all the pixels to come up with the new image. If you rotate the same image area several times, you may begin to notice some image degradation.

Figure 8-5:

To
straighten
out crooked
images
(left), use
the crop
tool's rotate
function.

Help for Unbalanced Colors

Both scanned images and images from digital cameras often have color balance problems. In other words, the images look too blue, too red, or too green, or exhibit some other color sickness. Color Plate 8-1 is a case in point. This image, shot in the botanical gardens at the Indianapolis Museum of Art, suffers from a green deficiency, or, if you prefer, an over-supply of red and blue.

PhotoDeluxe offers you two solutions to color balance problems: the Color Balance command and the Variations command. The following sections explore both options.

Using the Color Balance command

One way to correct the colors in your image is to choose Quality Color Balance, which brings up the Color Balance dialog box shown in Figure 8-6.

Figure 8-6: Drag the three sliders in the Color Balance dialog box to adjust the colors in your image.

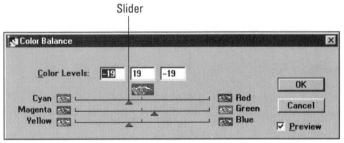

To display the dialog box lickety-split, press Ctrl+Y on a PC and \(\mathbb{H} + Y \) on a Mac.

The Color Balance dialog box offers three slider bars. You drag the sliders (the little triangles) to adjust the color mix in your image. To increase green, for example, drag the slider toward Green (duh!); to reduce the amount of green, drag the slider toward magenta, which lives directly opposite green on the color wheel.

As you move the sliders, the values in the corresponding option boxes at the top of the dialog box reflect your changes. If you prefer, you can doubleclick on an option box and enter the value you want to use from the keyboard. Maximum values are +100 and -100, but for best results, limit your moves to +30 or -30. Otherwise, you can create unnatural, blotchy colors. When you're satisfied with your image, click OK.

Be sure to select the Preview check box so that you can see the results of your changes on-screen, as discussed in "Editing Rules of the Road," earlier in this chapter. Also, if you want to apply color correction to only a portion of your image, select that area first. (Selection techniques are the subject of "Strap on Your Selection Toolbelt" in Chapter 9.)

Using the Variations command

For another approach to color correction, check out the Variations command. Choose Quality Variations or Effects Adjust Variations to display the dialog box shown in Figure 8-7.

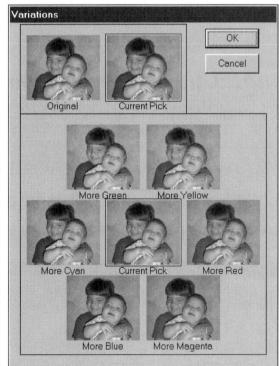

Figure 8-7:
The
Variations
dialog box
gives you
another
way to
correct
color
balance
in your
images.

This dialog box includes thumbnail views of your image. To shift colors around, click on the thumbnail corresponding to the color you want to boost. For example, click on the More Yellow thumbnail to add more vellow to your image. Each click adds color in preset increments; you can't adjust the amount as you can in the Color Balance dialog box. If you add too much of one color, click on the opposite thumbnail. If you add too much yellow, click on the More Blue thumbnail, for example.

Each time you click on a More thumbnail, the thumbnails labeled Current Pick update to show you how your image will appear if you go ahead and apply the color corrections. The Original thumbnail shows you . . . I know you can figure that one out for yourself. However, this dialog box lacks a Preview check box, which means that you can't preview the effects of your corrections in the image window.

Should you mess things up and want to return to square one, Alt+click (Option+click on the Mac) on the Cancel button. The Cancel button turns into the Reset button, and PhotoDeluxe returns all colors to the way they were before you opened the Variations dialog box. To apply your changes, click on OK.

Bring Your Image Out of the Shadows

At first glance, the top picture in Figure 8-8 appears to be a throw-away: The subject is so dark that you can barely make her out. But don't give up on images like this, because with some creative use of brightness and contrast controls, you may be able to rescue that too-dark image, as I did in the bottom picture in Figure 8-8. The image is still a little on the dark side, but I was able to bring it back into the acceptable range.

In PhotoDeluxe, you adjust brightness of an image by using the Ouality Brightness/Contrast command, which displays the dialog box shown in Figure 8-9. Drag the brightness slider to the right to lighten up your image; drag left to darken the scene. Alternatively, you can enter values between +100 and -100 in the corresponding option box.

To display the Brightness/Contrast command in a flash, press Ctrl+B (\#+B on the Mac).

The PhotoDeluxe brightness controls aren't as sophisticated as you find in some other editors, which offer a Levels command that enables you to adjust the brightness of the highlights, shadows, and midtones of the image individually. With the PhotoDeluxe brightness control, you lighten or darken all pixels simultaneously.

Figure 8-8: To bring this little beauty and her doll out of the darkness, I deselected the background before boosting the image brightness and contrast.

Figure 8-9:
You can
adjust
image
brightness
and
contrast
via this
dialog box.

That's fine as long as your entire image is dark. But if a portion of your image is already bright, as in Figure 8-8, you're in a bit of a pickle. If you lighten the image enough to make the dark areas visible, the light areas get *too* bright.

In cases like this, you need to select the dark areas of the image and apply the brightening only to the selection. (Creating selections is explained in depth in Chapter 9.) In Figure 8-8, I selected the girl, the doll, and the wood flooring in the bottom third of the image and then boosted the brightness of those areas only. Then I selected that too-hot area in the upper-left corner and decreased the brightness a little.

When you study Figure 8-8, you may wonder why I didn't go even further with the brightening. After all, the subject is still a little too dark. Well, notice the girl's hair on the left side of the image. Mixed in with the strands of hair are lots of areas where the bright background shows through. Brightening up the hair any more blasted those background areas to the point where my edits became far too noticeable. I attempted to select just the hair and not the background segments, but even though I was fairly successful, the results of applying the brightness command to just the hair created an unnatural effect.

After you brighten an image, you may find the colors a bit washed out. To bring some life back into your image, use the Saturation control in the Hue/Saturation dialog box, as explained in the upcoming section "Give Your Colors More Oomph." You may also need to tweak the contrast a bit by using the Contrast control in the Brightness/Contrast dialog box. Drag the slider right to increase contrast; drag left to decrease contrast.

Brightness adjustments at higher Levels

If your image editor offers a Levels command (PhotoDeluxe doesn't), take the time to learn how to use it. Levels dialog boxes are usually a little intimidating, full of strange-sounding options, graphs, and such. But broken down into their primary elements, Levels dialog boxes generally offer three important controls, often labeled Input Values:

- One control, sometimes referred to as the Low Point value, controls the darkest pixels in the image. Using this control, you can make your blacks blacker, for example.
- The second control, often called the Gamma or Midpoint value, controls the medium-brightness pixels. Typically, you need to brighten up medium pixels in digital images, especially for printing.

The third control, which may be labeled the High Point value, controls the brightest pixels in the image. You can use this control to make teeth and eyes look whiter, for example.

Levels dialog boxes also may contain Output Values options. Using these options, you can set the maximum and minimum brightness values in your image. In other words, you can make your blackest pixels lighter and your whitest pixels darker — which usually has the unwanted effect of decreasing the contrast in your image.

Note that your image editor may call the Levels command something else. Check your manual for information about brightening an image to see what kind of controls are available to you and where they're found.

Give Your Colors More Oomph

Images looking dull, lifeless? Toss them in the image-editing machine with a cupful of Saturation, the easy way to turn tired, faded colors into rich, vivid hues.

Now that you understand the kind of dangers of watching too many "day-time dramas" — you start sounding like a laundry-soap commercial without even knowing it — let me point your attention to Color Plate 8-2. The image on the left looks like it's been through the washing machine too many times — oops, there I go again. Anyway, the colors in the image are, well, sort of colorless.

All that's needed to give the image a more colorful outlook is the Saturation command. Like the Saturation knob on your television set (or, more likely, the Saturation adjustment available through your remote control), the Saturation control in an image editor strengthens the intensity of image colors. The image on the right in Color Plate 8-2 shows the effects of boosting the saturation. The greens are greener, the sky shows some blue, and the natural colors in the stone become more apparent. (Like several other images in this book, the image in Color Plate 8-2 was shot at the Indianapolis Museum of Art, by the way.)

To access the saturation knob in PhotoDeluxe, choose Quality[∞]Hue/Saturation or press Ctrl+U (**%**+U on the Mac). The dialog box shown in Figure 8-10 leaps to the screen, offering three controls, Hue, Saturation, and Lightness. Drag the Saturation slider to the right to increase color intensity; drag left to suck the colors out of your image.

Figure 8-10:
To make
your colors
more vivid,
increase
the
Saturation
value.

If you want to take all the color out of your image — in other words, convert it to a grayscale image — don't use the Saturation command. Instead, choose Effects Color to Black/White (Ctrl+0, %+0) or File SendTo Grayscale File. Both commands are explored in Chapter 11, in the section "Going Gray."

The Hue control shifts pixels around the *color wheel*, which is a circular graph that scientists and artists use to plot out all the colors of the rainbow (and other colored stuff). For a complete explanation, see "Swapping One Color for Another" in Chapter 10.

As for that Lightness control, don't get it mixed up with the Brightness control (Quality Prightness/Contrast). And don't use it to lighten your images; this command does bad things to contrast. Try applying Lightness to one portion of an image and Brightness to another to see the difference. Then stick with Brightness to lighten and darken images. The only time to use Lightness is when you want to give your image a faded or washed-out appearance.

Focus Adjustments (Sharpen and Blur)

Digital images are notorious for being "soft" — that is, appearing to be slightly out of focus. Although no image editor can make a terribly unfocused image appear completely sharp, you can usually improve things quite a bit. The following sections explain how to sharpen your image and also how to blur the background of an image, which has the effect of making the foreground subject appear more focused.

Sharpening

Before I show you how to sharpen your images, I want to make sure that you understand what sharpening really does. Sharpening creates the *illusion* of sharper focus by increasing the contrast of the image. Some sharpening commands increase the contrast between all adjacent pixels, while others are more selective, sharpening only the so-called *edges* in the image (areas where significant color changes occur).

In PhotoDeluxe, as in the program's pumped-up older sibling, Photoshop, you're provided with four sharpening filters. (Many other image editors supply similar filters.) As is so often true in life, the most complex option, Unsharp Mask, produces the best results.

Figure 8-11 shows my original image, which I was able to snap just an instant before baby Laura reached up to grab at my camera. I love this image, but it's a tad soft. It's not terrible, but it can certainly be improved by a little sharpening. Figure 8-12 shows this image subject to each of the PhotoDeluxe sharpening commands.

At a distance, the effects of the four sharpening options may look fairly similar. But when you zoom in close, as in Figure 8-13, you can see that the pixels are in fact manipulated in very different ways.

Figure 8-11:
Babies are supposed to be soft and cuddly, but this image is a little too soft.

Here's a look at how each sharpening command does its stuff:

✓ The plain old Sharpen command sharpens your entire image by a preset amount. To apply this command, choose Quality

Sharpen or Effects

Sharpen

Sharpen. Or, to make things easy, press Ctrl+1 (

+1 on the Mac). If your image isn't too bad off, Sharpen may do the trick. But more often than not, Sharpen either doesn't sharpen the image enough or goes too far.

What's that? You can sharpen an image too much? How can an image be *too* focused? Well, remember that sharpening isn't really refocusing your image, but rather creating the *appearance* of focus through some slick pixel manipulation. If you sharpen your image too much, you get jagged, unnatural results.

That said, I should also point out that printed images can usually stand more sharpening than on-screen images. So an image that looks a little over-sharpened on-screen may look just right when printed.

- ► Effects Sharpen Sharpen More does the same thing as Sharpen, only more strenuously. I feel safe in saying that this command will rarely be the answer to your problems. It simply oversharpens in most cases.
- ✓ Sharpen Edges looks for areas where significant color changes occur and increases the contrast in those areas only. You can give this filter a try, but as I said earlier, you can apply the same effect, and get better control over the amount of sharpening, by using Unsharp Mask.
- ✓ Despite its odd name, Unsharp Mask gives you the best of all sharpening worlds. You can sharpen either your entire image or just the edges, and you get precise control over how much sharpening is done. Color

Plate 8-3 shows what my original baby image looks like after an application of the Unsharp Mask filter, which you access by choosing Effects⇔Sharpen⇔Unsharp Mask.

Unsharp Mask is named after an old film-developing technique that was used to sharpen soft photographs, if you care to know.

Sharpen

Sharpen More

Sharpen Edges

Unsharp Mask

Figure 8-12: The results of applying four different sharpening commands.

Sharpen

Original

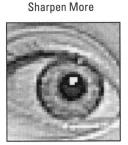

Figure 8-13:
Eyeballing
the
sharpening
options
from a
closer
perspective
shows more
clearly how
pixels are
affected.

Sharpen Edges

0

Unsharp Mask

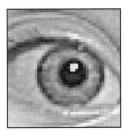

When you choose the first three sharpening commands, PhotoDeluxe applies the sharpening without any further input from you. When you choose the Unsharp Mask command, however, you get the dialog box shown in Figure 8-14. Here's how to adjust the controls in the dialog box to apply just the right amount of sharpening:

✓ The Amount value determines how much sharpening is applied — that is, how much the contrast is increased. Higher values mean more sharpening. Figure 8-15 demonstrates the effects of using three different Amount values in conjunction with the default Radius and Threshold values (1.0 and 0, respectively).

Figure 8-14:
The
Unsharp
Mask dialog
box is
key to
sharpening
images
properly.

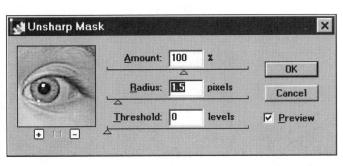

For best results, apply the Unsharp Mask filter with a low Amount value — between 50 and 100. If your image is too soft, reapply the filter using the same or lower Amount value. This technique usually gives you smoother results than applying the filter once with a high Amount value.

- ✓ The Radius value controls how many pixels neighboring an edge are affected by the sharpening. For a better idea of what that means, see Figure 8-16. I applied three different Radius values while keeping the Amount value at 100 and the Threshold at 0 throughout. As you can see, the higher the Radius value, the thicker your edges become. Generally, stick with Radius values in the .5 to 2 range. Use values in the low end of that range for images that will be displayed on-screen; values at the high end work better for high-resolution printed images. Also, you typically want to use higher Radius values for images that have a higher resolution (ppi).
- ✓ The Threshold value determines how different two pixels must be before they're considered an edge and, thus, sharpened. By default, the value is 0, which means that every pixel receives a kiss from the sharpening fairy. As you raise the value, fewer pixels are affected; highcontrast areas are sharpened, while the rest of the image is not (just as when using Sharpen Edges).

Figure 8-15: Raise the Unsharp Mask Amount value to increase the sharpening effect.

Figure 8-16: The effects of three different Radius values.

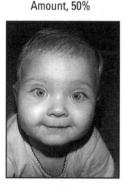

Radius, 2

Radius, 10

Radius, 20

In images with fleshtones, you may want to experiment with Threshold settings between 2 and 20, which can help keep the subject's skin looking smooth and natural. If your image suffers from graininess or noise, raising the Threshold value can enable you to sharpen your image without making the noise even more apparent. But because Threshold values higher than 0 can sometimes create abrupt, obvious transitions between sharpened and unsharpened areas, you should usually leave this value at the default setting or at least keep it under 3. For the record, I used an Amount value of 100, a Radius value of 1, and a Threshold setting of 2 in the image in Color Plate 8-3 and for the Unsharp Mask example in Figure 8-12. That doesn't mean that those exact settings will work for you, though; each image calls for different sharpening adjustments. Just play with the three values until you find the combination that looks best.

The Unsharp Mask filter takes a little getting used to, but after you acquaint yourself with the controls, you can see for yourself why I recommend that you forget about the preset sharpening filters and use Unsharp Mask exclusively. Yes, this filter requires a bit more effort to use than the others, but the results make that effort worthwhile.

Blur to sharpen?

Included in the PhotoDeluxe bag of tricks (as well as in most image editors) are several filters that blur images, creating an out-of-focus effect. Although these filters are usually reserved for special effects, you can actually use them on occasion to create the illusion of *sharper* focus.

If your main subject is slightly out of focus and using the sharpening tools explained in the preceding section doesn't totally correct the problem, try this: Select everything but the main subject (and other areas that you want to appear in sharpest focus). Then apply a blur filter to the rest of the image. Often, blurring the background in this way makes the foreground image appear sharper, as illustrated in Figure 8-17.

In this figure, I selected everything behind the car and applied a slight blur using the Soften command. I then reversed the selection so that the car and foreground were selected and applied just a wee bit of sharpening using Unsharp Mask. As a result, the car not only looks much crisper than before, but the distracting background elements become much less intrusive on the main subject.

Applying a slight blur followed by the Unsharp Mask filter can also sometimes eliminate much of the "noise" (graininess) that so often appears in digital images.

Figure 8-17: Applying a slight blur to everything behind the car makes the car appear more in focus and also helps deemphasize the distracting background.

While sharpening filters do their magic by increasing the contrast between neighboring pixels, blur filters do just the opposite. PhotoDeluxe gives you five blur filters, all accessed by choosing Effects⇔Blur. Two of the five filters, Circular Blur and Motion Blur, are for creating special effects only. For more "normal" blurring, turn to Blur, Blur More, and Soften.

Like Sharpen and Sharpen More, Blur and Blur More blur your image in preset amounts. Try Blur for subtle blurring; if the effect isn't strong enough, choose Blur More or apply Blur repeatedly until you get the amount of softening you're after. If you want to specify the amount of blurring, choose Soften. PhotoDeluxe then displays a dialog box with a single slider bar. Drag the slider to the right to increase the blur, and drag left to reduce the blur.

An Instant Fix Is Seldom the Best Fix

As you poke around in the PhotoDeluxe menus and Guided Activities tabs, you'll discover several options that seem to promise quick remedies for whatever ails your image — Quality Instant Fix, for example.

At the risk of sounding like a snob (or maybe a workaholic), I urge you to look elsewhere for a solution. The sad truth is that these instant-gratification commands just don't work very well in most cases. They attempt to automate more complex image-editing processes, and by applying a one-solution-fits-all approach, they often do more damage than good.

Of course, the automated commands can work on some images, too, so go ahead and give them a shot. If you don't like the results, click Undo. Then check out the following list, which explains what each of the automated commands does and suggests other alternatives.

- ✓ Quality➪ Instant Fix: This command is supposed to correct contrast problems. Unfortunately, Instant Fix can also alter the colors in your image, so use Quality➪ Brightness/Contrast instead. (See "Bring Your Image Out of the Shadows," earlier in this chapter, for more information.)
- ✓ Effects → PhotoDeluxe → Remove Red Eye: This command promises to get rid of those red, glowing eyes that often appear in pictures shot with a flash. (The problem occurs because the flash is reflected by your subjects' eyes.) After you select the eye area and apply the command, PhotoDeluxe searches for the red pixels and replaces them with regular eye-colored pixels. Or at least, that's how it's supposed to work. In practice, this command usually replaces red, glowing pixels with a big, dull blob of dark gray not a big improvement, if you ask me. If you want to get rid of red eyes hey, I kind of like that demonpossessed look use the clone tool to cover up the red pixels with pixels from the surrounding eye area. "Cloning without DNA," in Chapter 10, shows you how to do it.
- ✓ Quality⇒Remove Dust & Scratches: This command is also found in the Effects⇒Noise submenu. Like a digital vacuum cleaner, Remove Dust & Scratches is designed to remove flecks of dust and other tiny bits of debris that are sometimes introduced into images during the scanning process. The filter is also supposed to be able to remove hairline-size scratches in an image. Sounds like a miracle drug, right? Sorry to be the one to tell you otherwise.

To determine what's a flaw and should be eliminated, Dust & Scratches searches for areas where there are abrupt color changes. For example, if a thin white line appears in the midst of a sea of black, that white line would be detected as a scratch. After finding such an area, Dust & Scratches blurs the surrounding pixels to make the flaw less noticeable.

The problem is that Dust & Scratches often can't distinguish between a small color shift that represents a bit of cat fur on the scanner and a color shift that's part of your image. So although you may rub out some imperfections in your image, you may also rub out some image detail.

Still, the filter works when image conditions are just right. So if your image is afflicted with specks and scratches, give Dust & Scratches a whirl. If the scratch or dust is located in an area of smooth color — for example, in the midst of a blue sky — select the area around the scratch before applying the command so that you limit the effect of the filter to the flawed portion of the image. Press Ctrl+Z (\mathbb{H}+Z) to undo things if your image suffers as a result. Then use the cloning technique discussed in "Cloning without DNA," in Chapter 10, to cover up image flaws instead.

✓ Effects⇔Noise⇔Despeckle: Digital images often suffer from noise teeny-tiny flecks that give your image a grainy appearance. The problem is especially common in images shot with digital cameras at low light levels. Despeckle aims to solve this problem by blurring the pixels slightly. Despeckle often does a good job, so go ahead and apply it if your image has a noise problem. But more times than not, the filter also blurs details that you don't want blurred, so you end up solving one problem but creating another.

Unfortunately, I don't have a surefire alternative solution for getting rid of noise. But try this technique: After running your image through the Despeckle machine, use Unsharp Mask to sharpen things up. If Unsharp Mask makes the noise visible again, raise the Threshold value. You can usually bring back a good bit of your image detail without reintroducing too much noise. (See "Sharpening," earlier in this chapter, for specifics on how to use the Unsharp Mask filter.)

Resizing Do's and Don'ts

If any section in this book deserves a warning icon, this one's it. Changing the size of your image — which sounds like an innocuous enough procedure — can have disastrous results unless you do it correctly.

Okay, so maybe not disastrous, exactly. You're not going to lose your house or your spouse or anything else vital to health and human happiness. But you can lose image detail and quality, which has been known to result in some pretty unhappy moments and even the flinging of coffee cups and other breakable objects on rare occasions.

Before I tell you the safe way to resize your images, you really need to go to Chapter 2 and read the section "Resolution Rules!" All of it, please. Otherwise, you aren't going to understand the information in this section. Go ahead and do it now — I'll go scrub some coffee stains off the wall while you're reading. After you have a firm grasp on pixels and resolution, the following two sections explain how to safely resize your image and how to eliminate unnecessary pixels to reduce file size.

Resizing without altering the pixel count

The following steps explain how to resize images without changing the number of pixels in the image. Use this method for sizing images you plan to print. For information on sizing images for on-screen display, see "That's About the Size of It" and "What About Image Resolution?" in Chapter 7. If you need to reduce the number of pixels, see the next section in this chapter.

1. Choose Size⇔PhotoSize.

The Photo Size dialog box, shown in Figure 8-18, appears.

Figure 8-18:
To safely resize your images, always use the Photo Size dialog box and select the File Size check box.

	2.603 incl			OK
	2.241 inch			Cance
Resolution:	257 pixels	/inch		
New Size: 1. <u>Width:</u>	10M	inches	<u> </u>	
<u>H</u> eight:	2.241	inches	<u>-</u>	
	257	pixels/inch		

2. Select the File Size check box.

This option controls whether PhotoDeluxe can add or delete pixels as you change the image dimensions. When the option is turned on, the number of pixels can't be altered.

In order to access the File Size check box, you must also select the Proportions check box. This option ensures that the original proportions of your image are maintained.

3. Enter the new image dimensions in the Width and Height option boxes.

As you change the image dimensions, the Resolution value changes automatically. Remember, image size divided by the total number of pixels equals resolution (pixels per inch). And because PhotoDeluxe can't add or delete pixels while the File Size check box is selected, the resolution must go up when you reduce the image size and go down when you enlarge the image.

4. Click on OK.

If you did things correctly — that is, selected the File Size check box in Step 2 — you shouldn't see any change in your image on-screen, because you still have the same number of pixels to display. However, if you choose View⊸Show Rulers, which displays rulers along the top and left side of your image, you can see that the image will in fact print at the dimensions you specified.

What if you don't have enough pixels to get both the image size and resolution you want? Well, you have to choose which is more important. If you absolutely need a certain image size, you just have to sacrifice some image quality and accept a lower resolution. And if you absolutely need a certain resolution, you have to live with a smaller image. Hey, life's full of these little compromises, right?

If you're not using PhotoDeluxe, be sure to consult your image editor's help system or manual for information on resizing options available to you. Many programs offer you the option of controlling resolution as you resize, but some don't. Make sure you find out how the resizing commands in your software work so that you don't unwittingly destroy image quality.

Dumping excess pixels

In general, the more pixels you have, the better, because more pixels means higher resolution, which means better image quality. But on some occasions, you may have more pixels than you need. In that case, you may want to unload some pixels so that you can reduce the file size. (Read "Resolution Rules!", in Chapter 2, if all this resolution, pixel, and file size stuff is sounding like Greek to you.)

To take unwanted pixels to the digital landfill (recycling isn't an option, unfortunately), follow the same steps outlined in the preceding section. But in Step 2, deselect the File Size check box. You can now specify your image dimensions and resolution independently. After you enter the new values, click on OK.

Before you go tossing away pixels, however, always make a backup copy of your original image. After those pixels are gone, you can't get them back, and you never know when you may need them again in the future. You may only need a low-resolution image today, but tomorrow, things may be different.

The process of changing the number of pixels in an image is called *resampling*, by the way.

Hey Vincent, Get a Larger Canvas!

Size©Canvas Size enables you to add blank workspace around your image. You may need to do this when combining two images, for example, if you want to place those images side by side instead of on top of each other. (Many figures in this chapter, including Figure 8-17, were created this way. In Figure 8-17, for example, I placed the "before" and "after" images of the car together on one canvas.)

After choosing the Canvas Size command, you see the Canvas Size dialog box shown in Figure 8-19. Enter the new canvas dimensions into the Width and Height option boxes. (If you want, you can change the unit of measure by selecting an option from the drop-down menu next to the option boxes.)

Figure 8-19: Choose Size Canvas Size to enlarge the size of the transparent background on which your image rests.

Current Si Width: Height:	1.78	OK Cance			
New Size:	1.091	vi –			
<u>W</u> idth:	1.783			inches 🔻]
<u>H</u> eight:	2.347			inches	
lacement:	- ×	+	Я		
	+		-		
	K	+	¥		

Next, use the little grid at the bottom of the dialog box to specify where you want to position the existing image on the new canvas. For example, if you want the extra canvas area to be added equally around the entire image, click in the center square.

Should you want to trim away excess canvas, reduce the Width and Height values. Again, click in the grid to specify where you want the image to be located with respect to the new canvas. If you want to trim canvas from around all four edges of the image, for example, click the center square. Note that you can also use the crop tool to cut away excess canvas; see "Cream of the Crop," earlier in this chapter, for information on cropping. But using the Canvas Size command is a better option if you want to trim the canvas by a precise amount — a quarter-inch on all four sides, for example.

By default, the canvas appears white on-screen. But the canvas is really transparent. You can see this for yourself if you try the following experiment:

1. Open an image.

Any image will do.

2. Enlarge the canvas so that you can see the white canvas around your image.

Use the Canvas Size command, as described a few paragraphs ago. Raise both the Width and Height values by one inch. Write down the Width and Height values of the canvas.

3. Press Ctrl+A and then Ctrl+C (\mathfrak{H}+A, \mathfrak{H}+C).

These keyboard shortcuts select the entire image and copy it to the Clipboard.

4. Create a new image the same size as the one you just copied.

To do this, just choose File⇒New to display the New dialog box, and enter the Width and Height values you wrote down in Step 2. Set the resolution to the same value as your original image. Click OK to create the new image.

5. Press Ctrl+A.

This shortcut selects the entire new image.

6. Fill the image with blue or some other color.

Use the Effects➪ Selection Fill command to do the job. See "Pouring Color into a Selection," in Chapter 10, for details.

7. Press Ctrl+V (%+V) to paste the copied (original) image on top of the new image.

The inch of white canvas around the edges of the original image is invisible because it's transparent, enabling the bottom, colored image to show through. You can paint the canvas area just as you can paint any other portion of your image, though; it doesn't have to stay transparent forever. (Again, see Chapter 10 for information on painting on your image.)

If you prefer, PhotoDeluxe can display the background as a checkerboard pattern to help you distinguish transparent areas from solidly filled ones. To change the canvas display, choose File⇔Preferences⇔Background. When the Background dialog box appears, select either the Small, Medium, or Large grid option. (The sizes refer to the size of the squares in the checkerboard which one you use is entirely a matter of personal preference.) You can then pick the colors of the checkerboard pattern by clicking on the Colors squares and selecting a color from the Color Picker dialog box (more information in Chapter 10). Or choose one of the predefined patterns from the Set drop-down list. Click on OK to exit the dialog box.

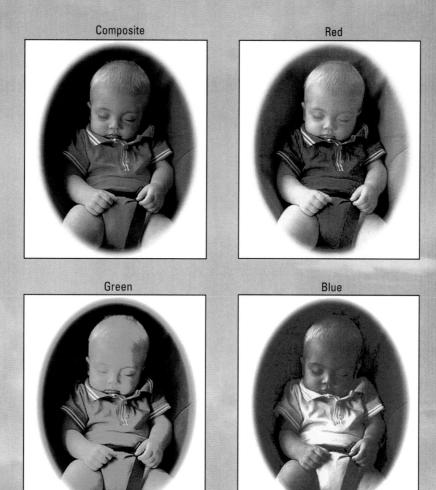

Color Plate 2-1:
An RGB image (top left) broken down into its red, green, and blue color channels.
The channels actually contain grayscale images, as shown in Figure 2-2 in
Chapter 2. I added the red, green, and blue tints here to make clear which channel was which.

Color Plate 2-2:

The higher the resolution, the better the image looks. The top image has a resolution of 300 ppi; the middle image, 150 ppi; and the bottom image, a meager 75 ppi. As you can see, the two lower images aren't really suitable for full-color professional printing. A resolution of 150 ppi is fine for printing on a laser printer, however, and a resolution of 75 ppi is acceptable for images displayed on a Web page or used in a multimedia presentation.

No Compression

Low Compression

High Compression

Color Plate 3-1:

When you save an image using JPEG compression, you sacrifice some image data. The top image is the original, uncompressed image. At a low compression setting (middle image), the image quality is still good, and the data loss is barely noticeable. But at a high compression setting, fine details get lost (bottom image). The difference in quality becomes more noticeable as you enlarge the image.

Minolta Dimâge V, 34mm

Kodak DC120, 38mm

Casio QV-120, color corrected

Color Plate 3-2:

The Lilly Mansion, on the grounds of the Indianapolis Museum of Art, as captured by three digital cameras, each of which has a different perspective on the colors in the scene. The cameras also recorded a slightly different image area; the smaller the lens number, the wider the angle of view. (The Minolta and Kodak have zoom lenses; for this image, I used the widest possible zoom setting.) The bottom-right image shows the Casio image after some tinkering in PhotoDeluxe. With just a few mouse clicks, I brought some green into the lawn.

Color Plate 4-1:

This classic fruit-in-a-bowl scene illustrates the problems of too much and too little light.

On the top of the lemon, too much light created a hot spot where all image detail was lost (see the insert area for a better view). In the bottom portion of the image, the light is too low, reducing contrast and clarity. Compare the amount of detail you can see in this area with that in the upper-left corner of the image, where the light is just about perfect.

Color Plate 5-1:

Zooming in on my fruit image reveals what can happen when you convert a 24-bit image (top) to an 8-bit (256 color) GIF image (bottom). Without a broad variety of shades to represent the fruit, the 256-color image looks blotchy.

Color Plate 6-1:

Using a higher grade paper improves the print quality noticeably. Here, I printed the same image at 720 dpi on plain paper (top), photo-quality inkjet paper (middle), and photo-quality glossy paper (bottom). The famous sculpture in the picture is by artist Robert Indiana and is located on the grounds of the Indianapolis Museum of Art.

Color Plate 8-1:

My original landscape (top) had severe color balance problems, with an over-abundance of red and blue and a lack of green. The image almost appears to be a fall scene, while I shot it in early July. To fix things, I used the Color Balance command, raising the Green value and lowering the Red and Blue values. Now that's what an Indiana summer really looks like — at least, at the Indianapolis Museum of Art, where this picture was taken. The view from my window isn't nearly this scenic.

Color Plate 8-2:
This little cherub initially led a rather colorless existence (left). Raising the saturation value gave the statue a new, more colorful life (right).

Color Plate 8-3:
My original image (left) was a little soft. Using the Unsharp Mask filter with an Amount value of 100, a Radius of 1, and a Threshold value of 2 resulted in a crisper image without destroying the baby-soft appearance of the skin (right).

Color Plate 9-1:

The range of colors the Color Wand selects is dependent on the Tolerance value. Low values cause the tool to select only those pixels that are very similar in color to the pixel you click. Higher values make the tool less discriminating.

Tolerance, 64

Tolerance, 150

Color Plate 9-2:

After selecting the rose in the left image, I copied it and pasted it into the marble image (middle), resulting in the composite image on the right.

Color Plate 10-1:

Pressing a number key changes the opacity of your brush strokes. At 100 percent opacity, the stroke completely covers the underlying image. Lower opacity values let the image show through the brush stroke.

Color Plate 10-2:

A slicked back, conservative toucan (left) gets a makeover (right) courtesy of the Smudge tool. Dragging upward from the crown with the tool set at 70 percent pressure gave this bird a stylin' look, perfect for his new career as big-time boxing promoter.

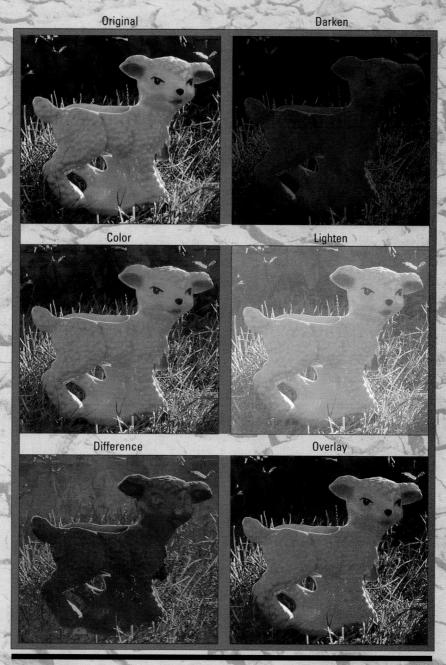

Color Plate 10-3:

After selecting the entire original image (top left), I filled it with the pink border color using five of the six blend modes available in PhotoDeluxe. The sixth blend mode, Normal, obliterated the entire image, resulting in a square of solid pink that was too boring to show here.

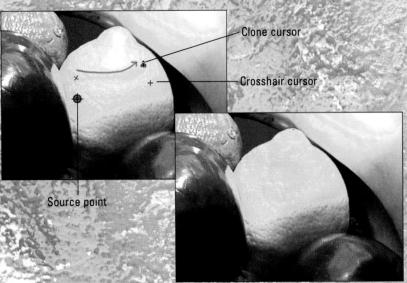

Color Plate 10-4:

Using the Clone tool, I was able to paint a good portion of the lemon rind over the hot spot at the top of the fruit (top). The red X and arrow show the starting point and direction of my initial drag; the source point and crosshair cursor indicate the path of pixels that I cloned with that first drag. I reset the source point and cloned from several different areas, using varying tool opacity settings to create a natural-looking, nearly perfect lemon (bottom).

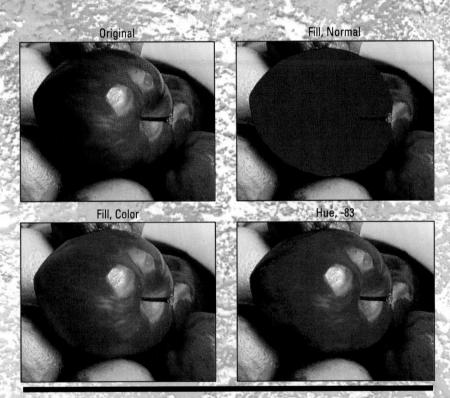

Color Plate 10-5:

To create a new species of apple, I selected the apple but not the stem. Filling the apple with the Selection Fill command set to the Normal blend mode resulted in a solid blob of color (top right). Using the Color blend mode turned the apple purple while retaining the original shadows and highlights (bottom left). Dragging the Hue slider in the Hue/Saturation dialog box to -83 turned the red parts of the apple purple while turning the yellowish areas pink (bottom right).

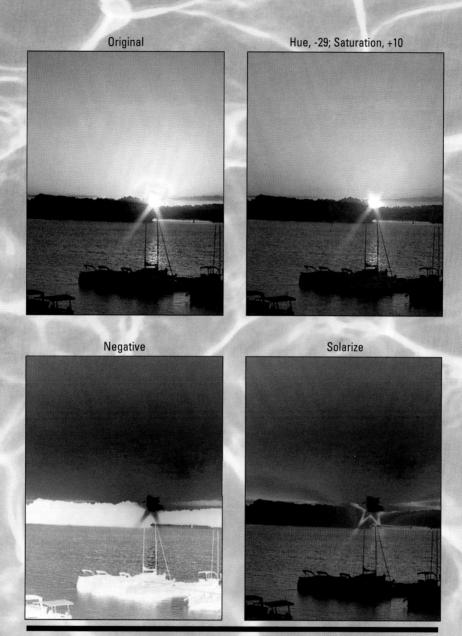

Color Plate 10-6:

Here, I shifted the colors in my original image (top left) using three different approaches. In the top right example, I used the Quality⇔Hue/Saturation command, setting the Hue value at -29 and Saturation value at +10. To create the lower left image, I applied the Effects⇔Negative command; to achieve the lower right image, I applied Effects⇔Stylize⇔Solarize.

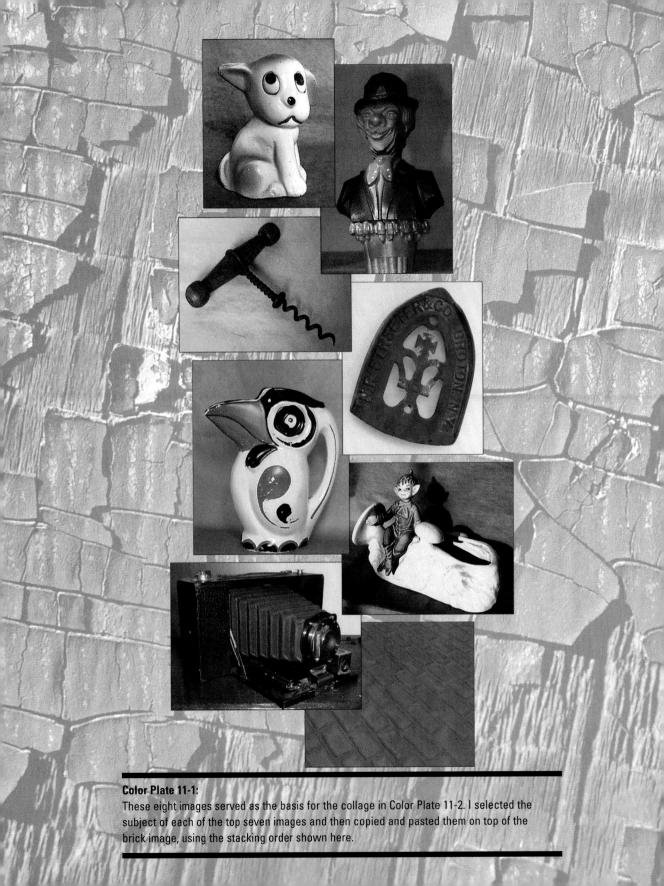

Color Plate 11-2:
By placing each of the images in Color Plate 11-1 on a separate layer, I created this collage featuring colorful objects from yesteryear.

Color Plate 11-3:

To create this antique photograph effect, I converted the color version of Color Plate 11-2 to grayscale. Then I created a new layer, filled the layer with dark gold, set the layer blend mode to Color, and set the layer opacity to 50 percent.

Color Plate 11-4: With the help of the Effects⇔Render⇔Clouds command, I turned a dull, gray, depressing sky (left) into a wild bue yonder dotted with

Glowing Edges

Colored Pencil

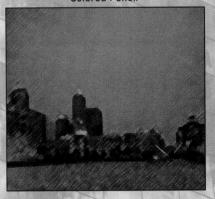

Crystallize

Color Plate 11-5:

With the help of special effects filters, you can sometimes create art out of a crummy image. Here, I applied three different PhotoDeluxe filters to a dark, grainy skyline scene to create three very different and interesting images.

Chapter 9

Selections on the Move

In This Chapter

- Making edits to specific parts of your image
- Using different types of selection tools
- ▶ Refining your selections
- Moving, copying, and pasting selections
- > Pasting a selection into a selection
- ▶ Creating a patch to cover up hot spots and other flaws
- Making your image fade into view

Sometimes, you want to apply a command or special effect to an entire image. But more often than not, you want to edit only specific portions of your picture. That's where *selections* come in.

When you create a selection, you rope off the portion of the image you want to edit. Only those pixels inside the selection boundaries get to enjoy the effects of your changes, whether you're blurring, sharpening, coloring, or applying some special effect to the image. Pixels outside the selection boundaries can only look on in envy (or dismay, depending on what you're doing to the selected pixels). Just like commoners barred from entering some tony club by a snooty doorman, unselected pixels can only dream about the wild life experienced by selected pixels.

Simple selections are easy enough to create. But selecting a complex area of your image requires a bit of finesse, not to mention some patience. This chapter shows you how to quickly tackle the easy selection jobs and also how to approach the more complicated ones.

You also find out how to move, copy, and delete selections and how to use a special type of selection, known as a *feathered* selection, to cover up small blemishes in your image. In other words, you take the first step to discovering how to completely obliterate reality and replace it with something more pleasing.

Why (And When) Do I Select Stuff?

If your computer were a smarter being, you could simply give it verbal instructions for how you wanted your image changed. You could simply say, "Computer, take my head and put it on Madonna's body," and the computer would do your bidding while you went to catch a special edition of the Jenny Jones or the Jerry Springer show or something equally enlightening.

Computers can do that sort of thing on Star Trek and in spy movies. But in real life, computers just aren't that clever (at least, not the ones that you and I get to use). If you want your computer to do something to a portion of your image, you have to draw the machine a picture — well, not a picture, exactly, but a selection outline. By outlining the area of the image you want to edit, you tell your image editor what pixels to change and what pixels to leave alone. For example, if you want to blur the background of an image but leave the foreground as is, you select the background and then apply the blur command (for an example of this, see Figure 8-17 in Chapter 8). If you don't select anything, the entire image gets the blur.

Selections don't just limit the impact of special effects and image-correction commands, though. They also protect you from yourself. Say that you have an image of a red flower on a green background. You decide that you want to paint a purple stripe over the flower petals (oh, I don't know why, maybe it's just been that kind of day). Anyway, if you have a steady hand, you may be able to get the paint just on the petals and avoid brushing any purple on the background. But people whose hands are that steady are usually busy wielding brain-surgery tools, not editing tools. Most people tackling the paint job get at least a few stray dabs of purple on the background.

If you select the petals before you paint, however, you can be as messy as you like. No matter where you move your paintbrush, the paint can't go anywhere but on those selected petals. The process is much the same as putting tape over your baseboards before you paint your walls. Areas underneath the tape are protected, just like pixels outside the selection outline.

So as you can see, selections are an invaluable tool. Unfortunately, creating precise selections requires a bit of practice and time. And precise selections are a major key to editing that looks natural and un-obvious, instead of editing that looks like a bull ran through the digital china shop. The first few times you try the techniques in this chapter, you may find yourself struggling to select the areas you want. But don't give up, because the more you work with your selection tools, the more you'll get the hang of things.

On-screen, selection outlines are usually indicated by a dotted outline known in image-editing cults as a selection marquee. Some people are so fond of this term that they also use it as a verb, as in "I shall now marquee that flower."

While we're on the subject of image-editing terminology, you should also know that many people refer to selections as *masks*. The deselected area is said to be *masked*.

Strap On Your Selection Toolbelt

Most image editors, including PhotoDeluxe, give you an assortment of selection tools. Some tools are special-occasion devices, while others you'll use most every day. The following sections discuss how to use each tool, as well as how to use the different tools in conjunction with each other to create expert selections.

Displaying and using the Selections palette

All told, PhotoDeluxe offers nine selection tools. To use a tool, you can choose it from the Select Selection Tools submenu. But a better option is to choose View Show Selections to display the Selections palette, shown in Figure 9-1. Now you can quickly grab the various selection tools without going through the rigors of using the Select menu. You also gain access to several options not available through the menu.

Figure 9-1:
The
Selections
palette puts
all the
selection
tools
at your
fingertips.

In fact, think of the Selections palette as a one-stop shop for all your selection needs. Here's what you need to know:

The active selection tool is the one showing in the drop-down list at the top of the palette. To use a different tool, just choose it from the list.

- ✓ When any tool but the Object Selection tool is active, the palette displays four icons directly below the drop-down list.
 - Click on the New icon to abandon your existing selection and start a new selection.
 - Click on the Add icon to add more pixels to the existing selection.
 - Click on the Reduce icon to subtract pixels from the selection.
 - Click on the Move icon to move the selection.

I explain more about the Add and Reduce options in the upcoming section "Refining your selection outline" and discuss the Move icon in "Selection Moves (and Copies and Pastes)."

- ✓ Beneath the four icons are three buttons. Click All to select every cotton-pickin' pixel in your image. Click None to get rid of your selection outline entirely and deselect all pixels. Click Invert to reverse the selection outline, so that the pixels that were previously selected are now deselected, and vice versa. (See "Refining your selection outline," later in this chapter, for more about the very useful Invert option.)
- For an easier way to invoke the All, None, and Invert commands, use these keyboard shortcuts: Press Ctrl+A (\H-A on the Mac) to select all pixels; Ctrl+D (\mathbb{H}+D) to deselect all pixels; and Ctrl+I (\mathbb{H}+I) to invert the selection.
- ✓ To put the Selections palette away, click on the Close button in the palette title bar or choose View⇔Hide Selections.

Foisting your selection weapon

Each selection tool has a specific purpose, as described in the following sections. You can find many of these same or similar tools in most other image-editing programs as well as in PhotoDeluxe. Usually, selection tools work pretty much the same no matter what program you're using, but be sure to consult your program's manual for specifics on adjusting the performance of your tools.

Rectangle, Oval, Circle, and Square tools

You have four tools at your disposal for drawing regularly shaped selections — the Rectangle, Oval, Circle, and Square tools. To draw a selection outline with any of these tools, simply drag from one side of the area you want to select to the other, as illustrated in Figure 9-2.

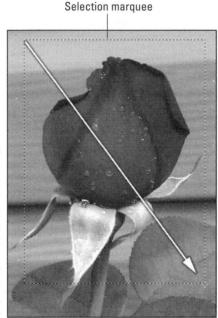

Figure 9-2:
To select a rectangular area, drag from one corner to another with the Rectangle tool.

You really don't need to ever pick up the Square or Circle selection tools, though. If you want to draw a square selection outline, just press and hold the Shift key as you drag with the Rectangle tool. To draw a circular selection outline, press Shift as you drag with the Oval tool.

To select the Rectangle tool quickly, press Ctrl+M (\%+M on the Mac).

Color Wand tool

The Color Wand — known as the Magic Wand, Color Selector, or something similar in other programs — selects continuous areas of similarly-colored pixels.

Okay, once more, this time in non-geek-speak. Suppose that you have an image like the one in Color Plate 9-1 (the color version of the rose shown in Figure 9-2). You can use the Color Wand to quickly select the red pixels in the rose, or the green pixels in the petals, or the icky, grayish-greenish pixels in that lovely vinyl siding in the background.

This image is on the CD accompanying this book, by the way. It's named ROSE.JPG and is found in the Images folder.

When you click with the Color Wand, PhotoDeluxe selects all pixels that are similar in color to the pixel you click. So to select the rose, you click on a red pixel in the rose.

However, similarly colored pixels are not selected if any pixels of another color lie between them and the pixel you click. For example, if you click the green leaf in the bottom-right corner of the rose image in Color Plate 9-1, that leaf is selected. But the leaf in the bottom-left corner isn't, because areas of gray lie between the two leaves.

When you work with the color wand, you can specify how discriminating you want the tool to be when searching for similar colors. Choose File⇔Preferences⇔Cursors to display the Cursors dialog box shown in Figure 9-3. If you want the Color Wand to select only pixels that are very close in color to the pixel you click, enter a low Tolerance value in the upper-right corner of the dialog box. To make the Color Wand select more pixels, enter a higher value.

Figure 9-3: To adjust the performance of the Color Wand, change the Tolerance value.

ool Cursors -		Color Wand Tolerance	
		Tolerance: 32	
inting Tools:	Other Tools:		
Standard	© Standard © Precise	OK	
Precise Brush Size		Cancel	

Color Plate 9-1 shows the results of using four different Tolerance values: 10, 32, 64, and 150. You can enter a value as high as 255, but anything above 150 or so tends to make the Color Wand too undiscriminating. In Color Plate 9-1, for example, raising the value beyond 150 selected some of the gray pixels at the edge of the rose instead of just the rosy-colored pixels. A value of 255 selects the entire image, which is pretty pointless; if you want to select the entire image, just press Ctrl+A (\mathbb{H}+A on the Mac).

As you can see in Color Plate 9-1, a value of 150 selected most of the rose pixels, leaving just a few spots of white and gray — areas representing the droplets of water — unselected. I can easily add those spots to the selection using the techniques described in "Refining your selection outline" later in this chapter.

When using the Color Wand — or any selection tool, for that matter — you can sometimes get quicker results if you select the area that you *don't* want to edit and then invert the selection. For example, if you have a bouquet of flowers set against a blue wall, don't select each of the flowers individually. Instead, click the blue wall with the Color Wand to select the wall and then invert the selection (press Ctrl+I on a PC and \Re +I on a Mac). See "Refining your selection outline," later in this chapter, for a more detailed explanation of this approach.

Trace and Polygon tools

The Polygon and Trace tools are both used for selecting irregular areas of an image. To create a selection with either tool, you simply draw around the area you want to select.

Well, I say "simply," but frankly, you need a pretty steady hand to draw precise selection outlines using these tools. Some people can do it; I don't possess that talent. So I normally use these tools to select a general area of the image and then use other tools to select the exact pixels I want to edit. (Building selection outlines in this way is discussed in the upcoming section "Refining your selection outline.")

At any rate, the Trace tool is for drawing freehand selections. Just drag around the area you want to edit.

You can select the Trace tool quickly by pressing Ctrl+L (\mathbb{H}-L), by the way. (L? For Trace? Where'd they get that? Well, don't quote me or anything, because heaven knows I haven't got an inside track to the Adobe keyboard-shortcut committee, but my guess is that this shortcut derives from Adobe Photoshop, the program from which PhotoDeluxe was spawned. In Photoshop, the shortcut for the freehand selection tool is also L, which makes sense in that program because the tool is called the Lasso. The good news is that when you upgrade to Photoshop, you'll already have the Lasso shortcut down cold. In the meantime, one of my technical editors, Anne Taylor, suggests that you can think of the L as standing for outLine.)

The Polygon tool works similarly to the Trace tool, but it gives you the added ability to easily draw straight-edged selections. To draw a curved outline, drag with the tool as you would with the Trace tool. To add a straight segment, let up on the mouse button at the point where you want the segment to begin. Click at the point where you want the segment to end. PhotoDeluxe automatically creates the straight segment between the two points you click. To complete the selection outline, double-click.

When working with either of these tools, by the way, you can usually increase your accuracy by zooming way in on your image. Press Ctrl along with the plus key to zoom in quickly on a PC; press \Re and the plus key on a Mac. Ctrl or \Re in conjunction with the minus key zooms you back out.

The SmartSelect tool

Here's a tool that takes some getting used to, but can come in very handy in certain situations. As you drag with the SmartSelect tool, it searches for edges — areas of significant color change — and lays down the selection outline along those edges. Figure 9-4 shows a close-up view of me in the process of using this tool to select the rose bud and one of the leaves in the rose image from Figure 9-2.

To use the tool, click at the point where you want the selection to begin and then drag. As you drag, the SmartSelect tool automatically creates the selection outline along the border between two differently colored areas. For example, in Figure 9-4, the tool found the border between the leaf-colored pixels and the siding-colored background pixels.

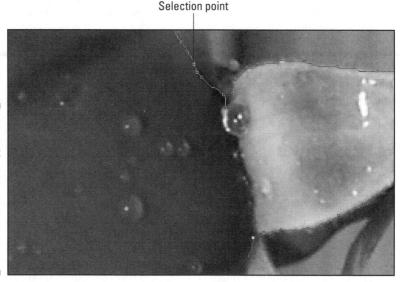

Figure 9-4: The SmartSelect tool detects edges and places the selection outline along those edges.

Every so often, the SmartSelect tool adds a tiny square, called a *selection* point, to the selection outline. If you're not happy with the placement of the selection outline, place your cursor over the most recent selection point and press Delete. Then drag again to redraw the segment. If you want, you can click to add your own selection point.

To finish the selection outline, place your cursor over the first point in the outline until your cursor turns into the letters OK and then click.

As with the Color Wand, you can control the sensitivity of the SmartSelect tool. When you select the tool, the SmartSelect options palette, shown in Figure 9-5, appears on-screen. The Edge Threshold value tells the tool how different pixels must be in order to be considered an edge. You can enter any value from 1 to 100. Use a higher value when you want the tool to perceive subtle differences in color — for example, to find the edges between a red tablecloth and an apple that's similar in color.

The Brush Size value determines how far the tool can roam in its search for edges. Larger values tell the tool to go farther afield; smaller values keep the tool closer to home. You can enter any value from 1 to 20.

Figure 9-5: Adjust the sensitivity of the SmartSelect tool in this dialog box.

Object Selection tool

Although the Object Selection tool is bunched in with all the other selection tools, it doesn't create selection outlines. Instead, it enables you to rotate, move, and otherwise manipulate one layer in a multilayered image and to resize and rotate text. To find out more about layers and how to edit them, see "Uncovering Layers of Possibility" in Chapter 11. Also check out "Cut, Copy, Paste: The old reliables," later in this chapter, for a look at how to use the Object Selection tool after you paste a selection. See "Painting Words on Your Image," in Chapter 10, for information about text.

The cursor thing is in the way!

PhotoDeluxe can display your selection tool cursor in two ways — either as a little picture that looks like the tool, or as a simple crosshair. I prefer the crosshair cursor, because the icon-like cursors sometimes make it difficult to see what I'm doing.

To switch between the two cursor display options, choose File⇔Preferences⇔Cursors or press Ctrl+K (ૠ+K on the Mac) to display the Cursors dialog box, the same one shown back in Figure 9-3. Choose the Standard option in

the Other Tools section of the dialog box if you want to see the picture-oriented cursors; choose Precise to use the crosshair cursor.

When the Standard option is selected, you can press the Caps Lock key to toggle between the two cursor options.

You can also change the cursor display for the painting tools; for more information on this subject, see "Giving Your Cursor a New Shape" in Chapter 10.

You can also use this tool to rotate and resize single-layered images with respect to the image canvas. The tool works just as described in "Moving." resizing, and rotating layers" in Chapter 11. But use caution: Rotating and resizing images in this fashion can damage image quality. For more about resizing images, see "Resizing Do's and Don'ts" in Chapter 8.

Refining your selection outline

In theory, creating selection outlines sounds like a simple thing. In reality, getting a selection outline just right on the first try is about as rare as Republicans and Democrats agreeing on who should pay fewer taxes and who should pony up more. In other words, you should expect to refine your selection outline at least a little bit after you make your initial attempt.

Most programs give you several ways to adjust your selection outline. Here are your options in PhotoDeluxe:

- ✓ To add more pixels to the selection outline, click on the Add icon in the Selections palette. You can then use any selection tool to incorporate more areas of your image into the selection. For example, to select the remaining areas in the lower-right image in Color Plate 9-1, you could click on each area with the Color Wand or drag around them with the Oval or Rectangle tool.
- ✓ If you selected too many pixels, click on the Reduce icon in the Selections palette. Now when you drag or click with a selection tool, you're deselecting pixels instead of selecting them. For example, suppose that you had selected both the flower and the petals in Color Plate 9-1. If you then changed your mind and decided just to select the petals, you could click on the Reduce icon and then click on the rose with the Color Wand to deselect the red pixels.
- ✓ Don't forget that you can use Undo to undo your last click or drag with a selection tool. Click the Undo button in the image window or press Ctrl+Z ($\Re+Z$ on the Mac).
- The Invert icon swaps the selected areas with the deselected areas. This tool is extremely useful because sometimes the area you don't want to edit is more easily selected than the area you do want to edit. Take the left image in Figure 9-6, for example. Suppose that you wanted to select just the buildings in this image. Drawing a selection outline around all those spires and ornate trimmings would take forever. But with a few swift clicks of the Color Wand, I was able to easily select the sky and then invert the selection to select the buildings. In the right image in Figure 9-6, I deleted the selection to illustrate how cleanly this technique selected the buildings.

Figure 9-6: To select these ornate architectural gems (left), I first selected the sky and then inverted the selection. Deleting the selection (right) shows how precisely the buildings were selected using this technique.

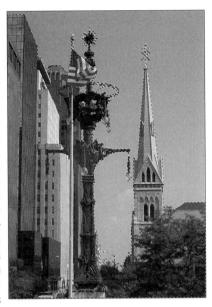

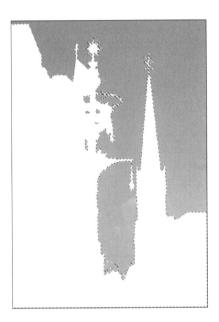

- ✓ You can also invert a selection by pressing Ctrl+I (ૠ+I on the Mac) or by choosing Select⇔Invert.
- ✓ To move the selection outline but not the pixels inside the outline first click either the New icon or the Move icon in the Selections palette. Then press Ctrl and Alt as you drag with any tool. (On a Mac, press **%** and Option as you drag.) Using this technique, you can reposition the selection outline in your image.

✓ If you want to get rid of your selection outline entirely, click the None icon in the Selections palette or just press Ctrl+D (ૠ+D on the Mac). Conversely, you can select your entire image by clicking the All icon or pressing Ctrl+A (ૠ+A).

Selection Moves (And Copies and Pastes)

After you select a portion of your image, you can do all sorts of things to the selected pixels. You can paint them without fear of dripping color on any unselected pixels, for example. You can apply special effects or apply color-correction commands just to the selected area, leaving reality undistorted in the rest of your image.

But one of the most common reasons for creating a selection outline is to move or copy the selected pixels to another position in the image or to another image entirely, as I did in Color Plate 9-2. I cut the rose out of the image on the left and pasted it into the marble image in the middle to create the image on the right.

The following sections give you all the information you need to become an expert at moving, copying, and pasting selections.

You can also copy pixels using the Clone tool. This specialized tool enables you to "paint" a portion of your image onto another portion of your image. which is why it's covered with the other painting tools in Chapter 10. See "Cloning without DNA" for details.

Cut, Copy, Paste: The old reliables

One way to move and copy selections from one place to another is to use those now old-time computer commands, Cut, Copy, and Paste, as follows:

✓ Edit⇔Cut snips the pixels out of your image and places them on the Clipboard, a temporary holding tank for data. You're left with a background-colored hole where the pixels used to be, as illustrated in the left image in Figure 9-7.

Rotate handle - Resize handle

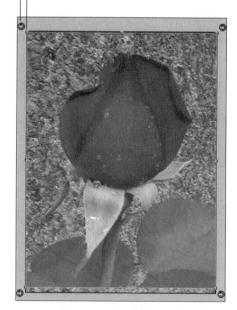

- ✓ Edit Copy duplicates the pixels in the selection and places the copy on the Clipboard. Your original image is left intact when you use this command.
- ✓ Editr⇒Paste glues the contents of the Clipboard onto your image. In PhotoDeluxe, the Clipboard pixels are pasted smack dab in the center of the image. Or, if you have an active selection outline, the pixels are pasted in the center of the outline.

To quickly choose the Copy, Cut, and Paste commands, use these keyboard shortcuts: Ctrl+C for Copy, Ctrl+X for Cut, and Ctrl+V for Paste. (On the Mac, that's $\mathcal{H}+C$, $\mathcal{H}+X$, and $\mathcal{H}+V$.) If V doesn't make any sense as a shortcut for Paste, take a look at the bottom row of your keyboard. The X, C, and V keys come right after the other, which is why (I guess) whoever first thought up these keyboard shortcuts decided on V for Paste, leaving P available as the shortcut for the Print command. Or perhaps the V stands for *Viscid*, as in *sticky*, like Paste.

Your pasted pixels are placed on a new *layer*. Layers are explained more fully in Chapter 11, but for now, just understand that your pasted selection exists independently from the rest of the image, which means that you can move it and rotate it without affecting the pixels in the rest of the image.

After you choose the Paste command, the selection is surrounded by rotate and resize handles, as shown in the right image in Figure 9-7, and the Object Selection tool is automatically selected for you. You can move the selection by dragging anywhere inside the selection outline. Drag on one of the rotate handles (labeled in Figure 9-7) to rotate the selection.

You can also resize the selection by dragging the square handles, but keep in mind that doing so can lead to image degradation. So for best results, use Size Photo Size to do your resizing *before* you copy or cut the selection to the clipboard. (See "Resizing Do's and Don'ts," in Chapter 8, for more information.)

Another way to move your selection around is to press Ctrl+G to select the Move tool (which is the same thing as clicking the Move icon in the Selections palette). With the Move tool selected, you can nudge your selection into place using the arrow keys on your keyboard. Each press of an arrow moves the selection one pixel in the direction of the arrow. To move the selection in 10-pixel increments, press Shift plus an arrow key. This technique is ideal when you want to move a selection precisely — for example, to move it a little bit horizontally without moving it vertically. Using the mouse, you might slip up and move the selection up or down as you tried to move it sideways.

When you have the pasted selection where you want it, you have two choices. You can keep the selection on its own layer or you can merge the selection with the underlying image. If you choose the former, you can continue to manipulate the selection separately from the rest of the image. If you want to merge the selection with the underlying image, choose the Merge Layers command from the Layers palette menu (click on the little arrow near the top-right corner of the palette to display the menu). For more on working inside the Layers palette and editing multilayered images, see "Uncovering Layers of Possibility" in Chapter 11.

For some reason, PhotoDeluxe doesn't enable you to use the Undo command to undo the Paste command. To get rid of a pasted selection, delete the layer on which the selection lives. In the Layers palette, drag the layer name to the little trash can icon.

Paste Into: Pasting your selection inside a fence

You can use the Paste Into command to paste a selection inside another selection outline. To see what I mean, look at Figure 9-8. I first selected the rosebud in the original rose image used throughout this chapter. Then I switched to the marble image and copied the entire image to the Clipboard by pressing Ctrl+A (\mathbb{H}+A) to select the image and then Ctrl+C (\mathbb{H}+C) to copy. Finally, I switched back to the rose image and chose Edit-Paste Into. Only those portions of the marble within the boundaries of the rose selection are visible; the rest of the marble image is hidden behind the rest of the rose image. The result is a marble rose. (There's a country song in there somewhere, I just know it. "My baby said he loved me, but he brought me marble roses. . . . ")

Unlike a regularly pasted selection, selections you paste using Paste Into are placed on a *floating layer*. A floating layer is a temporary layer, which means that you can drag the pasted selection around to reposition it inside the selection outline if necessary without harming the underlying image. To do so, click either the New or Move icon in the Selections palette and then drag inside the selection border.

You can also nudge the selection by pressing the arrow keys on the key-board. Press an arrow key once to move the selection one pixel; press Shift plus an arrow key to move the selection 10 pixels.

When you have the selection just so, click None or press Ctrl+D to defloat the floating layer, thereby forever merging the selection with the underlying layer. Or turn the floating selection into a new layer by dragging the Floating Selection item to the New Layer icon in the Layers palette. You can then continue to manipulate the pasted selection independently of the rest of the image. (For more about this Layers palette stuff, see "Uncovering Layers of Possibility" in Chapter 11.)

Clicking in your image with any selection tool also defloats a floating selection, unless the Move icon is selected in the Selections palette. So be careful what you do while you're in the process of working with a floating selection. If you accidentally defloat the selection, press Ctrl+Z ($\Re+Z$) to undo and bring the floating selection back.

Figure 9-8:
To create this marble rose, I used the Paste Into command to paste the marble image inside the boundaries of the rose.

Dragging to move and copy

In addition to using the Cut, Copy, Paste, and Paste Into commands described in the preceding sections, you can also use the *drag and drop* method to copy and move pixels, as follows:

To move a selection from one portion of your image to another, select any tool but the Object Selection tool and then click the New or Move icon in the Selections palette. Then drag inside the selection outline. Just as when you use the Cut command, moving a selection by dragging leaves a background-colored hole in your image.

After you complete your drag and release the mouse button, the selection is placed on a floating layer, just as when you use Paste Into. You can nudge your selection into place by pressing the arrow keys. Press an arrow key alone to move the selection one pixel; press Shift plus an arrow key to nudge in 10-pixel increments.

Press Ctrl+D (%+D on the Mac), click the None icon in the Selections palette, or click with any selection tool except the Object Selection tool to defloat the layer and merge the moved pixels with the underlying image. Drag the Floating Selection item in the Layers palette to the New

- Layer icon to turn the floating selection into a permanent independent layer. (See the preceding section and "Uncovering Layers of Possibility." in Chapter 11, for more on layers and floating selections.)
- ✓ To copy a selection and place the copy inside the same image, choose any selection tool but the Object Selection tool and click the New or Move icon in the Selections palette. Then press Alt as you drag (press Option on a Mac). Your copied selection ends up on a floating layer, just as described in the above bullet point. As long as the selection remains floating, you can nudge the selection using the arrow keys, which is also explained in the preceding point.
- ✓ To copy a selection between images, open both images and place them side by side. (Choose Windows Tile or Windows Cascade.) Choose any selection tool except the Object Selection tool, click the New or Move icon in the Selections palette, and drag the selection from one image to the other. (Make sure to keep your cursor inside the selection outline as you drag.) A little plus sign should appear next to your cursor as you drag to indicate that you're indeed copying the selection, not moving it. You don't need to press Alt as you do when copying within the same image.
- ✓ You can't move a selection from one image to another using the dragand-drop method. For that, you need to use Cut and Paste, as described earlier, in "Cut, Copy, Paste: The old reliables."
- You can drag and drop an entire layer from one image to another. Just click on the layer name in the Layers palette and then drag and drop as you would any other selection. Check out "Editing a multilayered image," in Chapter 11, for details.

You can select the Move tool — which is the same thing as clicking the Move icon in the Selections palette — from the keyboard by pressing Ctrl+G $(\mathcal{H}+G)$ on the Mac).

Sayonara, Selection!

Deleting a selection is a cinch: Just press that old Delete key on your keyboard. If you want to delete the deselected area instead, you can choose Edit

Delete Background. Or just press Ctrl+I (\mathbb{H}+I) to invert your original selection and then press Delete.

Whichever route you choose, your selection is sent to the great pixel hunting ground in the sky, nevermore to be seen on this earth. All that remains to remind you of your former selection is a background-colored hole in the shape of the selection. If you're working on a layer, you see the underlying layer through the hole. Remember, the background canvas on which your image sits is transparent, although it appears white on-screen by default. For more on this issue, see "Hey Vincent, Get a Bigger Canvas!" in Chapter 8.

Put a Feather in Your Selection Cap

Many image editors enable you to *feather* a selection. To feather the selection is to fuzz up the edges of the selection outline a little bit. This technique creates more natural-looking edits because the results of your edits fade gradually into view. Without feathering, you often get abrupt transitions at the edges of the selection, making your edits very noticeable.

You can use feathering not only to create more natural edits, but also to create some special effects, as discussed in the next two sections.

Covering up unsightly image blemishes

When I shot the image in Figure 9-9, the city of Indianapolis refused to cooperate and relocate that darned tower in the background. I shot the picture anyway, knowing that I could cover up the tower in the image-editing phase.

Figure 9-9:
This image
would be
great if it
weren't for
that ugly
tower in the
background.

To hide the tower, all I needed to do was copy some sky pixels and place them over the tower. I tried to do just that using the Copy and Paste technique described two sections ago. But as you can see from the left image in Figure 9-10, the result was less than satisfactory. At the top of the tower, my patch blended fairly well with the surrounding sky, because I was patching in a solid area of color. But in the bottom portion of the image, you can see distinct edges along the borders of the area I pasted because the patch has hard edges, which interrupts the natural fluffiness of the clouds. I was able to create a much less noticeable patch in the right image in the figure by using the feathering technique outlined in the upcoming steps.

Figure 9-10:
An
unfeathered
patch is
obvious
(left), while
a feathered
patch
blends
seamlessly
with the
original
image
(right).

In many image editors, you can feather a selection and then move or copy the feathered selection. In PhotoDeluxe, you get limited feathering capabilities. You can feather a selection, but all you can do is delete or fill either the selection or the unselected areas. That is, unless you trick the program by using the following bit of sleight-of-hand. (Note that these steps assume that you're working on an image that has only a standard background layer and a text layer — in other words, that you haven't created any layers in addition to those you get by default.)

1. Choose View Show Layers to display the Layers palette.

The palette is shown and fully explained in "Uncovering Layers of Possibility" in Chapter 11.

2. Copy the background layer to a new layer.

To do this, drag the background layer — which should be named Layer 0 if you haven't renamed it — to the New Layer icon at the bottom of the Layers palette. You now have two layers, each containing the exact same image. After you create the new layer, that layer is active, which is just what you want in this case.

3. Select an area to serve as your patch.

When creating a patch, select pixels that are as close as possible in color and brightness to those surrounding the pixels you want to cover up. In the bottom portion of my image, for example, I selected the cloud area just to the left of the tower.

To create a patch of a specific shape, first draw a selection outline around the area you're trying to cover. Then, with the New or Move icon selected in the Selections palette, Ctrl+Alt+drag (<code>%+Option+drag</code> on the Mac) the selection outline onto the pixels you want to use as the patch.

4. Choose Effects⇔Feather.

The Feather dialog box, shown in Figure 9-11, appears. The Feather value determines how fuzzy your selection gets. Higher values increase the feathering effect. I used a value of 15 when creating the sky patch for Figure 9-10.

Figure 9-11:
The Feather
dialog box
enables you
to create
more
natural
edits, as
well as
special
effects.

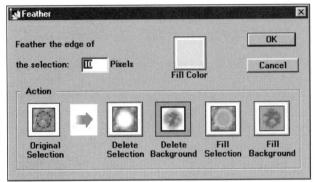

In the bottom portion of the dialog box, click on the Delete Background icon and then click on OK. The selected pixels fade into nothingness, creating a nicely feathered edge for your patch. (To see what the patch looks like by itself, Alt+click on the eyeball icon to the left of the patch layer name in the Layers palette. Alt+click again to make all your image layers visible again).

5. Click the None icon in the Selections palette or press Ctrl+D.

This step is important because it gets rid of the selection outline. If you leave the selection outline intact, you wind up copying a hard-edged selection instead of that nice, soft-edged patch you just created.

6. Select the Move tool and move the patch into place.

Press Ctrl+G (\mathbb{H}+G on the Mac) to select the Move tool quickly. Then drag the patch into place or use the arrow keys to nudge the patch into position.

If the patch isn't big enough to cover the entire blemish, drag the patch layer to the New Layer icon in the Layers palette to create a second patch. Then use that patch to cover up more pixels.

7. Flatten the image.

When you're all finished patching, choose Merge Layers from the Layers palette menu (click on the right-pointing arrow near the top-right corner of the palette to display the menu). Your patch is now firmly glued over those unsightly pixels.

You can use this same technique to cover up just about any blemish. But you should also investigate the alternative method for hiding image flaws, which is to use the Clone tool to paint pixels from another part of your image onto the ones you want to cover up. See "Cloning without DNA," in Chapter 10, for a look at this tool. In many cases, you may get a better result using the Clone tool rather than the patching method just described. But I wanted you to have both options in your bag of tricks.

Fading your image into nothingness

By design, the Feather command is meant to be used to delete a selection or fill a selection with a color. You can alternatively fill or delete the deselected pixels instead of the selection. Using this command, you can create an image that gradually fades into view from the background, as in Figure 9-12.

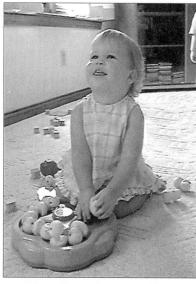

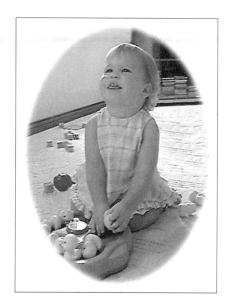

To use the Feather option, you must first draw a selection outline. Then choose Effects⇔Feather to display the Feather dialog box (refer to Figure 9-11).

Enter a feathering value in the option box to determine how gradually you want the selection to fade out. A higher value fades the image over a larger distance.

At the bottom of the dialog box, click on the icon for the effect you want to create. You can delete the selected area or delete the background, which is what I did in Figure 9-12. You can also fill the selection or the background with a color.

To specify the color for the fill, click on the Fill Color icon. PhotoDeluxe then displays the Color Picker dialog box. Click on the color you want to use, or, if none of the visible colors suit your needs, click on the colored square at the top of the dialog box to define your own color, as explained in "Choosing Your Paint Colors" in Chapter 10. Click on OK to select the color. Then click on OK in the Feather dialog box to apply the effect.

Those of you who are really paying attention will notice that I went beyond creating a feathered background for the image on the right in Figure 9-12. I also used the Clone tool to cover up that distracting electrical outlet and the windowsill on the wall behind my subject. I used the Clone tool again to paint some carpet pixels over the major dropout near the hemline on the little girl's dress, on the left side of the picture. The dropout was caused by a shiny surface on one of the toys that reflected my flash. Check out "Cloning without DNA," in Chapter 10, for information on how to use the very handy Clone tool.

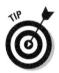

Whenever I apply these kinds of edits, I always create a copy of my image on a separate layer first. Then I apply the edits to that layer to see how I like my changes. That way, if I don't like how things turn out, I can go back to square one simply by deleting the new layer. And I don't have to worry about harming my original image in the process. (For more on working with layers, see "Uncovering Layers of Possibility" in Chapter 11.)

Chapter 10 Pixel Painting 101

In This Chapter

- Choosing the foreground and background paint colors
- > Painting with the Brush and Line tools
- ▶ Adjusting the size and softness of your brush
- Changing the paint opacity
- ▶ Smearing colors with the Smudge tool
- Experimenting with blend modes
- Filling a selection with a solid color or gradation
- ▶ Putting a border around your picture
- Erasing your way back to a transparent state
- ▶ Painting with a portion of your image (cloning)
- ▶ Replacing one color with another
- ▶ Adding witty captions and other text

Remember when you were in kindergarten and the teacher announced that it was time for some finger painting? In a world where you were normally admonished to be neat and clean, someone actually *encouraged* you to drag your hands through wet paint and make a big, colorful mess of yourself and everything around you.

Well, image editors bring back the bliss of youth by enabling you to paint on your digital photographs. You can paint a mustache on your former best friend, smear colors all around a canvas, and do all sorts of other creative things to your images. The process isn't quite as much fun and not nearly as messy as those childhood finger painting sessions, but it's a blast nonetheless.

Of course, the paint tools in an image editor aren't just for adding fun effects to your images. You can also use them to touch up small blemishes, add borders around your image, and perform other mundane, but necessary, editing tricks.

This chapter explains the basics of digital painting, including how to select a paint color, how to adjust the performance of your painting tools, and how to fill entire areas with a wash of color. You also discover some more advanced painting techniques, such as using different blend modes to mix colors in ways you never thought possible.

Choosing Your Paint Colors

Before you lay down a coat of paint, you need to choose the paint color you want to use. In PhotoDeluxe, two paint cans are available at any one time. One can holds the foreground color, and the other holds the background color.

In many image-editing programs, some tools paint with the foreground color and others paint with the background color. But in PhotoDeluxe, the two painting tools — the Brush tool and the Line tool — always paint in the foreground color. The background color is used only in some special effects, such as the Pointillize and Bas Relief effect.

Choose Colors. The Color Picker dialog box, shown in Figure 10-1, appears.

When the Brushes palette is displayed, you can click the Color swatch in the bottom-right corner of the palette to display the color picker. For more about the Brushes palette, see "Changing brush size and softness," later in this chapter.

Figure 10-1: Fill your foreground and background paint cans using this dialog box.

The color picker works as follows:

✓ The Foreground and Background swatches at the top of the dialog box indicate which color you're adjusting. The swatch that has the double border is the active color. (In Figure 10-1, the Foreground color is active.) To set the other color, click its swatch.

✓ Select the color for the active swatch by clicking in the color display beneath the Foreground and Background icons. When you move your cursor into the display, it becomes an eyedropper, as shown in Figure 10-1.

You can also click a pixel in the image window to lift a color right from your image. Using this technique, you can easily match the paint color to the color of an existing pixel in your image.

- ✓ Shift+click anywhere in the color display to switch between three available color spectrums. Shift+click once to get a grayscale spectrum. Shift+click again to get a display that fades gradually from the foreground color to the background color. Shift+click yet again to return to the original full-color display.
- ✓ If you have trouble clicking just the right color in the Color Picker dialog box, double-click on the Foreground or Background color swatch to open either the Windows or Apple color picker, depending on whether you're working on a PC or Macintosh system. In these system color pickers, you can more easily select a precise color, as outlined in the following two sections. (You just need to click the color swatch once if that color is the active color the one surrounded by the double border.)
- ✓ After setting your colors, click OK to close the color picker.

Using the Windows color picker

If you're working on a PC and double-click the Foreground or Background color swatch in the Color Picker dialog box, you open the Windows Color dialog box, shown in Figure 10-2.

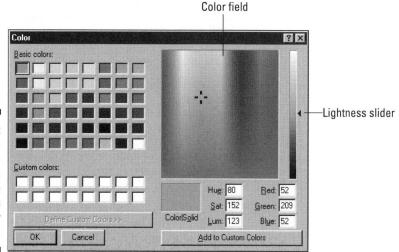

Figure 10-2:
To choose a precise color on a PC, use the Windows Color dialog box.

Inside the dialog box, you choose a color as follows:

- ✓ To choose one of the colors in the Basic Colors area, just click its swatch. Then click OK to return to the PhotoDeluxe Color Picker dialog box, as explained in the preceding section.
- ✓ To access more colors, click the Define Custom Colors button at the bottom of the dialog box to display the right half of the dialog box, as shown in Figure 10-2. (This button is grayed out in Figure 10-2 because I already clicked it, making it unavailable.)
- ✓ Drag the crosshair cursor in the main color field to choose the hue and saturation (intensity) of the color, and drag the slider to the right of the color field to adjust the amount of black and white in the color. As you drag the cursor or the slider, the values in the Hue, Sat, and Lum boxes change to reflect the hue, saturation, and brightness of the color.
 - The R, G, B option boxes reflect the amount of red, green, and blue in the color, according to the RGB color model. (See "RGB, CMYK, and Other Colorful Acronyms" in Chapter 2 for more about color models.) You can safely ignore these numbers, though — just drag the slider and crosshair until you get the color you want.
- ✓ However, after you create a color, you may want to record the Hue, Sat, and Lum values or RGB values for future reference. The next time you want to use the color, you can just enter the values in the option boxes instead of dragging the crosshair and slider. You're then guaranteed an exact match of the color you selected earlier.
- ✓ You can also add the color to the Custom Colors palette on the left side of the dialog box by clicking the Add to Custom Colors button. The palette can hold up to 16 custom colors. To use one of the custom colors, click its swatch.
- ✓ To replace one of the Custom Colors swatches with another color, click that swatch before clicking the Add to Custom Colors button. If all 16 swatches are already full, Windows replaces the selected swatch (the one that's surrounded by a heavy black outline). Click a different swatch to replace that swatch instead.
- ✓ The Color/Solid swatch beneath the color field previews the color. Technically, the swatch displays two versions of your color — the left side shows the color as you've defined it, and the right side shows the nearest solid color. See, a monitor can display only so many solid colors. The rest it creates by combining the available solid colors — a process known as dithering. Dithered colors have a patterned look to them and don't look as sharp on-screen as solid colors.

This issue typically comes into play only if your monitor is set to display a measly 256 colors, however. At any other setting, you probably won't notice any difference between the two sides of the Color/Solid swatch. If you are creating an image for display on a 256-color monitor, you can click on either side of the swatch to choose the corresponding color. Solid colors, of course, produce the best-looking on-screen images.

After you finish defining your color, click OK to return to the PhotoDeluxe Color Picker dialog box.

Using the Apple color picker

If you're doing your editing on a Macintosh computer, double-clicking the Foreground or Background icons in the PhotoDeluxe Color Picker dialog box (described two sections ago) displays the Apple color picker, shown in Figure 10-3.

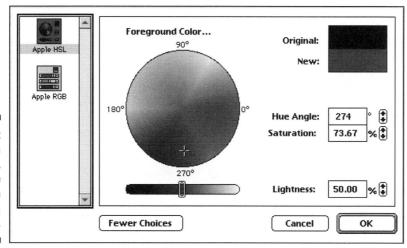

Figure 10-3: On a Macintosh, you define colors in this dialog box.

In the Apple color picker, you can select a color using either the Apple HSL color model or the RGB (Red, Green, and Blue) color model. Apple HSL (Hue, Saturation, and Lightness) is a variation of the standard HSB (Hue, Saturation, and Brightness) color model.

Use whichever color model suits your fancy — click the Apple HSL or Apple RGB icon in the left side of the dialog box to switch between the two models.

In HSL mode, drag the crosshair in the color wheel to set the hue (color) and saturation (intensity) of the color. Drag the lightness slider bar to adjust the, er, lightness of the color. Set the slider at the midpoint (50 percent lightness) to get the most vivid version of your color.

In RGB modes, drag the R, G, and B color sliders to select your color or enter values in the RGB option boxes. Remember that a value of 255 in all three option boxes creates white; 0 in all three option boxes creates black. That's because you're mixing colors using light — and full intensity red, green, and blue light creates white light. (Imagine pointing a red, a green, and a blue flashlight at the same spot.) Conversely, no red, no green, and no blue light creates black (just like turning off all three flashlights). If you enter any value other than 255 or 0 into all three option boxes — for example, if you enter 5 in the R, G, and B boxes — you get a shade of gray.

Whichever color model you use, the Original and New boxes at the top of the dialog box represent the current foreground or background color and the new color you're mixing, respectively. When you're satisfied with your color, press Return or click OK.

Brushing on Color

You can brush color on your image using two tools — the Brush tool and the Line tool. The Brush tool enables you to draw freehand strokes that can have either a hard edge or a soft, feathered edge. The Line tool draws straight, hard-edged lines exclusively. (However, you can also draw straight lines using the Brush tool, so you may never need to pick up the Line tool at all.)

The following sections explain how to use the Brush tool. The Line tool is explained in the upcoming section, "Painting a Line in the Sand."

I recommend that you do your painting on a separate layer so that you can easily erase your changes if you mess up. For more about erasing paint strokes, see "Brushing on Transparency" later in this chapter. And for information on how to create and use layers, see "Uncovering Layers of Possibility" in Chapter 11.

Plying the paint brush

To select the Brush tool, choose Tools⇔Brush or press Ctrl+J (ૠ+J on the Mac). You know, J as in "I want to Jazz up my image with some brush strokes." Or something like that.

To lay down a swath of paint, just drag across your image. If you want to paint a straight line, press Shift as you drag. Or click at the spot where you want the line to begin and then Shift+click at the point where you want the line to end. PhotoDeluxe draws the line automatically for you.

Changing brush size and softness

When you select the Brush tool, the Brushes palette shown in Figure 10-4 appears. The palette offers you a selection of brush tips, enabling you to paint differently sized strokes. Click the brush tip that you want to use. The smallest brush size is just one pixel big; the largest is 100 pixels in diameter.

Figure 10-4:
In this
palette, you
can change
the brush
tip used
by the
Brush tool.

The first six options in the Brushes palette are hard-edged brushes — they paint strokes resembling those made with a pen. You get solid color throughout the width of the stroke. The other brush tips are soft, giving you strokes that resemble those made with a regular paint brush. The color is solid at the center of the stroke and gradually fades out to nothingness.

The brush tips in the first two rows of the palette are shown at their actual size. The tips in the last row are too large to fit at their actual size, so a number representing the brush diameter (in pixels) appears beneath the icon.

The one-pixel brush (the first one in the palette) is ideal for making precise corrections in your image. For example, if you want to fix a red-eye problem, set the foreground color to a color that matches an unaffected portion of the eye. (Open the color picker and click the eye area with the eyedropper, as explained earlier in "Choosing Your Paint Colors.") Then zoom in on the eye and click the red pixels one by one. Every few clicks, change the foreground color slightly — make it a little lighter or a little darker, for example. That way, you end up with natural-looking eyes instead of an unhuman-like expanse of solid eye color.

To open the color picker and change the color of the paint applied by the Brush tool, click the Color icon at the bottom of the Brushes palette. Clicking the icon is equivalent to choosing Effects Choose Colors. For more information about setting the paint color, see "Choosing Your Paint Colors" earlier in this chapter.

This same palette is available when you work with the Eraser, Smudge, and Clone tools, all discussed later in this chapter. The only difference is that the Color icon is hidden because you don't need access to the color picker when you work with those tools. Also, the palette takes on the name of the tool you're using — it's called the Clone palette when you work with the Clone tool, for example.

To close the palette, click the Close button in the upper-right corner. The palette automatically disappears when you switch to a tool that doesn't use brushes — the Text tool or a selection tool, for example.

Changing tool opacity

By default, the Brush tool paints a solid stroke of color, completely covering any image detail you swipe across. But you can lower the tool opacity so that your color is partially transparent, allowing the underlying image to show through. Figure 10-5 and Color Plate 10-1 show the same size brush stroke at several different opacity levels. A value of 100 percent makes the stroke completely opaque, as illustrated in the far left example.

To change the opacity of the tool, just press a number key on your key-board. Press 1 for 10 percent opacity, 2 for 20 percent, and so on. Press 0 for 100 percent opaque strokes.

After you change the opacity setting, that setting remains in force until you press another number key. Unfortunately, PhotoDeluxe doesn't provide any on-screen reference to indicate the opacity level of the active tool. So it's easy to forget what setting you're using from one edit to the next. If your strokes don't look as solid as you expected, press 0 to make sure you're working at full opacity.

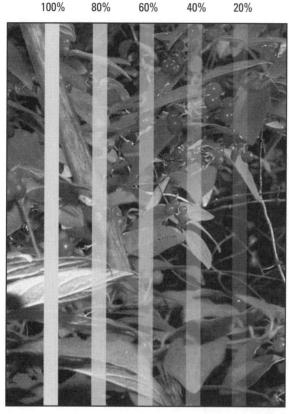

60%

100%

80%

Figure 10-5: You can change the opacity of your brush strokes by pressing a number key.

Painting a Line in the Sand

The Line tool can draw straight lines only. You can also draw straight lines by pressing Shift as you drag or click with the Brush tool. However, when you draw straight lines in that way, you're limited to the brush sizes available in the Brushes palette. If you want a line of a different width, pick up the Line tool by choosing Tools⇔Line.

When you select the Line tool, the Line Tool Options palette shown in Figure 10-6 appears. Here, you can specify the width of your line in pixels. To choose the line color, click the Color box, which displays the Color Picker dialog box (see "Choosing Your Paint Colors," a few pages back, for more information).

Figure 10-6: You can change the

size and color of lines painted with the Line tool in this palette.

Line Width:	1	pixels	
Color:			

To paint your line, just drag. If you press Shift as you drag, PhotoDeluxe constrains your line to a 45-degree angle, which means that you can create only a horizontal, vertical, or diagonal line. The Line tool always paints hardedged lines; you can't create a fuzzy line as you can with the Brush tool. However, you can vary the opacity of your lines by pressing the number keys on your keyboard. Press 1 for 10 percent opacity, 2 for 20 percent opacity, and so on. Press 0 to create a fully opaque line.

Giving Your Cursor a New Shape

As with the selection tool cursors discussed in Chapter 9, you can specify how you want your Brush, Eraser, Clone, and Smudge tool cursors displayed. Press Ctrl+K (ૠ+K) or choose File⇔Preferences⇔Cursors to display the Cursors dialog box shown in Figure 10-7. In the Painting Tools section of the dialog box, choose from these options:

- ✓ Standard displays the cursor as a little icon representing the active tool. For example, the cursor looks like a paintbrush when the Brush tool is selected. The cursors are all very cute, but they often get in the way of seeing the pixels you want to edit and figuring out exactly which pixel you're clicking.
- ✓ Precise displays a small crosshair cursor, which is a good option for doing detail work. This cursor is the least obtrusive of the bunch.
- **▶ Brush Size** displays a circle that represents the actual size of the brush. This option is helpful when you're using a large brush size and want to see just how far-reaching your stroke will be. When you use very small brushes, you get a crosshair cursor to help you see where the cursor is positioned.

Figure 10-7:
Using the
Painting
Tools
options, you
can make
your cursor
reflect the
current
brush size.

Smudging Colors Together

The Smudge tool is a special purpose tool that smears the colors in your image. The effect is like dragging your finger through a still-wet oil painting.

To select the Smudge tool, choose Tools Smudge. The Smudges palette, which is essentially the same thing as the Brushes palette discussed earlier, appears. In this palette, you can choose from various brush tips, as when you work with the Brush tool. (See "Changing brush size and softness," earlier in this chapter, for more information and a look at the palette.)

You can also adjust the effect of the Smudge tool by pressing the number keys, as you can with the Brush tool. Set at full strength, the Smudge tool drags a color the full length of your drag. At lower strengths, the colors aren't smeared the entire distance of your drag. To change the tool strength, just press the number keys on your keyboard. Press 0 for a full-power application of the Smudge tool. Press 1 to apply the tool at 10 percent pressure, 2 for 20 percent, and so on.

To get an idea of the kind of effects you can create with the Smudge tool, see Figure 10-8 and Color Plate 10-2. Using a variety of brush tips with the tool strength set to 70 percent, I gave my antique pottery toucan a new 'do. Who says a toucan can't have a little fun, after all? To create the effect, I just dragged upward from the crown of the bird.

Just in case you want to try your own hand at creating hairstyles for inanimate objects, the toucan image is found in the Images folder on the CD in the back of this book. The filename is Toucan.jpg.

Figure 10-8:
By dragging
upward
from my
toucan's
head with
the Smudge
tool, I gave
him a more
happenin'
hairstyle.

Pouring Color into a Selection

If you want to paint a large area, you may find it easier to use the Effects Selection Fill command than the Brush tool. This command fills a selection with the foreground color. You can also use it to fill the selection with a predefined pattern of color. (See "Strap on Your Selection Toolbelt" in Chapter 9 for information on how to create a selection prior to using the Selection Fill command.)

You can choose the Selection Fill command in a snap by pressing Ctrl+9 (#*+9 on the Mac).

When you choose the command, the dialog box shown in Figure 10-9 appears. The options in the dialog box work like so:

- ✓ If you want to fill the selection with a solid color, click the Color radio button. The swatch underneath the button shows the fill color. To change the color, click the swatch to select a new color from the color picker, explained in "Choosing Your Paint Colors," earlier in this chapter.
- ✓ To fill your selection with a pattern of color, click the Pattern radio button and then click the Next and Previous buttons to see the available patterns in the pattern preview area.
- ✓ Click the Selection icon if you want to fill the selected area; click the Background icon to fill the deselected pixels instead.

Figure 10-9:
The
Selection
Fill dialog
box offers
several
interesting
ways to
pour color
into a
selection.

- ✓ The Opacity value determines whether the color or pattern you apply is fully opaque that is, it covers all underlying pixels. Any value less than 100 results in a semi-transparent fill, just as with the brush stroke opacity values discussed earlier in this chapter. (See Figure 10-5 and Color Plate 10-1 for examples of different opacity settings.)
- ✓ The Blend options are a little tricky to understand, but fun to play around with. In fact, they're so entertaining that I decided they deserve their very own headline and section, which is coming up next.

✓ To quickly fill a selection with the foreground color, press Alt+Delete (Option+Delete on the Mac).

Playing with Blend Modes

When you fill a selection using Effects Selection Fill, you can choose from several different Blend options — referred to as blend *modes* by some image editors. Blend options control how the fill color (or fill pattern colors) mix with the colors in the underlying image.

Blend modes are easier understood by looking at examples than by reading verbal descriptions, which is why Color Plate 10-3 was born. I started with the image in the top-left corner of the page, which shows a ceramic lamb grazing in its natural habitat, the suburban backyard. I selected the entire image and filled it with the pink color you see in the borders of the color plate, using five of the Blend options in the Selection Fill dialog box. As you can see, the different blend modes resulted in very different results.

Predicting exactly how a blend mode will affect your image is a little difficult, so just try the different choices and see which one you like best. But just so that you can sound smart at your next office meeting, the following list explains how each mode works:

- ✓ Normal mixes the colors, er, normally. That is, if you dump blue paint into a selection, the selection turns blue — assuming you set the Opacity value to 100 percent, as discussed in the preceding section. I didn't bother to show this mode in Color Plate 10-3 because all you would see is a solid pink box.
- ✓ Darken mixes the underlying pixel color with the fill color to create a darker color. The underlying pixel color is changed only if adding the fill color results in a darker color. So when I added pink to the image in Color Plate 10-3, the lamb's eves and other dark areas weren't altered. If you apply a white fill to your image using this mode, you see no change at all, because white plus any color never equals a darker color.
- Lighten, as you may already have guessed, does the opposite of Darken. With this mode, underlying pixels are changed only if adding the fill pixels results in a lighter color. For example, the brighter pieces of grass in the image in Color Plate 10-3 weren't colored by the pink fill because adding the pink pixels to those areas would result in a darker, not a lighter, color.
- ✓ Overlay is perhaps the most complicated mode to explain. In fact, I probably shouldn't even try, but here goes: The fill and image pixels are mixed together in a way that retains the shadows and highlights of the image pixels. Where the fill color is brighter than the underlying pixels, the underlying pixels get lighter, as if you dabbed at them with bleach. Where the fill color is darker than the underlying pixels, the underlying pixels get darker, as if you stroked over them with a marker several times.

In other words, don't even try to figure out how this mode works. You'll just go bonkers, and you still won't be able to predict what's going to happen the next time you fill a selection using Overlay. Just remember that it usually results in vivid, highly saturated colors and often creates some interesting results.

✓ Difference creates an inverted effect, rather like a photo negative. After comparing the brightness values of the fill pixel and the underlying pixel, Difference subtracts either the fill color from the underlying color or the underlying color from the fill color, depending on which has the greater brightness. (Hey, you said you wanted to sound smarter at parties, so don't complain now that things are getting too obtuse.)

Anyway, as you can see, trying to figure out exactly what Difference is going to do to your image is like trying to figure out exactly what's in that hot dog you're eating. So just apply the fill and see whether you think the results are way cool or not so much. Press Ctrl+Z to undo the blend if you're not satisfied. Personally, I'm rather taken with the lambin-a-nuclear-warhead-testing-zone image in Color Plate 10-3.

✓ Color, when compared to Overlay and Difference, is an easy mode to understand. When you apply this mode, the underlying pixels acquire the fill color, but the original brightness information of the pixels is retained. That means that you don't lose any shadows or highlights — you just change the overall tint of the image. This mode is the most useful of the bunch. You can use it to replace the color of an element in your image, as discussed in "Swapping One Color for Another," later in this chapter, and to colorize grayscale images, as explored in "Going Gray" in Chapter 11.

With the exception of the Color and Normal modes, the blend modes are largely for creating special effects. But don't forget to experiment with them, because you can wind up with some unexpected and wonderful images in the process.

When you create multilayered images, these same blend modes are available for mixing the pixels on one layer with pixels on the underlying layer. So if you want to mix strokes applied by the Line or Brush tools in the same way you mix fills applied by Selection Fill, just do your painting on a separate layer and then choose the blend mode you want in the Layer Options dialog box. All this layer stuff is explored in "Uncovering Layers of Possibility" in Chapter 11.

Creating a Gradient Fill

To create a band of color that progresses slowly from one color to another — otherwise known as a *gradient* — choose Effects⇔Gradient Fill. This command is available only when you have a portion of your image (or the entire image) selected.

You can choose the Gradient Fill command quickly by pressing Ctrl+8 (第+8 on the Mac).

After you choose the command, the Gradient Fill dialog box shown in Figure 10-10 appears. To choose the starting and ending color of the gradient, click the Start Color and End Color swatches, respectively. When you click one of the swatches, the Color Picker dialog box appears. You can then select your color, as explained earlier in "Choosing Your Paint Colors."

At the bottom of the Gradient Fill dialog box, you can specify the style of gradient you want. Just click on the icon for the pattern you want to create. To create the background in Figure 10-11, I used the Bottom to Top option with black as the Start Color and white as the End Color.

Figure 10-10:
You can
choose from
several
types of
gradient fills
by clicking
the icons at
the bottom
of this
dialog box.

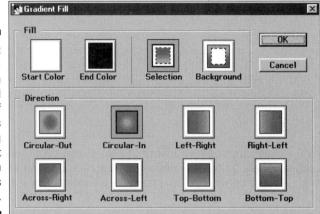

Click the Selection icon to fill the selected area with the gradient, or click the Background icon to fill the deselected area instead. Click OK to tell PhotoDeluxe to get busy and paint that gradient.

For some colorful gradient effects, create your gradient on a separate layer and then blend the gradient with the underlying pixels using Difference, Overlay, or one of the other layer blend modes. Set the layer opacity to less than 100 percent; otherwise, your gradient just obscures the pixels in the underlying layer. See "Uncovering Layers of Possibility" in Chapter 11 for more information about layers, and read about how the different blend modes work in "Playing with Blend Modes," earlier in this chapter.

Figure 10-11:

To give the toucan a more interesting backdrop, I selected the background and filled it with a black-towhite gradient.

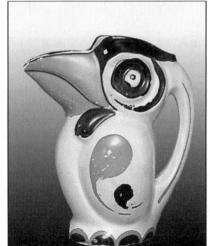

Adding a Border

If you want to create a border around your image or a portion of your image, you can do the job manually using the Brush or Line tools. But a better option is to use Effects⇔Outline.

Before you can access the Outline command, you must have an active selection. To select the entire image, press Ctrl+A (%+A on the Mac). To select a portion of the image, use the selection tools as explained in "Strap on Your Selection Toolbelt" in Chapter 9.

Choosing the Outline command displays the dialog box shown in Figure 10-12. The options work as follows:

- ✓ The Width value determines the thickness of the border. The value is specified in pixels.
- ✓ Select a Location radio button to determine where your border falls in relation to the selection outline just inside the outline, just outside it, or centered directly on it. If your entire image is selected, choose the Inside option. If you choose the Center option when the entire image is selected, the border is partially cut off, and if you choose Outside, you wind up with no border at all. In order to create a border using either option, you would need to enlarge the canvas size; the selection outline is already at the far edge of the canvas, so there's no room for PhotoDeluxe to place half the border or the entire border outside the selection outline.
- ✓ The Opacity and Blend mode options work just as described earlier in this chapter, in "Changing tool opacity" and "Playing with Blend Modes," respectively.
- Click the Color icon to display the color picker and select the color for your border. The color picker is described in deadly detail earlier in this chapter, in "Choosing Your Paint Colors."

Figure 10-12:

To add a simple border around your image or selection, use the Outline command.

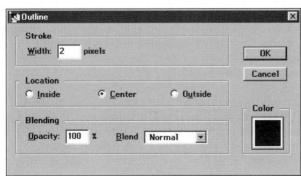

While the Outline command paints a simple, solid line around your selection, you can also apply more imaginative frames around your image. Like most entry-level image editors, PhotoDeluxe offers several ready-made frames for images. To use them, click the Cards & More Guided Activities button, click the Frames & More tab, and then click the Frames icon. You need to have the PhotoDeluxe CD in your CD-ROM drive to access the available frames.

If you want to sound like you know what you're doing in the image-editing business, use the word *stroke* instead of *outline*. The term comes from the fact that when you apply an outline, you're really painting a stroke along the selection border — stroking the selection with color, as it were. Or at least, that's the rumor. One can never tell exactly how these computer people come up with their terminology.

Brushing on Transparency

The section "Editing Safety Nets," in Chapter 8, discusses several options for undoing mistakes. In addition to the Undo and Revert to Last Saved commands, you have an additional mop-up tool at your beck and call: the Eraser tool. To select the tool, choose Tools⇔Eraser or press Ctrl+E (ૠ+E on a Mac).

The Eraser tool wipes away pixels in your image to reveal the transparent canvas behind. If you're working on a multilayered image, as discussed in Chapter 11, the Eraser rubs a hole in the active layer, revealing the pixels in the underlying layer, as illustrated in Figure 10-13. In the left half of the image, I nestled my ceramic elf into a field of wildflowers, with the elf occupying the top layer in the image and the wildflowers consuming the bottom layer. The right half of the image shows me swiping away at the elf's chest and legs with the Eraser, bringing the wildflowers in the bottom layer into view.

If you're working on a single-layered image, the Eraser also makes pixels transparent. But if you're using the default background setting, it may appear to you that the Eraser tool is painting with white because the default background color is white. If you change the background setting to one of the transparent grid options, as explained in "Hey Vincent, Get a Bigger Canvas!" in Chapter 8, you can see that the Eraser is in fact stroking on transparency and not white paint.

As you can with the Brush tool, you can alter the size and softness of the Eraser stroke by selecting a different brush tip from the Erasers palette, which is nothing more than the Brushes palette minus the Color swatch. (Refer to Figure 10-4 to see the palette.) The palette appears automatically when you choose the Eraser tool.

Figure 10-13: To create this image, I put the elf on the top layer of the image and the wildflowers on the bottom layer (left). Using the Eraser tool, I rubbed away some elf pixels, revealing wildflower pixels below

(right).

You can also adjust the opacity of the Eraser by pressing a number key. Press 1 for 10 percent opacity, 5 for 50 percent opacity, and so on, up to 0 for 100 percent opacity. At 100 percent, you swipe the pixels clean; anything less than 100 percent leaves some of your pixels behind.

Cloning without DNA

Now that humankind has successfully figured out how to clone sheep — like sheep needed our help to replicate themselves — it should come as no surprise to you that you can easily clone pixels in your image.

With the Clone tool, you can paint pixels from one image onto another image, as I did in the right half of Figure 10-14. But I usually use the Clone tool to duplicate pixels within the same image in order to cover up blemishes and hot spots, such as the drop-out area at the top of the lemon in Color Plate 10-4.

Figure 10-14: The Clone tool enables you to paint one image (left) onto another image (right).

Crosshair cursor Source point Clone cursor

The Clone tool has no real-life counterpart — mad scientists excepted — so it takes some practice to understand how it works. Here's what you need to know:

- ✓ To select the tool, choose Tools⇔Clone. When you do, you see the Clone palette, which is the Brushes palette (see Figure 10-4, earlier in this chapter) without the Color icon. As with the Brush tool, you can select from several different brush sizes and choose either a hardedged brush or feathered (soft-edged) brush when you work with the Clone tool. To select a brush, click it in the Clone palette.
- ✓ Choosing the Clone tool also displays several cursors in your image window. The round, target-like cursor represents the source point. This cursor indicates where the Clone tool will start its cloning mission the initial pixels that will be cloned when you click or drag with the tool. To reposition the source point, just drag inside it.
- ✓ The Clone cursor indicates where the cloned pixels will be painted. If you have the Standard option selected in the Cursors dialog box, the Clone cursor looks like a little rubber stamp, as in Figure 10-14 and Color Plate 10-4. (See "Giving Your Cursor a New Shape," earlier in this chapter, for more information about choosing a cursor type.) The rubber stamp icon is a carryover from Adobe Photoshop, in which the Clone tool is called the Rubber Stamp tool. Evidently, the PhotoDeluxe icon budget was too tight to allow a new cursor for the Clone tool. Personally, I think a little sheep icon would be perfect.

- ✓ To do your actual cloning, you can either click or drag. If you click, the pixels directly underneath the source point cursor are painted onto the pixels underneath the Clone cursor (the rubber stamp icon). How many pixels are cloned depends on the size of the brush you chose the larger the brush, the more pixels you clone.
- When you drag with the Clone tool, you clone pixels along the direction and distance of your drag, relative to the source point. As soon as you begin your drag, a crosshair cursor emerges from the source point cursor to indicate what pixels you're cloning. The crosshair cursor moves in tandem with the Clone tool cursor, mirroring your every move. For example, if you drag down and to the left, you clone pixels that fall below and to the left of the source point cursor.

If that explanation sounds like gibberish, just give the tool a try. This is one of those concepts that makes perfect sense when you see it on-screen but is difficult to describe in text. (Or at least I'm certainly finding it difficult.)

- If you release the mouse button and start a new drag, the crosshair cursor flies home to the source point cursor, and you begin cloning from the source point all over again.
- ✓ Before you clone, copy the layer that contains the pixels you want to clone to a new layer. Then do your cloning work on the new layer. That way, you can easily get rid of your clones if you don't like the results just delete the layer or use the Eraser to wipe away the offending pixels. For information on how to copy layers and work with layers, see "Uncovering Layers of Possibility" in Chapter 11.
- ✓ The Clone tool can't see through layers; it can clone only pixels on the active layer. So if you're working on Layer 2, for example, you can't clone pixels from Layer 1.
- ✓ You can however, clone between images quite easily. Just open both images side by side (choose Window Tile to arrange the image windows). Click with the Clone tool in the image that has the pixels you want to clone. Drag the source point cursor into position. Then drag in the image where you want to paint the cloned pixels.
- ✓ You can vary the opacity of the pixels you clone by pressing the number keys on your keyboard. Press 0 to clone at full opacity; press 1 to clone at 10 percent opacity, 2 to clone at 20 percent opacity, and so on.

Most image-editing programs these days offer some semblance of a cloning tool, so if you're not using PhotoDeluxe, be sure to check your program's manual or Help system. The Clone tool can be a lifesaver in many situations — after you get acquainted with this tool, you'll find yourself picking it up often.

The Clone tool isn't the only way to copy pixels from one spot to another, however. For information on other techniques, see "Selection Moves (And Copies and Pastes)" and "Covering up unsightly image blemishes," both in Chapter 9.

Swapping One Color for Another

One of the great things about digital imaging is that you no longer have to be content with reality. Take the apple in Color Plate 10-5, for example. Frankly, I'm a little bored with ordinary red apples. Why not invent a new fruit — say, a deep purple apple? We could call it the Prince apple, after that song "Purple Rain" (or, at least we could if that singer who used to be called Prince still used that name).

Anyhow, you can swap pixels of one color for pixels of another color with relative ease. In fact, in PhotoDeluxe you have several different ways to replace colors in your image:

✓ Select the area you want to color, and then choose Effects⇔Selection Fill. (See "Pouring Color into a Selection," earlier in this chapter, for more information on this command, and read "Strap on Your Selection Toolbelt" in Chapter 9 for information on how to create a selection outline.)

When you choose Selection Fill, you can select from several blend modes, as discussed in "Playing with Blend Modes," earlier in this chapter. If you choose Normal, you get a yucky, unnatural solid blob of color, as in the top-right image in Color Plate 10-5. You get the same result if you simply paint on the color using the Brush tool.

But if you select the Color blend mode in the Selection Fill dialog box, the shadows and highlights of the original pixels are retained, so you wind up with a purple apple that really looks like a mutant apple, as in the bottom-left image in Color Plate 10-5. Mmm, I can just taste that thing covered with caramel and nuts, can't you?

You can achieve the same result by setting purple as your foreground color and then painting with the Brush tool on a new layer with the layer mode set to Color. See "Choosing Your Paint Colors," earlier in this chapter, for information on establishing the foreground color, and read "Putting your layers in the blender" in Chapter 11 for information on changing the blend mode of your layers.

The other blending options in the Selection Fill dialog box mix your original apple colors with your fill color in strange and sometimes delightful ways. For more on these blend modes, see Color Plate 10-3 and read "Playing with Blend Modes" earlier in this chapter. Or just try them out for yourself — you've done enough serious work today. haven't vou?

the Fill tool in most image-editing programs. This tool is a combination of the Color Wand tool and the Selection Fill command. When you click in your image with the tool, PhotoDeluxe selects an area of the image as if you had clicked with the Color Wand. If you click a red pixel, for example, all adjacent red pixels are selected. (See "Color Wand tool" in Chapter 9 for more information about how the Color Wand works.) Then the selected area is filled with the color, just as if you had chosen Effects⇔Selection Fill. The fill color is set via the Color Change palette, shown in Figure 10-15, which appears when you choose the Color Change tool.

Figure 10-15:
To set the color applied by the Color Change tool, click the Color icon.

To change the fill color, click the Color icon in the Color Change palette. You get the Color Picker dialog box, where you can select a color, as explained earlier in this chapter in "Choosing Your Paint Colors."

You can adjust the opacity of the paint applied by the Color Change tool by pressing a number key — 1 for 10 percent opacity, 2 for 20 percent, and so on — just as you can when using the Brush tool. You can also adjust the sensitivity of the tool by changing the Tolerance value in the Cursors dialog box. Press Ctrl+K (\Re +K on the Mac) to open the dialog box. If you use a low Tolerance value, pixels must be closer in color to the pixel you click in order to be selected and filled. Figure 10-16 shows the results of clicking the interior of the apple from Color Plate 10-5 with the fill color set to white, the Tolerance value set to 32, and the opacity set to 100 percent.

I'm not fond of the Color Change tool because the results are too unpredictable. You don't have a good way of knowing in advance how much of your image will be filled. Had I clicked just a few pixels to the left or right in Figure 10-16, a totally different region of the apple would have been painted white. For better results, select the area you want to fill manually, using the selection tools described in "Strap on Your Selection Toolbelt" in Chapter 9. Then use the Selection Fill command or the Brush tool to paint the selection. As far as I'm concerned, the only reason to use the Color Change tool is to fill your entire image with color — for example, to give your image a blue background. Even then, you can just as easily press Ctrl+A (%+A on the Mac) to select the entire image and then use the Selection Fill command.

Figure 10-16:
The results
of clicking
with the
Color
Change tool
using a
Tolerance
value of 32,
100 percent
opacity, and
a white fill
color.

✓ Another way to shift colors is to select the area you want to alter and then choose Quality → Hue/Saturation, which opens the Hue/Saturation dialog box, shown in Figure 10-17. Drag the Hue slider to shift the pixels in the selection around the color wheel. In Color Plate 10-5, I dragged the slider to −83.

Figure 10-17: Spin pixels around the color wheel in the Hue/ Saturation dialog box.

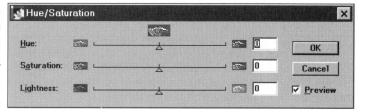

The color wheel is nothing more than a circular graph of available hues. Red is located at the 0-degree position on the circle, green at 120 degrees, and blue at 240 degrees. When you drag the Hue slider, you send pixels so many degrees around the wheel. If you start with green, for example, and drag the slider to +120, your pixel becomes blue. Green is located at 120 degrees, so adding 120 degrees takes you to 240 degrees, which is where blue is located.

As you can see in Color Plate 10-5, shifting your colors using the Hue/Saturation command has different results than using the Color blend mode. With the Color mode, all pixels are filled with the same hue — in

the apple, for example, you get lighter and darker shades of purple, but the basic color is purple throughout. Dragging the Hue slider, by contrast, shifted the red apple pixels to purple but shifted the yellowish-green areas near the center of the fruit to light pink.

You can open the Hue/Saturation dialog box in a jiffy by simply pressing Ctrl+U (\mathbb{H}+U on the Mac).

- ✓ If you want to move further away from reality and further into the realm of digital art, apply the Hue/Saturation command to your entire image, thereby shifting all colors around the color wheel. Press Ctrl+D (ૠ+D on the Mac) to deselect all pixels or Ctrl+A (ૠ+A) to select them all either has the result of applying the command to the entire image. The top-right image in Color Plate 10-6 shows what happened to my original sunset image (top-left image in Color Plate 10-6) when I set the Hue value to −29 and raised the Saturation value to +10.
- ✓ To really mess with your pixels' minds, apply the Effects➪ Stylize➪ Solarize or Effects➪ Negative command to your image, as I did in the bottom examples in Color Plate 10-6. These commands play with the colors in your image in ways that I won't even attempt to explain just try them out when you're in an artistic mood.

Don't forget that you can create additional effects by copying your image to a new layer, applying the Negative or Solarize filter to the copy, and then applying the various layer blend modes. For example, try applying the Negative filter to the new layer and then using the Color or Difference layer blend mode. You can read all about layers and layer blend modes in "Uncovering Layers of Possibility" in Chapter 11.

Painting Words on Your Image

Using the Text tool, you can add clever captions and other text to your image, as I did in Figure 10-18. Unfortunately, the PhotoDeluxe Text tool isn't very flexible. You can't make your text transparent so that some of your image shows through the words. Text is always fully opaque and resides on the top layer of your image. Nor can you select the text and fill it with an image or pattern, as you can in some other image editors.

Actually, you can do *all* those things, but you have to take a somewhat indirect approach. By default, the Text tool has all the limitations just mentioned. But by using the workaround method described in the upcoming "Creating special text effects" at the end of this section, you can give the Text tool new flexibility.

Creating ordinary text

To create text, you can choose Tools Text. But for quicker access to the Text tool, click the T button in the image window (labeled in the upcoming Figure 10-20) or press Ctrl+T (%+T on the Mac). The Text Tool dialog box shown in Figure 10-19 appears.

Figure 10-18: To create this shadowed text effect. I created two separate text blocks, one white and one black. Then I dragged the white text slightly up and to the right of the black text.

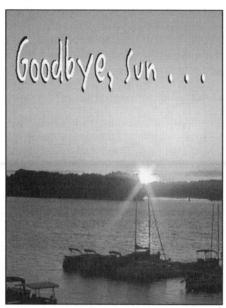

Figure 10-19: The Text Tool dialog box is your headquarters for creating captions.

Text Tool		Þ
Type your text in the box below:		
Goodbye, Sun	Eont: LitterboxICG	Ŧ
100018 ye ; 7011	Alignment	ОК
		Cancel
		Cancer
	Color:	

Click in the white box on the left side of the dialog box and then type your text. If you're working on a PC, press Enter to create a line break, just as you would in a word processor. On a Mac, press Return.

Select the font (type face) you want to use from the Font drop-down list. To specify how you want multiple lines of text to align, click one of the alignment radio buttons. For example, if you enter three lines of type, you can center them one above the other by clicking the middle radio button in the top row of buttons. The bottom three Alignment options reorient your text so that words are placed vertically on the page instead of horizontally. For example, if you add the word *Go*, the *G* appears above the *o* on the page instead of to the left of the *o*.

The Color icon indicates the text color. To change the color, click the icon and choose a new color from the Color Picker dialog box, as explained earlier in "Choosing Your Paint Colors."

After you finish entering your text, click OK to apply the text to your image. The text is placed in a text box and selected, as shown in Figure 10-20.

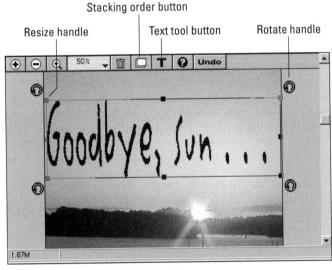

Figure 10-20:

Drag the resize or rotate handles to stretch, squish, or spin your text.

In PhotoDeluxe, all text is placed on a separate layer from the rest of the image, which means that you can resize, reshape, and rotate your characters independently of the underlying image. Drag the resize and rotate handles (labeled in Figure 10-20) to adjust your text as follows:

- Drag inside the text box to move the text.
- ✓ Drag the top or side resize handles to stretch the text in one dimension, thereby distorting the text. To retain the text's original proportions as you resize, drag a corner handle instead.
- Drag a rotate handle to spin the text around on the page.

Note that because of the way PhotoDeluxe creates text, you don't have to worry about affecting the sharpness of your text when you resize or rotate it as you do when editing the rest of your image. You can stretch, squeeze, or otherwise adjust your text without doing any damage.

When you have the text where you want it, click outside the text box to deselect the text. If you later need to reposition or resize the text, select the Object Selection tool from the Selections palette and click the text. To edit the text itself — for example, to correct a misspelling — or to change the color or alignment, double-click the text. The Text Tool dialog box reopens, and you can then alter your text as if you were creating it for the first time.

You can create as many different blocks of text as you like. All text blocks are placed on the same layer, called the Text layer, which always resides at the top of the image. For more about layers, see "Uncovering Layers of Possibility" in Chapter 11. To create the shadowed text effect in Figure 10-18, I created the text first in black and then created a duplicate in white. I then dragged the white text block up and to the right of the black text.

When you stack text blocks on top of each other as I did in Figure 10-18, you can reorder the text by clicking the text with the Object Selection tool and then choosing any of the four commands at the bottom of the Select menu: Send To Back, Bring To Front, Bring Forward One, and Send Back One. (You can access these same commands by clicking the Stacking Order button in the image window, labeled in Figure 10-20). Select Send to Back brings the active text layer to the back of the stack, for example, while Send Back One sends the layer back one position in the stack. You can't reorder the text layer with respect to other layers in the image, however.

To get rid of a text block, click it with the Object Selection tool and press Delete. The Text layer remains even when you delete all text on the layer (or never add any text to your image in the first place).

Creating special text effects

As mentioned earlier, the Text tool in PhotoDeluxe creates solid, rather uninspired text by default. The text always resides on the top layer of the image and is always fully opaque. But by taking a different approach to creating your text, you can create some special text effects. You can fade the text so that it is partially transparent, blend the text with the underlying image pixels using layer blend modes, fill your text with a pattern, and even apply special distortion or color effects just to the text and leave the rest of the image untouched.

The following steps contain the secret recipe for adding these fancy text effects to an image. Thanks to my astute technical editor, Anne Taylor, for figuring out this technique:

1. Create a new image that's the same size and resolution as the one to which you want to add some spiffy text.

First, check the size and resolution of the original image in the Photo Size dialog box (Size⇔Photo Size). Then choose File⇔New and enter those same values in the New dialog box.

2. Create your text in the new image.

Add the text as described in the preceding section. Size the text to the approximate size you want it to be in your final image. Also, make sure that you don't have any typos — you won't be able to go back and fix the text later.

3. Save the new image as a TIFF file.

In PhotoDeluxe, that requires choosing File⇔Send To⇔File Format. You now have an image that contains only text. And because the TIFF format flattens the image, the background layer and the text layer of your image are smashed into one, which is what you need for this particular creative endeavor. PhotoDeluxe no longer thinks of your text as being separate from the rest of the image.

4. Close the new text image and then open the TIFF version.

You need the TIFF version of your text image, not the one that's onscreen, which is still in the PhotoDeluxe format.

5. Select the text.

Use the Color Wand to select the background first. Set the tool tolerance to 0 so that you don't grab any text pixels at all. Be sure to select all the background areas — if your text includes the letter O, for example, select the interior of the O as well as the exterior. After the background is completely selected, press Ctrl+I (\mathbb{H}+I) to invert the selection so that your text is selected instead of the background.

6. Copy the text to the Clipboard.

Press Ctrl+C ($\Re+C$) to do the job in a flash.

7. Click anywhere in the original image window.

This image is the one to which you want to add the text. Clicking the image window makes the image active again.

8. Paste the text into the original image.

Press Ctrl+V (%+V) to do it quickly. Your text is pasted onto your image and sent to its own layer. But unlike the official Text layer you get by default when you create an image in PhotoDeluxe, this text layer is just

like any other layer. You can change the text opacity by double-clicking the text layer and changing the Opacity value in the Layer Options dialog box, for example. And you can blend the text with the underlying image using the Blend modes in that same dialog box.

You can also fill your text with a pattern. Just select the text and then fill it using the Effects Selection Fill command as you would any other selection. You can even apply special effects commands just to the text. For example, you can apply one of the color-shifting effects discussed earlier in this chapter.

If you need to reposition or resize the text, click it with the Object Selection tool to display the standard rotate and resize handles. (See "Moving, resizing, and rotating layers," in Chapter 11, for help.) But try not to resize the text too much. Because the text now lives on an ordinary layer, not the special PhotoDeluxe Text layer, resizing and rotating it can cause your characters to get a little jaggedy.

Note that you can rearrange the order of the new text layer if you like to create different effects. Just drag the layer up and down in the Layers palette, as explained in "Uncovering Layers of Possibility" in Chapter 11. And if you ever want to get rid of the text, just delete the layer on which it lives.

Chapter 11

Unleashing Your Creative Genius

In This Chapter

- Creating multilayered images
- Using blend modes to combine images in special ways
- > Adjusting layer opacity and stacking order
- Converting a color image to grayscale
- ▶ Colorizing grayscale images to create an antique photograph effect
- Twisting and stretching your image
- Creating a perspective effect
- Adding fluffy clouds to an overcast or colorless sky
- ▶ Distorting reality using special effects filters
- Turning a lousy image into art through creative editing

For the most part, the first three chapters in this part of the book discuss ways to enhance reality — to tweak color balance or brightness, for example, or correct for other flaws you either didn't notice when you snapped the picture or had no way to change.

In this chapter, however, all restraints of the real world are lifted. In the pages to follow, you explore ways to distort reality to the extent that you wouldn't recognize it if it came up to you and rapped your mouse-clicking paw with a ruler. You find out how to take several pictures and combine them into a multilayered collage like the one in Color Plate 11-2, for example. You also discover ways to use special-effects filters to take an image that's poorly focused, too dark, and wholly unusable and turn it into a colorful piece of art that has no resemblance to the original picture. You even get the top-secret recipe for replacing a flat, colorless sky with a sea of blue, dotted with fluffy white clouds.

Most importantly, this chapter explains how to use layers in order to give yourself additional editing flexibility as well as to protect yourself from editing slip-ups. After you get acquainted with layers, you'll wonder how you ever got anything done without them.

Remember that although the specific commands and tools I reference in this chapter are found in Adobe PhotoDeluxe 2.0, you can find similar features in most image editors. So if you use an image editor other than PhotoDeluxe, read the pages to come for inspiration and for information on the general editing approach to take when completing the various projects discussed. Then consult your program's manual or on-line help system for the details you need to adapt the steps presented in this chapter to your software.

Uncovering Layers of Possibility

If you really want to exploit the full capabilities of PhotoDeluxe, you need to acquaint yourself with the concept of image *layers*. The same is true of any image editor that offers layers, as most do these days.

To understand how layers work, think of those transparent sheets of acetate that people use to create transparencies for overhead projectors. Suppose that on the first sheet of acetate, you place a birdhouse. On the next sheet, you draw a bird. And on the third sheet, you add some blue sky and some green grass. If you stack the sheets on top of each other, you see the *composite image* — the elements of all three sheets merged together.

When you look at the composite image, the bird, birdhouse, and scenic background appear as if they are all part of the same picture. But the images in fact exist independently of each other. If you draw a worm on the birdhouse sheet, you in no way alter the sky/grass sheet or the, er, bird sheet (sorry, no play on words intended there — but I like to leave 'em in when they occur naturally, don't you?).

By shuffling the order of the sheets, you can alter the picture. For example, assume that your sky and grass images consume the entire sheet on which you drew them, and that both images are fully opaque (you can't see anything through them). But imagine that on the bird sheet, the only opaque area is the bird — the rest of the sheet is transparent. If you place the bird sheet (sorry, there I go again) on top of the sky/grass sheet, you see a bird against a sky/grass background. But if you put the sky/grass sheet on top of the bird, er, page, the bird image is completely obscured by the sky and grass.

Getting the picture? Good, because layers in a digital image work just like those acetate sheets. You can do anything at all to the pixels on one layer of your image without affecting the pixels on the other layers one whit. This aspect of layers makes them an invaluable editing tool because it enables you to edit freely without worrying about harming your image.

As long as you do your work on a separate layer, you can't damage the rest of the image. Furthermore, if you don't like the changes you make, you can remove the entire layer and start fresh — just as easily as you can throw an acetate transparency sheet away if you muck that up. You can also use the Eraser tool to rub away your edits, as discussed in "Brushing on Transparency" in Chapter 10.

You can create as many layers as you need to hold the various elements of your image. You can add and delete layers at will. And you can reorder layers to change how your image elements stack up on each other, just as you can shuffle those antiquated sheets of acetate. By rearranging your layers, you can create totally different images using the same layers, as shown in Figure 11-1.

In the left image, the metal Scotty dog occupies the top layer, his ceramic pal the next layer down, and the forest background brings up the rear. In this arrangement, Scotty jumps up and down in front of his ceramic pal, who is intently listening to some commotion in the distance. In the right image, I switched the order of Scotty and the ceramic canine, affectionately named Puppydog, so that Puppydog appears to be taking a ride on Scotty's back. Regardless of which layer arrangement is used, both animals remain completely oblivious to the dangers presented by the killer rabbit in the background forest layer.

Figure 11-1:

By
rearranging
the layers in
the original
image (left),
I gave
Puppydog a
ride on
Scotty's
back (right).

In addition to providing you with editing flexibility, layers also offer some creative possibilities that your run-of-the-mill acetate sheet does not. You can choose different blend modes to mix the pixels in one layer with those in the underlying layer in strange and unearthly ways, as discussed in the upcoming "Putting your layers in the blender." And as explored in "Fading layers in and out," you can also adjust the transparency of the pixels on a layer, so that more or less of the underlying image is visible.

The following sections provide you with an introduction to the many aspects of creating and editing multilayered images. I urge you to spend some time exploring the techniques presented here — they'll increase your image-editing abilities and creative output tenfold.

Editing a multilayered image

By default, all images start life with two layers. To view layer information. choose View[□]Show Layers to display the Layers palette, shown in Figure 11-2 and discussed in detail in the next section.

The bottom layer, given the unassuming name of Layer 0 in the Layers palette, holds your initial image pixels. When you first open an image, for example, all pixels in the image are placed on Layer 0. The top layer, called Text, is reserved for any text you create using the Text tool. (See "Painting Words on Your Image" in Chapter 10 for details about creating and editing text.)

At all times, your edits affect only the active layer, which is the layer whose name is highlighted in the Layers palette. The exception is when you paste a selection from the Clipboard, which creates a new layer and places the pasted pixels on that layer. (See "Cut, Copy, Paste: the old reliables" in Chapter 9 for the heady details about this process.)

To activate a layer, you simply click its name in the Layers palette. After activating a layer, you can perform all of these exciting moves:

- Apply paint using any of the painting tools discussed in Chapter 10. The effects of your paint tool reach only as far as the boundaries of the active layer, and no further.
- ✓ Apply image correction commands, such as the Brightness/Contrast command. Any command you apply affects the pixels on the active layer only.
- ✓ Rub a hole in the layer by using the Eraser tool, as described in "Brushing on Transparency" in Chapter 10. If you're erasing on the bottom layer of the image, you reveal the transparent canvas that lies behind every image. If you're working on another layer, you reveal the pixels in the underlying layer.

- Remember that you can vary the opacity of the Eraser by pressing a number key (1 for 10 percent, 2 for 20 percent, up to 0 for 100 percent).
- ✓ Another way to get rid of pixels on a layer is to select them and then press Delete. As when dragging with the eraser, you wind up with a transparent hole in the layer where the selection used to be. For help in creating selections, see Chapter 9.
- Speaking of selections, keep in mind that your selection outline is a separate entity and not permanently linked to the active layer. So if you create a selection outline on one layer and then make another layer active, the selection outline is transferred to the newly active layer.

You can quickly copy the contents of a layer to another image by using this method: Open both images and place them side by side on-screen. Click the title bar of the image that contains the layer you want to copy. Then drag the layer name from the Layers palette directly onto the other image window. The copied layer is added directly above the active layer in the second image, using the same layer name, blend mode, and opacity setting as in the original image.

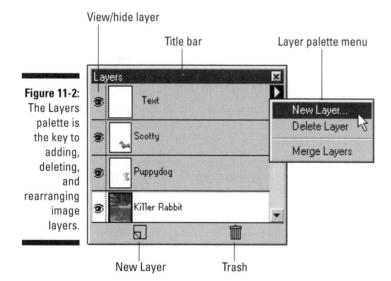

Navigating the Layers palette

To view, arrange, and otherwise manipulate the layers in your image, choose View

Show Layers to display the Layers palette, shown in glorious living grayscale in Figure 11-2. To put the palette away, choose View

Hide Layers or click the Close button in the palette title bar. Drag the title bar to move the palette to a different location on-screen.

As labeled in Figure 11-2, the Layers palette contains several key tools for working with layers:

- ✓ Each layer in the image is listed in the palette. To the left of the layer name is a thumbnail view of the elements on that laver.
- ✓ As mentioned in the preceding section, only one layer at a time is active — that is, available for editing. The active layer is the one whose name is highlighted in the Layers palette. To make a different layer active, click on its name in the palette.
- ✓ The eyeball icon to the left of the thumbnail indicates whether the layer is visible in the image window. Click the icon to hide the eyeball and thus hide the layer from view. Click again in the eyeball column to redisplay the eyeball and layer.
- ✓ To hide all layers but one, Alt+click on the eyeball next to the layer you want to see. (Option+click on the Mac.). Alt+click (Option+click) again to redisplay all layers.
- ✓ When you print your image, only visible layers are printed.
- Click the New Layer icon to add a layer to your image. For more about adding layers, see "Adding and deleting layers," a few brief paragraphs from now.
- ✓ Drag a layer from the palette to the Trash icon to delete the layer. Or click the layer name and then click the Trash icon. Read "Adding and deleting layers," now just around the corner, for more information.
- ✓ Drag a layer up or down in the palette to rearrange the layer's order in your image. Details on this juicy topic are found in "Shuffling layers," also just several notches away on your FM dial.
- Click the right-pointing arrow at the top of the palette to display a small pop-up menu of commands related to layers. The only reason to display this menu is to choose the bottom command, Merge Layers, however. You can choose the New Laver command and Delete Laver command more quickly by clicking on the New Layer and Trash icons at the bottom of the palette.

Adding and deleting layers

When you need to add or delete a layer, the New Layer and Trash icons at the bottom of the Layers palette make quick work of the job. Here's how to use these helpful tools:

✓ To add a new layer, click the New Layer icon. (You can also click the right-pointing arrow at the top of the palette to display the Layer palette menu and then choose New Layer from the menu, but why would you want to when clicking the icon is so much less work?)

✓ Clicking the New Layer icon displays the New Layer dialog box, shown in Figure 11-3. Here, you can give your layer a name (enter the name in the Name option box), set the layer opacity, and choose a layer blend mode. You can change all three options later by double-clicking the layer name in the Layers palette, which displays the Layer Options dialog box. That dialog box is the New Layer dialog box operating under an assumed name.

Figure 11-3:
You can
give your
new layer a
name and
set the
blend and
opacity
options
in this
dialog box.

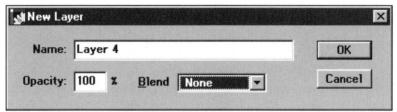

- If you want to create a new layer without messing with the New Layer dialog box, Alt+click the New Layer icon (Option+click on the Mac). PhotoDeluxe gives you a new layer using the default layer options settings (normal blending and 100 percent opacity). Your layer is assigned a number, such as Layer 3, depending on how many layers you already have.
- ✓ To copy the contents of one layer and place them on a new layer, drag the layer you want to copy onto the New Layer icon.
- Regardless of how you go about adding the layer, it is positioned directly above the layer that was active when you clicked the New Layer icon.
- ✓ To delete a layer, drag the layer name to the Trash icon in the Layers palette. Or click the layer name to make the layer active and then click the Trash icon. Remember, though, you're not just deleting the layer, you're deleting all pixels on that layer. So be sure that you really want to dump those pixels before you send the layer to the trash.

✓ The more layers you add, the more you increase your image file size. So try not to overdo it on layers, and merge layers together whenever possible. For more information on this topic, see "Smashing layers together" later in this chapter.

Moving, resizing, and rotating layers

To reposition or resize the contents of a layer, click the layer name and then click on any painted pixel on the layer with the Object Selection tool. Don't click a transparent area of the layer, or you end up selecting a different Show Selections and then select the tool from the Selections palette.

After you click with the Object Selection tool, you see the resize and rotate handles, as shown in Figure 11-4. You can now scale, rotate, and move the layer contents as follows:

- ✓ Drag the square resize handles to enlarge or reduce the layer contents. Drag a top or bottom handle to scale the layer contents vertically: drag a side handle to scale horizontally. Drag a corner handle to retain the original proportions as you resize.
- ✓ Drag the rotate handles to make the pixels kick up their heels and spin themselves around on the image canvas. Press Shift as you drag to limit the rotation to 15-degree angles.
- ✓ To reposition the layer contents, drag inside the selection outline. Note that even if you drag so that part of the layer moves outside the boundaries of the visible canvas, the pixels beyond the canvas aren't deleted — just hidden. If you want to reveal them, just select the layer again with the Object Selection tool and drag the hidden pixels back into view.

- Moving the layer using the Object Selection tool can be difficult because if you click on a transparent pixel inside the selection outline, you end up moving the underlying layer instead. So, for a more surefire method, press Ctrl+G (\mathbb{H}+G on the Mac) to select the Move tool. Now your drag can affect the active layer only. In addition, you can nudge the layer contents into position by pressing the arrow keys on your keyboard. Press an arrow key once to nudge the layer one pixel; press Shift plus an arrow key to nudge the layer ten pixels.
- ✓ After you're finished rotating, resizing, or moving the layer contents, click outside the selection outline to complete your changes. Or, if the Move tool is active, select a different tool. Press Ctrl+Z (策+Z) or click the Undo button if things go horribly awry and you can't live with what vou've done.

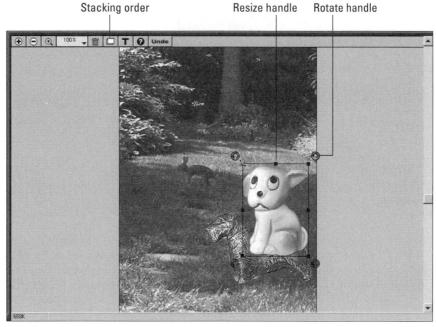

Figure 11-4:
Drag the resize and rotate handles to manipulate the contents of a layer.

✓ Remember that resizing and rotating image elements can damage your image quality. You can typically reduce your image without harm, but don't try to enlarge the image very much, and don't rotate the same layer repeatedly. For more on this subject, see "Resizing Do's and Don'ts" at the end of Chapter 8.

Shuffling layers

To reorder the layers in your image, just drag them up and down in the Layers palette, as shown in Figure 11-5. When you drag a layer from its original position, your cursor changes into a little clenched-fist cursor to show that PhotoDeluxe is holding onto your layer but tightly. The heavy black line that appears between the layer names indicates where the layer will be dropped if you release the mouse button.

You can also reorder your layers by clicking the layer you want to reposition with the Object Selection tool and then clicking the Stacking Order icon in the image window, labeled back in Figure 11-4. Clicking the icon displays a pop-up menu with four commands. Bring To Front sends the active layer to the front of the stack; Bring Forward One moves the active layer one notch up in the Layers palette and thus one step closer to the top of the image. I'm fully confident in your ability to figure out the other two commands, Send Back One and Send To Back, all by your lonesome.

Figure 11-5:
To move a layer up or down in the stacking order of the image, just drag the layer name in the Layers palette.

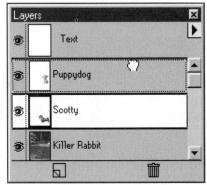

Sadly, the Text layer never gets to travel around the Layers palette like the other layers. In PhotoDeluxe, the Text layer always is the tippy-top layer in an image and can never be placed elsewhere. However, using the workaround technique explained in the last section in Chapter 10, you can create text on a regular old layer so that your text can enjoy the same freedom as other pixels in your image.

Fading layers in and out

As you can with fills created with the Selection Fill command, discussed in Chapter 10, you can vary the opacity of a layer. By lowering the layer opacity, you make the pixels on the layer partially transparent, allowing some of the pixels on the underlying layer to show through. Figure 11-6 shows how changing the opacity can lead to an entirely different image. This image contains two layers: One holds the rose image, and the other holds the marble image. In the left image, I placed the rose layer on top of the marble layer at 100 percent opacity. In the right image, I lowered the rose layer opacity to 50 percent, so that the rose now appears as a ghostly silhouette that almost appears to be part of the marble.

To set the layer opacity, enter a value in the Opacity option box in the New Layer dialog box when you first create a layer. (Read "Adding and deleting layers," earlier in this chapter, for more information.) Or, to change the opacity of an existing layer, double-click the layer name in the Layers palette to display the Layer Options dialog box (which is the same thing as the New Layer dialog box) and change the Opacity value there.

100% Opacity

50% Opacity

Figure 11-6: At left, the rose layer rests atop the marble laver at 100 percent opacity. At right, a 50 percent opacity setting makes the rose look like part of the marble.

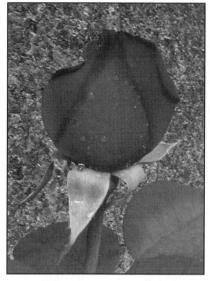

Putting your layers in the blender

Blend modes enable you to mix the pixels in one layer with those in the underlying layer in different ways. The blend modes available for layers are the same as those available when you use the Selection Fill command, discussed in "Playing with Blend Modes" in Chapter 10 and featured in living color in Color Plate 10-3. The only difference is that the Normal mode in the Selection Fill dialog box is called None when you're working with layers.

As when you use blend modes with the Selection Fill command, the layer blend modes affect how the colors in one layer mix with the colors in the underlying image. In fact, filling a selection on Layer A and blending it with the underlying Layer B using a particular layer blend mode gives you the exact same results as filling a selection on Layer B and selecting the same blend mode in the Selection Fill dialog box.

That didn't come out too smoothly, did it? Perhaps an example will help. Take a look again at Color Plate 10-3. To create the top right example, I opened the original lamb image, selected the entire image, and chose the Selection Fill command. I selected pink as the fill color and chose the Darken blend mode inside the Selection Fill dialog box. But I could have achieved the same result by opening the original lamb image, creating a new layer, setting the layer blend mode to Darken, and then filling the layer with pink using Normal as the blend mode in the Selection Fill dialog box. Get it?

If not, don't worry about it too much. The only reason I bring the subject up at all is that PhotoDeluxe doesn't offer blend modes for its Brush and Line tools, as some other programs do. But you can get around this problem by painting on a layer and then using the layer blend mode to blend your strokes with the underlying image.

So, to sum up: While the Selection Fill blend modes dictate how fill pixels mix with the pixels on the current layer, layer blend modes affect how the pixels in the current layer mix with those in the underlying image. But the formulas used to mix the pixel colors are the same.

You can establish the blend mode for a layer when you first create the layer by selecting an option from the Blend drop-down list in the New Layer dialog box, shown earlier in Figure 11-3. If you later want to change the blend mode, double-click the layer name in the Layers palette to display the Layer Options dialog box, which offers the same options as the New Layer dialog box. Select a different mode and click OK.

For a complete rundown of how each blend mode works, see "Playing with Blend Modes" in Chapter 10. Remember that you can vary the effect of each mode by varying the opacity value for the layer, as described in the preceding section.

Smashing layers together

The one drawback to using layers is that doing so increases the size of your image on disk and also requires more memory to process the image. So after you're happy with your image, you should smash all the layers together to reduce the file size — a process known as *flattening* or *merging* in image-editing parlance.

To flatten your image, choose Merge Layers from the Layers palette menu. All image layers are fused together, with the exception of the Text layer, which always remains separate from the rest of the image.

Remember that after you merge layers, though, you can no longer manipulate or edit the individual layer elements without affecting the rest of the image. So if you think you may want to do so in the future, save a copy of the image in the PhotoDeluxe native file format, PDD, or the Adobe Photoshop format, PSD. These are the only two file formats that can retain layer information. Saving to any other format automatically merges your layers together.

Building a multilayered collage

Layers are useful on an everyday editing basis, because they provide you with more flexibility and security. But where layers really shine is in the creation of image collages like the one in Figure 11-7.

To build this collage, I started with the original images shown in Color Plate 11-1 and Figure 11-8. I used the brick image as the background for the montage. Then I selected the subject of each of the other images, copied the selection to the Clipboard, and then pasted the selection into the brick image. In PhotoDeluxe, pasted selections are automatically placed on a new layer. Figure 11-9 shows you the order of the layers in the collage, while Color Plate 11-2 shows off the color version of the finished masterpiece.

When creating a collage, be sure that the Allow Multiple Document Windows option is checked in the File Preferences menu. This option enables you to have more than one image open at a time.

As you build your collage, don't be afraid to experiment. Play around with different blend modes, opacity levels, and image arrangements to see what's possible. Remember, you can always dump the contents of a layer and start fresh if you muck things up.

Figure 11-7:
This image actually started out as eight different images, combined through the magic of layers.

Figure 11-8: The images used to create the collage in Figure 11-7, shown in the order of their position in the collage.

Figure 11-9:
The Layers
palette from
the image in
Figure 11-8
shows you
the order
of the
individual
images in
the scene.

Working with multiple images and large images such as the one in Color Plate 11-2 puts a major strain on even the most hardy computer system. So be sure to save your collage at regular intervals so that you're protected in the case of a system breakdown. Saving your image also enables you to use the File⇔Revert to Last Saved command to return your image to the way it looked the last time you saved it to disk — the only way to undo a chain of editing mistakes in PhotoDeluxe. (See "Save Now! Save Often!" and "Editing Safety Nets," in Chapter 8, for more information on both topics.)

For the record, here's the process I used to create the collage in Color Plate 11-2:

- ✓ I opened the brick image and used the Size⇔Photo Size command to set the size and resolution for the image, as discussed in the section "Resizing Do's and Don'ts" in Chapter 8. This image was much larger than I needed for the finished product, so I reduced the image to the size you see in Color Plate 11-2 and Figure 11-7.
- ✓ I opened each of the other seven images and did whatever color correction and other touch-up edits were needed to get the images in good shape.
- ✓ One by one, I selected the portion of each image that I wanted to use in the collage. In every case but the elf, I selected the entire object, although you sometimes don't see the entire object in the finished collage (more on that later). To select the objects, I used a combination

of the Color Wand, SmartSelect, and other selection tools discussed in "Strap on Your Selection Toolbelt" in Chapter 9. To select the elf's head, I dragged around the area I wanted to use with the Trace tool.

As discussed in Chapter 4, in the section "Composing for Compositing," shooting your pictures with the end use of the image in mind can save you a good deal of time and trouble when you get to the editing stage. For example, I knew when I shot these images that I wanted to use them in a collage and would be cutting them out of their backgrounds. So I set up the pictures with that process in mind. I got as close as I could to each object so that the majority of the image pixels would be devoted to the subjects, not wasted on the background that I would be trimming away.

Additionally, I shot the objects against plain backgrounds, using background colors that contrasted with the subjects. I then was able to use the SmartSelect and Color Wand tools to select the backgrounds with relative ease. After selecting the background, I simply inverted the selection by pressing Ctrl+I ($\Re+I$), which selected the object and deselected the background.

- ✓ After selecting the portion of the image I wanted to use in the collage, I copied the selection to the Clipboard and then pasted it into the brick image. PhotoDeluxe pastes selections on new layers, so I ended up with eight layers when I was done with all my gluing. For more information on combining images in this way, see "Selection Moves (And Copies and Pastes)" in Chapter 9.
- Using the Object Selection tool, I repositioned and rotated the various elements of the collage, playing around with different compositions until I arrived at the final image. In a few cases, I scaled individual elements down slightly. (Remember, reducing a layer size is usually harmless; enlarging a layer very much usually does noticeable damage.) With the exception of the elf's head and the bottle stopper (that's that little guy in the bowler hat), I oriented the objects in a way that moved at least some of the original image outside the canvas area, as discussed earlier in "Moving, resizing, and rotating layers."
- ✓ To make the elf's head appear partially in front of and partially behind the iron, I put the elf layer under the iron layer. Then I used the Eraser tool to wipe away the iron pixels around the elf's ears and chin.
- ✓ When I got things just so, I selected the entire image and applied a black border by choosing the Effects⇔Outline command, as explained in "Adding a Border" in Chapter 10.
- ✓ I saved one copy of the image in the PhotoDeluxe native format so that I could retain the layers for further editing in case the mood to do some rearranging ever hit me. Then, because I needed to turn this image over to the folks in the IDG Books production department for printing, I chose the Merge Layers command from the Layers palette menu and saved the flattened image as a TIFF file. By flattening the image, I reduced the file size.

► For added effect, I converted the image to a grayscale image by using the Effects Color to Black/White command discussed in "Going Gray" later in this chapter. Then I created a new layer and filled that layer with a dark gold color. I set the layer blend mode to Color and set the layer opacity to 50 percent, resulting in the antique photograph look shown in Color Plate 11-3. That old-time atmosphere is perfect for the subject of this image.

Stretching Your Image Beyond Recognition

For a few laughs on a rainy day, play around with the Distort and Perspective commands, which enable you to stretch your image as if you were tugging on a piece of taffy:

- ✓ Choose Size Distort to slant your image or pull one or more corners out of alignment, as I did in Figure 11-10. When you choose the command, your image is surrounded by a solid selection outline sporting eight square handles, as shown in the figure. Drag a corner handle to distort the image, drag a side or top handle to slant the image. After you tug a handle, PhotoDeluxe displays a preview of how the image will look if you go forward with the transformation. (Be patient this process can take some time if you're working with a large image or using a slow computer.) To apply the transformation for good, click inside the selection outline. Press Esc anytime before you click to cancel the transformation.
- Choose Size

 Perspective to create a perspective effect by dragging two corners of your image in tandem, as I did in Figure 11-11. As with the Distort command, your image is surrounded by a solid selection outline and selection handles when you choose the Perspective command. If you drag one corner handle, the opposite corner handle moves as well. Click inside the selection outline to apply the effect; press Esc anytime before you click to get the heck out of Dodge and put away your perspective tools.

As you work with either command, keep these image-stretching rules in mind:

- If you select a portion of your image before you choose the Distort or Perspective command, only the selection is stretched.
- ► Before you click to set the transformation in stone, you can click Undo or press Ctrl+Z (ૠ+Z on the Mac) to undo your last handle pull.

Figure 11-10: By dragging the Distort handles (left), I slimmed down my friend, the toucan, considerably (right).

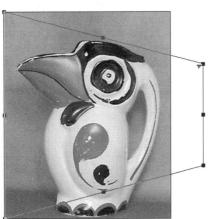

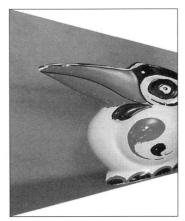

- ✓ If you don't see the selection border or handles after you choose the Distort or Perspective command, zoom out on your image. The handles are there; you just may not be able to see them if you're zoomed in too close.
- When you stretch or distort an image, some of the image may be moved outside the boundaries of the image canvas. As long as you save the image in the PhotoDeluxe format, the pixels outside the canvas are saved and available for later use. But if you save the image in any other file format, the out-of-bounds pixels are dumped. If you want your entire image to remain visible, use the Size

 Canvas Size command to enlarge the canvas, as explained in "Hey Vincent, Get a Larger Canvas!" in Chapter 8.

✓ To retain some semblance of clarity and quality in your image, do all your stretching and bending with just one pass of the Distort of Perspective command. Repeated applications of either effect have a serious negative impact on the image.

Twirling, Pinching, and Other Funhouse Effects

In addition to the Distort and Perspective commands, which give you manual control over how your image is distorted, PhotoDeluxe provides several pixel-stretching and shaping filters under the Effects: Distort menu. If you've chosen a different image-editing program, you can likely find similar effects in your program; consult your manual or on-line help system for information.

Digital imaging gurus like to refer to these commands as *filters*, by the way.

In Figure 11-12, my long-suffering toucan endures still more humiliation by being subjected to some of the more interesting distortion filters. In all cases, I applied the special effect to the entire image. If you don't select any portion of your image before applying a filter, the filter affects the entire image; if you have an active selection, only the selected pixels are changed.

Most of the special effects commands bring up a dialog box similar to the one in Figure 11-13, which is the dialog box for the Pinch filter. You typically can preview the effects of the filter in the small preview box at the top of the dialog box. Click the plus and minus buttons to zoom in and out on your image. The other options in the dialog box enable you to vary the effects of the filter.

Original

Pinch

Sphere

Pond Ripple

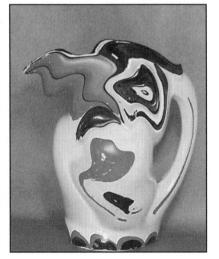

Figure 11-12:
A normally calm and collected bird (top left) gets all bent out of shape after applications of the Pinch, Sphere, and Pond Ripple filters.

To create even more variations on a filter, copy your image to edit to a new layer (by dragging the image layer to the New Layer icon in the Layers dialog box). Then apply the filter and experiment with different layer blend modes and opacity values. See "Putting your layers in the blender" and "Fading layers in and out," both earlier in this chapter, for more information on blend modes and layer opacity.

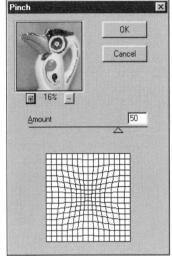

Figure 11-13:
Most special
effects
filters
display a
dialog box
that enables
you to adjust
and preview
the effect.

If you want to go beyond mild distortion and completely eradicate any semblance of your original image, give the Twirl and Funnel filters a try. In the left image in Figure 11-14, I sent the toucan spinning by applying the Twirl filter and setting the Amount value in the Twirl dialog box at 745. In the right image, I applied the Funnel filter, choosing the Rectangular to Polar option in the Funnel dialog box.

Figure 11-14:
The Twirl
(left) and
Funnel
(right) filters
applied to
the original
toucan
image from
Figure 11-12.

Going Gray

Consumer-level digital cameras always shoot color images — you can't shoot in black-and-white as you can with a film camera. But you can easily convert your image to a black-and-white image inside most any image editor.

Black-and-white images are commonly known as *grayscale* or *monochrome* images in the digital world.

To convert a color image to grayscale inside PhotoDeluxe, choose Effects Color to Black/White or just press Ctrl+0 (第+0 on a Macintosh computer). All color is sucked out of your image, but the original brightness and contrast of the image is retained.

After you convert an image to gray, you can't return to the color version (unless you choose Undo immediately after making the conversion). So be sure to save a color copy of the image before you choose the Color to Black/White command if you think you may want to see the image in living color sometime in the future

PhotoDeluxe does its grayscale conversions a little differently than many image editors. When you choose the Color to Black/White command, you don't change the color mode of the image itself — you create an RGB image in which the saturation of the colors has been completely drained, creating a grayscale effect. You could get the same result by choosing Qualityr → Hue/Saturation and dragging the Saturation slider all the way to −100. This conversion approach has a few important implications:

- ▶ Because you're still working with an RGB (color) image, you can paint colors onto your grayscale image and apply other color effects. One popular use of this function is to colorize a grayscale image, as I did in Color Plate 11-3. Just use the Selection Fill command to apply the color, using the Color blend mode and whatever opacity value suits your fancy. (See "Pouring Color into a Selection" and "Playing with Blend Modes," both in Chapter 10, for more details on using the Selection Fill command.)
- ✓ If you cut and paste a full-color selection from another image into your black-and-white image, the selection retains all its color.
- ✓ For special effects, you can make part of your image gray and leave the colors intact in the rest of the image. Just select the portion you want to convert to grayscale before you choose the Color to Black/White command.

✓ If you're going to export the image for use in another program — Adobe PageMaker, for example — and you need a true grayscale image, choose File⇔Send To⇔Grayscale File. You then get the Export dialog box, a variation of the Save dialog box, discussed in "Save Now! Save Often!" in Chapter 8. But when you click the Save button, your file is converted to a real grayscale image.

Inventing Clouds

When I first began working with image-editing software, I was *amazed* at how easy it was to alter reality. Even as a rank amateur, I could make portions of an image disappear, change an original color to something more pleasing, and even combine two images so successfully that you would swear they were always part of the same scene.

In addition to the painting and editing tools that enable you to create an entirely new version of an image, many image editors offer tools for adding color and texture where none existed before. One of my favorite effects in this category is the Clouds filter, found both in Adobe Photoshop and its younger sibling, PhotoDeluxe.

Located in the Effects⇔Render submenu in PhotoDeluxe, the Clouds filter creates a random pattern of clouds, where the cloud color is the background color and the "sky" is the foreground color. You can use the filter to create special effects, of course, but I often use it to replace a dull, hazy sky with something more picturesque. Color Plate 11-4 and Figure 11-15 offer an illustration. I set the background color to white, the foreground color to blue. Then I selected the sky area and choose the Clouds command. Voilà — instant scenic sky.

To create variations on the effect, try these options:

- Press Shift as you choose the Clouds command to create a more stark cloud pattern.
- ✓ To create a demons-walk-the-earth effect, choose the Merge Clouds command from the Effects⇔Render submenu. This command creates an inverted effect similar to what you get when you fill a selection using the Difference blend mode.

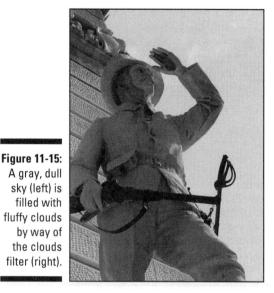

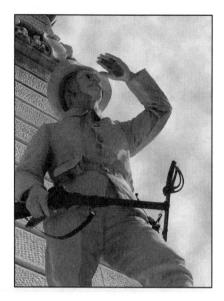

Mind you, I'm not saying that the Clouds pattern creates a wholly realistic sky. Anyone who's familiar with image editing can probably discern a real sky from a computer-generated one. But for the time being, you probably are one of the few folks in your circle of friends who even knows what a Cloud filter is, so go for it. After all, you didn't get into image editing to leave reality intact, did you?

But, Your Honor, I didn't know it was illegal!

Having encouraged you at several points in this chapter to completely abandon reality when editing your images, I feel compelled to say something about truth in advertising and other ethical issues. If you're preparing an image that will be used to sell goods or otherwise purports to illustrate the real world, you can't just go adding fake clouds and other enhancements willy-nilly. Well, I guess you

can if you don't have a conscience and do have a really good lawyer, but I certainly don't recommend the practice. That kind of behavior can get you in serious trouble, not only with clients who expect your products to be as shown in your pictures, but also with the legal system, which believes in this little thing known as truth in advertising.

Turning Garbage into Art

Sometimes, no amount of color correction, sharpening, or other editing can rescue an image. The top-left image in Color Plate 11-5 and Figure 11-16 is an example. I shot this city skyscape just past sunset, and I knew I was pushing the limits of my camera. Just as I feared, the image came out very grainy due to the low lighting conditions.

After trying all sorts of corrective edits, I decided that this image was never going to be acceptable in its "real" state. That is, I wasn't able to capture the scene with enough detail and brightness to create a decent printed or onscreen image. Still, I really liked the composition and colors of the image. So I decided to use the image as a basis for some digital creativity.

Original

Glowing Edges

Colored Pencil

Crystallize

Figure 11-16:

I applied three different special effects filters to turn my overly dark, grainy original image into something more interesting.

By applying different filters found in the Effects menu, I created the three other images in Figure 11-16 and Color Plate 11-6. Here are the filters and settings I used:

- ✓ To create the top-right image, I applied the Effects⇔Artistic⇔Colored Pencil filter. Inside the Colored Pencil dialog box, I set the Pencil Width value to 6, the Stroke Pressure value to 6, and the Paper Brightness value to 31.
- ✓ To turn my cityscape into the neon capital shown in the bottom-left image, I applied the Effects⇔Stylize⇔Glowing Edges filter. I used an Edge Width value of 5, an Edge Brightness value of 7, and a Smoothness value of 8.
- ✓ To create the effect in the bottom-right image, I turned to the Crystallize filter, found in the Effects⇔Pixelate submenu. Using a Cell Size value of 74 completely destroyed all image detail, leaving me with a colorful pattern that I would never have imagined on my own.

In just a few seconds, I was able to take a lousy image and turn it into an interesting composition. And the images in the figure and color plate are just the beginning of the creative work you can do with an image such as this. You can combine different filters, play with layering and blend modes, and use any of the other editing tricks discussed throughout this chapter and the others in this part of the book to create colorful, inventive artwork.

In other words, the artistic possibilities you can achieve with digital images aren't limited to the scene you see when you look through the viewfinder or place a photograph on a scanner. Nor are you restricted to the image that appears on your screen when you first open it in your image editor. So never give up on a rotten image — if you look hard enough, you can find art in them there pixels.

Part IV The Part of Tens

The 5th Wave By Rich Tennant

"...and now, a digital image of my dad trying to cheat on his income tax return."

In this part . . .

ome people say that instant gratification is wrong. I say, phooey. Why put off until tomorrow what you can enjoy right this minute? Heck, if you listen to some scientists, we could all get flattened by a plunging comet or some other astral body any day now, and then what will you have for all your waiting? A big fat nothing, that's what.

In the spirit of instant gratification, this part of the book is designed for those folks who want information right away. The three chapters herein present useful tips and ideas in small snippets that you can rush in and snag in seconds. Without further delay. *Now*, darn it.

Chapter 12 offers ten techniques for creating better digital images; Chapter 13 gives you ten suggestions for ways to use your images; and Chapter 14 lists ten great Internet resources for digital photographers.

If you like things quick and easy, this part of the book is for you. And if instant gratification is against your principles, you may want to . . . look up! I think that big, black ball in the sky is an asteroid, and it's headed this way!

Chapter 12

Ten Ways to Improve Your Digital Images

In This Chapter

- Capturing the most pixels
- Choosing the optimum compression setting
- Composing a scene for maximum impact
- > Shedding some light on the subject
- Avoiding "shaky" images
- Acquiring a digital perspective
- Correcting flaws inside your image editor
- Choosing paper for the best quality output
- Shooting more images than you need
- Paying attention to the manufacturer's instructions

igital cameras have what marketing pundits like to call a high "wow" factor. That is, if you walk into a room full of people and casually start snapping pictures with your digital camera, just about everyone in the room will say, "Wow!" and ask for a closer look. Oh sure, one guy will undoubtedly look unimpressed and even make a few snide remarks, but that's just because he's secretly jealous that you managed to sneak up unnoticed and kick his keister in the who's-got-the-latest-and-greatest-technology game.

Sooner or later, though, people will stop being distracted by the whiz-bang technology of your camera and start paying attention to the quality of pictures you turn out. And if your images are poor, whether in terms of image quality or photographic composition, the initial "wows" turn quickly to "ews," as in "Ew, that picture's *terrible*. You'd think after spending all that money on a digital camera, you could come up with something better than *that*."

To keep you from suffering that particular humiliation (sorry, can't do anything about other humiliations that may be coming your way), this chapter presents ten ways to create better digital images. If you pay attention to these guidelines, your audience will be as captivated by your pictures as they are by your shiny new camera.

Remember the Resolution!

With digital pictures, image quality is directly related to the number of image pixels per inch — known as the image *resolution*. The more pixels you have, the higher the resolution, and the better the image quality.

If your camera enables you to select from different resolution settings, always choose the highest setting. You won't be able to fit as many pictures in the camera's memory because more pixels also means larger file sizes. But the hassle of downloading pictures to your computer is well worth the improvement you see in your images.

When editing your pictures, remember that when you enlarge or reduce the size of an image, you affect the resolution. In most image editors, you can choose to maintain the current number of pixels when you resize images, so that resolution goes up as you reduce the image size and goes down as you enlarge the image. Keep in mind that pixels shrink when you reduce the image size in this fashion, and they get bigger when you enlarge the image. If you enlarge the image too much, your image can take on a blocky look because the individual pixels become noticeable.

Alternatively, you can specify that you want the current resolution maintained when you resize the image, in which case the image editor adds new pixels when you enlarge the image and dumps excess pixels when you reduce the image. Even sophisticated image-editing software doesn't do a great job of making up pixels, so avoid this option whenever possible.

For the complete lowdown on resolution and resizing images, see these sections: "Resolution Rules" in Chapter 2; "You Say You Want a Resolution" in Chapter 3; and "Resizing Do's and Don'ts" in Chapter 8.

Don't Overcompress Your Images

While some digital cameras offer a choice of resolution settings, others enable you to select from several *compression* settings. To compress a file is to mash all the image data together so that it takes up less room on disk or in the camera's memory.

In most cases, camera compression settings have quality-related names — Best, Better, Good, for example, or Fine and Normal. That's appropriate because compression affects image quality. Most digital cameras use *lossy* compression, which means that some of the image data is sacrificed in order to shrink the file size.

The more compression you apply, the lower the image quality. So for the best-looking images, always shoot your pictures using the highest quality setting, which applies the least amount of compression. Of course, less compression means larger file sizes, so you can't fit as many images in the camera's memory as you can at a lower-quality setting. But this chapter is about increasing your image quality, not about reducing the number of times you need to download your images during a day of shooting, right?

Compression is also an issue to consider when saving your images after editing them. Some file formats, such as JPEG, apply lossy compression during the save process, while others, such as TIFF, use *lossless* compression. With lossless compression, your file size isn't reduced as much as with lossy compression, but you lose virtually no image data.

To find out more about compression, check out "The Great Compression Scheme" in Chapter 3; "File Format Free-for-All" in Chapter 5; and "JPEG: The photographer's friend" in Chapter 7. Also see Color Plate 3-2 for a look at what different amounts of JPEG compression do to an image.

Look For the Unexpected Angle

As explored in "Composition 101," in Chapter 4, changing the angle from which you photograph your subject can add impact and interest to the picture. Instead of shooting a subject straight on, investigate the unexpected angle — lie on the floor and get a bug's-eye-view, for example, or perch yourself on a (sturdy) chair and capture the subject from above.

As you compose your scenes, also remember the rule of thirds — divide the frame into thirds and position the main focal point of the shot at a spot where the dividing lines intersect. And quickly scan the frame for any potentially distracting background elements before you press the shutter button.

Don't be shy about repositioning your subjects to create a more interesting scene, either. When taking pictures of babies and preschoolers, for example, I often ask them to lie down on the floor, and then I snap their picture from above. The kids think it's funny, which means I end up with laughing children in the frame. But just as important, this technique is a way to eliminate

background clutter from your pictures. Where you find toddlers, you usually find a room full of toys, books, and other paraphernalia, and clearing off a three-foot area of carpet is easier than making the entire room tidy.

For more illustrations of how to make your pictures more interesting, see Figures 4-1 through 4-5 in Chapter 4.

Light 'Er Up!

When you're working with a digital camera, good lighting is essential for good pictures. The light sensitivity of most digital cameras is equivalent to the sensitivity of ISO 100 film, which means that low lighting results in dark and grainy images.

If your camera has a flash, you may need to use the flash not just for interior photography, but also to bring your subjects out of the shadows when shooting outdoors. If your camera is flashless, you may want to invest in some inexpensive photography lights. But before you do, experiment with different lamps you may have around the house to see whether any of them will do the trick.

When the sun or light source is behind your subject, remember that you may need to illuminate the subject from the front. Many cameras determine the appropriate exposure by reading the light throughout the entire frame. Your camera may adjust the exposure based on the strong light in the background, resulting in a foreground subject that appears underexposed.

Also keep an eye out for light reflecting off shiny surfaces, such as chrome or glass. In some cases, you may need to turn off the flash and use indirect lighting instead. For example, for an interior still shot, place the subject in front of a sunny window or bounce a light off a background wall.

For a thorough exploration of lighting issues, read "Let There Be Light" in Chapter 4.

Use a Tripod

To capture the sharpest possible image, you must hold the camera absolutely still when you shoot a picture. Even the slightest hand movement can result in a blurry image.

This problem occurs with film cameras as well as digital cameras, of course. But because digital cameras have a low light sensitivity, they require a longer exposure time than a film camera using a fast film — say ISO 400 film. If you're used to shooting with fast film, remember that you need to hold the camera still longer when you go digital.

To steady the camera, try tucking your elbows firmly into your sides as you shoot. But for best results, mount the camera on a tripod or set it on a table, counter, or other immobile object when taking pictures. Although professional tripods can cost several hundred dollars, you can get an acceptable bare-bones model for about \$20 at discount stores.

Compose from a Digital Perspective

When shooting objects that you plan to incorporate into a montage, as I did in Color Plates 11-1 through 11-3, fill as much of the frame as possible with your subject. Your goal is to devote as many of the available image pixels to your subject, thereby achieving a higher resolution and better image quality. Don't waste precious pixels on a background that will be cropped away in the editing process.

While we're on the subject of creating composite images, you can make your life easier by shooting your subjects against a plain background, as I did in Color Plate 11-1. Make sure that the background color is significantly different from the subject color. That way, you can easily select the background using image-editing tools that select pixels according to color (such as the Color Wand in Adobe PhotoDeluxe). After selecting the background, you can then inverse the selection so that the subject, not the background is selected, and then copy and paste the subject into the composite image. (In PhotoDeluxe, press Ctrl+I on a PC and \Re +I on a Macintosh to inverse the selection.)

For more information on combining elements from several images into one image, read "Building a multilayered collage" in Chapter 11. And to find out how to select a portion of your image and then copy it to another image, check out "Strap On Your Selection Toolbelt" and "Selection Moves (And Copies and Pastes)," both in Chapter 9.

Take Advantage of Image-Correction Tools

Very few digital images emerge from the camera or scanner looking as good as they can. With some judicious use of an image editor, you can brighten up underexposed images, correct color balance, crop out distracting background elements, and even cover up small blemishes, such as hot spots created by reflected light.

Part III of this book explores all the different techniques and tools you can use to enhance your images. Some are simple to use, requiring just one swift click of the mouse button. Others involve a bit more effort, but are still easily mastered if you're willing to put in a little time.

Being able to edit your photographs is one of the major advantages of shooting with a digital camera. So take a few minutes each day to become acquainted with your image editor's correction commands, filters, and tools. After you start using them, you'll wonder how you ever did without them.

Print Your Images on Good Paper

As illustrated in Color Plate 6-1, the type of paper you use when printing your images can have a dramatic impact on how your pictures look. The same image that looks blurry, dark, and oversaturated when printed on cheap, multipurpose copy paper can look sharp, bright, and downright glorious when printed on special glossy photographic paper.

Check your printer's manual for information on the ideal paper to use with your model. Some printers are engineered to work with a specific brand of paper, but don't be afraid to experiment with paper from other manufacturers. Paper vendors are furiously developing new papers that are specifically designed for printing digital images on consumer-level color printers, so you just may find something that works even better than the recommended paper.

Practice, Practice, Practice!

Digital photography is no different from any other art form in that the more you do it, the better you become. So shoot as many pictures as you can, in as many different light situations as you can. As you shoot, record the

camera settings you used and the lighting conditions at the time you snapped the image. Then study the results to see what settings worked well in what situations.

Speaking of shooting as many pictures as you can, professional photographers make it a practice to shoot the same image several times, often varying the exposure or other camera settings for each shot. You should do the same. On cameras that have LCD screens, you can easily review and delete images you don't like, so don't be afraid to shoot more exposures of an image than you think you'll need. And if your camera doesn't have an LCD, which means that you can't review your images before you download, *always* shoot more exposures than you think you need. Doing so improves the odds that you'll end up with at least one good image.

Read the Manual (Gasp!)

Remember that instruction manual that came with your camera? The one you promptly stuffed in a drawer without bothering to read? Go get it. Then sit down and spend an hour devouring every bit of information inside it.

I know, I know. Manuals are deadly boring, which is why you invested in this book, which is so dang funny you find yourself slapping your knee and snorting milk through your nose at almost every paragraph. But digital cameras aren't simple pieces of equipment, and you aren't going to get the best pictures out of your camera unless you understand how all its controls work. I can give you general recommendations and instructions in this book, but for camera-specific information, the best resource is the manufacturer's own manual.

After your initial read-through, drag the manual out every so often and take another pass at it. You'll probably discover the answer to some problem that's been plaguing your pictures or be reminded of some option that you've forgotten was available. In fact, reading the manual has to be one of the easiest — and most overlooked — ways to get better performance out of your camera.

Chapter 13

Ten Great Uses for Digital Images

In This Chapter

- ▶ Join the merry band of communicators on the World Wide Web
- ▶ Skip the trip to the post office and e-mail your pictures instead
- Make your marketing materials sizzle
- ▶ Put your smiling face on a coffee cup or t-shirt
- ▶ Publish a customized calendar
- ▶ Add pictures to spreadsheets and databases
- ▶ Give your stationery and greeting cards a personal touch
- ▶ Create employee badges, name tags, and business cards
- ▶ Use a favorite scene as desktop wallpaper
- > Print and frame your best work

hen I introduce most people to their first digital camera, the exchange goes something like this:

Them: "What's that?"

Me: "It's a digital camera."

Them: "Oh." (Pause.) "What can you do with it?"

Me: "You can take digital pictures."

Them: (Thoughtful nod.) "Hmm." (Another pause, this time longer.)

"And then what?"

It is at this point that the conversation takes one of two tracks: If time is short, I simply discuss the most popular use for digital images — distributing them electronically via the World Wide Web and e-mail. But if I have some time to kill or have ingested an excess of caffeine in the past hour, I sit the person down and launch into a full-fledged discussion of all the wonderful things you can do with digital images. It is at this point that the person subtly begins looking for the closest escape route and wishing to heck that the phone would ring or some other interruption would distract me from the subject at hand. I can be a little, well, overenthusiastic when it comes to this topic.

This chapter enables you to enjoy the long version of my "what you can do with digital images" speech in the safety of your own home or office. Feel free to leave at any time — I'll be here with more ideas when you come back. But before you go, could you order up some more coffee? I have a feeling that someone else might pass by soon and ask me about this funny-looking camera thing, and I want to be ready.

Create a More Exciting Web Site

As I explored in Chapter 7 and alluded to a few sentences ago, perhaps the most popular use for digital images is to spice up Web pages. You can include pictures of your company's product, headquarters, or staff on your Web pages to help potential customers get a better idea of who you are and what you're selling.

Don't have a business to promote? That doesn't mean you can't experience the fun of participating in the Web community. Create a personal Web page for yourself or your family. Many Internet Service Providers make a limited amount of free space available for those who want to publish personal Web pages. And with today's Web-page creation software, the process of designing, creating, and maintaining a Web page isn't all that difficult.

If you'd like to create your own Web page, but you're not sure where to begin, grab a copy of Creating Web Pages For Dummies, by Bud Smith and Arthur Bebak, or Creating Web Pages For Kids & Parents, by Greg Holden (both published by IDG Books Worldwide, Inc.).

For information on how to prepare your images for use on a Web page. check out Chapter 7.

E-Mail Pictures to Friends and Family

By attaching an image to an e-mail message, you can share pictures with friends, family, and colleagues around the world in a matter of minutes. No more waiting for the film lab to develop and print your pictures. No more hunting for the right size envelope to mail those pictures, and no more waiting in line at the post office to find out how many stamps you need to slap on that envelope. Just snap the picture, download it to your computer, and click the Send button in your e-mail program.

Whether you want to send a favorite aunt a picture of your new baby or send a client an image of your latest product design, the ability to communicate visual information quickly is one of the best reasons to own a digital camera. For more about attaching images to e-mail messages, turn to Chapter 7.

Add Impact to Sales Materials

Using a desktop publishing program such as Adobe PageMaker or Microsoft Publisher, you can easily add your digital images to brochures, flyers, newsletters, and other marketing materials. You can also import your images into multimedia presentations created in Microsoft PowerPoint, Adobe Persuasion, or Corel Presentations.

For best results, size your images to the desired dimensions and resolution in your image editor before you export them. For information about resizing images, see "Resizing Do's and Don'ts" in Chapter 8. And for information about preparing images for use in on-screen presentations, see Chapter 7.

Put Your Mug on a Mug

If you own one of the new color printers designed expressly for printing digital images, the printer may come with accessories that enable you to put your images on mugs, T-shirts, and other objects. Many of the consumer-level image-editing programs also provide tools that make it a snap to prepare your images for use in this fashion.

Being a bit of a jaded person, I expected to get rather cheesy results from these kinds of print projects. But after I created my first set of mugs using the Fargo FotoFUN! printer, I was hooked. I chose four different images featuring my parents, my sisters, and their children and placed each image on a different mug. The process was quick — with this particular printer and mug accessory kit, you print the image, tape it to the mug, place a special clamp around the mug, and then bake the mug in an oven for 15 minutes. And the results were extremely professional-looking.

Call me sentimental, but I can envision these mugs being around for generations (assuming nobody breaks one, that is) to serve as a reminder of how we 20th-century Kings once looked. Hey, 100 years ago, nobody thought that old tintype photographs would be considered heirlooms, right? So who's to say that my photographic mugs won't be treasured tomorrow? In the meantime, the family members who have laid claim to the mugs I created seem to be treasuring them today.

Create a Family or Company Calendar

Many image-editing programs include templates that enable you to create customized calendars featuring your images. The only decision you need to make is which picture to put on December's page and which one to use on July's.

If your image editor doesn't include such templates, check the software that came with your printer. Many home- and small-office color printers now ship with software for creating calendars and similar projects.

When you want more than a handful of copies of your calendar, you may want to have the piece professionally reproduced instead of printing each copy one by one on your own printer. You can take the job to a quick-copy shop or to a commercial service bureau or printer. The printer may also be able to do the pre-printing work of placing images in the calendar template if you don't want to do so yourself or don't have the appropriate software.

Add Visual Information to Databases and Spreadsheets

Digital images can be easily added to company databases and spreadsheets, giving you a way to provide employees with visual as well as text information. For example, if you work in human resources, you can insert employee pictures into your employee database. Or if you're a small-business owner and maintain a product inventory in a spreadsheet program, you can insert pictures of individual products to help you remember which items go with which order numbers. Figure 1-3 in Chapter 1 shows an example of a spreadsheet that I created in Microsoft Excel to track the inventory in my antique shop.

Merging text and pictures in this fashion isn't just for business purposes, though. You can take the same approach to create a household inventory for your personal insurance records, for example.

Print Customized Stationery and Greeting Cards

Using any word processor or page layout program, you can easily add an image to your personal or business stationery. Many image-editing programs also offer templates for creating stationery. You can print the stationery on your home printer or have it professionally reproduced at a quick-copy shop or commercial printer.

In addition to stationery, you can create customized greeting cards and postcards. Again, most entry-level image editors offer templates for publishing such pieces. Some color printers also come with software that helps you do the job.

Don't forget that the paper you use to print your stationery or cards plays a large role in how professional the finished product appears. If you're printing the piece yourself, invest in some high-quality paper or special greeting card stock, available as an accessory for many color printers. If you're having your piece professionally printed, ask your printer for advice on which paper stock will generate the results you want.

Put a Name with the Face

You can put digital pictures on business cards, employee badges, and even name badges for guests at a conference or other large gathering. I love getting business cards that include the person's face, for example, because I'm one of those people who never forgets a face but almost always has trouble remembering the name.

If you have a regular need for creating badges or name tags, you may want to investigate one of the special-format printers such as the Casio QG-100, which prints images on label-sized, adhesive-backed paper. After printing the image, you simply stick it onto your preprinted badge or name tag.

Wallpaper Your Computer Screen

Tired of looking at the same old computer screen day after day? You can replace the standard-issue desktop wallpaper with one of your favorite images. Figure 7-9 in Chapter 7 gives you a look at this concept in action, while the section "Redecorate Your Computer's Living Room" gives you the how-tos.

Create a New Masterpiece for Your Wall

Many of the ideas discussed in this chapter capitalize on the special capabilities that going digital offers you — the ability to display images onscreen, incorporate them into desktop publishing projects, and so on. But you can also take a more traditional approach and simply print and frame your favorite images.

For the best-looking pictures, print your image on a dye-sub printer. If you don't own such a printer, you can take the image file to a commercial printer for output. Some commercial photo labs also offer this service. (For more on printer types and printing options, read Chapter 6.)

Keep in mind that prints from dye-sub printers do fade when exposed to sunlight, so for those really important pictures, you may want to invest in a frame that has UV-protective glass. Also, hang your picture in a spot where it won't get pummeled with strong light on a regular basis, and be sure to keep a copy of the original image file so that you can reprint the image if it should fade too badly.

Chapter 14

Ten Great Online Resources for Digital Photographers

In This Chapter

- www.kodak.com
- www.powershot.com
- www.digicam.org
- www.digitalphoto.com.nf/
- www.zonezero.com
- www.hyperzine.com
- www.publish.com
- rec.photo.digital
- comp.periphs.printers
- www.manufacturer'snamegoeshere.com

t's 2 a.m. You're aching for inspiration. You're yearning for answers. Where do you turn? No, not the refrigerator. Well, okay, maybe just to get a little snack — some nice cold pizza or some leftover chicken wings would be good — but then it's off to the computer for you. Whether you need ideas or solutions to difficult problems or just want to share experiences with likeminded people around the world, the Internet is the place to turn. At least it is for issues related to digital photography. For anything else, talk to your spiritual leader, psychic hotline, Magic 8-Ball, or whatever source you usually consult.

This chapter points you toward ten of my favorite online digital photography resources. New sites are springing up every day, so you can no doubt uncover more great pages to explore by doing a search on the words "digital photography" or "digital imaging."

Note that the site descriptions provided in this chapter were current as of press time. But because Web sites are always evolving, some of the specific features mentioned may be updated or replaced by the time you visit a particular site.

www.kodak.com

As one of the companies at the forefront of the digital photography movement, the Eastman Kodak Company is making a major effort to help the general consumer understand and take advantage of this new technology. In addition to marketing information about Kodak products, the Kodak site offers a wealth of basic information that's extremely useful to anyone wanting to learn more about digital photography.

From the Kodak home page, click the Digital Photography link to access the digital imaging information. Click the Digital Learning Center link for reference material that will help you get a firmer grasp on the science behind digital cameras. Click the PhotoChat link to find out how to participate in weekly chat sessions where you can exchange pictures and information with other digital photographers.

In addition, the Kodak site offers Picture This Postcards, a service that enables you to create and send electronic postcards featuring your digital images, and Kodak Picture Network, through which you can have undeveloped film processed and printed and have the images scanned to disk at the same time. You can view and download your images from the Web site and give your password to others so that they can access your images as well. (For more about the Kodak Picture Network, see the sidebar "Cyberstorage: The image closet of the future?" in Chapter 5.)

www.powershot.com

This site is presented by Canon, the manufacturer of the PowerShot line of digital camera equipment. Although much of the material on this site is specifically related to PowerShot cameras, you can also find solid basic information about digital photography in general. For example, one area of the site offers a history of digital photography, while another offers a glossary of technical terms. To access this information, click the From the Darkroom to the Desktop graphic link or the Feature text link on the PowerShot home page.

www.digicam.org

Log in to this site to join The Digital Camera Club, an online organization devoted to digital photography. Membership is free. After you join, you have access to all the club's services and information, which include reviews of new cameras, an area where members can share experiences with different camera models, a gallery where members can post their best digital images, a chat forum for discussion of digital photography, and a classified advertising area for buying and selling used equipment.

www.digitalphoto.com.nf/

Travel to this Web address to explore the latest issue of *DPI*, an online journal about digital photography and imaging. You can read reviews of digital imaging hardware and software, view images from photographic exhibitions at galleries all over the world, and get recommendations for other interesting sites to visit.

www.zonezero.com

Head to this site for a look at another great online magazine, *ZoneZero*. This magazine discusses both traditional and digital photography and is one of the most beautifully designed sites I've had the pleasure of exploring. The site has a definite international flavor, with contributors from all points of the globe. Photo essays from leading photographers, thoughtful editorials on the history and future of photography, and technical information are included.

www.hyperzine.com

This online magazine covers traditional photography, still digital photography, and digital video. You'll find lots of product reviews and technical information, as well as ideas and tips for creating better pictures. This site also maintains an excellent glossary of photographic terms and is home to several discussion groups related to different aspects of photography.

www.publish.com

Make your way to this site to view the online version of a popular print magazine, *Publish*. Here, you'll find articles about all aspects of publishing in the digital age. A recent issue included an article on choosing a large-screen computer monitor, a guide to color copier/printers, a discussion of removable storage media, and a look at high-end digital printing presses.

This magazine is geared toward publishing professionals, so some of the terminology and articles may be beyond the grasp of beginners. Still, it's a great place to go to find out more about the professional side of digital imaging and especially to increase your knowledge about commercial reproduction of your images.

rec.photo.digital

For help with specific technical questions as well as an interesting exchange of ideas about different equipment and approaches to digital photography, join the rec.photo.digital newsgroup. (For the uninitiated, a newsgroup is a bunch of folks with similar interests who send messages back and forth about a particular topic.) Many of the people who participate in this newsgroup have been working with digital imaging for years, while others are brand new to the game. Don't be shy about asking beginner-level questions, though, as the experts are happy to share what they know. In fact, this newsgroup has some of the most helpful members I've run across on the Internet.

comp.periphs.printers

While discussions in rec.photo.digital cover the broad spectrum of digital photography issues, those in the comp.periphs.printers newsgroup revolve solely around printing. Currently, members are hotly debating which printer model delivers the best output for digital images, discussing ways to cut down on ink and printer costs, and sharing solutions for problems like color matching and installing printer drivers. In other words, this is the place to go if you have any questions related to printing your images.

www.manufacturer'snamegoeshere.com

In addition to those sites operated by Kodak and Canon (see the first two listings in this chapter), you can find Web sites from just about every manufacturer of digital imaging hardware and software. Typically, sites are geared to marketing the company's products, but they also serve as a service resource for existing customers. Many manufacturers publish a list of answers to frequently asked questions (FAQs, for the non-Webbies in the crowd). In most cases, you can also e-mail the company's technical support staff for assistance with a specific problem.

Many vendors also make updates to software available through their Web sites. For example, you may be able to download an updated printer driver or a patch that fixes a bug in your image-editing program. I recommend that you get in the practice of checking your manufacturer's Web site routinely — say, once a month or so — to make sure that you're working with the most current version of the product software.

Part V Appendixes

"WOW! I DIDN'T EVEN THINK THEY MADE A 2,000-DOT-PER-INCH FONT!"

In this part . . .

ou're reading along in my digital tome here and see a term that you have no clue about. Whaddya do? You check out Appendix A, of course, which lists many of the technical terms in this book — and then defines them for you!

You can also find out in this part what's on the CD that's included with this book by taking a gander at Appendix B. You're gonna love the CD.

Appendix A

Digital Image Glossary

an't remember the difference between a pixel and a bit? Resolution and resampling? Turn here for a quick refresher on that digital imaging term that's stuck somewhere in the dark recesses of your brain and refuses to come out and play.

8-bit image: An image containing 256 or fewer colors.

16-bit image: An image containing roughly 32,000 colors.

24-bit image: An image containing approximately 64 million colors.

artifact: A defect in an image, caused by a poor scan, too much compression, or some other image capture or processing problem.

bit: Stands for *binary digit.* The basic unit of digital information. Eight bits equals one *byte.*

BMP: The Windows bitmap graphics format. Reserved today for images that will be used as system resources on PCs, such as screen savers or desktop wallpaper.

byte: Eight bits. See bit.

CCD: Short for *charge-coupled device*. One of two types of computer chips used to capture images in digital cameras.

CIE: A color model developed by the Commission International de l'Eclairange. Used mostly by higher-end digital imaging professionals.

cloning: The process of painting one portion of an image onto another image or another part of the same image.

CMOS: Pronounced *see moss.* A much easier way to say *complimentary metal-oxide semiconductor.* A type of computer chip used to capture images in digital cameras; used less often than CCD chips.

CMYK: A color model based on the printing process, where cyan, magenta, yellow, and black inks are mixed to create every other color.

color correction: The process of adjusting the amount of different primary colors in an image (for example, lowering the amount of red in an RGB image).

color model: A way of defining colors. In the RGB color model, for example, all colors are created by blending red, green, and blue light. In the CMYK model, colors are defined by mixing cyan, magenta, yellow, and black.

compositing: Combining two or more images in an image editor.

compression: The process of squeezing the data in an image file to shrink the size of the file.

downloading: The process of transferring data from one computer device to another.

dpi: Short for dots per inch. A measurement of how many dots of color a printer can create per linear inch. Higher dpi means better print quality on some types of printers, but on other printers, dpi is not as crucial to quality.

dye-sub: Short for *dye-sublimation*. A type of printer that produces excellent digital prints.

edges: Areas where neighboring image pixels are significantly different in color.

FlashPix: A new image file format being developed to facilitate the editing of digital images. Supported by only a handful of programs at this point, but gaining momentum.

gamut: Say it *gamm-ut*. The range of colors that a monitor, printer, or other device can produce. Colors that a device can't create are said to be out of gamut.

GIF: Pronounced *jif*, as in the peanut butter, by some, and *gif*, with a hard g, by others. Either way, GIF stands for graphics interchange format. One of the two image file formats used for images on the World Wide Web. Supports 256-color images only.

gigabyte: Approximately 1,000 megabytes, or one billion bytes. In other words, a really big collection of bytes. Abbreviated as GB.

grayscale: An image consisting solely of shades of gray, from white to black.

HSB: A color model comprising hue (color), saturation (purity or intensity of color), and brightness.

HSL: A variation of HSB, this color model is based on hue, saturation, and lightness. One of the color models used to mix colors in the Apple Color Picker on Macintosh computers.

JPEG: Pronounced *jay-peg.* One of two formats used for images on the World Wide Web and also for storing images on many digital cameras. Uses *lossy* compression, which deletes some image data in order to shrink file size.

Kilobyte: One thousand bytes. Abbreviated as K.

LCD: Stands for *liquid crystal display*. Often used to refer to the display screen included on some digital cameras.

lossless compression: A file-compression scheme that doesn't sacrifice any image data in the compression process.

lossy compression: A compression scheme that dumps some image data in order to achieve smaller file sizes.

marquee: The dotted outline that results when you select a portion of your image. Also sometimes used as a verb, as in "I'm in the mood to marquee some pixels."

megabyte: One million bytes. Abbreviated as MB. See bit.

megapixel: Refers to digital cameras that can capture images at high resolutions; typically, reserved for cameras that can capture one million pixels or more.

noise: Graininess in an image, created by some problem in the image-capture process.

PCMCIA card: Stands for *Personal Computer Memory Card International Association*. A type of removable memory card used in digital cameras. Now often referred to as simply PC cards.

Photo CD: A special image format for storing digital images on a CD.

PICT: The standard format for Macintosh system images. The equivalent of BMP on the Windows platform, PICT is most widely used when creating images for use as system resources, such as startup screens.

pixel: Short for *picture element*. The basic building block of every image.

platform: A fancy way of saying "type of computer system." Most folks work either on the PC platform or Macintosh platform.

ppi: Stands for *pixels per inch*. Used to state image resolution, and measured in terms of the number of pixels per linear inch. A higher ppi translates to better-looking printed images.

resampling: Adding or deleting image pixels. A large amount of resampling usually degrades images.

resolution: The number of pixels per linear inch (ppi) in an image. A higher resolution means higher-quality images. Also used to describe printer, screen, or scanner capabilities.

RGB: The standard color model for digital images; all colors are created by mixing red, green, and blue light.

sharpening: Applying an image-correction filter inside an image editor to create the appearance of sharper focus.

TIFF: Pronounced *tiff*, as in little quarrel. Stands for *tagged image file format*. A popular image format supported by most Macintosh and Windows programs.

TWAIN: Say it *twain*, as in "never the twain shall meet." A special software interface that enables image-editing programs to access images captured by digital cameras and scanners.

Unsharp masking: The process of using the Unsharp Mask filter, found in many image-editing programs, to create the appearance of a more focused image. The same thing as sharpening an image, only more-impressive sounding.

Uploading: The same as downloading; the process of transferring data between two computer devices.

Appendix B What's on the CD

Glued to the inside back cover of this book is a little plastic envelope containing a CD-ROM. The CD contains a treasure trove of goodies, including:

- Demo and trial versions of image-editing programs
- Demo and trial versions of image-catalog and browser programs
- Twenty of the original digital images used to create the figures in this book

If the programs included on the CD are available for both Macintosh and PC computers, both versions are provided. Several programs are available for Windows users only, while one is available on the Macintosh platform only.

For a brief description of each program included on the CD, see the section "What You'll Find" later in this appendix.

System Requirements

Make sure your computer meets the minimum system requirements listed below. If your computer doesn't match up to most of these requirements, you may have problems in using the contents of the CD.

- ✓ A PC with a 486 or faster processor, or a Mac OS computer with a 68030 or faster processor. Keep in mind that, with these minimum processor requirements, opening and editing large images may be very slow.
- ✓ Microsoft Windows 3.1 or later, or Mac OS System software 7.5 or later.
- At least 16MB of total RAM installed on your computer. For best performance, I recommend even more RAM.
- ✓ At least 630MB (for Windows) or 140MB (for Macs) of hard drive space available to install all the software from this CD. (You'll need less space if you don't install every program.)
- ✓ A CD-ROM drive double-speed (2x) or faster.
- ✓ A sound card for PCs. (Mac OS computers have built-in sound support.)
- A monitor capable of displaying at least 256 colors or grayscale.

If you need more information on the basics, check out *PCs For Dummies*, 5th Edition, by Dan Gookin; *Macs For Dummies*, 5th Edition, by David Pogue, *Windows 95 For Dummies*, 2nd Edition, by Andy Rathbone; or *Windows 3.11 For Dummies*, 4th Edition, by Andy Rathbone (all published by IDG Books Worldwide, Inc.).

How to Use the CD Using Microsoft Windows

To install the items from the CD to your hard drive, follow these steps.

- Insert the CD into your computer's CD-ROM drive and close the drive door.
- 2. Windows 3.x (that is, 3.1 or 3.11) users: From the Program Manager, choose File⇔Run.

Windows 95 users: Click the Start button and then click Run.

3. In the dialog box that appears, type D:\SETUP.EXE.

This instruction assumes that your CD-ROM drive is set up as drive D (check in My Computer in Windows 95 or the File Manager in Windows 3.1). Substitute the proper drive letter if your CD-ROM drive uses a different letter.

4. Click OK.

A license agreement window appears.

5. I'm sure you'll want to use the CD, so read through the license agreement, nod your head, and then click on the Accept button. After you click on Accept, you'll never be bothered by the License Agreement window again.

From here, the CD interface appears. The CD interface lets you install the programs on the CD without typing in cryptic commands or using yet another finger-twisting hot key in Windows.

The software on the interface is divided into categories whose names you see on the screen.

6. To view the items within a category, just click the category's name.

A list of programs in the category appears.

Note that the Images folder does not contain software, but rather sample images that you can open and edit from inside an image-editing program. So the remaining steps in this section don't apply to anything inside the Images folder.

7. For more information about a program, click on the program's name.

Be sure to read the information that's displayed. Sometimes a program may require you to do a few tricks on your computer first, and this screen will tell you where to go for that information, if necessary.

8. To install the program, click the appropriate Install button. If you don't want to install the program, click on the Go Back button to return to the previous category screen.

After you click on an install button, the CD interface drops to the background while the CD begins installation of the program you chose.

When installation is finished, the interface usually reappears in front of other opened windows. Sometimes the installation will confuse Windows and leave the interface in the background. To bring the interface forward, just click once anywhere in the interface's window, or use whatever keystroke or mouse move that your version of Windows uses to switch between programs (the Alt+Tab key, etc.).

- 9. To install other items, repeat Steps 6, 7, and 8.
- 10. When you're finished installing programs, click on the Quit button to close the interface.

You can eject the CD now. Carefully place it back in the plastic jacket of the book for safekeeping.

To run some of the programs, you may need to keep the CD inside your CD-ROM drive. Otherwise, the installed program would have required you to install a very large chunk of the program to your hard drive space, which would have kept you from installing other software.

How to Use the CD Using a Mac OS Computer

To install the items from the CD to your hard drive, follow these steps.

 Insert the CD into your computer's CD-ROM drive and close the drive door.

In a moment, an icon representing the CD you just inserted appears on your Mac desktop. Chances are, the icon looks like a CD-ROM.

2. Double-click on the Read Me First icon.

This text file contains information about the CD's programs and any last-minute instructions you need to know about installing the programs on the CD that we don't cover in this appendix.

3. Double-click on the CD icon to show the CD's contents.

- 4. To install most programs, just drag the program's folder from the CD window and drop it on your hard drive icon.
- 5. To install other, larger programs, open the program's folder on the CD, and double-click the icon with the words "Install" or "Installer."

After you have installed the programs that you want, you can eject the CD. Carefully place it back in the plastic jacket of the book for safekeeping.

What You'll Find

Here's a summary of the software on this CD. The programs are listed in alphabetical order.

If you use Windows, the CD interface helps you install software easily. (If you have no idea what I'm talking about when I say "CD interface," flip back a page or two to find the section, "How to Use the CD using Microsoft Windows.")

If you use a Mac OS computer, you can enjoy the ease of the Mac interface to quickly install the programs.

ACDSee, from ACD Systems

For Windows. The CD includes ACDSee, a shareware image browser and organizer that features an interface that resembles the Windows 95 Explorer/Windows 3.1 File Manager window. The program also includes a command that automatically turns a selected image into Windows wallpaper.

To find out more about this program, click your way to the ACD Systems Web page at www.acdvictoria.com.

Before & After, from Polaroid Corporation

For Windows 95. Before & After takes a one-click-and-you're-done approach to image editing. When you open an image, the program analyzes the sharpness, brightness, and contrast. It then shows you a preview of how the image will look when those elements are corrected. If you like the preview, click it to apply the corrections. You can also apply automatic color correction. You don't get traditional selection, painting, and effects tools found in other image editors, but if all you care about is a quick way to improve images from your camera or scanner, this program may do the trick.

A 30-day trial version is provided on the CD. The required registration code is 01-01-9999999. Visit the Polaroid Web site at www.polaroid.com for more information.

GraphicConverter, from Lemke Software

For Mac OS. GraphicConverter is a nifty shareware program that enables you to view images and also perform basic editing functions. Its primary strength, though, is its ability to open files saved in just about any imaginable file format and then convert those files to other formats. You can even do batch conversions — that is, convert a bunch of images to a different file format at one time.

For information about registering your copy of the software or to find out more about the program visit www.lemkesoft.de/.

LivePix, from The LivePix Company

For Windows and Mac OS. LivePix is designed to speed and simplify the process of using digital images to create personalized calendars, greeting cards, and other publishing projects. The program includes many templates that provide the basic structure for projects — the background for a thankyou card, for example. You then substitute the photos in the template with your own pictures.

This program doesn't offer many of the image-editing tools found in other programs, such as a clone tool or eraser, and its special effects are limited to a distortion tool, a red-eye removal tool, and a tool for placing a shadow behind a selected image. But for those who want an easy approach to basic desktop publishing projects, LivePix is a fun and easy-to-use option.

A 90-day trial version of the program is provided on the CD for both Windows and Macintosh computers. For more information, visit the LivePix Web site at www.livepix.com.

There were so many programs that we wanted to include on this CD that we ran into some space considerations. In order to include the LivePix demo, we had to trim it down a little bit, and leave the fonts out. This does not affect the way the demo works, but to insure a trouble-free installation, when you are asked to select the type of installation you want to perform, please select the Custom installation option. You will then be asked to select the components you want to install. Make sure the Fonts option is cleared, so the fonts will not be installed.

MGI PhotoSuite SE, from MGI Software

For Windows. MGI PhotoSuite SE is a "starter edition" of MGI PhotoSuite. Designed for newcomers to image editing, the SE version of PhotoSuite offers basic image-editing tools, a cataloging tool, templates for creating greeting cards, calendars, sports cards, and the like, and a utility that enables you to view your images as a slide show. If you upgrade to the standard version of PhotoSuite, you get more features, including additional special effects, templates, and other tools.

A 30-day trial of MGI PhotoSuite SE is provided on the CD. For more information, check out www.mgisoft.com.

Paint Shop Pro, from JASC, Inc.

For Windows. Paint Shop Pro is a shareware image editor that offers a good selection of editing tools and special effects. A screen capture program, image browser, and batch format converter (for changing the file format of several images at once) are built into the image editor, making this a wellrounded package.

The CD includes a 15-day trial version for both Windows 3.1 and Windows 95. Check out www.jasc.com on the World Wide Web for more information.

PhotoDeluxe 2.0, from Adobe Systems

For Windows and Mac OS. One of the leading entry-level image editors, PhotoDeluxe is shipped with many digital cameras. This software is featured throughout the image-editing section of this book (Chapters 8 through 11).

The CD includes a QuickTime movie that introduces you to PhotoDeluxe. For more information, log on to the Adobe Web site at www.adobe.com.

PhotoImpact, from Ulead Systems

For Windows 95. PhotoImpact offers an impressive lineup of image-editing and cataloging tools, which you can sample free using the 30-day trial version provided on the CD. In addition to image-correction and editing features, the program includes special tools for creating Web pages; a screen capture program that can snap a picture of whatever is displayed on your monitor; an image viewer that lets you browse images using an Explorer-like interface; and an image-management utility that makes it easy to organize your images into digital albums.

For more information about PhotoImpact, visit the Ulead site at www.ulead.com.

PhotoRecall, from G&A Imaging

For Windows. PhotoRecall helps you organize and manage your image files. The program interface resembles a traditional photo album — you create an album, place your images on album pages, and add captions if you like. Some basic image-correction tools are provided as well. You can adjust brightness and contrast, fix color-balance problems, and sharpen the image focus.

The version of PhotoRecall included on the CD in this book enables you to install and try out the program free for 30 days. For more information about the software, point your Web browser to www.ga-imaging.com.

PolyView, from Polybytes

For Windows 95. This shareware program is a combination graphics viewer and basic image editor. You can browse through thumbnails of your images using an interface that mimics the Windows 95 Explorer interface. You can also do some basic image editing, including color correction and brightness/contrast adjustment. Take a look at Figure 5-6, in Chapter 5, for an illustration of the browser portion of this program.

You can get more information about PolyView at www.polybytes.com.

Portfolio, from Extensis

For Windows 95 and Mac OS. Formerly known as Fetch, Extensis Portfolio has long been a favorite graphics-cataloging tool among Macintosh users and is now available for Windows 95 as well. You can catalog and organize images, sound files, movies files, and regular document files using Portfolio.

Portfolio is strictly a cataloging utility; you can't do any editing to your images. But if you have tons and tons of images, you'll appreciate the program's ability to tag images with keywords that you can later use to help you track down a particular image. For example, if you want to see all your sunset pictures, you can tell Portfolio to find any images tagged with the keyword *sunset*.

The CD contains a 60-day trial version of the program. For more information about Portfolio, visit the Extensis Web site at www.extensis.com. If you have trouble installing or running Extensis Portfolio on your 68K Mac, please check out the Extensis website for troubleshooting information.

Presto! PhotoAlbum, from NewSoft

For Windows 95. Pictured back in Figure 5-7, Presto! PhotoAlbum enables you to create a computerized version of a traditional photo album. After arranging your images on the album pages, you can apply special backgrounds, frames, shadows, and clip-art graphics to your pages. An image-browser/organizer feature is also included.

A 30-day trial version of the program is provided on the CD. To find out more details about the program, visit the NewSoft Web site at www.newsoftinc.com.

Images on the CD

I've included an assortment of the original images that I used to create some of the figures and color plates in this book. Figure B-1 provides thumbnail views of the images available.

You can open any of the images inside an image editor or view the image inside a browser by using the same procedure you would to open or view any other file. Just crack open the Images folder on the CD. All images are stored in the JPEG format. If you're working in Windows, the files have the file extension .JPG.

Feel free to use these images in whatever manner you see fit. They're copyright free — my little thank-you gift to you, if you will. I know, it's not much, but the store didn't have any "I heart Julie!" T-shirts in your size. Of course, if you do happen to win some big prize or cash award as a result of using one of my images, I expect to go halfsies with you.

If You've Got Problems (Of the CD Kind)

I tried my best to compile programs that work on most computers with the minimum system requirements. Alas, your computer may differ, and some programs may not work properly for some reason.

The two likeliest problems are that you don't have enough memory (RAM) for the programs you want to use, or you have other programs running that are affecting installation or running of a program. If you get error messages like Not enough memory or Setup cannot continue, try one or more of these methods and then try using the software again:

Figure B-1: You can find these images in the Images folder on the CD at the back of

- ✓ Turn off any anti-virus software that you have on your computer. Installers sometimes mimic virus activity and may make your computer incorrectly believe that it is being infected by a virus.
- ✓ Close all running programs. The more programs you're running, the less memory is available to other programs. Installers also typically update files and programs. So if you keep other programs running, installation may not work properly.
- ✓ Have your local computer store add more RAM to your computer. This is, admittedly, a drastic and somewhat expensive step. However, if you have a Windows 95 PC or a Mac OS computer with a PowerPC chip. adding more memory can really help the speed of your computer and allow more programs to run at the same time.

If you still have trouble with installing the items from the CD, please call the IDG Books Worldwide Customer Service phone number: 800-762-2974 (outside the U.S.: 317-596-5261).

Index

• A •

AC adapters, 54–55
Afga ePhoto 307 camera, 44
aperture
digital cameras, 36
film cameras, 34–35
aperture-priority, 53
Apple QuickTake 200 camera
flash, 49
illustration, 10
LCD display, 45–46
artifacts, 273
audio recording, 52
autofocus, 52

• B •

background fillers, 170 backgrounds coloring, 194 composition, and, 65 fillers, 170 image quality, and, 255 transparent, 170 backlighting compensating for, 67–68 illustration, 69 batteries, 54-55 bit depth, 37-38 bits, 273 black-and-white. See also grayscale converting to, 244-245 blemishes, touching up, 165–166, 187-190

blend modes, 214
Blend options, 205–207
blurred images, 71–72, 158–164
BMP. See Windows Bitmap format
borders, 209–210
bounce lighting, 71
brightness, 154–156
Brightness/Contrast command
description, 154
versus Lightness command, 158
Brush tool, 194
bytes, 273

• C •

camera cases, cost, 58 camera rental, cost, 59 cameras, digital. See also images AC adapters, 54–55 Afga ePhoto 307, 44 aperture-priority, 53 Apple QuickTake 200 flash, 49 illustration, 10 LCD display, 45-46 attaching to SLR bodies, 48-49 batteries, 54-55 Canon EOS • DCS1, 49 capture time, 16 Casio OV-120, 45-46 color fidelity, 53-54 computer connections, 56 Connectix QuickCam, 47 converting film cameras to, 48-49 cost, 17

(continued)

cameras, digital (continued)	PC cards, 43–45, 56–57
deleting images, 46, 55	physical size, 55
desktop, 47	playing to a TV/VCR, 51–52
durability, 55	principles of operation, 22
Dycam 10-C, 51	print quality, 15
ease of use, 55	recording audio, 52
flash, 49–50	recording from a TV/VCR, 51–52
floppy disk, built-in, 43–45	removable storage, 43–45
Fuji DS-7	renting, 59
flash, 49	Ricoh RDC-2
onboard memory, 44	illustration, 10
Kodak DC120	recording audio, 52
illustration, 10	video/audio connections, 82
lenses, 50–51	self-timers, 52
memory, 44	Sony Digital Mavica, 43
print quality, 15	storage space, 57
resolution, 41	tripod mount, 55
Kodak DVC-300, 47	tripods, 57
lag time, 56	video, 47–48
LCD viewfinders, 45–47	video-in, 51
learning curve, 16	video-out, 51
lenses, 50–51, 57	viewfinders, 45–47
lighting requirements, 16	warranties, 56
magazine reviews of, 58	cameras, film
maximum storage capacity, 45	aperture, 34–35
megapixel, 49	converting to digital, 48–49
memory, 43–45	f-stops, 34
memory card adapters, 57	shutter speed, 34–35
miniature, 48	Canon EOS • DCS1 camera, 49
Minolta Dimâge V	Canon Web site, 266
illustration, 10	Canvas Size command, 169–170
lenses, 50–51	Casio QG-100 camera, 95
moving images to computer. See	Casio QV-120 camera, 45-46
downloading images	CCD chips
Nikon Coolpix 100, 48	versus CMOS chips, 42
on-board memory, 43–45	defined, 273
original image quality, 16	CDs. See also companion CD
	writeable, 84

compression defined, 274 downloading images, 80 and image quality, 252-253 JPEG, 42-43 lossless, 86, 275 lossy, 86, 275 LZW compression, 86 RLE (Run-Length Encoding), 89 computer connections, 56 computer systems, cost, 19 Connectix QuickCam camera, 47 continuous-tone images, 120 contrast, 154-156 Contrast control, 156 conversion kit, film camera to digital, 49 conversion kits film camera to digital, 49 Copy command, 183 costs camera cases, 58 camera rental, 59 catalog programs, 58 computer systems, 19 digital cameras, 17 floppy disks, 83 hard drives, 83 image editors, 20, 58, 140 Jaz drives, 83 Kodak digital warehouse, 84 lens adapters, 57 lenses, 57 memory card adapters, 57 memory card readers, 57 PC cards, 45, 57 PhotoDeluxe, 140 printer consumables, 101-102, 104

printers, 20, 95-96 processing, 19 professional printing services, 105 removable memory, 45 removable storage, 43-45 resolution, 17 scanners, 18 scanning, 19 SLR conversion kits, 49 software, 58 storage devices, 20 storage space, 57 tripods, 57 writeable CDs, 84 Zip drives, 83 crop tool, 150-151 cropping, 150-151 cursor shapes, 179, 202-203 Cut command, 182

• D •

darkening images, 154–156, 206
daylight, 71
deleting images, 46, 55
desktop cameras, 47
Despeckle command, 166
dialog boxes. See also entries for
specific dialog boxes
resetting options, 149
thumbnail previews, 148–149
Digital Camera Club Web site, 267
digital formats
BMP (Windows Bitmap), 89, 273
changing, 145
EPS (Encapsulated PostScript), 89

FlashPix, 88, 274 GIF (Graphics Interchange Format), 88 color limitations, 121–122 defined, 274 interlaced, 122 versus JPEG format, 120–121 saving as, 122-123 transparent Web images, 121-125 JPEG (Joint Photographic Experts Group), 86–87, 275 PDD, 144 Photo CD, 87-88, 275 PICT, 89, 275 PNG (Portable Network Graphics), 88-89 Pro Photo CD, 87-88 TIFF (tagged image file format), 87, 276 digitizing, 11 displaying images on-screen interpolation, 116 monitor size, 115-116 pixels, converting to inches, 118 resolution, 116-118 sizing the image, 115–116 Distort command, 239-241 distorting images, 235–239 downloading images compression settings, 80 computer connection cable, 78 defined, 274 delete after download, 81 file format, choosing, 80 file names, 80 overwriting existing images, 80 procedures for, 79-80 RAM requirements, 44-45

software for, 56 troubleshooting, 80–81 dpi (dots per inch) defined, 274 versus ppi, 107–108 and printer resolution, 31 DPI magazine Web site, 267 drag and drop, 185–186 drawing images. See painting images drop-outs, 50, 67 Dycam 10-C camera, 51 dye-sub printers, 96–97, 274 dye-sublimation printers, 96–97, 274

• E •

edges, 274 8-bit images, 273 e-mail, attaching digital images, 128-130, 260 Encapsulated PostScript (EPS) format, 89 Epson Stylus Color 600 printer, 95 Eraser tool, 210 ethical issues, 246 exposure, digital cameras. See also lighting aperture opening, 36 defined, 33 f-stops, 36 manual control, 73 shutter speed, 36 exposure, film cameras aperture opening, 34–35 f-stops, 34 shutter speed, 34–35 Extensis Portfolio program, 92

• F •

Fargo Primera Pro printers, 96–97 Fargo Pro Elite printers, 96-97 Feather dialog box, 189-190 file formats. See digital formats fill flash, 67-69 film speed, ISO equivalents, 36-37 filters, special effect, 241–243 fish-eye shots, 51 fixed-focus, 52 flash photography. See also lighting Apple QuickTake 200, 49 drop-outs, 50 fill flash, 67-69 Fuji DS-7, 49 glare, 50 hot spots, 50 red-eye, 50 FlashPix format, 88, 274 fleshtones, 163 floating layers, 184–185 floppy disks, 83 built in to camera, 43-45 as storage devices, 83 focus adjusting in PhotoDeluxe, 158-164 autofocus, 52 camera controls, 72 fixed-focus, 52 focus lock, 53 multi-spot focus, 52 single-spot focus, 52 formats. See digital formats f-stops digital cameras, 36 film cameras, 34 Fuji DS-7 camera flash, 49 onboard memory, 44

Fuji Print-It printers, 98 Funnel filter, 243

• G •

gamut, 274 GIF (Graphics Interchange Format) format defined, 274 description, 88 interlaced, 122 versus JPEG format, 120-121 saving as, 122-123 transparent Web images, 121–125 gigabyte, 274 glare. See hot spots Gradient Fill dialog box, 208 graphic formats. See digital formats Graphics Interchange Format (GIF) format. See GIF (Graphics Interchange Format) format grayscale. See also black-and-white converting from color, 157 defined, 274 description, 38 Guided Activities, 141-143

• H •

hard drives, 83 host-based printing, 102–103 hot spots, 50, 67 HSB color model, 38, 275 HSL color model, 275 Hue/Saturation dialog box, 216–217 hyperlinks from images, 119 HyperZine, 267

•] •

image editing. See also colors; image layers; painting images; selections adding space around images, 169-170 background fillers, 170 blemishes, touching up, 165–166, 187 - 190blend modes, 214 blurred images, 158-164 borders, 209-210 brightness, 154-156 changing formats, 145 cloning pixels, 211–212 cloud effects, 245-246 Clue Cards, 143 contrast, 154-156 cost, 140 creating images, 144 cropping, 150–151 cursor shapes, 179, 202-203 darkening images, 154-156, 206 distorting images, 235–239 editing selected areas, 148 fading in and out, 190-191 filters, 241-243 fleshtones, 163 floating layers, 184–185 focus, 158-164 Guided Activities, 141–143 help, 141-143 lightening images, 154-156, 206 main window (illustration), 142 marquees creating, 150 defined, 143, 275 selection outlines, and, 172 opacity, 213, 215 See also transparency

opening images, 143–144 outlines, 209-210 overlaying images, 206 PDD format, 144 perspective, 235–239 photo negative effects, 206 pinching images, 241-243 Preview check box, blinking line, 148 previewing images, 148–149 red eye, removing, 165 resampling, 168 resizing images before copying, 183 do's and don'ts, 166-168 rotating images, 144, 151 saving images, 145–146 selection outlines, 172 selection points, 178 sharpening images, 158-164 special effects, 241-243, 247 stretching images, 235–239 strokes, 210 tools, accessing, 141-142 touching up blemishes, 165–166, 187-190 transparency, 210-211 See also opacity transparent backgrounds, 170 tutorials, 141-143 twirling images, 241–243 undoing mistakes, 147-148, 184 zoom marquee, 143 zooming in/out, 143, 148 image editors. See also PhotoDeluxe cost, 20, 58, 140 opening images on the camera, 82 sample images on companion CD, 140 image formats. See digital formats

image layers deleting from camera, 46 activating, 224-226, 228 displaying on-screen. See displaying adding, 228-229 images on-screen blend modes, and, 233-234 editing. See image editors; blending, 233-234 PhotoDeluxe copying, 227, 229 file names, 80 creating collages with, 235-239 on greeting cards, 263 defined, 224-226 hyperlinks from, 119 deleting, 228-229 inline graphics, 130 fading in/out, 232-233 interlaced, 122 and file size, 234 life expectancy, 85 flattening, 234 lightening, 154-156 hiding, 228 moving from camera to computer. See merging, 234 downloading images moving, 230-231 in multimedia presentations, 14, 114 opacity, 232-233 on name badges, 263 printing, 228 opening, 143-144 rearranging, 228, 231-232 organizing. See organizing images resizing, 230-231 painting. See painting images rotating, 230-231 previewing. See previewing images saving in non-PDD format, 230 printing. See printers; printing images selections, and, 227 progressive, 122 text, 232 resizing, 166-168 images. See also cameras, digital; online rotating, 144, 151 resources; PhotoDeluxe in sales materials, 261 attaching to e-mail, 13, 114, saving, 145-146 128-130, 260 scanning, 19 blemishes, touching up, 165-166 as screen savers, 114 sharpening, 158-164 See also image editing; selections on business cards, 263 special effects, 13 on calendars, 262 on specialty media, 261–263 cataloging. See organizing images in spreadsheets, 262 combining. See compositing illustration, 14 creating, 144 on stationery, 263 darkening, 154-156 touching up blemishes, 165-166 in databases, 13, 262 See also image editing; selections defined, 10

transparent backgrounds, 170 as wallpaper, 114, 131-135, 263 on Web sites, 119-120, 260 imaging arrays, 22 indexed color, color model, 38 inkjet printers, 95 inline graphics, 130 InstantFix command, 165-166 interlaced images, 122 Internet resources. See online resources Internet telephony, 48 interpolation displaying images on-screen, 116 resolution, and, 41 inverting selections, 180–181 ISO film speed equivalents, 36–37

• 1 •

Jaz drives, 83

(JPEG) format. See JPEG (Joint Photographic Experts Group) format

JPEG (Joint Photographic Experts Group) format, 275
compression, 42–43
defined, 86–87, 275
versus GIF format, 120–121
for photographs, 125–128
progressive, 122
saving as, 126–128

Joint Photographic Experts Group

keyboard shortcuts Brightness/Contrast command, 154 Color Balance command, 152–154

color saturation, 157 Color to Black/White command, 244 copy to Clipboard, 183 creating images, 144 crop tool, 150 cursor shapes, 202 Cursors dialog box, 215 cut to Clipboard, 183 deleting selections, 181 Eraser tool, 210 gradient fills, 207 Hue/Saturation dialog box, 217 inverting selections, 181 Move Tool, 183 opening images, 144 paint brushes, 198 painting large areas, 204, 205 paste from Clipboard, 183 Rectangle tool, 175 resetting dialog box options, 149 Saturation command, 157 saving images, 145-146 selection tools, 174 Text Tool dialog box, 218 undoing mistakes, 147-148 zooming in/out, 143 Kilobytes, 275 Kodak DC120 camera illustration, 10 lenses, 50-51 memory, 44 print quality, 15 resolution, 41 Kodak digital warehouse, 84 Kodak DVC-300 camera, 47

Kodak Web site, 266

• [•

lag time, 56 laser printers, 95–96 layers. See image layers Layers palette, 227–228 LCD screens defined, 275 as viewfinders, 45-47 lens adapters, cost, 57 lenses cost, 57 Dycam 10-C, 51 Kodak DC120, 50-51 Minolta Dimâge V, 50-51 Levels command, 156 lightening images, 154–156, 206 lighting. See also exposure, digital cameras; flash photography backlighting, 67–69 bounce lighting, 71 daylight, 71 drop outs, 67 hot spots, 67 and image quality, 254 makeshift studio, 70 reflections. See hot spots requirements for digital cameras, 16 shadows, 67 Lightness command versus Brightness/Contrast command, 158 line art. See grayscale Line tool, 194, 201–202 lossless compression, 86, 275 lossy compression, 86, 275 LZW compression, 86

• M •

Macintosh versus PC, 40 magazines, 58 marquees creating, 150 defined, 143, 275 selection outlines, and, 172 maximum storage capacity, 45 MD-1000 printers, 97 megabytes, 275 megapixel cameras, 49 megapixels, 275 memory, camera, 43-45 See also RAM memory card adapters, 57 memory card readers, 57 memory cards. See PC cards micro-dry printers, 97-98 miniature cameras, 48 Minolta Dimâge V camera illustration, 10 lenses, 50–51 monochrome images, 244 See also black-and-white; grayscale multi-spot focus, 52

• N •

National Television Standards Committee (NTSC), 51
native file formats, 85
negatives, transferring to CD, 87
New Layer dialog box, 229
newsgroups
digital photography, 268
printing images, 103
Nikon Coolpix 100 camera, 48
noise, 275

• 0 •

Object Selection tool, 179-180 on-board memory, 43-45 online magazines, 267-268 online resources Canon Web site, 266 Digital Camera Club Web site, 267 digital photography newsgroups, 268 DPI magazine Web site, 267 HyperZine, 267 Kodak Web site, 84, 266 manufacturers' Web sites, 269 newsgroups about printing, 103, 268 online magazines, 267-268 Publish magazine Web site, 268 ZoneZero magazine Web site, 267 opacity See also transparency image editing, 213, 215 image layers, 232-233 painting images, 198-200, 205 painting text, 222 opening images, 143-144 organizing images Extensis Portfolio, 92 by keyword, 92 PhotoRecall, 92 PolyView, 90-91 Presto! PhotoAlbum, 91 Outline command, 209-210 Oval tool, 174-175 overexposure, 33

overlaying images, 206

• p •

painting images background colors, 194 blend modes, 205-207 brushes, 198-200 colors, selecting Macintosh, 197-198 Windows, 195-197 drawing straight lines, 201–202 filling large areas, 204-205 foreground colors, 194 gradient fills, 207-208 opacity, 198-200, 205 smudging colors, 203-204 painting text deleting text blocks, 220 filling with patterns, 222 opacity, 222 plain, 217-220 reordering text, 220 special effects, 220-222 Text layer, 220 Panasonic TruPhoto printers, 98 paper print image quality, and, 256 selecting, 104 Paste command, 183 PC cards, 43-45, 56-57 PC versus Macintosh, 40 PCMCIA cards, 275 See also PC cards PDD format, 144 perspective, 235-239 Perspective command, 239-241

Phase Alteration Line-rate (PAL), 51 photo albums. See organizing images Photo CD format, 87–88, 275 photo negative effects, 206 Photo Size dialog box, 167 PhotoDeluxe program Blend options, 205–207 Brightness/Contrast command description, 154 versus Lightness command, 158 Brush tool, 194 Canvas Size command, 169–170 Circle tool, 174-175 Clone tool, 191, 211-213 Clouds filter, 245 Color Balance command, 152–153 Color Change tool, 215-216 Color to Black/White command, 244 Color Wand tool, 175–177 commands, accessing, 141-142 Contrast control, 156 Copy command, 183 crop tool, 150–151 Cut command, 182 Despeckle command, 166 Distort command, 239–241 Eraser tool, 210 Funnel filter, 243 Instant Fix command, 165-166 Layers palette, 227–228 Levels command, 156 Lightness command versus Brightness/Contrast command, 158 Line tool, 194, 201–202 Object Selection tool, 179–180 Outline command, 209–210 Oval tool, 174-175

Paste command, 183 Perspective command, 239–241 Polygon tool, 177 Rectangle tool, 174–175 Remove Dust & Scratches command, 165-166 Remove Red Eye command, 165 Saturation command, 156-158 Sharpen command, 159 Sharpen Edges command, 159 Sharpen More command, 159 SmartSelect tool, 178-179 Smudge tool, 203-204 Soften command, 163–164 Square tool, 174–175 Text Tool, 217-218 tools, accessing, 141–142 Trace tool, 177 Twirl filter, 243 Unsharp Mask command, 159–160 Variations command, 153–154 photographs JPEG format, and, 125-128 transferring to CD, 87 photography, film history of, 1 PhotoRecall program, 92 PICT format, 89, 275 pictures. See images pinching images, 241–243 pixel dimensions, 30 pixels computer monitors, and, 30–31 converting to inches, 118 defined, 275 and resolution, 25–33 platforms, defined, 276 playing to a TV/VCR, 51–52

Polygon tool, 177 PolyView program, 90-91 Portable Network Graphics (PNG) format, 88-89 PostScript printing, 103 ppi (pixels per inch) defined, 276 versus dpi (dots per inch), 107–108 Presto! PhotoAlbum program, 91 Preview check box, blinking line, 148 previewing images as thumbnails, 148-149 with TWAIN, 82 in viewfinder, 46 prices of equipment. See costs print speed, 101 printers cables, 110 Casio QG-100, 95 cost of consumables, 101-102, 104 cost of printers, 20 dpi (dots per inch), 99-100 drivers, 110 dye-sub, 96-97, 274 dye-sublimation, 96-97, 274 Epson Stylus Color 600, 95 Fargo Primera Pro, 96–97 Fargo Pro Elite, 96–97 Fuji Print-It, 98 host-based printing, 102–103 inkjet, 95 laser, 95-96 maintenance, 111 MD-1000, 97 micro-dry, 97-98 Panasonic TruPhoto, 98 paper, selecting, 104

PostScript printing, 103 print speed, 101 quality settings, 101 selecting, 98-100 thermal autochrome, 98 thermal wax, 97 thermal-dve, 96-97 warranties, 103 printing images color matching, 108-109 fading from sunlight, 111 output too dark, 110 print size, 107-108 professional services, 105 resolution, 107-108 sending files to the printer, 105–107 on specialty media, 14, 110 Pro Photo CD format, 87-88 proprietary file formats, 85 Publish magazine Web site, 268

• R •

RAM, requirements for downloading images, 44–45 recording audio, 52 recording from a TV/VCR, 51–52 Rectangle tool, 174–175 red eye defined, 50 removing, 165 reflections. See hot spots removable storage, 43–45 Remove Dust & Scratches command, 165–166 Remove Red Eye command, 165 resampling, 28–29, 168, 276

resizing images
before copying, 183
do's and don'ts, 166–168
resolution
calculating, 26, 32
camera settings, 40–41, 73
capturing images, 28–29, 32
on computer monitors, 30–31
cost, 17
defined, 276
displaying images on-screen, 116–118
enlargements, 32
file size, and, 33
image quality, and, 252
increasing, 28 – 29, 32
interpolation, 41
levels, comparison (illustration), 27
pixels, magnified (illustration), 26
pointillism, 25
print quality, and, 32
printing images, 31, 107–108
requirements, 29–30
resampling, 28
Revert to Last Saved command, 147
RGB color model
versus CMYK, 100
defined, 276
description, 37
illustration, 23–24
Ricoh RDC-2 camera
illustration, 10
recording audio, 52
video/audio connections, 82
rotating images, 144, 151
rule of thirds, 63
Run-Length Encoding (RLE), 89

• 5 •

Saturation command, 156–158 saving images, 145-146 scaling. See resizing images scanners, 11, 18 scanning, 19 screen savers, 114 Selection Fill dialog box, 205 selection outlines, 172 selection points, 178 selections copying, 182 creating, 171 deleting, 181, 186 feathering, 171, 187–190 inverting, 180-181 moving by dragging, 181, 185–186 moving by pixel, 183 moving with Clipboard, 182-184 pasting within selections, 184–185 refining, 180-181 self-timers, 52 shadows, 67 Sharpen command, 159 Sharpen Edges command, 159 Sharpen More command, 159 sharpening images defined, 276 image editing, 158-164 shutter speed digital cameras, 36 film cameras defined, 34 selecting, 35 shutters, 34 single-spot focus, 52

16-bit images, 273 slides, transferring to CD, 87 SLR conversion kits, 49 SmartSelect tool, 178-179 Smudge tool, 203-204 Soften command, 163-164 software catalog programs cost, 58 Extensis Portfolio, 92 opening images on the camera, 82 PhotoRecall, 92 PolyView, 90-91 Presto! PhotoAlbum, 91 on companion CD, 280-284 costs, 58 for downloading, 56 image editors. See also PhotoDeluxe cost, 20, 58, 140 opening images on the camera, 82 sample images on CD, 140 Sony Digital Mavica camera, 43 sound, recording, 52 special effects, 241-243, 247 Square tool, 174-175 storage devices floppy disks, 83 hard drives, 83 interchangeability, 85 Jaz drives, 83 Kodak digital warehouse, 84 removable storage, 43-45 Syjet drives, 83 writeable CDs, 84 Zip drives, 83 stretching images, 235-239 strokes, 210

Syjet drives, 83 system requirements computer systems, 19 image editors, 20 printers, 20 **RAM**, 19 scanners, 18 storage devices, 20

• T •

tagged image file format (TIFF) format, 87, 276 taking good pictures. See composition Talbot, William Henry Fox, 1 television displaying images on. See video-out North American versus European standards, 51, 81–82 NTSC standard, 51, 81-82 PAL standard, 51, 81-82 recording from. See video-in text. See painting text Text Tool, 217-218 Text Tool dialog box, 218 thermal autochrome printers, 98 thermal wax printers, 97 thermal-dye printers, 96-97 thumbnail previews, 148-149 touching up blemishes, 165–166, 187-190 Trace tool, 177 transparency, 210-211 See also opacity backgrounds, 170 brushing on, 210-211 Web images, 121–125 tripod mounts, 55

tripods
costs, 57
image quality, and, 254–255
truth in advertising, 246
TWAIN
defined, 276
previewing images with, 82
24-bit images
defined, 273
Twirl filter, 243
twirling images, 241–243

· U •

underexposure, 33
Undo command, 147–148
undoing mistakes
color to black-and-white
conversions, 244
PhotoDeluxe, 184
Revert to Last Saved command, 147
Undo command, 147–148
Unsharp Mask command, 159–160
Unsharp Mask dialog box, 161–162
Unsharp masking, 276
uploading images, 78, 276

. V .

Variations command, 153–154
Variations dialog box, 153
VCRs
displaying images on. See video-out recording from. See video-in video, 47–48
video cameras, 47–48
videoconferencing, 48
video-in
defined, 51
Ricoh RDC-2 camera, 81–82

video-out defined, 51 Ricoh RDC-2 camera, 81–82 viewfinders, 45–47

• W •

wallpaper, 114, 131–135 warranties, 56 Web sites. *See also* online resources digital images on, 13 wide angle shots, 51 Windows Bitmap (BMP) format, 89, 273 Windows Color dialog box, 195 writeable CDs, 84

• Z •

Zip drives, 83
ZoneZero magazine Web site, 267
zoom lenses, 50–51
zoom marquees, 143
zooming in/out, 143, 148

1,000			

			VALUE OF THE PARTY

	_
	-
	_
	_
	_
	_
	-
	_
	_
	-
	-
	_
	_
	_
	-
	-
	_
	_
	-
	_
	_
	_
	-
	-

		0		
				· · · · · · · · · · · · · · · · · · ·
2				
		8		
			2	
	*			

-	

		e ^c	
**************************************	1		

The Easiest Way to Share Your Photos with Family and Friends! SAVE \$5 — Order Presto!® PhotoAlbum™ NOW!

Take Digital Photos!

Take photos with your digital camera, or scan your favorite print photos from

- Vacations, holidays, special events. . .
- Birthdays, parties, graduations. . .
- Weddings, anniversaries, baby showers. . .
- Reunions, get-togethers, farewell parties, bon voyage parties, retirement parties. . .
- Picnics, BBQs, celebrations, sleep-overs. . .

Make Digital Photo Albums!

Add photos from digital cameras and scanners to Presto! PhotoAlbum for Windows 95!

- Share with family and friends via disk, e-mail, or post on the Internet!
- Real photo album interface
- Create custom or template albums
- Photo Browser views thumbnails quickly
- Drag and drop photos, frames, clip art, shadows, and more! 200+ clip art included!

Order the full version of Presto! PhotoAlbum!

www.newsoftinc.com

or call toll-free 800-214-7059!

While supplies last. For your \$5 discount, mention code IDG98.

Please add shipping/handling charges and 8.25% sales tax for California addresses.

Presto! PhotoAlbum 30-Day Trial Included on CD!

Better Photos for only \$99!

It's possible with Ulead PhotoImpact — the first image editing software for your PC to provide a complete range of state-of-the-art photographic editing tools. The result is first-rate, high-quality digital photos you can use practically anywhere — even on the Internet! With PhotoImpact's WebExtensions (included with your purchase), you can optimize your photos so they download quickly, create beautiful seamless backgrounds and 3-D buttons, and even design your very own GIF animations.

Use Photoimpact to

- ✓ Produce exciting images quickly using the Guided Workflow Tools™.
- ✓ Create advanced effects with Magic Text, Artist Textures, Particle Systems, and Painting Effects.
- ✓ Explore your creative potential with intuitive Pick-and-Apply[™] editing tools that allow you to paint or clone images using natural media brushes like Paintbrush, Airbrush, Crayon, Charcoal, Marker, and more!
- ✓ Create innovative 3-D text and objects with bevels, extrusions, and lighting-source controls.
- ✓ Design exciting photo frames with Frame Designer.
- ✓ Catalog your priceless photographs with PhotoImpact Album (included with your purchase).

Free Learning to See Creatively CD-Rom

Anyone serious about taking better photographs will benefit from this interactive CD-ROM based on the book by award-winning photographer Bryan Peterson. Peterson's proven teaching methods give you insight into elements of design, like line, form, color, shape, pattern, and texture. Learn practical ways to make the most of your lenses, in addition to reviewing composition techniques. Buy today, and receive *Learning to See Creatively* for free — a \$50 value.

Buy Today!

If you're a Windows® 95 or NT user, Ulead PhotoImpact is the easiest way to edit and manage your photographs!

Call:

(800) 85-ULEAD

and ask for offer D-CD

*Price does not include s/h and applicable CA sales tax.

LEARN THE ART OF PHOTOGRAPHIC COMPOSITION ON CD-ROM!

Learning to See Creatively features:

Learn photographic composition by exploring its principles, techniques, or specific examples

Customize your Photography
Workshop, choosing from
88 topics

Find that great composition hidden in your snapshot

Hundreds of before-andafter pairs reinforce composition techniques

More than 700 photographs, optimized for standard 256-color monitors

Hear the author narrate his experiences in over 200 sound clips

Experiment with different settings in PhotoLabs on aperture, shutter speed, film speed, and lenses

Choose different lenses in this Photolab — from 28mm to 300mm — and see results on-screen

DIAMAR

PhotoSuite...

The Easiest Way to Edit, Organize and Be Creative With Your Photos!

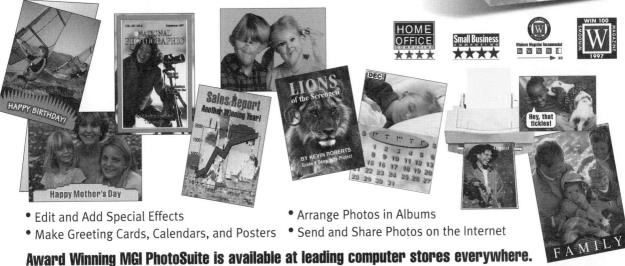

FREE MGI PhotoGallery A \$14.95 Value

when you purchase a copy of MGI PhotoSuite. Offer valid until Dec. 31, 1998 MGI PhotoGallery contains over 500 stunning professional photos and images in 24-bit color, including: Backgrounds, Textures, Landscapes, and much more!

BONUS MAIL-IN OFFER from MGI Software Corp.

To receive your FREE copy of MGI PhotoGallery:

- 1. Purchase a copy of MGI PhotoSuite between September 1, 1997 and December 31, 1998.
- 2. Complete the information below.
- 3. All store receipts must be dated no later than December 31, 1998.
- All mail-in coupons and appropriate paperwork must be received by MGI Software no later than January 31, 1999.
- 4. Please attach to this mail-in coupon your MGI PhotoSuite registration card and proof of purchase. You may send in either a photocopy of the original receipt OR the original itself.
- Please mail to: MGI PhotoSuite FREE PhotoGallery Offer (# MGI139), MGI Software Corp., P.O. Box 2017, Buffalo, NY 14240-8972

name:			
Address:		Suite/Apt/Unit #:	
City:	9	State/Prov:	
Zip/Postal Code:	9	Daytime Phone #:	

Limit one PhotoGallery per name/family/address. Offer good in USA and Canada only. Vold where prohibited, taxed, or restricted by law. MGI Software Corp. reserves the right to request additional information regarding this claim, and the right to confirm identification. Offer valid for future versions of MGI PhotoSuite. Cannot be combined with any other offer. Priority Code MGI139 © Copyright 1989-1997 MGI Software Corp. All rights reserved. PhotoSuite, the PhotoSuite logo, and the MGI logo are trademarks or registered trademarks of MGI Software Corp. All other product names are trademarks or registered trademarks of their respective trademark holders.

Award-winning imaging software.

How's that for a perfect picture?

Now you can save \$5.00 on Polaroid's Before & After, the digital imaging software that enhances the brightness, sharpness, color, and contrast of digitized pictures on a PC — instantly! No wonder Windows Sources magazine gave it the 1997 Expert Choice Award.

> IMAGE OHALITY ASSURED BY POLAROID

You can use it to correct

- Softness and fuzziness
- Over- or under-exposure
- Poor contrast, color imbalance, and dark shadows All you do is point, click, and voila!

For more information about Before & After — and other Polaroid digital products — call **1-800-816-2611.**

www.polaroid.com

End User Mail-in Rebate

'Polaroid" and "Before & After" are trademarks of Polaroid Corporation

Federal Tax ID #/Social Security # _

Receive a \$5.00 rebate on Before & After imaging software from Polaroid

Please Print:	Soutce + Colonor's Soutce		SOILWA
End User Name			
Company Name (if appli	cable)		
Street			
City		State	Zip
Federal Tax ID #/Social	Security#	Telepho	ne #

 Each claim form must be accompanied by a valid, computer generated invoice from your reseller to you. No purchase orders copies will be accepted. Invoice must reflect a delivery date between October 1, 1997 and December 31, 1999. • Multiple invoices may accompany one claim form per End User but may only be submitted once at the

CLAIM FORM REQUIREMENTS/PROGRAM GUIDELINES

end of the program. • Incomplete forms will not be accepted. • A check will be mailed within 45 days of receipt. • All claims must be submitted by January 31, 2000. No exceptions. • Any person who submits fraudulent claims will be excluded from participation in this or any future program. Please mail claim form with invoice to: Mary A. Walor-Kazalski, Polaroid Corporation, 575 Technology Square, 4, Cambridge, MA 02139, (617) 386-9337. NO FAX COPIES WILL BE ACC

Valid from October 1, 1997 through December 31, 1999

Introducing...
PhotoMAX ImageMaker Software

An easy-to-use imaging software product that helps you to

- Edit your pictures
 - Manually or with "one touch" IQA
- Create electronic postcards
 - Full multimedia: sound, pictures, video, and text
- The world's easiest Web page builder
 - Create, edit, and publish in minutes
- Create photo fantasies with your favorite pictures

For more information about PhotoMax and other Polaroid digital products — call

1-800-816-2611 www.polaroid.com

IMAGE QUALITY ASSURED BY POLAROID

Receive \$5.00 off PhotoMAX

End User Mail-in Rebate | Valid from October 1, 1997 through December 31, 1999

ImageMaker Software from Polaroid.

Please Print:		
End User Name		
Company Name (if applicable)		
Street		
City	State	. Zip

Federal Tax ID #/Social Security # _

CLAIM FORM REQUIREMENTS/PROGRAM GUIDELINES Each claim form must be accompanied by a valid, computer generated invoice from your reseller to you. No purchase orders copies will be accepted. Invoice must reflect a delivery date between October 1, 1997 and December 31, 1999. • Multiple invoices may accompany one claim form per End User but may only be submitted once at the end of the program. • Incomplete forms will not be accepted. • A check will be mailed within 45 days of receipt. • All claims must be submitted by January 31, 2000 No exceptions. • Any person who submits fraudulent claims will be excluded from participation in this or any future program. Please mail claim form with invoice to: Mary A. Walor-Kazalski, Polaroid Corporation, 575 Technology Square, 4, Cambridge, MA 02139, (617) 386-9337. NO FAX COPIES WILL BE ACCEPTED.

Photo Management Made Easy!

"The best program we've found for maintaining a useful photo catalog." FamilyPC, July/August 1997

> Designed for Windows® 95 and Windows® NT

And then....

E-mail your Photo Album to family and friends!

Photo Management Made Easy!

Visit us at www.ga-imaging.com Tel: 819-772-7600 or 1-888-772-7601

ADDITIONAL FEATURES:

- catalog images in a central database
- search albums, networks, and local drives
- · organize pictures in albums
- edit photos and apply special effects
- produce instant slide shows
- catalog photo CDs
- "Portable Player"

Save \$ 5.00 on the full version of

with this mail-in rebate!

Available at:

Attach this coupon to a copy of proof of purchase and return it to the address below.

Name: Address:

E-mail: Phone No.:

Only originals, no facsimiles will be accepted. G&A Imaging Ltd. 975 St-Joseph Blvd., Hull, Quebec, Canada J8Z 1W8

PRINT COLOR CONPUTER FROM YOUR COMPUTER

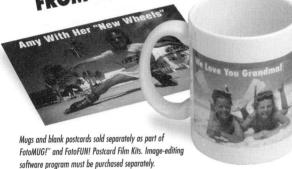

With the FotoFUN! Digital Color Photo Printer, you can take any image from a variety of sources — including Photo CDs,[™] digital cameras, and on-line services — and print real color photos from your computer. Your FotoFUN! prints will be bright, sharp, and clear — with quality as good as photos developed from traditional film.

Plus, you can

- Make your own photo postcards for holiday greetings or special announcements.
- Use your image-editing software to crop photos and add text for a unique, personal message.
- Create personalized photo coffee mugs for gifts or souvenirs.

SAVE \$10

On a FotoFUN! Print Film Kit

(Includes paper and ribbon for 36 prints; regular price \$34.95)

Please have your credit card number and FotoFUN!
Printer serial number available at the time of your call.
To redeem this offer, call 1-800-327-4690.

Limited to one redemption per customer. Not valid with any other offer.

Expires November 30, 1998, This offer is good in the U.S. only. ©1997 FARGO Electronics, Incorporated

Call 1-800-327-4622 to order your FotoFUN! today!

FARGO ELECTRONICS, INCORPORATED

7901 Flying Cloud Drive, Eden Prairie, MN 55344 U.S.A. For more information, call (800) 327-4622 or (612) 941-9470 or fax (612) 941-7836 World Wide Web: www.fargo.com • E-mail: sales@fargo.com

The more creative you get, the more creative it gets.

panoramic movies macro close-ups black & white color titles blue sepia tricolor sound slides posterization presentations

Introducing the Casio QV-200 digital camera

www.casio.com

	For free information about the new CASIO QV-200, please send this coupon to: CASIO INC., DIGITAL IMAGING DIVISION, 570 MT PLEASANT AVENUE, DOVER, NJ 07801
Name _	
Street _	Apt
City	State Zip

BUY PHOTO-PAINT 7 AND RECEIVE \$50* CASH BACK

Original Photo

Effects: Human Software SQUIZZ!™

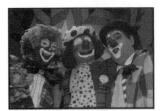

Merge Two Photos

Effects: AutoF/X™ Photo/Graphic Edges™

Effects: Kai's Power Tools® Spheroid Designer

Effects: Artistic/Impresionist

TEN REASONS TO PURCHASE PHOTO-PA

- 1. Internet graphic file formats (BIF, JPEG, PNG)
- 2. Thirty levels of command-based Undo
- 3. Accurate color representation with Kodak Digital Science™ Color Management System
- 4. Context-sensitive Property Bar with fully customizable user interface
- 5. Faster loading, editing and saving of large images
- 6. New tools Image Sprayer and Scissors Mask
- 7. Laver editing for easy object manipulation and movement
- 8. Graphic tablet and pen support
- 9. Free-form object transformation rotate, size, skew
- 10. Over 100 special effect filters

BUY PHOTO-PAINT 7 AND RECEIVE \$50* CASH BACK

To receive your Corel PHOTO-PAINT™ 7 Plus \$50 rebate:

- Buy Corel PHOTO-PAINT 7 Plus between Nov. 1, 1997 and Dec. 31, 1997 This rebate offer does not apply to Corel's licensing programs or to academic or OEM
- versions of the above mentioned Corel product

 Mail this form along with the UPC bar code from the box and the original or legible photocopy of your receipt from the product listed above to:

U.S.A.:

Corel PHOTO-PAINT™ 7 Plus Rebate Offer P.O. Box 52924, Dept. 12384 Phoenix, AZ, 85072-2924

Canada: Corel PHOTO-PAINT™ 7 Plus Rebate Offer P.O. Box 748, Dept. 12385 Haliburton, ON, KOM 1SO

(Photocopies, facsimiles or reproductions of bar codes will not be accepted.)

- To qualify, your redemption form must be received on or before Jan. 31, 1998
- . Allow up to 10 weeks to receive your rebate check
- Limit one rebate per name or household
- . This promotion is void where prohibited or restricted by law
- · All trademarks or registered trademarks are the property of their respective
- Corel is not responsible for lost, destroyed, misdirected, postage due or delayed mail . Offer valid in U.S.A. and Canada only

Warning: Fraudulent submission could result in federal p (Titles 18, United States Code, Sections 1341 and 1342) osecution under mail fraud statutes

Please print your full address clearly for proper delivery of your rebate:

Apt. No .: Address:

City:

State/Province:

ZIP + 4 Code/ Postal Code: Telephone:

Location Purchased:

IDG Books Worldwide, Inc., End-User License Agreement

READ THIS. You should carefully read these terms and conditions before opening the software packet(s) included with this book ("Book"). This is a license agreement ("Agreement") between you and IDG Books Worldwide, Inc. ("IDGB"). By opening the accompanying software packet(s), you acknowledge that you have read and accept the following terms and conditions. If you do not agree and do not want to be bound by such terms and conditions, promptly return the Book and the unopened software packet(s) to the place you obtained them for a full refund.

- 1. License Grant. IDGB grants to you (either an individual or entity) a nonexclusive license to use one copy of the enclosed software program(s) (collectively, the "Software") solely for your own personal or business purposes on a single computer (whether a standard computer or a workstation component of a multiuser network). The Software is in use on a computer when it is loaded into temporary memory (RAM) or installed into permanent memory (hard disk, CD-ROM, or other storage device). IDGB reserves all rights not expressly granted herein.
- 2. Ownership. IDGB is the owner of all right, title, and interest, including copyright, in and to the compilation of the Software recorded on the disk(s) or CD-ROM ("Software Media"). Copyright to the individual programs recorded on the Software Media is owned by the author or other authorized copyright owner of each program. Ownership of the Software and all proprietary rights relating thereto remain with IDGB and its licensers.

3. Restrictions on Use and Transfer.

- (a) You may only (i) make one copy of the Software for backup or archival purposes, or (ii) transfer the Software to a single hard disk, provided that you keep the original for backup or archival purposes. You may not (i) rent or lease the Software, (ii) copy or reproduce the Software through a LAN or other network system or through any computer subscriber system or bulletin-board system, or (iii) modify, adapt, or create derivative works based on the Software.
- (b) You may not reverse engineer, decompile, or disassemble the Software. You may transfer the Software and user documentation on a permanent basis, provided that the transferee agrees to accept the terms and conditions of this Agreement and you retain no copies. If the Software is an update or has been updated, any transfer must include the most recent update and all prior versions.
- 4. Restrictions on Use of Individual Programs. You must follow the individual requirements and restrictions detailed for each individual program in the "About the CD" Appendix of this Book. These limitations are also contained in the individual license agreements recorded on the Software Media. These limitations may include a requirement that after using the program for a specified period of time, the user must pay a registration fee or discontinue use. By opening the Software packet(s), you will be agreeing to abide by the licenses and restrictions for these individual programs that are detailed in the "About the CD" Appendix and on the Software Media. None of the material on this Software Media or listed in this Book may ever be redistributed, in original or modified form, for commercial purposes.

5. Limited Warranty.

- (a) IDGB warrants that the Software and Software Media are free from defects in materials and workmanship under normal use for a period of sixty (60) days from the date of purchase of this Book. If IDGB receives notification within the warranty period of defects in materials or workmanship, IDGB will replace the defective Software Media.
- (b) IDGB AND THE AUTHOR OF THE BOOK DISCLAIM ALL OTHER WARRANTIES, EXPRESS OR IMPLIED, INCLUDING WITHOUT LIMITATION IMPLIED WARRANTIES OF MERCHANTABILITY AND FITNESS FOR A PARTICULAR PURPOSE, WITH RESPECT TO THE SOFTWARE, THE PROGRAMS, THE SOURCE CODE CONTAINED THEREIN, AND/OR THE TECHNIQUES DESCRIBED IN THIS BOOK. IDGB DOES NOT WARRANT THAT THE FUNCTIONS CONTAINED IN THE SOFTWARE WILL MEET YOUR REQUIREMENTS OR THAT THE OPERATION OF THE SOFTWARE WILL BE ERROR FREE.
- (c) This limited warranty gives you specific legal rights, and you may have other rights that vary from jurisdiction to jurisdiction.

6. Remedies.

- (a) IDGB's entire liability and your exclusive remedy for defects in materials and workmanship shall be limited to replacement of the Software Media, which may be returned to IDGB with a copy of your receipt at the following address: Software Media Fulfillment Department, Attn.: Digital Photography For Dummies, IDG Books Worldwide, Inc., 7260 Shadeland Station, Ste. 100, Indianapolis, IN 46256, or call 800-762-2974. Please allow three to four weeks for delivery. This Limited Warranty is void if failure of the Software Media has resulted from accident, abuse, or misapplication. Any replacement Software Media will be warranted for the remainder of the original warranty period or thirty (30) days, whichever is longer.
- (b) In no event shall IDGB or the author be liable for any damages whatsoever (including without limitation damages for loss of business profits, business interruption, loss of business information, or any other pecuniary loss) arising from the use of or inability to use the Book or the Software, even if IDGB has been advised of the possibility of such damages.
- (c) Because some jurisdictions do not allow the exclusion or limitation of liability for consequential or incidental damages, the above limitation or exclusion may not apply to you.
- 7. U.S. Government Restricted Rights. Use, duplication, or disclosure of the Software by the U.S. Government is subject to restrictions stated in paragraph (c)(1)(ii) of the Rights in Technical Data and Computer Software clause of DFARS 252.227-7013, and in subparagraphs (a) through (d) of the Commercial Computer–Restricted Rights clause at FAR 52.227-19, and in similar clauses in the NASA FAR supplement, when applicable.
- 8. General. This Agreement constitutes the entire understanding of the parties and revokes and supersedes all prior agreements, oral or written, between them and may not be modified or amended except in a writing signed by both parties hereto that specifically refers to this Agreement. This Agreement shall take precedence over any other documents that may be in conflict herewith. If any one or more provisions contained in this Agreement are held by any court or tribunal to be invalid, illegal, or otherwise unenforceable, each and every other provision shall remain in full force and effect.

Installation Instructions

his is the bare-bones information you need to get to see the stuff on the CD. For more-detailed information, see Appendix B, "What's on the CD?"

For Windows 3.x Users:

- 1. Insert the CD into the CD-ROM drive and close the drive.
- 2. From the Program Manager, choose File⇔Run.
- 3. Type d:\setup.exe (assuming that D is your CD-ROM drive).
 A license agreement window appears.
- 4. Click Accept and the CD interface appears.
- 5. To view the items within a category, click the category's name.
- 6. For more information about a program, click the program's name.

For Windows 95 Users:

- 1. Insert the CD into the CD-ROM drive and close the drive.
- 2. Click the START button, and then click RUN.
- 3. Type d:\setup.exe (assuming that D is your CD-ROM drive). A license agreement window appears.
- 4. Click Accept and the CD interface appears.
- 5. To view the items within a category, click the category's name.
- 6. For more information about a program, click the program's name.

For Macintosh Users:

- 1. Insert the CD into the CD-ROM drive and close the drive.
- 2. Double-click on the CD icon to show the CD's contents.
- 3. To install a program, drag the program's folder from the CD window and drop it on the Hard Drive icon.
- 4. For larger programs, open the program's folder on the CD and double-click the icon with the word Install or Installer.

Discover Dummies Online!

The Dummies Web Site is your fun and friendly online resource for the latest information about ... For Dummies® books and your favorite topics. The Web site is the place to communicate with us, exchange ideas with other ... For Dummies readers, chat with authors, and have fun!

Ten Fun and Useful Things You Can Do at www.dummies.com

- 1. Win free ... For Dummies books and more!
- 2. Register your book and be entered in a prize drawing.
- 3. Meet your favorite authors through the IDG Books Author Chat Series.
- 4. Exchange helpful information with other ... For Dummies readers.
- 5. Discover other great ... For Dummies books you must have!
- 6. Purchase Dummieswear™ exclusively from our Web site.
- 7. Buy ... For Dummies books online.
- 8. Talk to us. Make comments, ask questions, aet answers!
- 9. Download free software.
- 10. Find additional useful resources from authors.

Link directly to these ten fun and useful things at

http://www.dummies.com/10useful

For other technology titles from IDG Books Worldwide, go to www.idgbooks.com

Not on the Web yet? It's easy to get started with Dummies 101°: The Internet For Windows 95 or The Internet For Dummies, 4th Edition, at local retailers everywhere.

Find other ...For Dummies books on these topics:

Business • Career • Databases • Food & Beverage • Games • Gardening • Graphics

Hardware • Health & Fitness • Internet and the World Wide Web • Networking

Office Suites • Operating Systems • Personal Finance • Pets • Programming • Recreation

Sports • Spreadsheets • Teacher Resources • Test Prep • Word Processing

IDG BOOKS WORLDWIDE BOOK REGISTRATION

We want to hear from you!

Visit **http://my2cents.dummies.com** to register this book and tell us how you liked it!

- Get entered in our monthly prize giveaway.
- ✓ Give us feedback about this book tell us what you like best, what you like least, or maybe what you'd like to ask the author and us to change!
- ✓ Let us know any other ... For Dummies topics that interest you.

Your feedback helps us determine what books to publish, tells us what coverage to add as we revise our books, and lets us know whether we're meeting your needs as a ... For Dummies reader. You're our most valuable resource, and what you have to say is important to us!

Not on the Web yet? It's easy to get started with *Dummies 101*®: *The Internet For Windows*® 95 or *The Internet For Dummies*®, 4th Edition, at local retailers everywhere.

Or let us know what you think by sending us a letter at the following address:

...For Dummies Book Registration Dummies Press 7260 Shadeland Station, Suite 100 Indianapolis, IN 46256 Fax 317-596-5498